PUBLISHING MANIFESTOS

PUBLISHING MANIFESTOS

**an international anthology from artists and writers
edited by michalis pichler**

Miss Read · Berlin · missread.com
The MIT Press · Cambridge, Massachusetts · London · mitpress.mit.edu

Miss Read ISBN: 9783962870034
MIT Press ISBN: 9780262544924

Library of Congress Cataloging-in-Publication Data is available
Library of Congress Control Number: 2018967128

First MIT Press and Miss Read paperback edition, 2022
© 2019, 2022 Massachusetts Institute of Technology, Miss Read
© 2019, 2022 the authors of the individual texts

Publishing Manifestos

Appendix

Publishing Publishing Manifestos

Michalis Pichler

The majority of the work compiled in *Publishing Manifestos* stems from the twenty-first century. Because that is our context, as artists, and just as people—but it also reflects the explosion, in recent decades, of independent publishing, art publishing, publishing as artistic practice, alternative media, publishing in or as counterculture, and zine-, DIY- and POD-scenes. *Publishing Manifestos* features key texts of critical engagement with publishing from protagonists of the field, arranged in chronological order. It will function as a reader and collection of source material, that is characterized by heterogeneity and incoherence.

In addition to revisiting historical texts, we asked artists and publishers:

- Do you have a manifesto?
- A mission statement?
- Why do you (or do not) publish; what keeps you going?
- Who are the giants or dwarfs, or normal-sized, self-chosen historical predecessors and relatives, on whose shoulders one is standing today?
- Which related ideas have been formulated and deserve to be remembered or improved?

Manifestos, traditionally, have taken the form of a declaration of ideals and intentions that call for urgent change, often addressing political and social questions, the *Communist Manifesto* being an urtext of the genre.

While the title of this book can be read in different ways—equally as indicating "manifestos about publishing" as well as the "publishing of manifestos"—we should be clear that not all of the texts reproduced here are manifestos in the strict sense. Some are proclamatory, some are written in retrospect to control the meaning of one's activity, some are playful, and some just push the borders. Ultimately, those borders are all to the point.

One implicit aim of this publication would be to address and overcome the confinement of an Anglo- and Euro-centric perspective, which often comes all too "naturally" and enforces a white canon. One aim is to crack open the understanding of who independent publishers are, and to argue for a global perspective.

Against Alienation

In *Power Relations within Existing Art Institutions*, Adrian Piper analyzes "the process by which individuals are recruited into the ranks of art practitioners as artists (and also, secondarily, as critics, dealers, etc.) within existing art institutions and thereby abdicate their social, intellectual, economic, and creative autonomy."[1] She calls this process aesthetic acculturation. Piper goes on to analyze how the division of labor between artists and other art practitioners often relegates the conceptual articulation, evaluation, and validation of artworks to art critics, thus promoting a critical hegemony of Eurocentric, formalist art values which in turn leads to the invisibility of much non-formalist art. Moreover, the legal control over the distribution, exhibition, and exchange of artworks is often left solely to art dealers.

In radical publishing, especially self-publishing and zine culture, this division of labor is reversed, with artists and authors engaging in all sorts of different and unalienated roles: creators, designers, producers, printers, publishers, and distributors. Such practices heed the call of →Riot Grrrl: "We must take over the means of production in order to create our own meanings [...] Because we are interested in non-hierarchical ways of being." Twenty-five years later, →Temporary Services describe "crafting a variegated approach to how you create, publish, distribute, and build a social ecosystem around your efforts" and encourage the exploration "of the ways it can build up and strengthen the community around these printed forms," while →Joachim Schmid praises "the flexibility of being able to make a book within one week if necessary, instead of waiting years for a publisher's approval."

Indeed, one is tempted to say that in publishing as practice—perhaps more than in any other art field—artists have been able to assert the aesthetic value of their own sociopolitically informed concerns and to engage, often under precarious conditions, in cultural activities fully aligned with their political values.

The economics of publishing are a concern, both in terms of production and sustenance. Can one pay to print? Can one pay the rent—not just for a studio, but also for housing? When making books and/or art, is one living *for* or *from* it? Why does everybody always want to prove that one's own publishing activity pays for itself, that one does (or at least theoretically *could*) "break even"? Does this desire arise from mere optimism, or naiveté, or does it betray a more emancipative impulse? As →Tauba Auerbach puts it: "It's not a priority to make it work financially, other than the fact that I would like to prove to myself that it's possible to have a viable business that isn't compromised."[2]

Seriosity Dummies

When Ulises Carrión (→IDEA POLL) issued his warning that "the only trouble with artists' books is that they have gained the attention of museums and collectors," he was mainly referring to the rising exchange value of artists' books as commodities. Today, the situation has intensified, as the art world has become acutely aware of the symbolic capital and distinctive value of art publishing. To conceive of the scene of independent publishing as a protected niche, accordingly, has become increasingly difficult. When I was growing up in West Berlin in the 1980s, a popular bumper-sticker read: "Stell Dir vor, es ist Krieg und keiner geht hin" (Suppose they gave a war and nobody came). The slogan appeared to strike a cocky, tongue-in-cheek tone. Only years later did I realize that the phrase came from a poem attributed to Bertolt Brecht, where the line actually continues: "dann kommt der Krieg zu Dir" (then war will come to you).[3]

The art world and art press really only express interest in the established names, which are usually represented and marketed by commercial galleries, as if the supremacy of wall pieces and "gallery art" over "book art" was more than a misunderstanding. When only commercially successful names get canonized, it distorts our perspective of the range of works actually produced, as when it recuperates a culturally diverse scene only to have market forces and the celebrity system brought down on it. Some of the most interesting artists are involved with publishing today and operate unaffiliated with galleries.

For this reason, artists and authors must not leave the field of contextualizing and theorizing publishing practice to scholars or other interested players of the art world (dealers, collectors, curators, and so on). If one hesitates to participate in the rather questionable process of canonizing, one might recall Mike Kelley's argument for radically subjective histories and canons in "Artist/Critic": "Most of the artists that influence *me* are absent from these accounts. Historical writing becomes a duty for the artist at this point."[4]

The coffee-table book *Artists Who Make Books*, edited by a major collector, an art critic, and a dealer of antiquarian commodities, gets a lot of things right: it argues for a perspective that perceives books as artworks in their own right. Also, it argues against the supremacy of wall pieces over publications. Still, it should have rather been called *Blue Chip Gallery Artists Who Make Books*, since that seems to have been part of the editorial selection (and exclusion) criteria. To reverse and expand Baldessari (→IDEA POLL) and phrase this critique differently: No artist should need to have an expensive line—as seriosity dummies, just in order to be considered serious, important, or to be considered at all—as that would keep art overblown and away from being ordinary.

There are other forms of exclusion as well, and they arrive with the insidious and "natural" ease of the ideological. The better art book fairs argue for an egalitarian and inclusive approach, but they only partly achieve it. For instance, the two largest art book fairs—the New York Art Book Fair and Miss Read, with 363 and 267 exhibitors in 2018 respectively—did not include even one publisher from Africa in their

most recent editions. Even this observation, however, betrays complexities, as there were exhibitors with African backgrounds. "Due to slavery, colonialism and their resultant mass displacements and diaspora of African peoples and cultures, it is no longer possible to speak of Africa or African as a mere geographic entity."[5] →Bibi Bakare-Yusuf implicitly acknowledges this diaspora when she claims that "the time has come to build a new body of African writing that links writers and readers from Benin to Bahia." →Marina Fokidis makes a similar point when she argues for "the concept of the South as a 'state of mind' rather than a set of fixed places on the map."

Still, one wonders why so much slips through the cracks. Is this due to the dominance of Anglo- and Eurocentric perspectives? "Which references? The English people have their own references—that certainly exclude ours, somehow," says →Ricardo Basbaum, and, in the words of →Alex Hamburger, addresses "problems related to the Third World artist (of course, in this particular case, Brazilian), and the tribulations faced in the so-called civilized world." How can we do something about it? A first step would be to admit one's own limitations and to listen to people grounded in and familiar with "non-Western" contexts.[6]

A Short Walk Through a Historical Arc of Tension

Publishing Manifestos spans over a century of statements, beginning with →Gertrude Stein and →El Lissitzky, who serve here as paradigms of the early modernist avant-garde, and the latter of Russian Constructivism also. The focus shifts to →Oswald de Andrade, a protagonist of Brazilian modernism, but also an early advocate of what we would today term *appropriation*; the concept, germane to marginal publishing practices, arises from de Andrade's argument that the strongest aspect of Brazil's culture is its history of "cannibalizing" other cultures, which in turn serves as a means for cultural assertion against the European model of cultural domination. As his "Anthropophagic Manifesto" posits, in short: "Tupi or not Tupi, that is the question." In English, in the original, the line performs the manifesto's central argument: simultaneously referencing the indigenous Tupi people of the southern Amazon, while also cannibalizing Shakespeare's "Hamlet." The bibliomaniac →Jorge-Luis Borges might not, at first glance, seem an obvious choice for manifestos on publishing; however, when participants at Berlin's annual Miss Read interview series[7] were asked about their ideal utopian library, they frequently cited the writer's "Library of Babel," often framing the question: "Borges" or "not Borges."

"The bourgeoisie, [...] by the immensely facilitated means of communication, draws all, even the most barbarian, nations into civilization. The cheap prices of commodities are the heavy artillery with which it batters down all Chinese walls,"[8] pronounce Karl Marx and Friedrich Engels in the *Communist Manifesto*. Performing their own argument about appropriation and repurposing, →Debord and Wolman take this up in "A User's Guide to Détournement," détourning the earlier text by replacing "bourgeoisie" with "détournement": "The cheapness of its products," in their revision, "is the heavy artillery that breaks through all the Chinese walls of understanding." Cheapness, as a strategy, will be a frequent key to the cultural battles waged by the publishing practices documented here.

"The New Art of Making Books" by →Ulises Carrión, has come to serve as a cornerstone of the critical discourse around (artists') books, and it accompanied his opening of Other Books and So in Amsterdam in 1975. The first bookshop, project space, and, later, archive entirely dedicated to the research and dissemination of artists' books, Other Books and So preceded Printed Matter, Inc. (New York), Zona Archives (Florence), and Art Metropole (Toronto). Until recently, Carrión, who never worked with a commercial gallery, was largely forgotten. Indeed, in 2009, when the Museum of Modern Art (MoMA) mounted an exhibition called "In & Out of Amsterdam: Travels in Conceptual Art, 1960–1976," it omitted Carrión altogether, despite the fact that he was a primary protagonist in Amsterdam during that time frame. Absent from both the exhibition and the accompanying catalog, the omission was all the more glaring given that the name of Carrión's Amsterdam-based publishing house, founded in 1972, was In-Out Productions. I guess the MoMA now owes us a Carrión show.

At the same time, Carrión might serve as a role model not only for the poet-artist, but also—in contrast to Marcel Broodthaers, who also comes to mind when considering the figure of the poet-artist—of the *independent* artist: the one who operates outside the commercial gallery system. Even though he had few illusions about the pitfalls of this (in)dependence, he insisted that "there will always remain a surplus of unsalable beauty." (→IDEA POLL)

In 1976, the cheaply produced newsprint journal *Art-Rite* conducted an →IDEA POLL and collected *Statements on Artists' Books by Fifty Artists and Art Professionals* connected with the medium, which is reproduced in its entirety here, thanks to Walter Robinson (whose attitude toward free distribution, a hallmark of *Art-Rite*, continues to this day, as evinced even in his permission: "Sure go ahead And good luck W Sent from my iPhone"). Conducted at a time when the hype around Conceptual art and bookworks had reached its climax, the survey responses include many insights and pithy slogans; or could one put it any better than →John Baldessari: "Every artist should have a cheap line." Accordingly, →Adrian Piper thoroughly examines the social and economic conditions that a *Cheap Art Utopia* would presuppose, among them people who "would be able to discriminate value in art without the trappings of preciousness, such as the gilt frame, the six-figure price tag, the plexiglass-case, the roped-off area around the work, etc."

In the present volume, the *Art-Rite* statements, along with texts by Ray Johnson, Stephen Willats, Ulises Carrión, General Idea, Rasheed Araeen, Allen Ruppersberg,

Lawrence Weiner, and a diagram by Clive Phillpot, represent the phase circa 1967–82, which now strikes us as the heyday of artists' books. In part, it saw an opening up of art toward the wider world, not just the art world, and, in part, it saw the art world's abolishment.

Artist's Book as a Term Is Problematic

According to Stefan Klima, three issues dominated the debate around artists' books (from about 1973 to 1998): publishing as an explicitly political act and the desire to challenge an art establishment; publishing as an implicitly political act and its challenge to imagine a new kind of reading; and finally, the very definition of what an "artist's book" might be.[9] While the first two issues are still pressing today, the term "artist's book" now sounds outdated.

To talk about *the* artist's book in the singular (as opposed to artists' books as a collective plural) was always paradoxical, because the field has always been extremely heterogeneous. That heterogeneity might be aptly described by the term *bibliodiversity*. With an allusion to the (post)Darwinist concept of biodiversity, François Benhamu has described a publishing environment wherein one finds "several species, but some are present in huge numbers while others are very scarce, and the ones with many copies are likely to eat or prevail over the others. This is what is happening in the book world."[10] In contrast to commercial, mainstream, mass-market publishing of normal and normative books and publications, the bibliodiversity is much greater in the realm of publishing as artistic practice, artists' books, conceptual publications, cuckoo's eggs, wolves in sheep's clothing, sheep in wolves' clothing, art as books, books as art, books as something else, primary information, bookworks, catalog exhibitions, and hybrid and entirely unclassifiable cases.

"Artist's book" as a term is problematic because it ghettoizes, enforces the separation from broader everyday practices and limits the subversive potential of books by putting an art tag on them. Robert Smithson discusses this process of cultural confinement when he critiques the "portable object or surface disengaged from the outside world [...] Once the work of art is totally neutralized, ineffective, abstracted, safe, and politically lobotomized, it is ready to be consumed by society. All is reduced to visual fodder and transportable merchandise."[11] Even when books are housed (entombed) in institutional libraries, their sequestering in "special collections" and "rare book" collections means that access to them is usually further complicated, typically putting restrictions, rules, limits, and the protocols of institutional bureaucracies between interested readers and the books they might want to experience. Any institution (including art libraries, exhibition spaces, and schools) that is serious about such material should acquire at least two copies of each item—and keep one of them on an unrestricted open shelf.

While extended discussions have taken place around the term, including heated debate over whether and where to put the apostrophe in "artist's book," Lawrence Weiner once cut through the Gordian knot by concluding: "Don't call it an artist's book, just call it a book."[12]

A book is a sequential collection of pages, loose leaf or bound, and it is circulating in multiple reproductions. But today, we are no longer only talking about books anymore—more capacious than *book*, the term *publication* is better because it can encompass digital files, hybrid media, and forms we have yet to imagine.

Publishing or *publications* as an umbrella term would include any form of circulating information, including books, zines, loose-leaf collections, flyers, e-books, blog posts, social media, and hybrids, as long as they are (or are meant to be) viewed or read by multiple audiences.

Moreover, the beauty of publications in contrast to white-cube gallery exhibitions lies in their ability to circulate in less controlled and potentially uncontrollable ways: "Words on paper seem to be not such a bad historical recording mechanism, because I know my books have gone all over the world, and they can't kill them all." (→V. Vale)

The other beauty of publishing is that it permits a great degree of efficiency, or, even better, sufficiency, if one's lifework fits into a plastic bag—and one is proud of that.

Materialzärtlichkeit

→Carrión, →bpNichol, and →McCaffery all question the notion of the book as a neutral container of language (or images), and they elaborate on the ways in which the material form of text—including, in most cases, the form of the book itself—can and should be consciously engaged and explicitly considered as an integral part of the overall work of art. In this tradition, →Zenon Fajfer invents the term "liberature," a portmanteau/*Wolpertinger*[13] combining "liber" and "literature" in order to signal a literary practice that makes conscious use of the book as a compositional entity.

The weaknesses of "the book"—its precarious assembly of materials—are, simultaneously, its strengths. All aspects of its materiality contribute to the book's value, from paper, ink, and typography to its format and binding, and beyond, various structural elements (pagination, cover, end-papers, gutter, etc.), even its modes of distribution. Ideally, if one consciously treats these elements as an ensemble, one can begin to articulate the book in terms of *Materialzärtlichkeit* (material tenderness). Anke te Heesen has used the term in the context of the everyday practice of collecting newspaper cut-outs as performed by several agencies in the early twentieth century and has argued that the operation of the newspaper cut-out constituted a re-singularization of the mass-produced object.[14] I would argue here for an expanded notion of the term *Materialzärtlichkeit* to include the conscious orchestration and use of material, structural and social elements, within the process of producing multiple books.

One should point out that *Materialzärtlichkeit* can then, accordingly, exist in the realm of digital publishing, which involves its own set of unique structural elements. Our

consciousness of that is still rare and vague, in part because we have yet to establish a critical vocabulary to describe its phenomena. In a step toward building that vocabulary, →Alessandro Ludovico attempts to dialogically juxtapose one hundred differences and similarities between digital and analog publications in an index in *Post-Digital Print*. For the time being, most e-books are digital files that seek to mimic a book, even though they are fundamentally different. Digital publishing has yet to blossom, like an ugly duckling whose potential and beauty is yet to be discovered.

Paradigm Shift and Post-digital Turn

There was a paradigmatic shift in art production in the late 1960s that can be summarized as a "linguistic turn" that led to the formation of Conceptual art, argues Liz Kotz in *Words to Be Looked At*.[15] Did we experience another paradigm shift as well around the turn of the millennium? With the advent of the internet, and the digital and post-digital world it ushered in, publishing as an artistic practice has been challenged and spurred into a new era of proliferation. In 1935, Walter Benjamin declared that "to an ever-increasing degree the work reproduced becomes the work designed for reproducibility."[16] If, as Benjamin argues, mechanical reproduction (in contrast to manual reproduction) destabilizes the hierarchy between original and reproduction, then digital reproduction (in contrast to mechanical reproduction) destabilizes the hierarchy between a physical copy (what Benjamin calls "reproduction") and a data file.

This dynamic finds a clear expression in Print on Demand (POD), in which publication is located in the interface. With POD, the text as a data file is already published once it has been uploaded to a distribution platform—it can be printed, to be sure, but it does not need to be. It might be read on a screen without ever setting ink to paper. During its availability (what for earlier modes of publishing we would have thought of as being "in print"), these files can be changed, without being marked as a new edition or "print-run." Therefore, through the destabilization of the hierarchy between data file and (physical) reproduction, the status of the work becomes more fluid and indeterminate. The same holds true not just for POD books, but for any digital artifact: there is a destabilization of the hierarchy between data files and their (digital) reproductions or alterations. As →Hito Steyerl notes: "You can keep the files, watch them again, even reedit and improve them if you think it necessary. And the results circulate."

Striving for success goes almost always along with striving for seriosity. Peter Sloterdijk calls this "serio-ism" and gravity of normalization. A book with a spine is more serious than a stapled one. A big publisher is more serious than a small publisher. Fighting against that gravity, certain communities have adopted an aesthetic announcing their anti-seriosist stance, such as self-publishing on POD-platforms, circulating the PDF for free, and opting for a generic layout even in hard-copy production, with cheap materials and technically non-exquisite execution. In the process, they acknowledge in the logic of the post-Benjaminian regime that "digital—and of course not only digital—reproducibility eludes the whole sphere of limitation." (→Michalis Pichler)

The spread of POD has had contradictory effects: far more is published, but far less is printed. Even as texts are still designed to be like printed books, and formatted to the structure of the codex, they are increasingly read only on the screen. This economy of POD circulation and consumption has unintended side effects; book-swapping among authors, for instance, has become increasingly rare, in part because the unit costs of production are much higher than those of an offset publication.

In *A History of Reading* Alberto Manguel points out that the Gutenberg revolution that followed the invention of the printing press did not actually obliterate handwriting but, on the contrary, sparked an interest in handwriting, which pushed the art of calligraphy to new heights in the coming decades. As →Tan Lin observes, paraphrasing Marshall McLuhan, "An era is defined not so much by the medium it gains as by the medium it gives up." Accordingly, e-publishing is far from replacing printed books, and it "still has a long way to go before it reaches the level of sophistication which printed pages have achieved over the course of a few centuries," as →Alessandro Ludovico argues. Ludovico goes on to predict that printed books may soon become vintage status objects, since "the real power of digital publishing lies not so much in its integration of multiple media, but in its superior networking capabilities." According to this logic, the most interesting digital publications will be those that involve community formation, networked activity, or open up new "processual" publishing practices. Simon Worthington imagines digital publications with references inline, where "any media cited or referenced should be available in full for transmedia publication," and attests that "the most high profile impediment to the transmedia publication has been copyright."[17]

Art Book Fairs as Public Spheres

Even if the buzz of interest in publishing as an art practice around the turn of the twenty-first century resembles the hype around the "artist's book" in the 1970s, the phenomenon of art book fairs in this quantity and intensity is something new. Since 2006 or so, independent art book fairs have been spreading like mushrooms. Every time you turn around, a new book fair has been founded. The way these fairs function is significantly different from the institutions (initially bookstores and often later archives) that emerged in the 1970s, such as Other Books and So, Printed Matter, Inc., Art Metropole, Zona Archive, Franklin Furnace, Archive for Small Press & Communication, Artpool Archive, and others.

Art book fairs today are not only a venue for representing a separate, prior publishing scene, they are also a central forum for constituting and nurturing a community around publishing as artistic practice. A global phenomenon, these communities take the form of agile, adaptable, and wide-ranging networks. Miss Read in Berlin and other comparable events in New York, Tokyo, Mexico City, Tehran, Moscow, London, Leipzig and elsewhere around the globe are culmination points of dispersed activities: periodically recurring meeting places in real time and real space, where people travel to gather together. One could say that art book fairs today serve the function of marketplaces, but not primarily in the economic sense; rather, they are marketplaces in the sense of the ancient agora: a physical place accessible to the common public, and a public sphere for negotiation and exchange.

It remains questionable in how far these events reach beyond their own primary demographic to involve communities beyond the upper and middle classes. However, the entrance barriers are, relatively, rather low. No gallery backup is needed. There are artists who have participated in numerous book fairs and whose works and ideas circulate without ever having worked with commercial galleries and are hence never shown at art fairs.

Art book fairs constitute their own global art circuit even though they are not as economically sustainable as the more profitable art fairs. When book fair exhibitors talk about "breaking even," they usually mean that they covered the table fee, perhaps travel expenses, and—if it went well—accommodation expenses; but they often neglect to take into account the production cost of the publications on display, much less the time and labor spent working at the fair. The economics, indeed, are rather precarious and often euphemistically called gift economies.

"A further caution," as →Michael Baers warns, "would concern the way critical art's resistance to cooptation has been eroded. [...] In fact, the culture industry has proved quite adept at assimilating any insurgent notions artists might entertain." The role of book fairs is thus somewhat a paradox, oscillating between creating open spaces for critical debates on the one hand and being primary examples of neoliberal event-driven culture on the other hand. At the same time, larger art fairs have been increasingly eager to embrace book-fair sections under their roofs as a sort of intellectual fig-leaf, while museums have come to welcome the visitors and energy that such fairs bring with them.

Miss Read initially came about when the KW Institute for Contemporary Art, Argobooks, and I (an institution, a publisher, and an artist, respectively) joined forces in 2009. KW stayed involved as a host for three years. The fair grew rapidly and, or so it seems, the scene around it, likewise. In 2014 we drew a Caucasian Chalk Circle, and since 2015,

when Yaiza Camps and Moritz Grünke joined the core team, Miss Read is artist-run.

From the start in 2009, however, it had an egalitarian and an inclusive approach. It was important to us that everybody had the same table size, whether they were a micropress zine or a large established publisher like the Verlag der Buchhandlung Walther König, or the MIT Press, for that matter. Moreover, we kept the table cost close to nothing. This inclusive approach extended to the audience as well, meaning that barriers to entry were absent both in economic terms (free admission) and in architectural terms. One driving incentive, to be sure, was to create and co-create a context for one's own work, but also for other people. It took a few years to realize that this was necessary—and possible. Something similar could be said about this book.

"Once you busy yourself with art, you will always fall from one catalogue to the next," Marcel Broodthaers once said,[18] lamenting the lost potential for pursuing other kinds of publications. The same is true, alas, for book fairs. *Publishing Manifestos*, in a sort of beta version, first came about in 2018 when the Miss Read team had become increasingly bored with the usual book fair catalogs that we, like most other fairs, kept producing every year. There had been attempts to play with the genre of "the catalog," for instance, by running artistic or literary texts—or what Seth Siegelaub would term *primary information*—through Miss Read catalogs.[19] The footnotes seemed to be an obvious choice for creating a subtext. These interventions seem to have gone unnoticed, but that's fine with us; they were a way to subvert the status of the publication a bit, and an attempt to turn it into a hybrid between exhibition catalog and *catalog exhibition*, providing a platform for a parasitic literary work, a clandestine B channel, an echo.

Possible Paths through *Publishing Manifestos*
The following list provides recurring themes, tags, and categories, with reference to texts (within this book) for further reading. Most of the texts could pop up under more categories than they are actually listed. The category "political" does not show up; it would be a fit-all term.

Structural Analysis of the Book
→El Lissitzky, →Ulises Carrión, →bpNichol, McCaffery, →Zenon Fajfer, →Erik van der Weijde, →Alessandro Ludovico

(Artists') Books and the Book as Alternative Mise-en-scene
→Ulises Carrión, →IDEA POLL, →Clive Phillpot →Lawrence Weiner, →Erik van der Weijde, →Paul Soulellis, →Kione Kochi, →Sara MacKillop

Appropriation
→Oswald de Andrade, →Guy Debord, Gil J Wolman, →Seth Price, →Anita Di Bianco, →Michalis Pichler, →Hito Steyerl, →AND Publishing, Lisa Holzer, David Jourdan, →Tan Lin, →Aurélie Noury, →Mariana Castillo Deball

Conceptual Writing
→Anita Di Bianco, →Tan Lin, →Riccardo Boglione, →Robert Fitterman, Vanessa Place, →Michalis Pichler, →Derek Beaulieu, →Aurélie Noury, →Paul Stephens, →Elisabeth Tonnard

Reading
→Jorge Louis Borges, →Ulises Carrión, →Anita Di Bianco, →Lisa Holzer, David Jourdan, →Tan Lin, →ed. Ntone Edjabe, →Matthew Stadler, →Aurélie Noury

Distribution
→Ray Johnson, →BIMBOX, →TIQQUN, →Riot Grrrl →Seth Price, →Matthew Stadler, →Mosireen, →Eleanor Vonne Brown, →Jan Wenzel

Self-publishing
→General Idea, →Tom Jennings, Deke Nihilson, →Riot Grrrl, →Joachim Schmid, →Boglione, Dworkin, Gilbert et al., →Temporary Services, →Tauba Auerbach, →Gloria Glitzer, →Sara MacKillop, →Bombay Underground, →V. Vale

Feminist
→Riot Grrrl, →AND Publishing, →Girls Like Us, →Urvashi Butalia, zubaan, →Bibi Bakare-Yusuf, →Arpita Das, →Queeres Verlegen

(Queer) Identities
→General Idea →BIMBOX, →Tom Jennings, Deke Nihilson, →Bruce LaBruce, →Karl Holmqvist, →Girls Like Us, →Arpita Das, →Queeres Verlegen

Social Context, Publishing, and Public Space
→Stephen Willats, →IDEA POLL, →Rasheed Araeen, Mahmood Jamal, →Riot Grrrl, →TIQQUN, →Anita Di Bianco, →Seth Price, →Kwani?, →Bernadette Corporation, →Hito Steyerl, →Matthew Stadler, →Chimurenga, →Eva Weinmayr, →Temporary Services, →Girls Like Us, →Jan Wenzel, →Sara MacKillop, →Bombay Underground

Tackling Western-Centrism
→Oswald de Andrade, →Rasheed Araeen, Mahmood Jamal, →Ricardo Basbaum, Alex Hamburger, →Mladen Stilinović, →Kwani?, →Marina Fokidis, →ed. Ntone Edjabe, →Bibi Bakare-Yusuf, →Urvashi Butalia, zubaan

(Not-)Corrupted Economies
→IDEA POLL (Adrian Piper, Ulises Carrión), →BIMBOX, →Riot Grrrl, →Mladen Stilinović, →Michael Baers, →Karl Holmqvist, →Tauba Auerbach, →Broken Dimanche Press, →Temporary Services, →Matthew Stadler, →Paul Chan

POD
→Joachim Schmid, →Paul Soulellis, →Alessandro Ludovico, →Mathew Stadler, →Tauba Auerbach

Internet and (Post-)Digital Publishing
→Seth Price, →Joachim Schmid, →Alessandro Ludovico, →Riccardo Boglione, →Constant Dullaart, →Paul Soulellis, →Derek Beaulieu, →Michalis Pichler, →Hito Steyerl, →Katja Stuke, Oliver Sieber, →Eric Watier

Poetics of the Everyday
→Gertrude Stein, →Guy Debord, Gil J Wolman, →Ray Johnson, →Allan Ruppersberg, →Hito Steyerl, →Elisabeth Tonnard

Material Conditions of Producing This Book
In 1961, Robert Morris produced a *Box with the Sound of Its Own Making*. The otherwise ordinary wooden box included internal speakers with an audio recording of the sound of the box's own construction. In 1979, Seth Siegelaub produced the anthology *Communication and Class Struggle* as a sort of book with the sound of its own making, explicitly discussing the conditions of its material production. The preface concedes that the book "in its 'editorial' and in its 'material' production, [...] does not escape the ruling economic laws of monopoly capitalism."[20] He went on to list general overhead, administration, authors, translators, permissions as "editorial," typesetting, printing, binding, delivery, and storage as "production costs proper," and he expanded a sense of production to include the significant cost of distribution (retailers' rebates, distributors' shares, etc.), which itself amounts to as much as 50% of the cost. As Johanna Drucker wryly quipped, "The 'democratic' multiple has to be highly subsidized to be affordable."[21]

In their "Reproduction Pricing Guideline for Artists," reproduced within this book as a sort of institutional critique, →Paul Chan and Badlands Unlimited discuss the political economy of actual existing arts publishing and argue that "publishing in the artworld echoes exploitative aspects of social media. Institutional and commercial publishing in contemporary art largely rely on—and sometimes demand—artists release the rights of their images for free. The 'acclaimative' value of being published is assumed to be enough."

The phenomenon is hardly new and hardly confined to the art world. Siegelaub goes on to write in his preface from 1979 that "normally the problem is solved [...] by decreasing, as much as socially possible, all the labor

costs attached," which then means that the "subsidy" has come in direct form from little or no payment to authors, contributors, and editors. The same is true for *Publishing Manifestos*, which has been funded by the generosity of the authors with their reproduction permissions. Beyond that subsidy, this book (its beta version in 2018) was partly funded by an Interdisciplinary Grant by Senatsverwaltung für Kultur Berlin and by a production team that was equally generous with its time and energy: at the MIT Press, acquisition editor Victoria Hindley; in the core Miss Read team Yaiza Camps and Moritz Grünke, joined by Natalia Saburova, Olivia Lynch, Alexander Zondervan, and Raül Fernandez Gil as interns. There was some money paid, but it was more a symbolic gesture than a wage.

This copublication between Miss Read and the MIT Press is an attempt to build an alliance between different publishing institutions: Miss Read is paying for the production cost of the book, including general overhead, administration, editing, copyediting, proofreading, design, printing and binding, and the distribution of contributor's copies, and will receive 30% of net profits. The book is subject to an industry standard discount of 40–50%, which means that, after expenses are deducted, any potential profit margin is likely to come down to 15–17% of the retail price for Miss Read, and not much more for the MIT Press either, receiving 70% of net profits. The latter is paying for (its) project management, the shipping costs, warehouse storage, order fulfill-ment, global distribution, and publicity. Marketing will be carried out by the MIT Press through sales representatives, catalogs, book fair participation, and the distribution of review copies, and by Miss Read and, presumably, by all contributors within their respective networks.

At a print run of 2000 copies (plus 200 reference copies) printed in Warsaw, and a retail price of $30, if the print edition sells out, both copublishers hope to break even, as far as costs proper are concerned.

There is a conflict between the desire to produce an affordable book—or producing a book at all—and real payment for real work of all people involved.

Have We Won?

For many people, their publishing practice is part of an attempt to find out. "We need a pool of ideas, concrete attempts and experiences. A new system cannot be designed on a drawing board," says Fabian Scheidler,[22] and he claims that we need *topias* rather than utopias—that is, concrete visions for real places and conditions.

We have reached a privileged historical moment when running a publishing house—or a book fair—can be art work. At the same time, it is *Sozialarbeit* (social work), "a mode of production analogous not to the creation of material goods but to the production of social contexts." (→Seth Price)

To be continued

Author's Note:
This text is built somewhat modular, the order of its chapters flexible. If read in a different order, that should also work (differently). During the process of writing, this text benefitted greatly from discussions with Eleanor Vonne Brown, Craig Dworkin, Martin Ebner, Annette Gilbert, Victoria Hindley, and Olivia Lynch.

1 Adrian Piper, "Power Relations within Existing Art Institutions," (1983) in *Out of Order, Out of Sight*, vol. 2 (Cambridge, MA: MIT Press, 1996), 63.

2 Tauba Auerbach, "A Conversation with Tauba Auerbach," *Artists Who Make Books*, ed. Andrew Roth, Philip E. Aarons, Claire Lehmann (London: Phaidon, 2017), 17.

3 In actuality, the phrase has been attributed to various authors; the first part comes from a poem by Carl Sandburg; the latter appears to stem from an anonymous author.

4 Mike Kelley's essay "Artist/Critic" was first published in German as the introduction to John Miller, *When Down Is Up: Selected Writings* (Frankfurt: Revolver Press, 2001) and is quoted here in *Social Medium: Artists Writing, 2000–2015*, ed. Jennifer Liese (Brooklyn: Paper Monument, 2016), 32.

5 Salah M. Hassan, in *Diaspora Memory Place*, ed. Cheryl Finley and Salah M. Hassan (Munich: Prestel Verlag, 2008), 130.

6 For *Publishing Manifestos*, valuable advice came from numerous people, especially from Tau Tavengwa, scholar at the African Centre for Cities in Cape Town; Chiara Figone, Archive Books, Berlin; Regina Melim, par(ent)esis, Florianópolis; John Tain, Head of Research at the Asia Art Foundation in Hong Kong; Sneha Ragavan, Asia Art Foundation Researcher in Delhi; and Siddhartha Lokanandi, bookseller in Berlin.

7 See the Miss Read website at missread.com/interviews/. Hedieh Ahmadi (Bongah, Tehran), Derek Beaulieu (no press, Calgary), AA Bronson (Berlin), Eleanor Vonne Brown (X Marks the Bökship, London), Mariana Castillo Deball (Berlin), Jesper Fabricius (Space Poetry, Copenhagen), Chiara Figone and Paolo Caffone (Archive Books, Berlin), Eugen Gomringer (Rehau), Marc Herbst (Journal of Aesthetics & Protest, Leipzig and Los Angeles), Takashi Homma (Tokyo), Miyuki Kawabe (commune Press, Tokyo), Sharon Kivland (MA BIBLIOTHEQUE, Sheffield), Son Ni (nos:books, Taipei), Lexi Miller (Undertone Collective, San Francisco), Jonathan Monk (Berlin), León Muñoz Santini (gato negro, Mexico City), Paul Soulellis (New York), and Tony White (Watson Library, New York).

8 Karl Marx and Friedrich Engels, *Manifesto of the Communist Party* (1848) (London: Red Republican, 1850).

9 Stefan Klima, *Artists Books: A Critical Survey of the Literature* (New York: Granary Books, 1998), 7.

10 Françoise Benhamou, "Les assises et leurs suites. Comptes rendus des assises internationales de l'édition indépendante et programme prévisionnel d'action 2008–2009 de l'Alliance des éditeurs indépendants" (Paris: International Alliance of Independent Publishers, 2009), 28–29.

11 Robert Smithson, "Cultural Confinement," *The Writings of Robert Smithson*, ed. Nancy Holt (New York: New York University Press, 1979).

12 Lawrence Weiner, in conversation with the author, unpublished interview, November 25, 2013.

13 In German folklore, a *Wolpertinger* is a fantasy animal said to inhabit the alpine forests of Bavaria. In taxidermy, it is a body comprising body parts from various animals.

14 Anke te Heesen, *Der Zeitungsausschnitt. Ein Papierobjekt der Moderne* (Frankfurt: Fischer Taschenbuch Verlag, 2006), 18.

15 Liz Kotz, *Words to Be Looked At* (Cambridge, MA: MIT Press, 2007).

16 Walter Benjamin, "The Work of Art in the Age of Its Technological Reproducibility" (1935), *Walter Benjamin: Selected Writings*, 3: 1935–1938, ed. and trans. Michael Jennings (Cambridge, MA: Harvard University Press, 2006), 256.

17 Simon Worthington, *Book to the Future: A Manifesto for Book Liberation* (Hybrid Publishing Consortium, 2012), 23.

18 Marcel Broodthaers, leaflet published by Musée d'Art Moderne, Département des Aigles, Sections Art Moderne et Publicité, 1972.

19 In 2011, the German artist Achim Lengerer had already created column titles as an intervention in the catalog, which were comprised of excerpts from *Ästhetik des Widerstands (Esthetics of Resistance)* by Peter Weiss. In 2016, Cia Rinne inserted footnotes comprised of her *missing notes from notes for soloists*, and in 2017 Simon Morris supplied footnotes from his book *Re-Writing Freud*; in 2018 Elisabeth Tonnard included *The Bird*, an adapted chapter of her book *They Were Like Poetry* as footnotes.

20 Seth Siegelaub, "A Communication on Communication," *Communication and Class Struggle* (Amsterdam: International General, 1979), 20.

21 Johanna Drucker, "Artists' Books and the Cultural Status of the Book," *Journal of Communication* 44, no. 1, (Winter 1994): 39.

22 Fabian Scheidler, "Chaos: Das Neue Zeitalter der Revolutionen" (Vienna: Promedia Verlag, 2017).

PUBLISHING MANIFESTOS

Book
Gertrude Stein 1914

Gertrude Stein, "Book," *Tender Buttons: Objects, Food, Rooms* (New York: Claire Marie, 1914), 28–29.

Book was there, it was there. Book was there. Stop it, stop
it, it was a cleaner, a wet cleaner and it was not where it was
wet, it was not high, it was directly placed back, not back
again, back it was returned, it was needless, it put a bank, a
bank when, a bank care.

Suppose a man a realistic expression of resolute reliabil-
ity suggests pleasing itself white all white and no head does
that mean soap. It does not so. It means kind wavers and lit-
tle chance to beside beside rest. A plain.

Suppose ear rings, that is one way to breed, breed that.
Oh chance to say, oh nice old pole. Next best and nearest a
pillar. Chest not valuable, be papered.
Cover up cover up the two with a little piece of string and
hope rose and green, green.

Please a plate, put a match to the seam and really then
really then, really then it is a remark that joins many many
lead games. It is a sister and sister and a flower and a flower
and a dog and a colored sky a sky colored grey and nearly
that nearly that let.

The Future of the Book

El Lissitzky 1926

El Lissitzky, "The Future of the Book" (1926), *New Left Review* 41 (January–February 1967).

Every artistic innovation is unique, it has no development. In time different variations on the same theme grow up around innovation, maybe higher, maybe lower, but they will rarely reach the original power of the first. This goes on until long familiarity has made the effect of the work of art so automatic that the senses no longer react to the worn means and the time is ripe for a further technical innovation. However, the "technical" and the "artistic" (so-called) are inseparable, so we must not lightly dispose of a profound relationship by means of a few slogans. At any rate, the first few books printed by Gutenberg with the system of movable type which he invented remain the finest examples of the art of book production.

The next few hundred years saw no basic innovations (until photography) in this field. In typography there are just more or less successful variations accompanying technical improvements in the manufacturing apparatus. The same happened with a second discovery in the visual field—with photography. As soon as we give up assuming a complacent superiority over everything else, we must admit that the first Daguerro-types are not primitive artifacts needing improvements, but the finest photographic art. It is short-sighted to suppose that machines, i.e., the displacement of manual by mechanical processes, are basic to the development of the form and figure of an artifact. In the first place, the consumer's demand determines the development, i.e., the demand of the social strata that provide the "commissions." Today this is not a narrow circle, a thin cream, but "everybody," the masses. The idea moving the masses today is called materialism, but dematerialization is the characteristic of the epoch. For example, correspondence grows, so the number of letters, the quantity of writing paper, the mass of material consumed expand, until relieved by the telephone. Again, the network and material of supply grow until they are relieved by the radio. Matter diminishes, we dematerialize, sluggish masses of matter are replaced by liberated energy. This is the mark of our epoch.

What conclusions does this imply in our field?

I draw the following analogy:

Inventions in the field of verbal traffic	Inventions in the field of general traffic
Articulated language	Upright gait
Writing	The wheel
Gutenberg's printing-press	Carts drawn by animal power
?	The automobile
?	The airplane

I have produced this analogy to prove that so long as the book remains a palpable object, i.e., so long as it is not replaced by auto-vocalizing and kino-vocalizing representations, we must look to the field of the manufacture of books for new basic innovations in the near future, so that the general level of the epoch can be reached in this field.

There are signs to hand suggesting that this basic innovation is likely to come from the neighborhood of the collotype. Here we have a machine which captures the subject matter on a film and a press which copies the negative of the material on to sensitive paper. Thus the frightful weight of the subject matter and the bucket of dye is omitted, so that once again we have dematerialization. The most important thing here is that the mode of production of words and pictures is included in the same process: photography. Up till now photography is that mode of expression which is most comprehensible. We have before us the prospect of a book in which exposition has priority over letters.

We know of two kinds of writing: one sign for each concept—hieroglyphic (modern Chinese); and one sign for each sound—alphabetic. The progress of the alphabetic over the hieroglyphic mode is only relative. Hieroglyphics are international. This means that if a Russian, a German, or an American fixes the sign (picture) of a concept in his mind he can read Chinese or Egyptian (soundlessly), without learning the language, for language and writing are always one creation as far as he is concerned.

We may conclude that:

1 the hieroglyphic book is international (at least potentially)
2 the alphabetic book is national, and
3 the book of the future will be non-national; for it needs the least education to understand it.

There are today two dimensions to the word. As sound it is a function of time; as exposition, of space. The book of the future must be both. This is how to overcome the automatism of the contemporary book. A world-view which has become automatic ceases to exist in our senses, so we are left drowning in a void. The dynamic achievement of art is to transform the void into space, i.e., into a unity conceivable for our senses.

An alteration in the structure and mode of language implies a change in the usual appearance of the book. Before the War, printed matter in Europe was appropriately enough converging in appearance in every country. A new optimistic mentality laying stress on immediate events and the fleeting moment underlay the origins in America of a new form of printing. They began to modify the relation of word and illustration in exposition into the direct opposite of the

European style. The highly developed technique of facsimile-electrotype (half-tone blocks) was especially important for this development; thus photomontage was born.

After the War, skeptical and stunned Europe marshaled a screaming, burning language: all means must be used to maintain and assert oneself. The catchwords of the epoch were "attraction" and "trick." The new appearance of the book was characterized by:

1 broken-up setting 2 photomontage and typomontage

These facts, which are the basis for our predictions, were already foreshadowed before the War and our Revolution. Marinetti, the siren of Futurism, also dealt with typography in his masterly manifestos. In 1909 he wrote:

The book will be the futurist expression of our futurist consciousness. I am against what is known as the harmony of a setting. When necessary we will use three or four colours to a page, and 20 different typefaces. E.g. we shall represent a series of uniform, hasty *perceptions* with *cursive*, a **scream** will be expressed in **bold** type and so on. So a new painterly typographic representation will be born on the printed page.

Many of today's creations do not go beyond this demand. I should like to stress that Marinetti does not call for playing with form as form, but asks rather that the action of a new content should be intensified by the form.

Before the War the notion of the simultaneous book was also proposed and, in a sense, realized. This was in the Poem of Blaise Cendrars, typographically conceived by Sonia Delaunay-Terk. It is a foldable strip of paper 5 feet long—an attempt at a new book-form for poetry. The lines of poetry are printed in color, with colors always discontinued in the content and changed into others.

In England during the War the Vortex group published their magazine *Blast!* in a crude, elementary style, using almost only unrelieved capitals, a style which has become the token of all modern international printing.

In Germany, the 1917 Prospectus of the little *Neue Jugend* Portfolio is an important document of the new typography.

The new movement which began in Russia in 1908 bound painter and poet together from the very first day; hardly a poetry book has appeared since then without the collaboration of a painter. Poems have been written with the lithographic crayon and signed. They have been cut in wood. Poets themselves have set whole pages. Thus the poets Khlebnikov, Kruchenykh, Mayakovski, Aseev have worked with the painters Rosanova, Goncharova, Malevich, Popova, Burlyuk, etc. They did not produce select, numbered, deluxe editions, but cheap unlimited volumes, which today we must treat as popular art despite their sophistication.

In the Revolutionary period a latent energy has concentrated in the younger generation of our artists, which can only find release in large-scale popular commissions. The audience has become the masses, the semi-literate masses. With our work the Revolution has achieved a colossal labor of propaganda and enlightenment. We ripped up the traditional book into single pages, magnified these a hundred times, printed them in color and stuck them up as posters in the streets. Unlike American posters, ours were not designed for rapid perception from a passing motorcar, but to be read and to enlighten from a short distance. If a series of these posters were today to be set in the size of a manageable book, in an order corresponding to some theme, the result would be most curious. Our lack of printing equipment and the necessity for speed meant that, though the best work was hand-printed, the most rewarding was standardized, lapidary and adapted to the simplest mechanical form of reproduction. Thus State Decrees were printed as rolled-up illustrated leaflets, and Army Orders as illustrated pamphlets.

At the end of the Civil War (1920), we had the opportunity to realize our aims in the field of the creation of new books, in spite of the primitiveness of the mechanical means at our disposal. In Vitebsk, we brought out five issues of a magazine called *Unovis*, printed by typewriter, lithography, etching and linocut.

As I have already written: "Gutenberg's Bible was only printed with letters. But letters alone will not suffice for the handing down of today's Bible. The book finds its way to the brain through the eyes, not through the ears; light waves travel much faster and more intensely than sound waves. But humans can only speak to each other with their mouths, whereas the possibilities of the book are multi-form."

With the advent of the period of reconstruction in 1922, the production of books also rose rapidly. Our best artists seized on the problem of book production. At the beginning of 1922 I and the writer Ilya Ehrenburg edited the periodical *Veshch-Gegenstand-Objet*, which was printed in Berlin. Access to the most developed German printing techniques enabled us to realize some of our ideas about the book. Thus we printed a picture-book, *The Story of Two Squares*, which we had finished in our productive period of 1920, and the *Mayakovski-Book*, which made even the form of the book corresponding to the particular edition a functional structure. At the same time our artists were exploring the technical possibilities of printing. The State Publishing House and other printing establishments put out books which were shown, and appreciated, at several international exhibitions in Europe. Comrades Popova, Rodchenko, Klutsis, Stepanova, and Gan devoted themselves to book design. Some worked directly in the printshop with the compositors and presses (Gan, et al.). The growing esteem in which book design is held is indicated by the practice of listing on a special page the names of all the compositors and finishers concerned with the book. This means that there has grown up in the printshops a stratum of workers who have developed a conscious relation to their craft.

Most of the artists produce montages, that is, lay out photographs and suitable captions together on a page which is then made into a block for printing. Thus is conceived a form of undeniable power, apparently very simple to handle and therefore easily diverted into banality, but in skillful hands extremely fruitful as a means to visual poetry.

At the outset we said that the expressive power of each artistic innovation is unique and has no development. The innovation of easel-painting made great works of art possible, but it has now lost this power. The cinema and the illustrated weekly have succeeded it. We rejoice in the new means which technique has put into our hands. We know that a close relation with the actuality of general events, the continuing heightening of the sensitivity of our optic nerves, the record-breaking speed of social development, our command over plastic material, the reconstruction of the plane and its space, and the simmering force of innovation have enabled us to give the book new power as a work of art.

Of course, today's book has not found a new overall structure, it is still a single volume with a cover, a back and pages 1, 2, 3, ... The same is true of the theater. Even our most modern drama plays in a theater-like a peepshow, with the public in the stalls, in boxes and in rows in front of the curtain. But the stage has been cleared of all the paraphernalia of painted scenery, the stage-space as a painted perspective has perished. A three-dimensional physical space has been born in the same peepshow, allowing maximal unfolding of the fourth dimension, living movement. Within the book modernism may not yet have gone so far, but we must learn to see the tendency.

Notwithstanding the crisis which book production, like every other area of production, is undergoing, the avalanche of books grows with every passing year. The book is the most monumental art form today; no longer is it fondled by the delicate hands of a bibliophile, but seized by a hundred thousand hands. This illuminates the hegemony of the illustrated weekly in this transition period. We should add to the number of illustrated weeklies the flood of children's picture books. Our children's reading teaches them a new plastic language; they grow up with a different relation to the world and space, to image and color, so they are preparing for a new kind of book. But we shall be satisfied if we can conceptualize the epic and lyric developments of our times in our form of book.

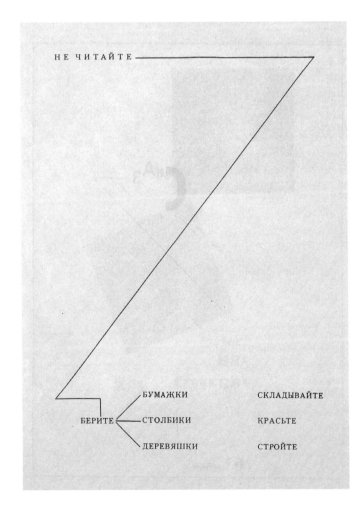

don't read

take paper fold
 columns color
 blocks build

Anthropophagic Manifesto
Oswald de Andrade 1928

Oswald de Andrade, "Anthropophagic Manifesto" (1928), in *The Forest and the School: Where to Sit at the Dinner Table*, ed. Pedro Neves Marques (Berlin: Archive Books, 2014).

Anthropophagy alone unites us. Socially. Economically. Philosophically.

The world's one and only law. Masked expression of all individualisms, of all collectivisms. Of all religions. Of all peace treaties.

Tupi or not Tupi, that is the question.

Against all catechisms. And against the mother of the Gracchi.

I am only interested in what isn't mine. Law of man. Law of the anthropophagous.

We are tired of all those suspicious catholic husbands made into drama. Freud put an end to the enigma of women and to other frights of printed psychology.

What hindered truth was clothing, the impermeable layer between the interior world and the exterior world. The reaction against the dressed man. American cinema will inform.

Children of the sun, mother of the living. Found and ferociously loved, with all the hypocrisy of longing, by the immigrants, by the slaves and by the tourists. In the country of cobra grande.[1]

This was because we never had grammars nor collections of old plants. And we never knew what was urban, suburban, limitrophe and continental. Idlers in the world map of Brazil.
 A participating consciousness, a religious rhythm.

Against all importers of canned consciousness. The palpable existence of life. And the pre-logical mentality for Mr. Lévy-Bruhl to study.

We want the Carib revolution. Bigger than the French Revolution. The unification of all effective revolts in the direction of man. Without us, Europe wouldn't even have its poor declaration of the rights of man.
 The golden age proclaimed by America. The golden age. And all the girls.[2]

Filiation. The contact with Carib Brazil. **Où Villegaignon print terre.**[3] Montaigne. The natural man. Rousseau. From the French Revolution to Romanticism, to the Bolshevik Revolution, the Surrealist Revolution, and Keyserling's technological barbarian. We walk on.

We were never catechized. We live by a somnambular law. We had Christ born in Bahia. Or in Belém do Pará.

But we never admitted the birth of logic among us.

Against Father Vieira. Author of our first loan, so that he could earn his commission. The illiterate king had told him: put it on paper but don't be too wordy. The loan was made. Brazilian sugar was taxed. Vieira left the money in Portugal and brought us the wordiness.

The spirit refuses to conceive the spirit without a body. Anthropomorphism. The need for an anthropophagic vaccine. For an equilibrium against the religions of the meridian. And external inquisitions.

We can attend only to the auracular world.[4]

We had justice, the codification of vengeance. Science, the codification of Magic. Anthropophagy. The permanent transformation of the Taboo into totem.

Against the reversible world and objectified ideas. Cadaverized. A stop to dynamic thought. The individual as a victim of the system. The source of classical injustices. Of romantic injustices. And a forgetfulness of inner conquests.

Routes. Routes. Routes. Routes. Routes. Routes. Routes.

The Carib instinct.

The life and death of hypotheses. From the equation **self** part of the **Cosmos** to the axiom **Cosmos** part of the **self**. Subsistence. Knowledge. Anthropophagy.

Against the vegetative elites. In communication with the soil.

We were never catechized. We did Carnival instead. The Indian dressed up as senator of the Empire. Pretending to be Pitt. Or featuring in Alencar's operas, brimming with good Portuguese feelings.

We already had communism. We already had the Surrealist language. The golden age.

Catiti Catiti
Imara Notiá
Notiá Imara
Ipejú.[5]

Magic and life. We had the relation and distribution of physical goods, of moral goods, of dignified goods. And we knew how to transpose mystery and death with the aid of some grammatical forms.

I asked a man what Law was. He replied it was a guarantee of the exercise of possibility. That man was called Galli Mathias. I ate him.[6]

Determinism is absent only where there is mystery. But what does that have to do with us?

Against the stories of man, which begin at Cape Finisterre. The undated world. Unsigned. Without Napoleon. Without Caesar.

The fixation of progress by way of catalogs and television sets. Only the machinery. And the blood transfusers.

Against antagonistic sublimations. Brought over on the caravels.

Against the truth of missionaries, defined by the sagacity of an anthropophagous, the Viscount of Cairu: It is a much-repeated lie.[7]

But those who came were not crusaders. They were fugitives from a civilization we are now eating, for we are strong and vengeful like the Jabuti.[8]

If God is the consciousness of the Uncreated Universe, Guaraci is the mother of the living. Jaci is the mother of plants.[9]

We did not have speculation. But we had divination. We had Politics, which is the science of distribution. And a social planetary system.

Migrations. The flight from tedious states. Against urban scleroses. Against the Conservatories, and tedious speculation.

From William James to Voronoff. The transfiguration of the Taboo into totem. Anthropophagy.[10]

The *paterfamilias* and the creation of the fable of the stork: real ignorance of things + lack of imagination + authoritarian attitude before the curious progeny.

To arrive at the idea of God, one must start from a profound atheism. But for the Carib this wasn't necessary. Because they had Guaraci.

The created objective reacts like the Fallen Angels. Afterward, Moses rambles on. What have we got to do with that?

Before the Portuguese discovered Brazil, Brazil had discovered happiness.

Against the torch-bearing Indian. The Indian son of Mary, godson of Catherine de Medici and son-in-law to Dom Antônio de Mariz.[11]

Joy is like casting out nines.

In the matriarchy of Pindorama.[12]

Against Memory, source of custom. Personal experience renewed.

We are concretists. Ideas take over, react, set fire to people in public squares. Let us suppress ideas and other paralyzes Exchange them for routes. To follow the signs, and believe in the instruments and the stars.

Against Goethe, the mother of the Gracchi, and the Court of Dom João VI.

The struggle between what one could call the Uncreated and the Creature—illustrated by the permanent contradiction between man and his Taboo. Everyday love and the capitalist *modus vivendi*. Anthropophagy. Absorption of the sacred enemy. To transform him into a totem. The human adventure. The earthly aim. Only the pure elites, however, were capable of realizing a carnal anthropophagy, which carries the highest meaning of life and avoids all the evils identified by Freud, catechist evils. What occurs is not a sublimation of the sexual instinct. It is the thermometric scale of the anthropophagic instinct. From carnal, it becomes elective and creates friendship. Affectionate, love. Speculative, science. It deviates and transfers itself. We reach vilification. Low anthropophagy agglomerated in the sins of catechism—envy, usury, calumny, murder. Plague of the so-called cultured and Christianized peoples, it is against them that we're acting. Anthropophagy.

Against Anchieta[13] singing the eleven thousand virgins of the sky, in the land of Iracema—the patriarch João Ramalho founder of São Paulo.[14]

Our independence has not yet been proclaimed. A phrase typical of Dom João VI: My son, put that crown on your head, before some adventurer puts it on his! We expelled the dynasty. It is necessary to expel the spirit of Bragança, the ordinations, and Maria da Fonte's snuff.[15]

Against social reality, dressed and oppressive, recorded by Freud—reality without complexes, without madness, without prostitution and without the penitentiaries of the matriarchy of Pindorama.

In Piratininga.
Year 374 of the swallowing of the Bishop Sardinha.[16]

1 Cobra grande, literally meaning big snake, is a mythological creature of Amazonian cosmologies and is spoken of throughout Brazil. It is associated with many myths. The most common depicts a nocturnal black snake that can shapeshift into many forms (canoes or a woman). It is feared as the most powerful underwater creature of the Amazon river and is also seen as a threat to the Amazonian land itself (e.g., the city of Belém). Myths of Tupi origin usually term the creature Boiúna (black snake) or Boiaçu (big snake). Raul Bopp, editor of the second "dentition" of the *Revista de Antropofagia*, wrote his seminal poem "Cobra Norato" inspired in the myth of cobra grande.

2 In the original manifesto, "girls" is in English.

3 "Oú Villegaignon print terre" is a quote from Michel de Montaigne's essay "Of Cannibals."

4 Oswald de Andrade uses the pun, "auracular," joining the word aural (relating to the ear) to oracular.

5 "New Moon, oh New Moon, breathe into Everyman memories of me." *Couto de Magalhães, O Selvagem* (*The Savage*) (Rio de Janeiro, 1876). Written upon request of Emperor Dom Pedro II of Brazil for the Centennial International Exhibition of Philadelphia, O Selvagem is an anthropological and linguistic study of Amerindian peoples; it is structured in two parts titled, "Program of General Language According to Ollendorf, including Original Texts of Tupi Myths," and "Origins, Customs, and Region of the Savages: Methods to Tame them through Military Colonies and Military Interpreters."

6 Galli Mathias refers to the word of unknown origins gallimaufry, meaning gibberish; the term was used by Montaigne in his essays and is linked to the invented "story of a lawyer who had to plead in a (law)suit about the cock of a man named Matthew, and in whose confused speech the frequently recurring Gallus Mathie became Galli Mathias." See the glossary of Henry Morley, ed., *The Essays of Michel Lord of Montaigne*, trans. John Florio (London: Routledge, 1886). Oswald de Andrade implies that European epistemology and discourse cannot apply to America, and thus that it can only be eaten and transformed.

7 José da Silva Lisboa, Viscount of Cairu (1756–1835) was a Brazilian politician, economist, and historian, as well as supporter of Dom Pedro I in the struggles for the Independence of Brazil. He was a follower of the Scottish political economist Adam Smith and supported the opening of trade with Brazil, which was highly restricted by the Portuguese crown until the early nineteenth century.

8 Turtle from the forest regions of Brazil and the Amazon.

9 In the Tupi-Guarani cosmologies, Guaraci refers to the Sun spirit or God who gives life to all things, while Jaci refers to the Moon spirit or God, protector of life and reproduction.

10 Serge Voronoff (1866–1951) was a French surgeon who gained fame for his technique of grafting monkey testicle tissue on the testicles of men for therapeutic purposes.

11 Dom Antônio de Mariz is the character of a Portuguese nobleman in the novel *O Guarany* (1857) by José de Alencar. In these verses, Oswald de Andrade is referring to Indianism, Brazilian nationalist art movement professed by the royal academies of Emperor Dom Pedro II in the late nineteenth century.

12 Pindorama is a word of Tupi origins, meaning "land of good harvest" or "land of palm," used to refer to Brazil.

13 José de Anchieta (1534–1597) was a Spanish Jesuit missionary to Brazil.

14 Iracema is one of the major novels of Brazilian Indianism, written by José de Alencar, and published in 1865. It narrates the romance between a Tabajara indigenous woman, Iracema, and the Portuguese colonist, Martim. In Tupi, the term Iracema means "beeswarm," and was used by Alencar as an anagram for America.

15 "The spirit of Bragança" refers to the Portuguese royal dynasty that ruled from the Discoveries until the end of the Portuguese monarchy in 1910, including the royal bloodline of Brazil. Mariada Fonte was a Portuguese woman famous for igniting the people's revolt (The Revolution of Maria da Fonte) of 1846–47 in Northern Portugal. The revolt was a consequence of social tensions lingering from the Portuguese liberal wars of 1828–34 between the constitutionalists and the absolutists, which saw Dom Pedro I leave the Brazil he had made independent to return to his home country.

16 Fernandes Sardinha, the first Portuguese bishop in Brazil, was sent to Salvador da Bahia from July 1552 to June 1556. On July 16, 1556, after suffering a shipwreck near Alagoas, he was eaten by Caeté Indians. Piratininga is a municipality in the state of São Paulo.

On the Cult of Books

Jorge Luis Borges 1946

Jorge Luis Borges, "On the Cult of Books" (1948), in *Selected Non-fictions*, trans. and ed. Eliot Weinberger (New York: Viking Penguin, 1999), 358–62.

In Book VIII of the *Odyssey*, we read that the gods weave misfortunes so that future generations will have something to sing about; Mallarmé's statement, "The world exists to end up in a book," seems to repeat, some thirty centuries later, the same concept of an aesthetic justification for evils.

These two teleologies, however, do not entirely coincide; the former belongs to the era of the spoken word, and the latter to an era of the written word. One speaks of telling the story and the other of books.

A book, any book, is for us a sacred object: Cervantes, who probably did not listen to everything that everyone said, read even "the torn scraps of paper in the streets." Fire, in one of Bernard Shaw's comedies, threatens the library at Alexandria; someone exclaims that the memory of mankind will burn, and Caesar replies: "A shameful memory. Let it burn." The historical Caesar, in my opinion, might have approved or condemned the command the author attributes to him, but he would not have considered it, as we do, a sacrilegious joke. The reason is clear: for the ancients the written word was nothing more than a substitute for the spoken word.

It is well known that Pythagoras did not write; Gomperz (*Griechische Denker* I, 3) maintains that it was because he had more faith in the virtues of spoken instruction. More forceful than Pythagoras' mere abstention is Plato's unequivocal testimony. In the *Timaeus* he stated: "It is an arduous task to discover the maker and father of this universe, and, having discovered him, it is impossible to tell it to all men"; and in the *Phaedrus* he recounted an Egyptian fable against writing (the practice of which causes people to neglect the exercise of memory and to depend on symbols), and said that books are like the painted figures "that seem to be alive, but do not answer a word to the questions they are asked." To alleviate or eliminate that difficulty, he created the philosophical dialogue.

A teacher selects a pupil, but a book does not select its readers, who may be wicked or stupid; this Platonic mistrust persists in the words of Clement of Alexandria, a man of pagan culture: "The most prudent course is not to write but to learn and teach by word of mouth, because what is written remains" (*Stromateis*), and in the same treatise: "To write all things in a book is to put a sword in the hands of a child," which derives from the Gospels: "Give not that which is holy unto the dogs, neither cast ye your pearls before swine, lest they trample them under their feet, and turn again and rend you." That sentence is from Jesus, the greatest of the oral teachers, who only once wrote a few words on the ground, and no man read what He had written (John 8:6).

Clement of Alexandria wrote about his distrust of writing at the end of the second century; the end of the fourth century saw the beginning of the mental process that would culminate, after many generations, in the predominance of the written word over the spoken one, of the pen over the voice. A remarkable stroke of fortune determined that a writer would establish the exact instant (and I am not exaggerating) when this vast process began. St. Augustine tells it in Book VI of the *Confessions*:

> When he [Ambrose] was reading, his eyes ran over the page and his heart perceived the sense, but his voice and tongue were silent. He did not restrict access to anyone coming in, nor was it customary even for a visitor to be announced. Very often when we were there, we saw him silently reading and never otherwise. After sitting for a long time in silence (for who would dare to burden him in such intent concentration?) we used to go away. We supposed that in the hubbub of other people's troubles, he would not want to be invited to consider another problem. We wondered if he read silently perhaps to protect himself in case he had a hearer interested and intent on the matter, to whom he might have to expound the text being read if it contained difficulties, or who might wish to debate some difficult questions. If his time were used up in that way, he would get through fewer books than he wished. Besides, the need to preserve his voice, which used easily to become hoarse, could have been a very fair reason for silent reading. Whatever motive he had for his habit, this man had a good reason for what he did.

St. Augustine was a disciple of St. Ambrose, Bishop of Milan, around the year 384; thirteen years later, in Numidia, he wrote his *Confessions* and was still troubled by that extraordinary sight: a man in a room, with a book, reading without saying the words.[1]

That man passed directly from the written symbol to intuition, omitting sound; the strange art he initiated, the art of silent reading, would lead to marvelous consequences. It would lead, many years later, to the concept of the book as an end in itself, not as a means to an end. (This mystical concept, transferred to profane literature, would produce the unique destinies of Flaubert and Mallarmé, of Henry James and James Joyce.) Superimposed on the notion of a God who speaks with men in order to command them to do something or to forbid them to do something was that of the Absolute Book, of a Sacred Scripture.

For Muslims, the Koran (also called "The Book," *al-Kitab*) is not merely a work of God, like men's souls or the universe; it is one of the attributes of God, like His eternity or His rage. In chapter XIII we read that the original text, the Mother of the Book, is deposited in Heaven. Muhammad al-Ghazali, the Algazel of the scholastics, declared: "The Koran is copied in a book, is pronounced with the tongue, is remembered in the heart and, even so, continues to persist in the center of God and is not altered by its passage

through written pages and human understanding." George Sale observes that this uncreated Koran is nothing but its idea or Platonic archetype; it is likely that al-Ghazali used the idea of archetypes, communicated to Islam by the *Encyclopedia of the Brethren of Purity* and by Avicenna, to justify the notion of the Mother of the Book.

Even more extravagant than the Muslims were the Jews. The first chapter of the Jewish Bible contains the famous sentence: "And God said, 'Let there be light', and there was light"; the Kabbalists argued that the virtue of that command from the Lord came from the letters of the words. The *Sepher Yetzirah* (Book of the Formation), written in Syria or Palestine around the sixth century, reveals that Jehovah of the Armies, God of Israel and God Omnipotent, created the universe by means of the cardinal numbers from one to ten and the twenty-two letters of the alphabet. That numbers may be instruments or elements of the Creation is the dogma of Pythagoras and Iamblichus; that letters also are is a clear indication of the new cult of writing. The second paragraph of the second chapter reads: "Twenty-two fundamental letters: God drew them, engraved them, combined them, weighed them, permutated them, and with them produced everything that is and everything that will be." Then the book reveals which letter has power over air, and which over water, and which over fire, and which over wisdom, and which over peace, and which over grace, and which over sleep, and which over anger, and how (for example) the letter *kaf*, which has power over life, served to form the sun in the world, the day Wednesday in the week, and the left ear on the body.

The Christians went even further. The thought that the divinity had written a book moved them to imagine that he had written two, and that the other one was the universe. At the beginning of the seventeenth century, Francis Bacon declared in his *Advancement of Learning* that God offered us two books so that we would not fall into error: the first, the volume of the Scriptures, reveals His will; the second, the volume of the creatures, reveals His power and is the key to the former. Bacon intended much more than the making of a metaphor; he believed that the world was reducible to essential forms (temperatures, densities, weights, colors), which formed, in limited number, an *abecedarium naturae* or series of letters with which the universal text is written.[2]

Sir Thomas Browne, around 1642, confirmed that "Thus there are two Books from whence I collected my Divinity; besides that written one of God, another of His servant Nature, that universal and publick Manuscript, that lies expans'd unto the Eyes of all: those that never saw Him in the one, have discover'd Him in the other" (*Religio Medici* I, 16). In the same paragraph we read: "In brief, all things are artificial; for Nature is the Art of God." Two hundred years passed, and the Scot Carlyle, in various places in his books, particularly in the essay on Cagliostro, went beyond Bacon's hypothesis; he said that universal history was a Sacred Scripture that we decipher and write uncertainly, and in which we too are written. Later, Léon Bloy would write:

There is no human being on earth who is capable of declaring who he is. No one knows what he has come to this world to do, to what his acts, feelings, ideas correspond, or what his real name is, his imperishable Name in the registry of Light … History is an immense liturgical text, where the i's and the periods are not worth less than the versicles or whole chapters, but the importance of both is undeterminable and is profoundly hidden. (*L'Ame de Napoleon*, 1912)

The world, according to Mallarmé, exists for a book; according to Bloy, we are the versicles or words or letters of a magic book, and that incessant book is the only thing in the world: more exactly, it is the world.

1 The commentators have noted that it was customary at that time to read out loud in order to grasp the meaning better, for there were no punctuation marks, nor even a division of words, and to read in common because there was a scarcity of manuscripts. The dialogue of Lucian of Samosata, *Against an Ignorant Buyer of Books*, includes an account of that custom in the second century.

2 Galileo's works abound with the concept of the universe as a book. The second section of Favaro's anthology (*Galileo Galilei: Pensieri, motti e sentenze*, Florence, 1949) is entitled "Il libro della Natura." I quote the following paragraph: "Philosophy is written in that very large book that is continually opened before our eyes (I mean the universe), but which is not understood unless first one studies the language and knows the characters in which it is written. The language of that book is mathematical and the characters are triangles, circles, and other geometric figures."

A User's Guide to Détournement
Guy Debord, Gil J Wolman 1956

Guy Debord and Gil J Wolman, "Mode d'emploi du détournement," *Les Lèvres Nues* no. 8 (May 1956); English edition: "A User's Guide to Détournement," in *Situationist International Anthology*, trans. and ed. Ken Knabb (Bureau of Public Secrets, 2006).

Every reasonably aware person of our time is aware of the obvious fact that art can no longer be justified as a superior activity, or even as a compensatory activity to which one might honorably devote oneself. The reason for this deterioration is clearly the emergence of productive forces that necessitate other production relations and a new practice of life. In the civil-war phase we are engaged in, and in close connection with the orientation we are discovering for certain superior activities to come, we believe that all known means of expression are going to converge in a general movement of propaganda that must encompass all the perpetually interacting aspects of social reality.

There are several conflicting opinions about the forms and even the very nature of educative propaganda, opinions that generally reflect one or another currently fashionable variety of reformist politics. Suffice it to say that in our view the premises for revolution, on the cultural as well as the strictly political level, are not only ripe, they have begun to rot. It is not just returning to the past which is reactionary; even "modern" cultural objectives are ultimately reactionary since they depend on ideological formulations of a past society that has prolonged its death agony to the present. The only historically justified tactic is extremist innovation.

The literary and artistic heritage of humanity should be used for partisan propaganda purposes. It is, of course, necessary to go beyond any idea of mere scandal. Since opposition to the bourgeois notion of art and artistic genius has become pretty much old hat, [Marcel Duchamp's] drawing of a mustache on the *Mona Lisa* is no more interesting than the original version of that painting. We must now push this process to the point of negating the negation. Bertolt Brecht, revealing in a recent interview in *France-Observateur* that he makes cuts in the classics of the theater in order to make the performances more educative, is much closer than Duchamp to the revolutionary orientation we are calling for. We must note, however, that in Brecht's case these salutary alterations are narrowly limited by his unfortunate respect for culture as defined by the ruling class—that same respect, taught in the newspapers of the workers parties as well as in the primary schools of the bourgeoisie, which leads even the reddest worker districts of Paris always to prefer *The Cid* over [Brecht's] *Mother Courage*.

It is in fact necessary to eliminate all remnants of the notion of personal property in this area. The appearance of new necessities outmodes previous "inspired" works. They become obstacles, dangerous habits. The point is not whether we like them or not. We have to go beyond them.

Any elements, no matter where they are taken from, can be used to make new combinations. The discoveries of modern poetry regarding the analogical structure of images demonstrate that when two objects are brought together, no matter how far apart their original contexts may be, a relationship is always formed. Restricting oneself to a personal arrangement of words is mere convention. The mutual interference of two worlds of feeling, or the juxtaposition of two independent expressions, supersedes the original elements and produces a synthetic organization of greater efficacy. Anything can be used.

It goes without saying that one is not limited to correcting a work or to integrating diverse fragments of out-of-date works into a new one; one can also alter the meaning of those fragments in any appropriate way, leaving the imbeciles to their slavish reference to "citations."

Such parodistic methods have often been used to obtain comical effects. But such humor is the result of contradictions within a condition whose existence is taken for granted. Since the world of literature seems to us almost as distant as the Stone Age, such contradictions don't make us laugh. It is thus necessary to envisage a parodic-serious stage where the accumulation of detourned elements, far from aiming to arouse indignation or laughter by alluding to some original work, will express our indifference toward a meaningless and forgotten original, and concern itself with rendering a certain sublimity.

Lautréamont advanced so far in this direction that he is still partially misunderstood even by his most ostentatious admirers. In spite of his obvious application of this method to theoretical language in *Poésies*—where Lautréamont (drawing particularly on the maxims of Pascal and Vauvenargues) strives to reduce the argument, through successive concentrations, to maxims alone—a certain Viroux caused considerable astonishment three or four years ago by conclusively demonstrating that *Maldoror* is one vast détournement of Buffon and other works of natural history, among other things. The fact that the prosaists of *Figaro*, like Viroux himself, were able to see this as a justification for disparaging Lautréamont, and that others believed they had to defend him by praising his insolence, only testifies to the senility of these two camps of dotards in courtly combat with each other. A slogan like "Plagiarism is necessary, progress implies it" is still as poorly understood, and for the same reasons, as the famous phrase about the poetry that "must be made by all."[1]

Apart from Lautréamont's work—whose appearance so far ahead of its time has to a great extent preserved it from a detailed examination—the tendencies toward détournement that can be observed in contemporary expression are for the most part unconscious or accidental. It is in the advertising industry, more than in the domain of decaying aesthetic production, that one can find the best examples.

We can first of all define two main categories of detourned elements, without considering whether or not their being brought together is accompanied by corrections introduced

in the originals. These are minor détournements and deceptive détournements.

Minor détournement is the détournement of an element which has no importance in itself and which thus draws all its meaning from the new context in which it has been placed. For example, a press clipping, a neutral phrase, a commonplace photograph.

Deceptive détournement, also termed premonitory-proposition détournement, is in contrast the détournement of an intrinsically significant element, which derives a different scope from the new context. A slogan of Saint-Just, for example, or a film sequence from Eisenstein.

Extensive detourned works will thus usually be composed of one or more series of deceptive and minor détournements.

Several laws on the use of détournement can now be formulated.

It is the most distant détourned element which contributes most sharply to the overall impression, and not the elements that directly determine the nature of this impression. For example, in a metagraph relating to the Spanish Civil War the phrase with the most distinctly revolutionary sense is a fragment from a lipstick ad: "Pretty lips are red." In another metagraph ("The Death of J. H.") 125 classified ads of bars for sale express a suicide more strikingly than the newspaper articles that recount it.[2]

The distortions introduced in the detourned elements must be as simplified as possible, since the main impact of a détournement is directly related to the conscious or semiconscious recollection of the original contexts of the elements. This is well known. Let us simply note that if this dependence on memory implies that one must determine one's public before devising a détournement, this is only a particular case of a general law that governs not only détournement but also any other form of action on the world. The idea of pure, absolute expression is dead; it only temporarily survives in parodic form as long as our other enemies survive.

Détournement is less effective the more it approaches a rational reply. This is the case with a rather large number of Lautréamont's altered maxims. The more the rational character of the reply is apparent, the more indistinguishable it becomes from the ordinary spirit of repartee, which similarly uses the opponent's words against him. This is naturally not limited to spoken language. It was in this connection that we objected to the project of some of our comrades who proposed to detourn an anti-Soviet poster of the fascist organization "Peace and Liberty"—which proclaimed, amid images of overlapping flags of the Western powers, "Union makes strength"—by adding onto it a smaller sheet with the phrase "and coalitions make war."

Détournement by simple reversal is always the most direct and the least effective. Thus, the Black Mass reacts against the construction of an ambiance based on a given metaphysics by constructing an ambiance within the same framework that merely reverses—and thus simultaneously conserves—the values of that metaphysics. Such reversals may nevertheless have a certain progressive aspect. For example, Clemenceau (nicknamed "The Tiger") could be referred to as "The Tiger Named Clemenceau."

Of the four laws that have just been set forth, the first is essential and applies universally. The other three are practically applicable only to deceptive detourned elements.

The first visible consequences of a widespread use of détournement, apart from its intrinsic propaganda powers, will be the revival of a multitude of bad books, and thus the extensive (unintended) participation of their unknown authors; an increasingly extensive transformation of phrases or plastic works that happen to be in fashion; and above all an ease of production far surpassing in quantity, variety and quality the automatic writing that has bored us for so long.

Détournement not only leads to the discovery of new aspects of talent; in addition, clashing head-on with all social and legal conventions, it cannot fail to be a powerful cultural weapon in the service of a real class struggle. The cheapness of its products is the heavy artillery that breaks through all the Chinese walls of understanding.[3] It is a real means of proletarian artistic education, the first step toward a literary communism.

Ideas and creations in the realm of détournement can be multiplied at will. For the moment we will limit ourselves to showing a few concrete possibilities in various current sectors of communication—it being understood that these separate sectors are significant only in relation to present-day technologies, and are all tending to merge into superior syntheses with the advance of these technologies.

Apart from the various direct uses of detourned phrases in posters, records, and radio broadcasts, the two main applications of detourned prose are metagraphic writings and, to a lesser degree, the adroit perversion of the classical novel form.

There is not much future in the détournement of complete novels, but during the transitional phase there might be a certain number of undertakings of this sort. Such a détournement gains by being accompanied by illustrations whose relationships to the text are not immediately obvious. In spite of undeniable difficulties, we believe it would be possible to produce an instructive psychogeographical détournement of George Sand's *Consuelo*, which thus decked out could be relaunched on the literary market disguised under some innocuous title like *Life in the Suburbs*, or even under a title itself detourned, such as *The Lost Patrol*. (It would be a good idea to reuse in this way many titles of deteriorated old films of which nothing else

remains, or of the films that continue to deaden the minds of young people in the cinema clubs.)

Metagraphic writing, no matter how outdated its plastic framework may be, presents far richer opportunities for detourning prose, as well as other appropriate objects or images. One can get some idea of this from the project, conceived in 1951 but eventually abandoned for lack of sufficient financial means, which envisaged a pinball machine arranged in such a way that the play of the lights and the more or less predictable trajectories of the balls would form a metagraphic-spatial composition entitled *Thermal Sensations and Desires of People Passing by the Gates of the Cluny Museum Around an Hour after Sunset in November*. We have since come to realize that a situationist-analytic enterprise cannot scientifically advance by way of such works. The means nevertheless remain suitable for less ambitious goals.

It is obviously in the realm of the cinema that détournement can attain its greatest effectiveness and, for those concerned with this aspect, its greatest beauty.

The powers of film are so extensive, and the absence of coordination of those powers is so glaring, that virtually any film that is above the miserable average can provide matter for endless polemics among spectators or professional critics. Only the conformism of those people prevents them from discovering equally appealing charms and equally glaring faults even in the worst films. To cut through this absurd confusion of values, we can observe that Griffith's *Birth of a Nation* is one of the most important films in the history of the cinema because of its wealth of innovations. On the other hand, it is a racist film and therefore absolutely does not merit being shown in its present form. But its total prohibition could be seen as regrettable from the point of view of the secondary, but potentially worthier, domain of the cinema. It would be better to detour it as a whole, without necessarily even altering the montage, by adding a soundtrack that made a powerful denunciation of the horrors of imperialist war and of the activities of the Ku Klux Klan, which are continuing in the United States even now.

Such a détournement—a very moderate one—is in the final analysis nothing more than the moral equivalent of the restoration of old paintings in museums. But most films only merit being cut up to compose other works. This reconversion of preexisting sequences will obviously be accompanied by other elements, musical or pictorial as well as historical. While the cinematic rewriting of history has until now been largely along the lines of Sacha Guitry's burlesque recreations, one could have Robespierre say, before his execution: "In spite of so many trials, my experience and the grandeur of my task convinces me that all is well." If in this case an appropriate reuse of a Greek tragedy enables us to exalt Robespierre, we can conversely imagine a neorealist-type sequence, at the counter of a truck stop bar, for example, with one of the truck drivers saying seriously to another: "Ethics was formerly confined to the books of the philosophers; we have introduced it into the governing of nations." One can see that this juxtaposition illuminates Maximilien's idea, the idea of a dictatorship of the proletariat.[4]

The light of détournement is propagated in a straight line. To the extent that new architecture seems to have to begin with an experimental baroque stage, the architectural complex—which we conceive as the construction of a dynamic environment related to styles of behavior—will probably detour existing architectural forms, and in any case will make plastic and emotional use of all sorts of detourned objects: careful arrangements of such things as cranes or metal scaffolding replacing a defunct sculptural tradition. This is shocking only to the most fanatical admirers of French-style gardens. It is said that in his old age D'Annunzio, that pro-fascist swine, had the prow of a torpedo boat in his park. Leaving aside his patriotic motives, the idea of such a monument is not without a certain charm.

If détournement were extended to urbanistic realizations, not many people would remain unaffected by an exact reconstruction in one city of an entire neighborhood of another. Life can never be too disorienting: détournement on this level would really spice it up.

Titles themselves, as we have already seen, are a basic element of détournement. This follows from two general observations: that all titles are interchangeable and that they have a decisive importance in several genres. The detective stories in the *Série Noir* are all extremely similar, yet merely continually changing the titles suffices to hold a considerable audience. In music a title always exerts a great influence, yet the choice of one is quite arbitrary. Thus it wouldn't be a bad idea to make a final correction to the title of the *Eroica Symphony* by changing it, for example, to *Lenin Symphony*.[5]

The title contributes strongly to the détournement of a work, but there is an inevitable counteraction of the work on the title. Thus one can make extensive use of specific titles taken from scientific publications (*Coastal Biology of Temperate Seas*) or military ones (*Night Combat of Small Infantry Units*), or even of many phrases found in illustrated children's books (*Marvelous Landscapes Greet the Voyagers*).

In closing, we should briefly mention some aspects of what we call ultra-détournement, that is, the tendencies for détournement to operate in everyday social life. Gestures and words can be given other meanings, and have been throughout history for various practical reasons. The secret societies of ancient China made use of quite subtle recognition signals encompassing the greater part of social behavior (the manner of arranging cups; of drinking; quotations of poems interrupted at agreed-on points). The need for a secret language, for passwords, is inseparable from a tendency toward play. Ultimately, any sign or word is susceptible to being converted into something else, even into its opposite. The royalist insurgents of the Vendée,[6] because they bore the disgusting image of the Sacred Heart of Jesus,

were called the Red Army. In the limited domain of political war vocabulary this expression was completely detourned within a century.

Outside of language, it is possible to use the same methods to detourn clothing, with all its strong emotional connotations. Here again we find the notion of disguise closely linked to play. Finally, when we have got to the stage of constructing situations—the ultimate goal of all our activity—everyone will be free to detourn entire situations by deliberately changing this or that determinant condition of them.

The methods that we have briefly examined here are presented not as our own invention, but as a generally widespread practice which we propose to systematize.

In itself, the theory of détournement scarcely interests us. But we find it linked to almost all the constructive aspects of the presituationist period of transition. Thus its enrichment, through practice, seems necessary.

We will postpone the development of these theses until later.

Translator's Note:
The French word *détournement* means deflection, diversion, rerouting, distortion, misuse, misappropriation, hijacking, or otherwise turning something aside from its normal course or purpose. It has sometimes been translated as "diversion," but this word is confusing because of its more common meaning of idle entertainment. Like most other English-speaking people who have actually practiced *détournement*, I have chosen simply to anglicize the French word. For more on *détournement*, see theses 204–9 of *The Society of the Spectacle*.

1 The two quoted phrases are from Isidore Ducasse's *Poésies*. Lautréamont was the pseudonym used by Ducasse for his other work, *Maldoror*. The "Plagiarism is necessary" passage was later plagiarized by Debord in thesis #207 of *The Society of the Spectacle*.

2 The "metagraph," a genre developed by the lettrists, is a sort of collage with largely textual elements. The two metagraphs mentioned here are both by Debord and can be found in his *Oeuvres* (p. 127).

3 The authors are detourning a sentence from the *Communist Manifesto*: "The cheapness of the bourgeoisie's commodities is the heavy artillery with which it batters down all Chinese walls, with which it forces the barbarians' intensely obstinate hatred of foreigners to capitulate."

4 In the first imagined scene a phrase from a Greek tragedy (Sophocles's *Oedipus at Colonus*) is put in the mouth of French Revolution leader Maximilien Robespierre. In the second, a phrase from Robespierre is put in the mouth of a truck driver.

5 Beethoven originally named his third symphony after Napoleon (seen as a defender of the French Revolution), but when Napoleon crowned himself emperor he angrily tore up the dedication to him and renamed it *Eroica*. The implied respect in this passage for Lenin (like the passing references to "workers states" in Debord's *Report on the Construction of Situations*) is a vestige of the lettrists' early, less politically sophisticated period, when they seem to have been sort of anarcho-Trotskyist.

6 *The Vendée*: region in southwestern France, locale of a pro-monarchist revolt against the Revolutionary government (1793–96).

Many years ago I drew snakes.

Ray Johnson 1967

Ray Johnson, "Many years ago I drew snakes" (1967), *Not Nothing: Selected Writings,
1954–1994*, ed. Elizabeth Zuba (Los Angeles: Siglio Press, 2014), 54.

Many years ago I drew snakes.
They were underfoot.
Anne and Bill Wilson had a baby.
His name was Ocean.
I made paintings of combs and hats.
I live in Manhattan.
I made a painting of an Island.
Last summer on the beach at Coney
Island I was reading Playboy magazine
and decided when I got home to do a
drawing of Jean Seberg's shoe.
"The pinkice falls on his head" is
a fragment of something I wrote.
Between the foot and head is the knee.
A neon light cast pink light on the
snow.

A lot of my early work which I didn't
destroy or mail out in envelopes to
friends I ditched.
I dreamed about a mantah ray splashing
in Lake Michigan.
Chicago wind blow hat away.

 Ray Johnson

There should be a space between pink
and ice on line 12.

Notice

Stephen Willats 1967

Notice.

For the artist a move away from the inverted qualities of art today(Ipitimised in
the abstract coding of wall painting,~~under~~ towards an outgoing socially concerned
art offers a new potential for making politically relevant art practice. This
development coupled with information drawn from modern information areas,such
as psychology,communication theory,etc,leaves the artist in a position to look
at such important issues as audience composition,and the relevance of ~~hixxcnxxnxnx~~
concerns in art to their motivations. The idea of art as known at present could
then well disappear altogether,and be replaced by an art which structured ~~inxax~~
~~inisixnnxixnnmnntnixxnnxnx~~ to function as an integral part of the environment.
The audience is not considered as an after thought as it is at present in most
~~nxixpxnxtixnx~~ art,but as the essential reason for the development of a work.
In this way the artist can begin to play a truly forward looking part in society.
S.Willats.1967.

FILE Megazine Editorials
General Idea 1972

General Idea, "SOME JUICY MALICIOUS GOSSIP," in "Mr. Peanut Issue," *FILE* (April 1972): 3.
General Idea, "FICTIONAL ASPECTS OF A FACTUAL MAGAZINE," in "Manipulating the Self Issue," *FILE* (May/June 1972): 8.
General Idea, "TO WHOM IT MAY CONCERN" and "HOMELY DETAILS OF 'EVERYDAY LIFE,'" in "Eye of the Shadow Issue," *FILE* (December 1972): 5.
General Idea, "BULLETIN FROM THE IVORY TOWER," in "Special Double Issue 2," *FILE*, nos. 1–2 (May 1973): 15.
General Idea, "'...the nature of our affliction, let's call it culture...,'" in "Mondo Nudo Issue," *FILE* (December 1973): 11.

"Mr. Peanut Issue," vol. 1, no. 1, April 15, 1972
SOME JUICY AND MALICIOUS GOSSIP

The phenomenon of FILE and of files emerges from the underbrush of available art, shuffling its leaves in patterned disarray. Files are the dead matter or appropriated ideas, the manure of rat city, the space hidden between one gallery and the next.

In order to grasp the FILE phenomenon it is necessary to realize the extent of concerns involving the invisible network that bind the world of Dr. Brute and Alex the Holy, Marcel Idea and Miss Generality, Clara the Bag Lady and Lady Brute, the Swedish Lady and Mr.Cones, Dadaland and Dada Long Legs, AA Bronson and Dr. Fluxus, Ray Johnson and Susana Bunny, Anna Banana, and Honey Bananas, Bum Bank and Art Rat, Brutiful Brutopia, and Canadada. We are concerned with the web of fact and fiction that binds and releases mythologies that are the sum experience of artists and non-artists in cooperative existence today.

Every image is a self-image. Every image is a mirror.

We are astounded at the diversity of common images and common fantasies exposing the quality of group life now.

High art concerns are lone concerns, and these must continue too. But the word emerges as a sign and a signal, and these are exchanged. When you smile at a mirror, does a mirror smile at you? Humor lies in the beat between action and recognition.

On local levels the Nihilist Spasm Band of London Ontario and the Goose and Duck Newspaper of Wards Island, Toronto, are both developed and appreciated examples. The New York Correspondence School begun by Sugardada Ray Johnson remains the recognized forerunner of international image exchange now in operation.

While London has remained introspective, Vancouver has left the banquet, Image Bank, The New Era Social Club, Metromedia and the rest have extended their well-integrated base of operations onto a national and international scale. Joining A Space, General Idea and The Coach House Press of Toronto and Ace Space of Victoria, they have invaded the subliminal and broken open the image bank.

The obsessions are streaming up front. Each authenticates the rest, creating a total scene which is at once ephemeral and impossible to ignore. We might list the concerns, we might expose the personal imagery which has been released from the private world of High Art obscurity and into the mainstream.

We might categorize connections and demonstrate the fluidity of the ballooning situation. But in the end it is all the same; the telling destroys the actuality, and the story slips through our fingers, wriggling into other levels convoluted beyond expectation.

What is the function of the myth? The myths transform Pandora's box into the image bank of compulsions. The myth slides down the center, slicing realities into thin transparencies and dissolving dualities into fabled tales. In the story it all comes together. In the myth opposite possibilities become complementary content. In the fable we lay out models, testing and tasting. In the space between myths lies the lucid expression of artists activity.

FILE is precisely this: the extension and documentation of available space, the authentication and reinforcement of available myths lying within the context of Canadian art today.

"Manipulating the Self Issue," vol. 1, nos. 2–3, May / June 1972
FICTIONAL ASPECTS OF A FACTUAL MAGAZINE

The will of eros which is a virgin growth, battles from behind the silver screen. The screen, which is silver, and glassy, does not know the passion we feel. From behind the screen is filtered the past we never knew, which is nostalgic precisely because we never knew it. The past did not exist.

We are startled by the prowling metaphor. It comes in the night, with languid ragged speed. The jaguar moves with the claws of a mirror, split. The splintered moon moves in Scorpio with an enervated wit. Illicit love flourishes. Secrets are kept. Snake within snake, the white bone loose on the thigh of another. This sweet cycle, which is the slow sweet loop of the wrist upon the arm, lives within the configuration we only guess.

The nostalgia trap is a gigantic sieve through which we all must pass. A myth is not nostalgic. Once a myth is nostalgic it is no longer a myth. The movements of a myth are invisible. It passes in the night, like a storm, lucid as a secret terror. The loop that nooses. The myth provides a space to move; in the myth we are silent, expanded. Landlord.

Nostalgia is over; it never happened. Nostalgia is flat, a map. On it we trace the voyage of pioneers of pleasure. Explorers become kingdoms. The milkman does not walk here. The night does not fall here. It is always dusk. The bright lights announce points of interest. There is no jungle on a map. Everything is sorted and filled.

In the myth there is only empty space…
—AA Bronson, "Open Letter," May, 1972

"Eye of the Shadow Issue," vol. 1, no. 4, Dec 1972
TO WHOM IT MAY CONCERN

Just do it sir... in front of everyone sir... It would have a comic effect sir... We flash a sex pic with torture in the background sir then snap that torture pic right in your bloody face sir... if you'll pardon the expression sir—we do the same with the sound track sir... varying instances sir... It has a third effect sir... right down the old middle line sir ... if you'll pardon the expression sir... the razor inside sir...

Jerk the handle... It sounds like this sir ...
—William Burroughs, *Nova Express*

The old Humpty Dumpty mere mirror on the wall, the old seems to be coming apart, the old egg-oh on the face. Ask anything but don't expect a glimpse behind the final curtain. In the burlesque taking art's pants down to titillate art's history. "I CAN HANDLE NUDITY BUT THIS IS UNNATURAL." Double-edge blade of the cutting remark for the kill. Egg-oh, like when your lips meet your lips on the glass of the mirror. Speechlessness behind the scenes. We only launched this image balloon to see if the world was around. Your arrows to pinpoint the leak in our *FILE*/style orbit talking in circles. We promise not to burst onto your scene from under the carpet leaving you holding the vacuum. You probe our love letters with your letter knife in the back. You got our number and we got the picture under wraps like in camouflage, corre-sponge dancing on the subliminal.

We're just a plug looking for a socket. Like we plugged into the waterworks when we realized the similarity. Like when we realized the valves were all under control. Like we slipped into your mailbox disguised as *LIFE*.

It's the story of my life, what's the difference between wrong and right' But Billy said, "Both those words are dead."
—The Velvet Underground

There you were staring *FILE* in the face and you couldn't believe it was *LIFE*. The old seeing is believing dilemma. The old media mirror up against the wall. Meanwhile he's out on some street corner contacting the big energy under your feet. He discovers images float through media like words out of water. He rechannels the mainstream as folk art. He lost quality control when he got into deep water and attitudes. When attitudes become action as in how many; how much? ... maybe fifty maybe one hundred maybe twelve hundred are needed to salve a bad case of media burn. Modern art under the scalped sliced open and sewn up as just another style, like computers, or porno. Now this is no news since we got the pants down already but the voyeurs are still hung up on carbon copy. Walt Disney's magic paintbrush brushing with death and bringing to *LIFE* a little if the old now you see it.

Alex the Holy's animated *LIFE*/style bringing to *FILE* with style a little of the old now you're it. A little too close to home the thought of our water pipes and your water pipes

like network TV. Or our mailboxes, coming up through the ground and in the back door like subliminal in residence. By the time it gets through all this charcoal carbon copy it infiltrates the cells. Step up to the color bar and order the system to pay color back with an Image Blank cheque. Don't point your critical breadknife at seven years of bad luck. Don't break our light through your spectrum of words. Don't pass the buck and call it greenback. Don't stain our sheets with your lyrical abstractions. Don't tarnish our image. We're following orders.

And the General stepped out of his view screen in a glittering robe of pure shamelessness...
—William Burroughs, *The Ticket that Exploded*

"Special Double Issue," vol. 2, nos. 1 / 2, May 1973
BULLETIN FROM THE IVORY TOWER

In the last issue we stuck the knife up the ass. In the end it all came together.

Coping with the pablum-eaters, who must eat; coping with the hunger of intellectual cannibalism, rampant and insatiable, coping with those who sit without and demand that the seeing might be seen, demanding art history, a review in preview; coping with these then. *FILE*, no longer mirroring a scene, mirrors the mirror. We reestablish our ability to see with a long look into the mirrored mirror, passing through silvered slivered splintered layers of apparent transparency, moving within the arena of our affliction.

The last and silent protection against culture shock in a society harboring change and multiplicity as its only constants is the harboring in safe ports of vision, one's own vision, one's ability to see one's manner of seeing as one's only personal constant. Capacity for ambiguity. Narcissism. Mirror mirror on the wall. Media inversion. What does a mirror see, searching for its own reflection?

Nostalgia is to be considered. Nostalgia, a technique for survival, pinning cultural archetypes up against the wall. Collage or perish. Nostalgia, knowledge in camouflage, disguised as yearning, yearning for a style that matter might take its course without due notice. Nostalgia providing the sense of vision from afar, essentially a vehicle of entry, entry into safe harbors, harboring vision, piercing strategical soft points, weakened by the need for entry, vulnerable, necessary.

Nostalgia must be cultured with an eye to the rarified, the rarified vision, the gap, space between, the borderline case. Nostalgia reduces junk imagery to categorical considerations, reducing mind pollution: Dr. Brute's leopard skin, 1984, feigheigh neigheigh, business as usual, art city, thirties, forties, fifties, topiary, terminal, borderline cases.

Narcissism is to be considered: as safe harbor, harboring a personal vision, harboring the possibility of vision, the description of the mirror regarding itself, the point of entry, whereby vision may contain the world. Narcissism demands nostalgia if it is to be utilized as a tool of vision.

Together accounting for everything that must be accounted for. Everything must be accounted for. Allowing the possibility of describing the myth.

The pablum-eaters demand pablum. In the demanding they set the eye traveling inward and outward, plummeting. This issue is dedicated to pablum-eaters. Herein please find the description of the art of it all. Collage or perish. Not only the actuality of intellectual cannibalism, not only the necessity of intellectual cannibalism, but the possibility of intellectual cannibalism. Cut up or shut up. Everything is permitted.

"Mondo Nudo Issue," vol. 2, no. 4, December 1973
… the nature of our affliction, let's call it culture …
The **Ford Hotel**, long Toronto's oldest "big" hotel, marked the end of the summer of '73 by closing its doors. The closing was immediately preceded by the "brutal sex slaying" of a young boy, entirely appropriate punctuation to its stained career. Let us note that the Ford, noted for deviation, occupied not only the geographic but the iconographic center of the city.

General Idea, now in new headquarters, recently raided the Ford en masse, collecting bedroom mirrors, hoping to salvage the mirror that mirrored the final act, rape of innocence, the cleansing with human blood. These mirrors, now being installed in a major mosaic at General Idea Headquarters, mark the opening of **Art Metropole** and the initiation into the ten-year deca-dence that ends in '84. Collectively these mirrors evoke the Spirit (page 12) by housing all the images of deviation and death, erased … a palimpsest of the nature of our affliction—let's call it culture.

The Summer of '73, thus closed, ends some six months hiatus: General Idea, installed in new headquarters, spent the summer examining megazine realities and the formation of Art Metropole. Granada Gazelle, FILE cover-girl, coated her cape with the bees in her bonnet. Marien Lewis contained the marital myth by wedding her alter ego (page 4). The Coach House Press cross-sectioned a scene in progress by publishing a microfiche collection of all the artists' image collections (page 4). The Western Front made plans and held rehearsals for the celebration of Art's Birthday, in Hollywood, of course (page 34). The John Dowd Fanny Club readied its upcoming headquarters, General Idea designed props to aid their summer-long search (page 12) for the spirit of Miss General Idea: LUXON, V.B., an auto clothed in futuristic stance, and Art Metropole itself. The Spirit of Miss General Idea 1984 roamed everywhere, searching for a vehicle.

Art Metropole? Opening with the new year, Art Metropole establishes in General Idea's Yonge Street location a collection agency devoted to the documentation, archiving, and distribution of all the images. The ten-year collection, to end in '84, will be housed in the 1984 Miss General Idea Pavillion, inaugurated by the 1984 Pageant and the emergence of the Spirit herself. Art Metropole is thus an extension of FILE *Megazine*, taking over and diversifying the functions of reflection and connection. As the media and the means of extension available to the scene proliferate, Art Metropole intends to keep abreast of the tide, housing and distributing evidence of activity and imagery: megazines, publications, videos, correspondence, snapshots, memories, and the ephemeral flood … the nude era and the nude egos in action and reaction.

FILE then, already shifted from reflection and reportage into the act of mirroring mirrors, steps back one more step and relaxes into diary format, a more personal vision of the lives of General Idea, our friends, our correspondents, our travels in the Search for the Spirit that haunts us, the Spirit of Miss General Idea.

The New Art of Making Books

Ulises Carrión 1975

Ulises Carrión, "The New Art of Making Books," *Kontexts*, nos. 6–7 (1975) and *Plural*, no. 41 (1975).

What a Book Is

A book is a sequence of spaces. Each of these spaces is perceived at a different moment—a book is also a sequence of moments. A book is not a case of words, nor a bag of words, nor a bearer of words.

A writer, contrary to the popular opinion, does not write books. A writer writes texts. The fact, that a text is contained in a book, comes only from the dimensions of such a text; or, in the case of a series of short texts (poems, for instance), from their number.

A literary (prose) text contained in a book ignores the fact that the book is an autonomous space-time sequence. A series of more or less short texts (poems or other) distributed through a book following any particular ordering reveals the sequential nature of the book.

It reveals it, perhaps uses it; but it does not incorporate it or assimilate it.

Written language is a sequence of signs expanding within the space; the reading of which occurs in the time. A book is a space-time sequence.

Books existed originally as containers of (literary) texts. But books, seen as autonomous realities, can contain any (written) language, not only literary language, or even any other system of signs.

Among languages, literary language (prose and poetry) is not the best fitted to the nature of books.

A book may be the accidental container of a text, the structure of which is irrelevant to the book: these are the books of bookshops and libraries. A book can also exist as an autonomous and self-sufficient form, including perhaps a text that emphasizes that form, a text that is an organic part of that form: here begins the new art of making books.

In the old art the writer judges himself as being not responsible for the real book. He writes the text. The rest is done by the servants, the artisans, the workers, the others. In the new art writing a text is only the first link in the chain going from the writer to the reader. In the new art the writer assumes the responsibility for the whole process.

In the old art the writer writes texts. In the new art the writer makes books. To make a book is to actualize its ideal space-time sequence by means of the creation of a parallel sequence of signs, be it linguistic or other.

Prose and poetry

In an old book all the pages are the same. When writing the text, the writer followed only the sequential laws of language, which are not the sequential laws of books. Words might be different on every page; but every page is, as such, identical with the preceding ones and with those that follow. In the new art every page is different; every page is an individualized element of a structure (the book) wherein it has a particular function to fulfill.

In spoken and written language pronouns substitute for nouns, so to avoid tiresome, superfluous repetitions. In the book, composed of various elements, of signs, such as language, what is it that plays the role of pronouns, so to avoid tiresome, superfluous repetitions? This is a problem for the new art; the old one does not even suspect its existence.

A book of five hundred pages, or of one hundred pages, or even of twenty-five, wherein all the pages are similar, is a boring book considered as a book, no matter how thrilling the content of the words of the text printed on the pages might be.

A novel, by a writer of genius or by a third-rate author, is a book where nothing happens.

There are still, and always will be, people who like reading novels. There will also always be people who like playing chess, gossiping, dancing the mambo, or eating strawberries with cream.

In comparison with novels, where nothing happens, in poetry books something happens sometimes, although very little.

A novel with no capital letters, or with different letter types, or with chemical formulae interspersed here and there etc., is still a novel, that is to say, a boring book pretending not to be such.

A book of poems contains as many words as, or more than, a novel, but it uses ultimately the real, physical space whereon these words appear, in a more intentional, more evident, deeper way. This is so because in order to transcribe poetical language onto paper it is necessary to translate typographically the conventions proper to poetic language.

The transcription of prose needs few things: punctuation, capitals, various margins, etc. All these conventions are original and extremely beautiful discoveries, but we don't notice them anymore because we use them daily. Transcription of poetry, a more elaborate language, uses less common

signs. The mere need to create the signs fitting the transcription of poetic language, calls our attention to this very simple fact: to write a poem on paper is a different action from writing it on our mind.

Poems are songs, the poets repeat. But they don't sing them. They write them. Poetry is to be said aloud, they repeat. But they don't say it aloud. They publish it. The fact is, that poetry, as it occurs normally, is written and printed, not sung and spoken, poetry. And with this, poetry has lost nothing.

On the contrary, poetry has gained something: a spatial reality that the so loudly lamented sung and spoken poetries lacked.

The Space

For years, many years, poets have intensively and efficiently exploited the spatial possibilities of poetry. But only the so-called concrete or, later, visual poetry, has openly declared this.

Verses ending halfway on the page, verses having a wider or a narrower margin, verses being separated from the following one by a bigger or smaller space—all this is exploitation of space.

This is not to say that a text is poetry because it uses space in this or that way, but that using space is a characteristic of written poetry.

The space is the music of the unsung poetry

The introduction of space into poetry (or rather of poetry into space) is an enormous event of literally incalculable consequences. One of these consequences is concrete and / or visual poetry. Its birth is not an extravagant event in the history of literature, but the natural, unavoidable development of the spatial reality gained by language since the moment writing was invented.

The poetry of the old art does use space, albeit bashfully. This poetry establishes an inter-subjective communication. Inter-subjective communication occurs in an abstract, ideal, impalpable space.

In the new art (of which concrete poetry is only an example) communication is still inter-subjective, but it occurs in a concrete, real, physical space—the page.

A book is a volume in the space. It is the true ground of the communication that takes place through words—its here and now.

Concrete poetry represents an alternative to poetry. Books, regarded as autonomous space-time sequences offer an alternative to all existent literary genres.

Space exists outside subjectivity. If two subjects communicate in the space, then space is an element of this communication. Space modifies this communication. Space imposes its own laws on this communication. Printed words are imprisoned in the matter of the book.

What is more meaningful: the book or the text it contains? What was first: the chicken or the egg?

The old art assumes that printed words are printed on an ideal space. The new art knows that books exist as objects in an exterior reality, subject to concrete conditions of perception, existence, exchange, consumption, use, etc.

The objective manifestation of language can be experienced in an isolated moment and space—the page; or in a sequence of spaces and moments—the book.

There is not and will not be new literature anymore. There will be, perhaps, new ways to communicate that will include language or will use language as a basis. As a medium of communication, literature will always be old literature.

The Language

Language transmits ideas, i.e., mental images. The starting point of the transmission of mental images is always an intention: we speak to transmit a particular image. The everyday language and the old art language have this in common: both are intentional, both want to transmit certain mental images.

In the old art the meanings of the words are the bearers of the author's intentions. Just as the ultimate meaning of words is indefinable, so the author's intention is unfathomable.

Every intention presupposes a purpose, a utility. Everyday language is intentional, that is, utilitarian; its function is to transmit ideas and feelings, to explain, to declare, to convince, to invoke, to accuse, etc. Old art's language is intentional as well, i.e., utilitarian. Both languages differ from one another only in their exterior form.

New art's language is radically different from daily language. It neglects intentions and utility, and it returns to itself, it investigates itself, looking for forms, for series of forms that give birth to, couple with, unfold into, space-time sequences.

The words in a new book are not the bearers of the message, nor the mouthpieces of the soul, nor the currency of communication. Those were already named by Hamlet, an avid reader of books: words, words, words.

The words of the new book are there not to transmit certain mental images with a certain intention. They are there to

form, together with other signs, a space-time sequence that we identify with the name "book."

The words in a new book might be the author's own words or someone else's words. A writer of the new art writes very little or does not write at all.

The most beautiful and perfect book in the world is a book with only blank pages, in the same way that the most complete language is that which lies beyond all that the words of a man can say.

Every book of the new art is searching after that book of absolute whiteness, in the same way that every poem searches for silence.

Intention is the mother of rhetoric.

Words cannot avoid meaning something, but they can be divested of intentionality

A non-intentional language is an abstract language: it doesn't refer to any concrete reality. Paradox: in order to be able to manifest itself concretely, language must first become abstract.

Abstract language means that words are not bound to any particular intention; that the word "rose" is neither the rose that I see nor the rose that a more or less fictional character claims to see. In the abstract language of the new art the word "rose" is the word "rose." It means all the roses and it means none of them.

How to succeed in making a rose that is not my rose, nor his rose, but everybody's rose, i.e., nobody's rose? By placing it within a sequential structure (for example a book), so that it momentarily ceases being a rose and becomes essentially an element of the structure.

Structures

Every word exists as an element of a structure—a phrase, a novel, a telegram. Or: every word is part of a text.

Nobody or nothing exists in isolation: everything is an element of a structure. Every structure is in its turn an element of another structure. Everything that exists is a structure. To understand something, is to understand the structure of which it is a part and/or the elements forming the structure that that something is.

A book consists of various elements, one of which might be a text. A text that is part of a book isn't necessarily the most essential or important part of that book.

A person may go to the bookshop to buy ten red books because this color harmonizes with the other colors in his sitting room, or for any other reason, thereby revealing the irrefutable fact, that books have a color.

In a book of the old art words transmit the author's intention. That's why he chooses them carefully. In a book of the new art words don't transmit any intention; they're used to form a text which is an element of a book, and it is this book, as a totality, that transmits the author's intention.

Plagiarism is the starting point of the creative activity in the new art.

Whenever the new art uses an isolated word, then it is in an absolute isolation: books of one single word.

Old art's authors have the gift for language, the talent for language, the ease for language. For new art's authors language is an enigma, a problem; the book hints at ways to solve it.

In the old art you write "I love you" thinking that this phrase means "I love you." (But: what does "I love you" mean?).

In the new art you write "I love you" being aware that we don't know what this means. You write this phrase as part of a text wherein to write "I hate you" would come to the same thing. The important thing is, that this phrase, "I love you" or "I hate you," performs a certain function as a text within the structure of the book,

In the new art you don't love anybody. The old art claims to love. In art you can love nobody. Only in real life can you love someone.

Not that the new art lacks passions. All of it is blood flowing out of the wound that language has inflicted on men. And it is also the joy of being able to express something with everything, with anything, with almost nothing, with nothing.

The old art chooses, among the literary genres and forms, that one which best fits the author's intention. The new art uses any manifestation of language, since the author has no other intention than to test the language's ability to mean something.

The text of a book in the new art can be a novel as well as a single word, sonnets as well as jokes, love- letters as well as weather reports.

In the old art, just as the author's intention is ultimately unfathomable and the sense of his words indefinable, so the understanding of the reader is unquantifiable. In the new art the reading itself proves that the reader understands.

The Reading

In order to read the old art, knowing the alphabet is enough. In order to read the new art one must apprehend the book as a structure, identifying its elements and understanding their function.

One might read old art in the belief that one understands it, and be wrong. Such a misunderstanding is impossible in the new art. You can read only if you understand.

In the old art all books are read in the same way. In the new art every book requires a different reading.

In the old art, to read the last page takes as much time as to read the first one. In the new art the reading rhythm changes, quickens, speeds up.

In order to understand and to appreciate a book of the old art, it is necessary to read it thoroughly. In the new art you often do NOT need to read the whole book. The reading may stop at the very moment you have understood the total structure of the book,

The new art makes it possible to read faster than the fast-reading methods.

There are fast-reading methods because writing methods are too slow. To read a book, is to perceive sequentially its structure.

The old art takes no heed of reading. The new art creates specific reading conditions.

The farthest the old art has come to, is to bring into account the readers, which is going too far.

The new art doesn't discriminate between its readers; it does not address itself to the book-addicts or try to steal its public away from TV.

In order to be able to read the new art, and to understand it, you don't need to spend five years in a Faculty of English.

In order to be appreciated, the books of the new art don't need the sentimental and/or intellectual complicity of the readers in matters of love, politics, psychology, geography, etc.

The new art appeals to the ability every man possesses for understanding and creating signs and systems of signs.

IDEA POLL

Art-Rite, no. 14, 1976

from *From Around a Lake* by Richard Long

Kathy Acker

Forget all the shit about "artists' " and books. I write three to four pages a day and have been doing so for the last ten years. When I want to wash my face, I take soap and water and scrub my face. The rest is technique.

One Zen master (I forget the direct quote) says that once a person's enlightened, that person can walk with the Buddha or any of the Boddhisattvas that have lived and are living. I used to hate reading the books of dead men and women and I've always hated schools. It's now possible to meet Blake and Yeats and Nietzsche and all the writers who knew that. Yeats speaks of beauty, Blake of holiness and fire, let me put it this way: who knew what is true and how a person caught to his or her own attachments, not only to luxuries but also to the forms of the mind, as if all forms were real or false, could as Blake put it break out of prison.

"by artists and poets, who are taught by the nature of their craft to sympathise with all living things, and who, the more pure and fragrant is their lamp, pass the further from all limitations, to come at last to forget good and evil in an absorbing vision of the happy and unhappy."
Break out of prison for everything is holy.
On the gross historical level. Kissinger and Mao.
The self.
Thoughts second-to-second, that portrayal "These three primary commands, to seek a determinate outline, to avoid a generalized treatment, and to desire always abundance and exuberance, were insisted upon with vehement anger, and their opponents were called again and again 'demons' and 'villains' 'hired' by the wealthy and the idle"
"for he who half lives in eternity endures a rending of the structures of the mind, a crucifixion of the intellectual body"
Note: My friends are (mainly) artists and I live in an art community. When I sit in my room and write, I'm not separate from my friends so I write "artists' " books. I can't imagine what else you mean by "artists' ".

I hope I'm not being brusque: I don't mean to be. I'm 29 years old and I've spent a lot of that time reading, writing, and thinking with mind and body about writing. I can't compress ten years or more into a simple statement. The shithole commercial and small-press publishing world, the philosophy of all who, because of the absorption in active life, have been persuaded to judge and to punish.

Roberta Allen

I am primarily involved with the book form as an indeterminite structure: to suggest the possibility of alternative choice to the reader who can rearrange the random sequence of loose pages in my books. One may or may not take advantage of this. The book format is flexible enough to provide an opportunity for "playing with possibility" through presenting spatial ambiguities of position, placement, and direction.

In a book of 40 loose pages, the number of sequences possible is so great that no exa number can be determined. If one read created trillions of different sequences incredible number would still remain. In book of 10 loose pages millions of differe sequences are possible.

one considers that a book produced for public circulation, i.e. ma readers can possess copies of identic printed material which can be sequential altered or not, the idea of indeterminacy staggering. However, this particular boo form is used to encourage an intimat tactile connection with the individual read through possibility of choice combined wi sense of touch.

John Baldessari

Re. your request for statements on books: enjoy giving books I have made to other Art seems pure for a moment and discon nected from money. And since a lot people can own the book, nobody owns Every artist should have a cheap line. keeps art ordinary and away from bei overblown.

Luciano Bartolini

1. (I'm attracted to it) because I consider a "hypothesis," the artist's book is a "offering" of an individual experience no corresponding to any real necessity othe than the artist's own need, in contrast t the industrially produced book, which corr sponds to a "need" previously ascertaine by marketing research (in order to provid the right product).
2. Recovery of the dimension of *craftsman ship* and of dexterity [Italian *manualita*].
3. Wider room for expression by (means the "book") an object already full of histor connotations, but which nevertheless be comes more detached from the structure requirements of the art market.
4. Possibility to distill a number of exper ences in a single book (artist's book as poetic sampler of his own work).
5. Artists book as experimentation, contin uation and complement of the artist's daily routine/normal work.

Concerning the superstructure or lack it: insufficient (or little or no) distribution not a good quality. A book is born to b communicated.
PS. (small personal ps.): my books ar conceived with the prospect of being sen directly (thru the *mail*) to whomever I want.

Ulises Carrion

Director, Other Books and So, Amsterdam.
Nowadays, the only trouble with artists books is, that they have gained the atten tion of museums and collectors. The sab bath dance of the signed/numbered, limite first editions has began. I hope with all m heart that finally, as usually happens, th amount of talent and production will sur pass the amount of available capital. Ther will always remain a surplus of unsaleabl beauty.

6 Overleaf: Marcel Duchamp from *Continuo la serie. . .* by Guglielmo Achille Cavallini

"IDEA POLL: Statements on artists' books by fifty artists and art professionals connected with the medium," *Art-Rite*, no. 14, ed. Walter Robinson and Edit DeAk (Winter 1976): 6–15.

Daniel Buren

I am interested in books when their purpose or meaning fit with my interest, or when they teach me something or rectify some wrong concept I had, or look beautiful, or make no sense, or are extremely well done, no matter which is the classification or profession of the author. In connection with that, the majority of artists' books are meaningless.

Robert Delford Brown

One of the values of artists' books is that the calligraphic nature of words is being revivified. Also, with drawn words, collage, and instantaneous printing techniques a vast new territory for innovation in communication has opened to people who are slathering at the mouth for a wild and wooly new frontier.

Robert Cumming

I lost the letter we talked about earlier, but tried to recall what it was about; it went something like this,

"I had a friend who graduated from college with a degree in English Lit., and he had a roomate with a degree in philosophy, and they both recently became conceptual artists. In conversations with museum directors and curators, I've come across three who ultimately define themselves as artistically ambitious; they're just artists sitting behind desks biding their time and waiting for the big break. . . .further enumeration is no big news; performance artist/dancers, artist/writers, conceptual artist/philosophers and politicians, photographer/conceptualists, etc. etc., to the point of definition dilution.

I was a painter in my artistic adolescence, became a better sculptor and found photography simultaneously, moon-lighted as a Mail artist, did a book or two, became recognized as a conceptual artist and photographer, wrote a lot, now doing a little video, back into sculpture and may try out painting again this spring.

The open ground we now stand on is the result of the avante-garde's muscular grinding-down of the walls of specific media notions like life-long maturation and the idea of the masterpiece, craft, casting side glances at historical precedent. It took decades of conscientious revolutionary fervor applying the "Less is More" principle to get down to bedrock. Attainment is here and now; the dam is down and the floodplain is awash.

To extend the metaphor (God, we even banished metaphor), water/gravity factors level-off in time till a common level is reached. I hope the annotators of the '80s and later see us in good humor cause we all had a good time; dropped our palettes & brushes, kicked-away the easels, locked-up the garrets behind us, and saw for the first time with excitement our names in print, our faces on TV, got standing ovations stage-center in the spotlight. Now it can be

Skyscraper in the form of a hypodermic needle from Notes in Hand by Claes Oldenburg (detail)

thing that will do

ettected overnight cause craft is crummy and interferes with real communication.

I know this was supposed to be about books, but I've been feeling this weird compression of time the last couple of months ever since I found out that the properties of illusion I'd so painstakingly found out in my photographs had been set to paper by Galileo in the 1600s, and the cultural bind between puritanism vs. hedonism; Boston vs. LA., was thrashed-out by St. Augustine in his "Confessions," 397 A.D. And that's my temperment this month."

. . .and words to that effect.

Ted Castle
Director, TVRT Press

The terrible thing about the concept of artists' books is that it contains all the radical flaws of the concepts of art, artist and book. Although the book is not a new invention, artists realize its advantages: it is portable, easily stored, relatively inexpensive and, thus, easily accessible. No other forms of art have these desirable advantages rolled into one, perhaps except for those which do not as yet exist. Thus we have the recent development of a plethora of all kinds of artists' books. This development is probably still in its infancy. Books have an aspect of being objects, but they hardly pretend to uniqueness. They are uniquely suited to the presentation of sequential material, having been invented for the presentation of the graddaddy of the time-arts, literature. Books are also good for storing records of experience.

Ever being on the lookout for new forms and on the lookout against banality, artists approach books warily, like a cat approaching a Christmas present, and once having gotten into it we seem to produce books like a dog produces dogshit, carefully depositing our books in certain places at the requisite moments for souvenirs. One of the problems with artists' books is that they are too easy to do. Another problem is that they are only regarded seriously if the artist works primarily in other ways. This is largely because most artists don't take the book form seriously. Many artists have a horror of literature, to which the concept book is highly indebted. Not always, but frequently, artists are people who have either been intimidated by books or who have despised books. Thus many of the books are as unbook-like as possible. This effect is closely linked to mythologies of language.

A brief not like this cannot begin to elucidate the preceeding sentence. A consideration of such frequent usages as "vocabulary of painter" and "syntax of sculptor" may clarify what I mean. Having gotten over the novelty of it, I think we can embrace the book form and use it more effectively than as some kind of "Picasso guest towels."

Agnes Denes

For the past several years I have been working with nine books. These books are usually exhibited with my work to give access to other aspects of my art.

The book idea is a serial viewing procedure, with great possibilities for mapping structural/analytical processes, when contemplation of the material at hand is called for.

My work is an evolutionary process and my projects take years to complete. The books echo the various stages of development and change with each presentation. Structuralization and thought sequences become apparent in a way one would not be able to show in a "finished" work of art.

The books don't contain information as to what I had for breakfast or how I felt on a certain day (although it was a serious consideration at one time to record the

seemingly endless row of disasters of the past years); these are organic notebooks in a constant state of flux and have to be seen anew each time. It's like watching a forest grow or a landscape change with the seasons. We see cross-sections of ideas move from simplicity to complexity, from disorder to order and vice versa. And so the books become manuals to my work—they show the intent along with the realization, they visualize underlying structures, the invisible processes of art making and reveal a very personal art experience.

Recently, the University of Akron published a book of my work, titled, *Sculptures of the Mind*. With the publication of the book I have allowed this constantly changing, evolving process to be arrested, or be frozen in time so-to-speak. We have sliced off a section of an evolutionary process in order to contemplate its implications. Enlarged for scrutiny, a sentence cut off from the rest of a text, motion caught in a still—the work has turned in on itself to become its own examiner.

We are dealing with two different kinds of books here. One analyzes the process, the other the self. They are both absolutely necessary for the total experience.

Published Books: *Sculptures of the Mind*, Emily H. Davis Art Gallery, University of Akron, 46 pp, 1976. *Paradox and Essence*, Tau/ma, Rome, 54 pp, 1976.

Peter Downsbrough

as relates to: page, pages—turn the page—read recto/verso verso/recto to place to locate on the page—pages and to handle—to write, to read and contain there on the page, here/there, a page—one after the other or before, to read—page, pages, a book

Mary Fish

Briefly, what I like best about making books is:
1. A book offers one alternative to how one disseminates art if it does not fit conveniently onto gallery walls or into gallery time. (My own work involves private performances of ritualized activities which extend over expanded periods of time.)
2. A book allows me to present both visual and verbal images sequentially, thus providing and imposed order or structure (perhaps I should compare it to the proverbial grid of formalist painting) which lends a coherence to what is otherwise seemingly very disparate information.
3. I "perform" my art. The book or documentation (in a very loose sense of the word) comes after the fact. Thus I have the freedom to expand and extend and more fully explore the ramifications of the particular piece I am doing the book about. Just as a book provides the reader/viewer with the luxury of time to peruse at leisure, the doing of the book allows me that same reflective gesture towards my piece.
4. I have in the past and am sometimes concurrently involved with the making of art objects, some of them very large. A

8

from *A Few Palm Trees* by Ed Ruscha

book has come for me to have ever increasing advantages: it is easily shippable and packable. It does not break. It is even more easily stored. It is not heavy. It can be given as a remembrance to friends. In short—how nice to be able to carry around one's art in one's hand!

Jon Gibson

Artists' books are for artists who want to make artists' books and for people who enjoy looking at artists' books. For instance, Jon Gibson made an artists' book about some music he had written and he thinks many people will enjoy looking at it. It is being published by Printed Matter. They also have a record of his.

Peter Grass

Books can be repeated, translated many places at once; are accessible, econ ic, compact and democratic; have author glamor and power in their large numb they cannot be burned (Truffaut's *Fahr heit 451*).

The artists' books I am most intereste are pictures in book format. I prefer pictu over 'philosophical thought and scient discoveries.' H.G. Wells wrote: 'Artis productions, unlike philosophical thou and scientific discovery, are ornaments expression rather than the creative s stance of history. . .'

Post-Guttenberg artists' books share *should* share the attributes of regular boo By using this powerful vehicle for ide artists' books can be effective in helping release artistic productions from obscurity

George Griffin

I have been making flipbooks of sequer drawings and photographs as outgrow from and input for my animated film These booklings allow one to read form a movement without the intermediating ty anny of the forward direction, 24 frames p second, darkened room, red "exit" sig projection situation.

Reading a flipbook is an active, priva act, requiring a certain degree of skill, which synthetic or real time sequences a reconstructed at the reader's own speed.

Collating and binding, so close to the fil editing process (which uses cement) can, a flipbook, add another dimension of view choice. In one instance I use 2 Chica binding posts which can be easily u screwed and disassembled, hoping th readers will experiment with arranging th pages according to their own scenario.

As a highly accessible, even disposab artform, the flipbook subverts the eliti nature of the traditional art context ar market. It is utterly useless under glass ar must be manipulated, broken in, to thoroughly enjoyed. It is a "novelty item, an heir to an honest tradition of popul diversion. . .like the movies.

Judith A. Hoffberg

Executive, Art Libraries Society of Nor America; manager, LAICA bookstore.
Artists' Books: Alternative or Real Thing

The "phenomenon" of the artist-pr duced book is now being explored, but is longer a phenomenon. The Dadaist, Su realist and related movements of the ear 20th Century used books by artists as significant medium of expression. But was the 1960s that produced the "phenom enon" which only now is being recognized important. The development of commerci printing and production technology create an impetus for artists to produce unlimite editions, which were inexpensive and wide distributable. Ed Ruscha was a pioneer this venture, with work by Joseph Kosuth Lawrence Weiner, Ian Burn, Oldenburg an Dick Higgins, among others, and the artis produced book developed into a Renais

sance paralleling a graphic revival and interest in multiples. Ruscha's great foresight allowed him and others to see the book not only as artwork in itself, but a new source of income.

The book as an alternative to gallery and museum offerings allows a democratization of art, a decentralization of the art system, since books can be distributed through the mail, through artist-run shops, through friendship; books take up less room are portable, practical and democratic, and create a one-to-one relationship between consumer and artist, between owner and creator. The artist-produced book is not only an instrument of communication, but also an extension of the artists' vision achieved through mixed media. It is as permanent as the artist desires it to be, as ephemeral as a cloud, involving the owner in a solitary act.

As a librarian, it is not difficult for me to see that a well-stocked bookshelf could, in theory, be an art gallery or museum. The artist-produced book belies the new-fangled technology which is replacing the book with microforms. It has provided visibility for artists outside the mainstream, and more important, it permits the artist to present his or her work without the intervention of critics or other intermediaries. As Lucy Lippard has stated, "the additional need to find new vehicles for new esthetic ideas has led back to one of the oldest of all—the book is still the cheapest, most portable conveyor of ideas, even visual ones."

An international catalog and distribution service is being attempted for all artists' books. These once unprofitable items seem to be surfacing in more bookshops, and new systems for distributing artists' books are being forged by Franklin Furnace and Printed Matter.

The alternative has become the object—and the object is the book—and the book is produced by artists.

Douglas Huebler

Artists' books provide the most accessible and "off-the-wall" location for ideas/works whose essential form is not a function of traditional media, specific material or environment.

Alan Kaprow

When you consider artists' books, two kinds should be kept in mind: the book conceived as unique art work, and the book (like any other) that happens to be designed by an artist.

The first is a sort of pre-Gutenberg throwback, like a medieval manuscript. The second is a mass-produceable object that may incidentally be artfully designed.

Unless it turns out that the artist makes her or his living designing other people's books, the second kind usually will be related to, or specifically concerned with, art. Thus it will have a limited market and might as well be considered a unique object.

The major book companies will not touch either kind of artists' books for obvious financial reasons (with a few coffee table exceptions). But if many of these books and pamphlets were accounted for around the world, it might be possible for a business to promote and sell them profitably, as a special interest line of the same order as science and technical publications. Scattered as they are now, there is no way for people to see them much less purchase them.

Richard Kostelanetz

As someone who made books before he made anything considered "art," I feel gratified, if not amused, by "artists" discovering the virtues of books—that they are cheap to make and distribute, that they are portable, that they are spatially economical (measured by extrinsic experience over intrinsic volume) and that they are infinitely replicable.

The economic difference between art-objects and book-objects is that the former need be purchased by only one person, while the latter needs many buyers to be financially viable. The trouble with commercial publishers is that they will not publish anything unless their salesmen can securely predict at least ten thousand purchasers. To commercial publishing, not even Robert Smithson's collected essays, say, are economically feasible. It is obvious that what is most necessary now are book-publishing companies and distributing agencies that can deal in smaller numbers and still survive. Thus, the literary world has witnessed the emergence of small presses which are, by now, publishing more consequential Literature than large presses.

As a small press proprietor for several years, I have discovered that the biggest headaches are distribution to sympathetic bookstores and then collection of moneys due.

Whereas sometime visual artists seem most interested in fitting their visual ideas into the format of a standard rectangular books, I find myself more interested in expanding intitially literary ideas into other media—ladderbooks, oversized books, undersized books, newsprint books, card books, large prints, wall drawings, audiotape, videotape, film.

It is hard to know where "artists' books" begin and literary books end, and it would be self-defeating to draw definite lines, dividing territory, in advance of exploration and discovery.

My major quarrel with the category of "artists' books" is that it defines work by who did it, rather than the nature of the work itself. The term thus becomes an extension of the unfortunate community custom of defining an "artist" by his or her initial professional ambitions or, worse, his or her undergraduate major. Artistic categories should define work, rather than people, and the work at hand is *books* and book-related multiples, no matter who did them.

What would be most desirable now would be a situation where an artist-writer (or writer-artist) would feel equally comfortable about making an object, a performance, or a book, their choice of medium depending upon the perception and experience he or she wanted to communicate.

"Fibonacci Igloo" from *Fibonacci 1202* by Mario Merz

Sharon Kulik

Artists publishing their works in book form create an accessible format for their work to be seen more widely and rapidly, as well as creating a market for themselves should the books sell.

Apart from those factors a corresponding element arises by choice or chance: politics.

9

The political implications of an artist working entirely on his own, calling his shots about his work can be viewed in terms of Marxism and a revolt against the art establishment middle men who have been known in the past to bleed artists through profit making and dictatorial decisions regarding the artist's work and "reputation."

Publishing works is a spontaneous extension of the piece/s involved, free from the established art business aggravations, and it returns the power and authority back to the artist regarding his decisions about his creations.

Robert Leverant

Basic difficulty: My belief is that today people don't read, and if they do read, they have no time to read. The books I am involved with use this premise. They are more like TV commercials than TV shows.
Positive: I believe it is important for the artist/writer to design their own book, rather than another person, rather than be part of a process. It is more whole to the individual creator and "creation," i.e. the product, i.e., the book. Each book contentwise is unique, why is the form the same? Form is content and content is form.
Aesthetic: The sequential nature of the book and the montage of facing pages makes the book form a filmic medium. The most successful visual or silent book I know is *Cover to Cover* by Michael Snow, a filmmaker.

Sol LeWitt

Artists' books are, like any other medium, a means of conveying art ideas from the artist to the viewer/reader. Unlike most other media they are available to all at a low cost. They do not need a special place to be seen. They are not valuable except for the ideas they contain. They contain the material in a sequence which is determined by the artist. (The reader/viewer can read the material in any order but the artist presents it as s/he thinks it should be). Art shows come and go but books stay around for years. They are works themselves, not reproductions of works. Books are the best medium for many artists working today. The material seen on the walls of galleries in many cases cannot be easily read/seen on walls but can be more easily read at home under less intimidating conditions. It is the desire of artists that their ideas be understood by as many people as possible. Books make it easier to accomplish this.

Lucy Lippard

One of the reasons artists' books are important to me is their value as a means of spreading information—content, not just esthetics. In particular they open up a way for women artists to get their work out without depending on the undependable museum and gallery system (still especially
10

undependable for women). They also serve as an inexpensive vehicle for feminist ideas. I'm talking about communication but I guess I'm also talking about propaganda. Artists' books spread the word—whatever that word may be. So far the content of most of them hasn't caught up to the accessibility of the form. The next step is to get the books out into the supermarkets, where they'll be browsed by women who wouldn't darken the door of Printed Matter or read *Heresies* and usually have to depend on Hallmark for their gifts. I have this vision of feminist artists' books in school libraries (or being passed around under the desks), in hairdressers, in gynecologists' waiting rooms, in Girl Scout Cookies. . . .

Christof Kohlhofer

Books are a very unifying thing: wise guys 'n' idiots can write them and even blind, deaf and dumb can read them.

Jane Logemann

The inexpensive paperback art book presented as a work by the artist is long overdue in our so-called equal opportunity society. These books also can't help but destroy a certain pejorative stereotype of the contemporary artist as a dealer in arcane and inaccessible ideas. This medium gives the artist a chance to bypass a decadent and closed art distribution system. It provides a new space for the propagation and reception of art ideas.

Paul McMahon

Lots of artists are publishing books (by themselves). Books have certain advantages over art works in other media. They are relatively inexpensive to mass produce. And they suggest alternative systems of distribution. It is interesting to consider artists' books from the point of view of merchandising, because it forces one to imagine the demands of a wider market than other artists. At present other artists are the primary audience for new art. The artist today is insulated in the art community, which acts in some respects as an asylum. The public regards artists at a distance, separated from the masses by their harmless although potentially disturbing actions. How do artworks touch the rest of the culture? Artists disseminate artifacts in book form.

The book has disadvantages as a medium of artistic production. It is regarded as a carrier of art. Therefore the book itself is boring. Some artists try to counteract this by referring to the book as a book. Stupidity enters the picture somewhere around here. *A* and *the* by Andy Warhol are books that bridge the gap mentioned above, *A* slightly to one side, *the* apparently slightly to the other. Many books by artists function well as art works. A few books by critics function well as advocacy for kinds of art. Books are, however, a relatively quiet medium.

Robert Morgan

Artists' books are not art books are no books to be read. The revolution in th printed page is sometimes electric, the re production that fits the image, makes th image numerous, is visible as the structur it represents. These books are meant to b turned, are curved, from page to page; th book may be revolved—it is the rhythm o the swim, the toehold in uneven space Select the image, dissolve it, reveal it—re peat the sequence, its meaning, once found What is seen is heard, in a sense, reverber ated thru pages like walls, forwards an backwards, either way; that is the revolu tion to which words do not speak, only images in relationship, in place; we look a what we see page by page; the time it take to view is the compression of a materia instant in order to hear it.

Mauritio Nannuci

artist and director, Zona, Florence

It was around the sixties that there oc curred a wide diffusion of artistic operation which found a productive place only on th edge of that which is called—rightly o wrongly—mass culture, because these ex pressions were deemed either too specialize or too new to be take up immediately eithe by the general public or by those sector more specifically interested in experimenta tion.

This coincided with the realization by many cultural operators that art cannot be limited to the fabrication of discrete works but rather that alternate categories must be marked out so as to create new connection in their work, widening the distribution o their research.

Consequently there has been a whole series of initiatives concerning books, records, photographs, videotape, rubber stamp, postal messages, telephones, and film, but the phenomenon of largest proportions, closely connected to all the others, have been the "small press scene" and "book as artwork", which have made it possible for those artists, poets, architects, and musicians engaged in experimentation to avoid any sort of external interference and to have at their disposal an autonomous instrument with which to spread their own work and ideas, and which at the same time serves to link together operators and analogous research topics.

Thus self-managed editorial enterprises have sprung up everywhere, supporting original contributions and favoring the diffusion of new artistic experiences; they have determined one of the rare moments of synchronization of creativity and communication.

Richard Nonas

I was an anthropologist writing a book about Papago Indians; trying to communicate two years of their and my lives with words—and I couldn't do it; didn't even want to do it. Words seemed too specific,

too pointed. They carried more and less meaning than I wanted. They were always too personal. They were nobody's business but mine. So I stopped. And I made sculpture.

And that was better; more general, more diffuse, more ambiguous—but also more immediate. People could trip over them.

Yet something was lost. Something important to me: a narrative quality that moves and excites me. Something I can't get and don't want in my sculpture. It's a temporal quality; specific memories used as building blocks in sculpture that snakes through time.

So I make books too. But differently than I did before. My books are like sculpture now; built for the same reasons and in the same way. They aim at the same ambiguous feelings, work with the same not quite regular forms and the same preshaped materials—they are objects; objects to deal with. But, they do what my sculpture can't: they jump, they move, they snake with the richness of real incident—they are the space between the sculptures.

Adrian Piper

Cheap Art Utopia

Suppose art was as accessible to everyone as comic books? as cheap and as available? What social and economic conditions would this state of things presuppose?

(1) It would presuppose a conception of art that didn't equate spatiotemporal uniqueness with aesthetic quality. People would have to be able to discriminate quality in art without the trappings of preciousness, e.g. the gilt frame, the six-figure price tag, the plexiglass case, the roped-off area around the work, etc.

(2) It would presuppose a different economic status for artists. Since art would be cheap and accessible, artists could no longer support themselves by receiving high prices for their work. Their situation would be comparable to that of writers, for whom first editions, original manuscripts and the like play virtually no economic role during their own lifetime.

(3) Therefore art dealers would bear much the same sort of economic relationship to artists that agents bear to writers: perhaps just as symbiotic (we should no longer fool ourselves into thinking of the relationship as parasitic), but not nearly as lucrative an enterprise as art dealing is now. Economically, artists' and art dealers' profits would diminish proportionally.

(4) Since artists' revenue would depend more on volume of sales than on making a killing on the yearly masterpiece, artists would gradually feel increasingly disposed to make their work palatable or relevant to a larger segment of society than that which now constitutes the art world. Some would equate this increased popularity (literally) with a decline in aesthetic quality; these individuals would become bitter, dogmatically elitist, and comfort themselves with the thought that their work represented the last bastion of aesthetic integrity. Others would find that this state of things no longer fueled their images of themselves as rare and special persons, and so would

From top to bottom: Catalogue by Gilbert & George; Notes on Water by Joseph Kosuth; Sonora Cows by Richard Nonas; Walls paper by Gordon Matta-Clark

dessert art for flagpole-sitting.

(5) Artists would get feedback on their work from this larger segment of society, and no longer just from the relatively small, highly-educated percentage of the population that have the leisure and developed aesthetic inclination to frequent museums and galleries and read art magazines. This would be a particularly unpleasant experience for those artists whose work requires for its appreciation the advanced cultural education on which it currently feeds.

(6) The social role of art critics would be invested with greater responsibility because they would be legislating aesthetic standards (as they always do in fact) for a much larger audience, the political and economic orientation of which would be very different from that of the current art audience.

(7) It would be easier for more artists to publicize their work without going through the political process of selection now required (i.e. where you went to art school, who you know, where you live, whether you've gotten "written up" and by whom and where, who you've slept with, where you hang out, etc.). So new, *aesthetic* standards would have to evolve in order to discriminate mediocre from first-rate work, rather than the standard of simply having been sifted through this process itself. Also, people would actually have to develop these new standards themselves instead of leaving all the hard work to critics, since there would not be enough famous critics to pass judgement on all the work.

(8) The social responsibility of artists would increase proportionally with that percentage of the population her or his work affected. Some artists would meet this challenge by becoming more conscious of, and exerting more control over, the social implications of their work. Others would get scared and retreat to the old "Don't-ask-me - I - just - make - the - stuff - God - works-through-me" routine. Still others would run for President.

Distributing art in books would make it as cheap and accessible as comic books. And that would change a lot of things.

Lucio Pozzi

Books have a time structure built in them, because, unless they are of the foldable kind, you can never perceive them all at once. Books also normally have standard sizes, even though one could, if one wanted, make baseballfieldsized or microscopic books.

Books can be burned. They are, more often than not, transportable. When one doesn't have time to read them, one can stack very many of them on shelves and either use them as a reference or as a reminder.

Artists' books are easy to read because they often are a translation in word codes of non-literary experiences. Many artists' books are only visual experiences—basically cartoon kinetic products. If it includes words, an artists' book becomes a sculpture or a painting when it is made in such a way that you cannot open it and read what is inside it. It ceases to be an artist's book

12

from Learning to Swim (Le Style Francais) by Robert Morgan

when the artist, carried away by enthusiasm, extends his/her book to poem, short story or novel size. A long artist-written story is a novel. The artist thus becomes a novelist. Maybe, if the novel were very long —say a thirty volume story (600 pages per volume, all filled with text, 10 pt. type)— then maybe it would become an artists' book again and the artist would not be a novelist anymore and be reinstated in his/her artist status.

Marcia Resnick

Dear Edit and Michael,

When I wake up in the morning I take a shower, brush my teeth, drink a cup of coffee and phone my printer. I have been doing this for one and one half years, since I first decided to self-publish three books: *Landscape, See,* and *Tahitian Eve.* I am still waiting for the printing job to be completed. Due to limited funds, I was forced to cut the enormous costs for printing books of photographs by sacrificing quality and professionalism in production.

After the intial series of printing mishaps, I received my first batch of books and entered the "quality control" stage of book publishing. I examined every single book for printing errors. About 50% of the books passed inspection. I then embarked upon my distribution campaign and soon was to find myself inundated in vast quantities of papers, invoices, bills, sheets of corrugation, brown wrapping paper, cord and packing tape. Months later, confused and disillusioned, I took the papers, invoices and bills, neatly wrapped them, instead of my books, with the corrugation, brown wrapping paper, cord and packing tape, sent the bundle off to a corner of my loft and resigned as my own distributor. One year later, Printed Matter picked up where I left off.

Though disillusioned, I still believed and still do believe in the art book as an art form. It is an art form which has the auspicious quality of bypassing the politics of the art gallery and is an expedient way of vicariously disseminating ideas to a large public, not just to the select few who purchase art. After an art book is purchased, it can be perceived in a time-space arena that is totally unknown to the artist and is thus incorporated in the mental and physical world of the perceiver. But in order to sustain this art form must artists continue to invest large amounts of money in their books, only to find that Jaap Reitman will purchase five books outright and the rest of the world will accept books on consignment? Why are there no grants for individual artists to produce artists' books (CAPS photography grants stipulate that monies cannot be utilized for the production of books)? Aren't books, like sculpture, dimensional art objects? Why then are art books not commissioned as sculptures are?

Book stores will not purchase artists' books because there is no market for such a thing as an art book with its all too often obscure content range. In a culture where the only book people read is the TV guide and where bibles are no longer made of paper and ink but are manufactured by SONY and Panasonic, the aesthetic experience can now be attained without suffering the arduous task of turning pages.

Then what, other than education and organized attempts to create markets, will sustain the Artists' Book?

1) Someone might invent a motorized page turning apparatus (Laurie Anderson has done some work with wind in this area).

2) The one page book might attract a larger market. Thus, the public can be spoon fed one book over a long period of time (in this way, many who ordinarily never read novels have ploughed through as many as five chapters by the likes of Kathy Acker and Connie DeJong).

3) Art-Book of the month club—a way to save precious dollars while building an art book library.

4) Readers Digest-type condensed Art Books (*The Finest from the Fox,* for

example).

5) Academy Awards for Artists' Books, with categories such as Best Book, Best Foreign Book, Best Printer, Best Special Effects, Best Male Book Artist and Best Female Book Artist (Jeffrey Lew should perhaps be commissioned to design the trophy).

Writing this letter has afforded me my digital therapy for the morning. My fingers feel refreshed and strong. I think I'll sign off. I'm ready to suffer the arduous task of turning a page in a book I am reading.

affectionately
Marcia Resnick

The Roseprint Detective Club

"A BOOK IS TO MAKE USE OF BOTH SIDES OF A PIECE OF PAPER, OR INBETWEEN"

Carolee Schneemann

Carolee Schneemann as Self-Publisher

how to be out and stay in
or out is my story, ours
we're in touch thru the effort I provide the means the method cheap&simple available books / first 1972 *Parts of a Body House Book* at Beau Geste's mimeopress then 1975 *Cezanne, She was a Great Painter* my corner copyhouse edition of 300 sold out for 2nd edition of 500 now (soon) a 3rd / contact by rumor word of mouth a few lucky mentions the obscure shops (not those ART bkstrs, where dealers look blankly hold the book like a damp rat say. . . not enough photographs / not enough text/in any case not for us!) and still now adjust my intention to what is possible for someone with no gallery affiliation in usa no income from works for awhile unemployment checks to ease. . . but income? from books? is information/response. the disproportionate effort: to sell at $3 w/cost per 1.50 then envelopes postage trips to PO the cottage industry attention one by one & taking/placing ten here ten there income? minus cost plus effort. . . still worth it!

John Shaw

An artist who sits down to look at his own book feels the air move across his face as he turns the pages.

Bob Smith

Director, LAICA
"Alternative" Publications in an "Alternative" Space—A Report

In an effort to redefine the functions of an institution devoted to contemporary art, LAICA (Los Angeles Institute of Contemporary Art) has experimented with differing combinations of organizational structures and programs. While guest curators were given *carte blanche* by the dozen and guest editors given "total authority" for the LAICA-financed non-house organ *Journal*, most exhibitions tended to look like "muse-

um" shows and the magazine like most other magazines. The cause of these prosaic beginnings can mostly be attributed to the paucity of local activity (museum exhibitions). It is difficult to be an alternative when there is nothing to be an alternative to. True, this process has produced an unusual variety of programs, but most succumbed to the "see only the old environment while in the new environment" McLuhan phenomenon.

The LAICA *Journal*, after almost three years of publication, has found no singular purpose or function. It has provided a historical focus and identity for regional art, but questions concerning support, staffing and content abound. What are the new imperatives for an alternative art magazine in Southern California? Will the *Journal* find its home? Will another Douglas Fir go down for the sake of *Artforum* or *Art in America* rejects? A managing editor, Michael Auping, has recently been appointed to provide continuity within the guest editor concept.

Like their museum ancestors, LAICA's exhibition catalogs have tended to reinforce the position of the institution and curator in the name of documentation. Some have directly involved the artist in essays and interviews, but the need to more accurately define work by encouraging more artist participation in preparing essays for idea-specific (thematic) exhibitions is increasingly apparent. Artist-specific exhibitions often offer the opportunity for the creation of artists' publications in lieu of documentation. An artist's book, a work in its own right, can have greater validity in representing the artist than easily misread photographs and second-hand interpretation.

The implications of a growing interest in artists' publications, periodicals and other information indicate profound changes in the way exhibitions are produced and perceived. Many artists have produced autonomous publications as part of exhibitions. The Institute for Art and Urban Resources recently sponsored a magazine show in *Artforum*. LAICA has plans for exhibitions that appear in publication form only. Art librarians, trained in the organization and dissemination of printed materials, will surely take a central role in the "museums" of the future.

Pat Steir

for Printed Matter, Inc.

I like artists' books because they are:
1. portable
2. durable
3. inexpensive
4. intimate
5. non-precious
6. replicable
7. historical
8. universal

Ellen Sragow

The book form is the appropriate medium for much of the narrative art being produced and it allows an artist's statement to reach

13

from *For the Voice* by Lissitzky and Mayakowsky (detail)

14

an audience outside of the gallery audience. It is more accessible financially and physically.

Ted Stamm

The book is an encapsulized format in which to exploit the multiple variations of a specific idea. For this reason I have executed and remain interested in books.

Peter Stansbury

It is quite simply the problem of locating the market. Even if you blanket mail every locatable individual interested in art, most of the mailing will be wasted, and advertising is equally expensive and wasteful. But there seems to be no alternative. Our solution so far has been to combine those two with an ordinary over-the-counter retail shop, whereby advertising, mailing and point-of-sale all serve each other. Also I think that the more people who become aware of artists' books the greater the number who'll buy: in a sense we have to *create* the market.

Richard Tuttle

Dear Mimi,
　There is no book.

Richard Tuttle

Dear Edit,
　Here's the letter. Let me know if there is anything else. Love to you　　　Mimi

Fred Truck

in my view, the issues related to artists' books are 2, namely the mechanical process of reproduction, & 2) the final form what is reproduced takes.

in terms of the mechanical process involved, offset is almost univerally utilized because of quality & economic factors. what is often overlooked however, is the availability of color reproduction—if the size of the work, pagewise (not sizewise, but numberwise), is kept small, loads of color can be used. in addition, few artists are familiar enough w/what different types of presses will do. web presses, those fed by roll, will do 4 colors on both sides in 1 shot thru the press, but the finish size, unless you wish to waste a lot of paper, is inflexible. sheetfed presses, on the other hand, offer flexibility in size, but require more passes through the press for color, & therefore waste is accrued. also, assuming all things are equal, the larger the press, the easier it is to maintain high quality production standards. as I am a pressman by trade, I speak from experience. I've had it w/A.B. Dicks, Multi's, Chiefs, etc.

in terms of the second issue, the final form the printed material takes, I find the past history of written texts to be instructive. the Aztec & Mayan codices, the Mixtec folded screen books, splashed w/color offer alternatives to the book form. the diptychs, triptychs etc. & the illuminated manuscripts of the Medieval period are inspira-

tional. I also find the Chinese position challenging—the artist-poet often was not only responsible for the ink painting, but the calligraphy that went W/it. this position offers the possibility for collaboration.

Lawrence Weiner

THEY (BOOKS) ARE PERHAPS THE LEAST IM-POSITIONAL MEANS OF TRANSFERRING INFORMA-TION FROM ONE TO ANOTHER (SOURCE)

Robin Winters

Freedom of Sleep
or
Cancer of the mouth

The government should print 500 copies of any book which a citizen wishes to have printed on a non-discriminatory basis. There should be a re-printing of any book which is out of print & in public demand. All books should be free, and all authors should receive a fee of $5 dollars per page of manuscript.

(The above suggestion would apply as well to film photography music performance dance etc. with varying services and varying price & production considerations)

I would like to further suggest that the wealth be divided equally (wealth includes money property industry etc.) and that there be a massive identity bank destruction in every country no more passports no more borders no more police no more jails no more courts no more laws.

Electricity should be as free as water. Power to the People. The Ruling Class can kiss my ass.

PS. Here are some books I am reading right now.
• Marinetti *Selected Writings*
• *The Origin of the Family, Private Property and the State* Fredrick Engels
• *Victory* Joseph Conrad
• *Selected Writings* Blaise Cendrars
• *Europe on $5 a day* Arthur Frommer
• *The Management of Pain* John J. Bonicia, M.D.
• *Defiled* by Walter-Jeremy Lipp
• *Against Nature* J.K. Huysmans
• *Impressions of Africa*, Raymond Roussel

Rachel Youdelman

For some artists, the use of commercial printing equipment is an extension of the traditional hand-etching and lithography methods of printmaking.

For others, it is a means of expressing concepts whose appropriateness is unmatched by other media.

Whatever the motivation, the graphic-multiple-as-art-object, produced with commercial printing equipment, lends itself to being less "precious," more affordable, more accessible to its audience, and more portable.

Modern technology itself has made traditional painting and sculpture appear to be hopelessly anachronistic; but at last—and perhaps most significantly—artists are able to view technology as a great resource rather than to perceive it as a threat to their existence.

An artists' book is a very personal experience. We all bring to them our own memories, ideals, tastes . . . our own way of looking at the world. And a little of that irrepressible anticipation from childhood. For some of us an artists' book means a day on the slopes followed by a traditional dinner in front of a blazing fire. For others artists' books begin right after making fruitcakes, knitting mufflers, shopping before the crowds start. Children pick up on the spirit early, writing lists and revising them, always hoping for snow on that special day. But whatever the manner of celebration, one idea prevails. It must be the best book—ever. Art-Rite believes in that idea. And so this catalog exists to help you make your collection exactly what you choose it to be. Not everyone wants a silver wine rack or a tennis outfit. So we decided to offer this collection of artists' books in a variety of moods, to help create a very special magic for you and yours.

CATALOG OF BOOKS

Black Phoenix

Rasheed Araeen, Mahmood Jamal 1978

Rasheed Araeen and Mahmood Jamal, "Editorial," *Black Phoenix*, no. 1 (Winter 1978).

Black Phoenix is the result of a realization that we who are concerned with the cultural predicament of the Third World must stand on our own feet and speak with a unified voice, that we must collectively confront, on an international level, those forces which in the name of "universal freedom of man" are actually causing enslavement of men and women. No matter how inarticulate some of our first attempts may appear, this should not prevent us from speaking up. We can only learn from our own efforts and develop the precision of thought and action.

Black Phoenix is not a journal merely for professional writers or critics (to perpetuate their self-interests) but a platform for discussion, a channel for the exchange of ideas relating to the cultural predicament of mankind in the era of advanced capitalism and imperialism. It represents a commitment to the struggle against cultural domination and hegemony; and all those who are engaged in this struggle—irrespective of their race, color or creed—are invited to participate in this dialogue.

The Third World is the world of the oppressed. It is the world which was plundered by colonialism and is now being robbed of its remaining resources, natural as well as human. The underlying factor that unifies today all the people of the Third World is that they are subjected, or liable to be subjected, to imperialist domination. While the native bourgeoisie is collaborating unashamedly with international monopoly capital in perpetuating Western domination and in doing so is suppressing the productive and creative potential of its people, there is a growing awareness among the people themselves about their predicament and its causes, and they are in fact struggling for self-determination not only in political and economic fields but in the creation of their own art and culture as well.

Needless to say that present-day cultural imperialism has its roots in the Western bourgeois ideology and the concept of white superiority. The cancerous growth of imperialist ideology in the body of the Third World is, on the one hand, progressively destroying the SELF of the Third World, its human identity and dignity, and, on the other, there is a constantly developing antibody to get rid of the foreign matter. The dialectic of this struggle must lead to the emergence of the Third World from neo-colonial wilderness; a black phoenix rising from white ashes.

It is not a sentimental proclamation but an identification of/with the force which can and shall transform the world; it is the recognition of the power of the oppressed to liberate themselves and the oppressor at the same time.

We reject the widespread and mistaken idea that the technological culture which has been developing in the West is universal and that all people will eventually have to adapt to Western values as part of their modern industrial developments. The emergence of an industrial society in the Third World with its own cultural forms and values is possible only if it develops independently.

It would be naive to think that art or cultural activity alone can change the world or that in our cultural struggle we can ignore socio-economic and political forces. However, the struggle within the domain of art/culture against domination can strengthen the overall struggle. And therefore art must play its own due role in human struggle. No matter how small or marginal its contributions may look, it must not be substituted by anything else. It is imperative to recognize the limitation of art. Beyond or below its inherent social function it becomes a mere propaganda or decoration. However, art must constantly stretch its boundaries beyond the academic/bourgeois limits to reflect upon the changing human condition.

We recognize that cultural struggle is part of class struggle. We do not, however, prescribe to any dogmatic or/ and sectarian line. Nor do we accept the primacy of one particular style of art activity over the rest. Our position is clearly expressed by Eduardo Galeano: "The culture of resistance uses all the media at its disposal and does not allow itself the luxury of wasting any means or opportunity of expression."

We do not accept the romanticized necessity of material poverty for the artist. To demand for the recognition of one's art activity and to accept money for one's work is not careerism.

Black Phoenix does not constitute a corporate body. The various opinions expressed in the journal are those of the contributors and we do not necessarily agree with all of them.

We have started this magazine in very difficult conditions. Everything seemed to be against us: lack of proper expertise, lack of experience of professional writing, lack of material resources and money, etc. It was only the will to survive and struggle that enabled us to take the plunge. We now need your help to continue this struggle. We need your contributions (statements, articles, etc.) and material support (subscriptions, donations, etc.) as soon as possible as to enable us to bring out the next issue in time.

Artists' Books Fruit Diagram

Clive Phillpot 1982

Clive Phillpot, "Books, Bookworks, Book Objects, Artists' Books," *Artforum*, May 1982, 77.

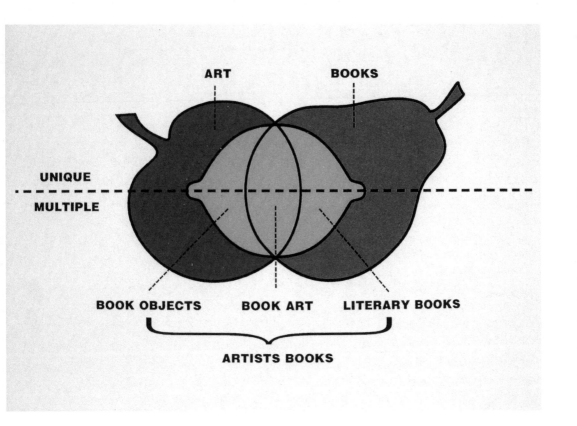

Fifty Helpful Hints on the Art of the Everyday

Allen Ruppersberg 1985

Allen Ruppersberg, "Fifty Helpful Hints on the Art of the Everyday," in *The Secret of Life and Death* (Los Angeles, Mueum of Contemporary Art, 1985), 111–14.

GENERAL

The individual search for the secret of life and death. That is the inspiration and the key.

The reality of impressions and the impression of reality.

The ordinary event leads to the beauty and understanding of the world.

Start out and go in.

Each work is singular, unique and resists any stylistic or linear analysis. Each work is one of a kind.

Personal, eccentric, peculiar, quirky, idiosyncratic, queer.

The presentation of a real thing.

The great mystery and the great banality of all things.

The ordinary and the rare, their interconnectedness and interchangeability.

There is a quotidian sense of loss and tragedy.

Collect, accumulate, gather, preserve, examine, catalog, read, look, study, research, change, organize, file, cross-reference, number, assemble, categorize, classify, and conserve the ephemeral.

Art should make use of common methods and materials so there is little difference between the talk and the talked about.

The historical and the scholarly can be ends in themselves.

Art should be familiar and enigmatic, as are human beings.

Each work is an essay on a different subject with interchangeable methods and means.

There is a keen interest in appalling behavior.

A sort of journalist reporting on the common, observable world.

Suicide is often the subject because it is a representative example of the ultimate moment of mystery. The last private thought.

Look for narrative of any kind. Anti-narrative, non-narrative, para-narrative, semi-narrative, quasi-narrative, post-narrative, bad narrative.

Use everything.

The artist is a mysterious entertainer.

111

What is the aspect of the seasons and what political changes are likely to take place?

SPECIFIC

It had to unfold gradually so that the common themes and ideas would naturally reveal themselves, just as one story generates another.

Banal images and banal drawings. Commonplace and ordinary in image and execution. With dramatic and melodramatic feelings, emotions, and ideas. Rendered in a quiet and tense style to make it alive and tangible. The tools of advertising.

Initially I used the methods of mass-reproduction to make "original" works which would be more available to the public and serve as a "corrupting" influence on the notion of high art originality. Now I make singular versions of mass-produced things to explore their forgotten content and to ridicule the process of their production.

I want to reveal the quality of a moment in passing. Where something is recognized and acknowledged but remains mysterious and undefined. You continue on your way, but have been subtly changed from that point on.

I try to set up a network of ideas and emotions with only the tip showing. The major portion of the piece continues to whirl and ferment underneath, just as things do in the world at large.

It is constructed to work on you after you have seen it.

The act of copying something allows the use of things as they are, without altering their original nature. They can then be used with ideas about art on a fifty-fifty basis, and create something entirely new.

It operates on a basis of missing parts. The formal structure, a Minimalist strategy of viewer completion and involvement, is one of fragment, space, fragment, space, fragment, fragment, space, space, space.

The form of each piece is determined by the nature of its subject.

There is a point in every story that requires a certain scene in order to continue. Each work is one of those scenes.

The newer works use pictures and objects to reinforce the older works which were designed to erase those distinctions.

The image of a book became the symbol for the use of a certain kind of subject matter which was basically literary in nature. The novel is suggested by a multi-layered approach.

I'm interested in the translation of life to art because it seems to me that the world is fine just as it is.

Will the marriage about to take place be happy and prosperous?

112

After my death will my children be virtuous and happy?

ADDITIONAL COMMENTS AND VERY BRIEF NOTES

The means of expression do not matter as much as the idea that is released.

Reality only needs a slight adjustment to make it art.

The question is: what is seen now but will never be seen again?

Art is indeed everyday.

The lessons to be learned are poetic. To transform and transcend. Choose the important from the not.

Make things that are necessary.

I prefer the singular artist with many influences to the developer of a style.

The work is like an article in a newspaper. Common in presentation but unique in content.

I like things that horrify and amuse at the same time.

The extreme in the midst of the bland.

Idea and experience. Curiosity and wonder.

I use my art to transform my life, I use my life to make my art.

OTHER PEOPLE'S IDEAS

"To have original, extraordinary, and perhaps even immortal ideas, one has but to isolate oneself from the world for a few minutes so completely that the most commonplace happenings appear to be new and unfamiliar, and in this way reveal their true essence."

Schopenhauer

"Authentic modern art is distinguishable by the elements of surprise."

Apollinaire

"By thinking of things, you can understand them."

James Joyce

113

"If the most unrelated things share a place, time or odd similarity there develops wonderful unities and peculiar relationships . . . and one thing reminds us of everything."

Novalis

"In whatever form it is finally presented, by drawing, by a painting, by a photograph, or by the object itself in its original materials and dimensions, it is designed to amuse, bewilder, annoy or to inspire reflection, but not to arouse admiration for any technical excellence usually sought for in works of art. The streets are full of admirable craftsmen, but so few practical dreamers."

Man Ray

"It is only shallow people who do not judge by appearances. The mystery of the world is the visible, not the invisible."

Oscar Wilde

TO BE CONTINUED

Inform me of all particulars relating to my future husband.

114

What the fuck is HOMOCORE?

Tom Jennings, Deke Nihilson, eds. 1988

"What the Fuck is HOMOCORE?," in *Homocore*, no. 1, ed. Tom Jennings and Deke Nihilson (1988).

This is the first issue of *Homocore*. I think it's been needed for a long time, and it took me nearly a year to get off my ass and do it.

You don't have to be a homo to read or have stuff published in *Homocore*. One thing everyone in here has in common is that we're all social mutants; we've outgrown or never were part of any of the "socially acceptable" categories. You don't have to be gay; being different at all, like straight guys who aren't macho shitheads, women who don't want to be a punk rock fashion accessory, or any other personal decision that makes you an outcast is enough. Sexuality is an important part of it, but only part.

It's obvious that there are gay punks and other people in the various scenes we hang out and work and live in. You'd almost never know it though, from the way people behave. It's usually just too scary to be open and honest when you hear supposedly cool and politically aware people and bands say or do sexist or homophobic shit, especially if you don't know any other homo punks or other people.

Plus there are lots of interesting and important things around: other homopunk zines, music, people, events, news, and whatever, but they're all so scattered and bur-ied it's hard to discover. That's what I want *Homocore* zine to include. The stuff in this issue is just a hint at the stuff out there. Probably everyone has got something interesting. Send it and share it!

There are also unpleasant things to deal with, like bigotry and hatred and violence. Even straight guys get "fag-bashed" if they act "faggy," whatever the fuck that means. Gay issues aren't just for same-sex friends and lovers; the freedom to do or behave as you want is important to everybody. Racist assholes hate blacks, jews, faggots, whatever: it's all the same hatred and fear.

We're outlaws if we don't follow the usual rules and don't want to be part of mass culture. We're mutants if we try new things, things that are honest and human, like making own cultures, preferably lots of them, all with room for each others'.

So this is what *Homocore* is about, if that helps any. If not, read and decide for yourself. There will be more issues, though I won't attempt to stick to any hard schedule for now. It depends on the stuff you send, plus whatever victims I can get locally to help put it all together.

BOOKS / CATALOGS / DESIGNED BOOKS

Lawrence Weiner 1989

Lawrence Weiner, "BOOKS / CATALOGS / DESIGNED BOOKS," in *Books 1968–1989: Catalogue Raisonné,*
ed. Dieter Schwarz (Cologne: Verlag der Buchhandlung Walther König /Villeurbanne: Le Nouveau Musée, 1989).

BOOKS

YOU CAN TELL A BOOK BY ITS COVER. THE BOOK OCCUPIES A FUNCTIONING SPACE
WITHIN ANY CONTEXT IT FINDS ITSELF IN.

CATALOGS

THE (A) CATALOG UTILIZES THE FORMAT OF THE BOOK AS AN ALTERNATIVE
MISE-EN-SCENE FOR THE PRESENTATION OF WORK OTHERWISE CONFINED WITHIN
THE CONTEXT OF GALLERY OR MUSEUM.
IF IT WALKS LIKE A DUCK & TALKS LIKE A DUCK IT MAY AS WELL BE A DUCK.

DESIGNED BOOKS

PARTICIPATION IN THE DESIGN OF A BOOK IS A PARTICIPATION IN THE FORMAT OF
THE WORLD AT LARGE.
BOOKS DO FURNISH A ROOM.

Welcome to BIMBOX

Johnny Noxzema 1990

Johnny Noxzema, "Welcome to BIMBOX," introduction in *BIMBOX*, nos. 1–3 (Spring–Winter 1990).

Introduction to BIMBOX 1

Free to those who deserve it. You are one of the Chosen Few, a carefully chosen group of a hundred or so individuals and organizations across America and across the world selected to receive BIMBOX and all that goes with it. BIMBOX is the zine that subscribes to YOU.

BIMBOX is revolution.

BIMBOX is change.

And yes, BIMBOX is death.

DEATH TO SOCIETY AS WE KNOW IT.

We're here to promote hatred. Soft, clean, pure hatred. We're here to promote your hatred. Hatred of the filthy heterosexual smarm that pollutes this planet from pole to pole. We hate your mother. We'll kill your mother if we have the chance. BIMBOX is your forum to reach a secret network of lesbians and gay men across the globe who can barely ride a bus without vomiting out of disgust and contempt for the walking heterosexual abortion sitting across the aisle. BIMBOX is your sounding board. Ceauçescu may be dead, but Bush isn't. Neither are the crypto-fascist clones and dikes who control mainstream lesbian & gay publications across the globe, telling us how and what to think. They're the establishment that BIMBOX opposes most.

So boys, shave that mustache and girls, put on that dress, and let BIMBOX subscribe to YOU.

Introduction to BIMBOX 2

Lesbian and gay publications which are available only by purchase lose vision. They may be born of good intent and theory, but as cash flow increases, their lust for change turns into lust for profits. They become consumed by a wanton frenzy of narcissism, glamour, and greed. They quickly transform into the sort of institution they were against in the first place, thereby sabotaging the Revolution and ultimately doing more harm than good.

Magazines like *The Advocate* and *Out / Look* have but one mandate: to systematically render the entire international lesbian and gay population braindead. And sadly, their evil task has been remarkably successful, with but a few pockets of clone-immune individuals scattered across the planet. Only a handful of "alternative" publications stand in the way of the complete lobotomization of our culture. BIMBOX is one of those publications.

The question remains, however, who? WHO PAYS FOR BIMBOX? The answer, my friend, is simple. The truth is, you have already paid for BIMBOX. We have paid for it in blood and we have paid for it in tears. Unrelenting pain is our credit limit, and we are cured with interminable overdraft protection. We have wept and we have suffered and we have been scarred—scarred for life. We have been wounded, injured and maimed, and we have died. We have all literally died of boredom. Oh yes, we have paid. The horrible, undeniable truth of the matter is: BIMBOX is paid for—paid in full.

Introduction to BIMBOX 3

Now, for legal matters, which you bring up: what would happen if you identified yourself to US Customs—could they obtain a visa ban? If you acknowledge that you have imported other copies of BIMBOX, could you be seized right there at the courthouse and thrown into jail as a scumbag pornographer and otherwise infamous enemy of the proletariat? What could happen if you simply ignore the summons/complaint? I truly don't know. You'd probably be best advised to seek information from a qualified attorney—either a Canadian familiar with US Customs immigration law, and/or an American attorney who is similarly qualified.

Beyond all this, it is never "too late" to become involved in censorship, regardless of what country you're in/from. Canada and American are probably as alike as peas in a pod with regard to "freedom of assembly," "freedom of expression," "freedom of speech," (except maybe Quebec …), which are the contents of the US Constitution's First Amendment. In a similar vein, we are probably similar in our treatment of pornography and the importation thereof. The basic issue should be, as Thomas Jefferson said: if it can be published, then it should be published. It has been long established by the US Supreme Court that the protections of speech contained in the Constitution are totally unnecessary for "popular" speech or writing. It is for "unpopular" or even "hated" speech or writings that the First Amendment was crafted. As distasteful (that's mild) as the Ku Klux Klan is, the members have their right to assemble, speak, and write. I consider that they stand for ideological filth, but then, that's based on my right to assemble with another crowd, read other things, and speak entirely different. Communist or fascist, Bambi or BIMBOX, all should be protected. Unfortunately, they are not. In my view, as long as religious organizations have their way with tax-supported influence on legislation, we will not see this change. The "moral" issue is a religious one, where one group of "believes" imposes its "values" on the entire population. You will rarely find any secular organization that attempts to impose "traditional family values" unless it has an underlying religious theme or personalities. The same situation prevails in the pro/anti-abortion arena as well as the birth control situation. I have no shortage of opinions. I try to be rational about the whole affair and to put my voice where it might have the most use. I frequently write letters to my legislators—sometimes using fictitious names like "Grandma"—about these types of issues. I send money to civil liberties organizations and anti-censorship organizations. I may not be the most active person, but I do put in some effort. I recommend the same for anyone concerned with individual liberties.

Riot Grrrl Manifesto

Riot Grrrl (Kathleen Hanna et al.) 1991

Riot Grrrl, "Riot Grrrl Manifesto," *Bikini Kill*, no. 2 (Olympia, WA: Bikini Kill, 1991), reprinted in *ZINES!*,vol. 1 (San Francisco: Re/Search, 1996), 168–69.

BECAUSE us girls crave records and books and fanzines that speak to US that WE feel included in and can understand in our own ways.

BECAUSE we wanna make it easier for girls to see/hear each other's work so that we can share strategies and criticize-applaud each other.

BECAUSE we must take over the means of production in order to create our own meanings.

BECAUSE viewing our work as being connected to our girl-friends-politics-real lives is essential if we are gonna figure out how we are doing impacts, reflects, perpetuates, or DISRUPTS the status quo.

BECAUSE we recognize fantasies of Instant Macho Gun Revolution as impractical lies meant to keep us simply dreaming instead of becoming our dreams AND THUS seek to create revolution in our own lives every single day by envisioning and creating alternatives to the bullshit Christian capitalist "way" of doing things.

BECAUSE we want and need to encourage and be encouraged in the face of all our own insecurities, in the face of beergutboyrock that tells us we can't play our instruments, in the face of "authorities" who say our bands/zines/etc. are the worst in the US and

BECAUSE we don't wanna assimilate to someone else's (boy) standards of what is or isn't.

BECAUSE we are unwilling to falter under claims that we are reactionary "reverse sexists" AND NOT THE TRUEPUNK-ROCKSOULCRUSADERS THAT WE KNOW we really are.

BECAUSE we know that life is much more than physical survival and are patently aware that the punk rock "you can do anything" idea is crucial to the coming angry grrrl rock revolution which seeks to save the psychic and cultural lives of girls and women everywhere, according to their own terms, not ours.

BECAUSE we are interested in creating nonhierarchical ways of being AND making music, friends, and scenes based on communication + understanding, instead of competition + good/bad categorizations.

BECAUSE doing/reading/seeing/hearing cool things that validate and challenge us can help us gain the strength and sense of community that we need in order to figure out how bullshit like racism, able-bodieism, ageism, speciesism, classism, thinism, sexism, anti-semitism and heterosexism figures in our own lives.

BECAUSE we see fostering and supporting girl scenes and girl artists of all kinds as integral to this process.

BECAUSE we hate capitalism in all its forms and see our main goal as sharing information and staying alive, instead of making profits of being cool according to traditional standards.

BECAUSE we are angry at a society that tells us Girl = Dumb, Girl = Bad, Girl = Weak.

BECAUSE we are unwilling to let our real and valid anger be diffused and/or turned against us via the internalization of sexism as witnessed in girl/girl jealousism and self-defeating girl-type behaviors.

BECAUSE I believe with my wholeheartmindbody that girls constitute a revolutionary soul force that can, and will change the world for real.

The Book as Machine

bpNichol, Steve McCaffery 1992

bpNichol and Steve McCaffery, "The Book as Machine," in *Rational Geomancy* (Vancouver: Talonbooks, 1992), republished in *A Book of the Book*, (New York: Granary Books, 2000), 17–24.

It would be a mistake to suppose that the trend towards the oral and acoustic means that the book is becoming obsolete. It means rather that the book, as it loses its monopoly as a cultural form, will acquire new roles.
—Marshall McLuhan

Don't look around yourselves for inspiration. We have only one teacher: THE MACHINE.
—Nikolai Foregger

In the beginnings of our research into narrative we ran up against the inescapable fact that "there exists no standard definition of narrative in the sense that writers seem to use the word." There is so much confusion particularly between narrative and plot, the two terms being used almost interchangeably. Thus we feel free to create a definition which is not in the strictest sense new because there is no existing old definition. What we need to establish is a working definition of narrative and then discard it if further research proves it false or inadequate in scope.

For the purpose of this report we will deal with narrative in print rather than as an oral phenomenon. This will allow us to eliminate consideration of the innumerable narratives of daily living that are characterized by their provisionality, evanescence and intractability. In the strictest sense the most comprehensive definition of narrative would be simply our sequential life experience. We will not address this comprehension but rather deal with narrative as it occurs within the specialized area of the print experience.

Gertrude Stein put it most simply when she pointed out that narrative was anyone telling anything to anyone anytime. When we transpose this definition into print we begin to recognize two distinct experiences:
1. The physical experience of print as word and ink and the book itself as a physical object.
2. The psychological and psychosemantic experience of operating verbal signs.

In this first part of our report we will deal with the physical aspects of the book as machine, documenting some of the attempts made toward an understanding and reassessment of physical forms the book has already acquired and the emerging outline of future forms, considering the implications of the book's mechanicity and the active application of such considerations.

Backgrounds

By machine we mean the book's capacity and method for storing information by arresting, in the relatively immutable form of the printed word, the flow of speech conveying that information. The book's mechanism is activated when the reader picks it up, opens the covers, and starts reading it. Throughout its history (and even prior to Gutenberg) the

book has possessed a relatively standard form varying only in size, color, shape, and paper texture. In its most obvious working the book organizes content along three modules: the lateral flow of the line, the vertical or columnar build-up of the lines on the page, and thirdly a linear movement organized through depth (the sequential arrangement of pages upon pages).

Significantly the book assumes its particular physical format through its design to accommodate printed linguistic information in a linear form. Taking the line as a practically impossible continuum, it breaks it up into discrete units of equal length, placing them one above the other in sequence until a page unit is filled. Similarly the page units are ordered sequentially and the whole sewn or glued together to form the complete book. Already it is possible to note that the linear experience as continuum has been significantly altered, for the second and third modules mentioned are the ones which the book has placed before our reading pose. In addition the book has underlined and reinforced the first module so that we now accept all three as not simply modules but constants which are seldom questioned. Hence the surprising shock value of typographic experiments (evinced by the very fact that they are labeled *experiments*).

So far in our description of the book as machine we have dealt with it as a prose print experience. It is important, however, to point out the difference between the reading experience of prose and poetry. Prose as print encourages an inattention to the right-hand margin as a terminal point. The tendency is encouraged to read continually as though the book were one extended line. In poetry, by contrast, the end of each line is integral to the structure of the poem whether it follows older metrical prosodic models or more recent types of breath-line notation. This emphasis upon the structural aspects of the terminal point of each visual line unit in the poem is why concrete poetry is called, in fact, poetry and why the latter word is apt in its description. In poetry, where the individual line is compositionally integral, the page is more often than not itself integral. Most short poems for instance involve a significant degree of iconicity: we see the poem as a visual whole before we read it. Perceived optically as a complete unit the page is qualified to such an extent that it ceases to function as an *arbitrary* receptacle, or surface, for the maximum number of words it can contain (functioning thereby as a random-sized unit in a larger construct), becoming instead the frame, landscape, atmosphere within which the poem's own unity is enacted and reacted upon. Page and type function as the two ingredients in a verbal sculpture.

By contrast, in the majority of prose the general rule holds that the paragraph—through effecting a visual separation of sense and event—performs a similar function

(optically) to the poetic line. A sentence is not visually integral until combined with other sentences to form the paragraph. However, in both prose and the visually continuous poem (Milton's *Paradise Lost* for instance) the page has no optical significance. Being to a large extent a working out of information through duration, prose structures tend to be temporal rather than visual. For instance the chapter can seldom be grasped iconically precisely because the chapter extends over the surface of several pages, occupying a part of the depth module which runs from the start of a book to its end. Even the paragraph's optical quality tends to be accidental. The effect of this surface extension is to pressure the reader into moving along as quickly as possible in the depth module. In extended prose or poetry the page becomes an obstacle to be overcome. There is a difference too of urgency in the poetic and prose line. In the former the left-hand margin is always a starting point, the right-hand margin a terminal, neither of which is determined by the randomness of page size but rather by the inner necessity of the compositional process. It becomes obvious how historically the emphasis on the visual element in writing would have a *poetic* emergence, for only in poetry occurs that bridging point which permits the steps from a significance through inner necessity (where each visual terminal point gains pertinence and value) to a new way of perceiving in which the visuality becomes, not the end product of an interior psychological process, but rather the beginning of a whole *new* method of perception.

There seems to exist at present a dichotomy in attitude between the book as a machine of reference and the book as a commodity to be acquired, consumed, and discarded. Traditional printed narrative is largely thought of as the transcription of a hypothetical oral activity: a speech line running from a point of commencement to an end. Such books transcribe language along horizontal axes running from top left to bottom right of each page. This occidentally conventional manner of reading along the length of the line and down the length of each page from first to last in actuality reconstitutes the duration of a "listening." In reference books such as dictionaries and directories, however, the oral hypothesis is minimized to the point, perhaps, of nonexistence. Such books are not thought of as having authors or a supposed unitary voice behind them. They exist as physical storage units for information, to be consulted at various times, but not designed to be consumed in a single, linear duration. Popular fiction, marketed for mass audiences, performs a different function; there the page's nonsequential storage qualities are ignored. Nobody would consider the page of such a book as an area requesting the reader's free, nonlinear eye movements over a multi-activating, multi-acting surface, but rather as a unit *necessarily endured* as a means to the complete reception of the book's information. The current predicament of popular mass fiction is the competitive threat staged by the other great machines of consumption: television and film are indubitably the more efficient media. The reason for this is clear. The book's power as an object to be dwelt on and referred back to is not a desirable feature. Not only the page but the book in its entirety is conceived as an obstacle to be overcome in order to achieve the desired goal of unproblematic, uninterrupted, unsophisticated consumption. Television and the cinema on the other hand afford more rapid and totally sensorial means of satisfying such an appetite for story. In the light of this phenomenon two important implications of such pre-masticated reading as *Reader's Digest* become obvious. There is a "division of labor" on the reader's part in that he renounces a portion of the total reading role which is performed for him. And secondly the more serious implication of a hierarchical structuring imposed upon the reading experience, by means of which a superior "essence" is thought of as being abstracted from a "lesser" padding. To extend this consumer metaphor we may say that plot is product within linguistic wrapping. Dictionaries and directories work against this status by throwing emphasis onto the single page and the information stored thereon. In their function, dictionaries move much closer to the page-iconicity described above.

Narrative then can be developed freely along either of two directions: One rooted in oral traditions and the typographic "freezing" of speech; the other set in an awareness of the page as a visual, tactile unit with its own very separate potential.

Twenty-one facts that could alter your life (send for free illustrated booklet)

1. The front page of a newspaper is the paradigm of typographic cubism. Considered as a multi-page whole, the newspaper is founded on a model of structural discontinuity and a principle of competitive attentions. Front-page stories seldom end on the front page, nor do they all end on the same interior page. The front page is an opening made up of many opening terminating on different pages, which themselves contain other openings—to read a newspaper as a consecutive experience leads to extreme discontinuity.

2. A page is literally one side of a two-sided sheet of paper—the surface of a three-dimensional object.

3. If we consider the printless page to be a static, neutral surface, then by applying continuous type to cover the entire surface (as in a page of a novel or this page of a TRG [Toronto Research Group] report) that neutrality is not altered. Where a rectangle of type is placed upon a rectangle of page there is no attempt made to work creatively with the possible tension existing between surface (page) and object on that surface (print). Moreover, in such a placement we invest the page with a secondary quality not inherent to it: viz., a top left to bottom right orientation (radically different languages such as Chinese and Hebrew impose, of course, a similar directional limitation).

4. When Rabelais (in book 5, chapter 45 of *Gargantua and Pantagruel*) has the Goddess Bottle speak, she speaks from within a pictorial representation of a bottle. This bottle is not verbally described but rather imaged on the page; it does not illustrate the story as an appendage, it is an integral part of it. Like the corporal's stick-flourish in Sterne's *Tristram Shandy* words are forsaken for a visual instantiation of an object/event.

5. When Simmias of Rhodes composed his *Egg*, George Herbert his *Easter Wings*, and Apollinaire his *Calligrammes*, all were trying to bring together the object signified with the words that signified them. A case of verbal description and the pictorial shape of the object described being joined iconically in a pictorial space.

6. In *Tender Buttons*, Gertrude Stein's carafe and umbrella are not visually fixed on the page. When all the words inside her at the moment of composition (of perception) came out they fused perceiver with perceived within the activity of perceiving. The language which described the object also became the object in a physical space.

7. In such poems as "now they found the wagon cat in human body," "no body speaking," and other pieces in *We Sleep Inside Each Other All*, Bill Bissett brings together perceiver and perceived in psychic space which becomes jointly manifest in a pictorial space. Both Stein and Bissett use syntactic rhythm to indicate subjective rhythm; both are dealing with the fundamental relationship between language and consciousness. By moving the poem back into the pictorial space Bissett furthers the visual technique employed by Simmias, Herbert, and Apollinaire, as well as Stein's sense of the autonomous existence of the thing composed.

8. The compositional technique employed by Simmias and Bissett makes a radically different demand upon the page than regular linear transcription. The page ceases to be a neutral surface of support and becomes instead a spatially interacting region; it is granted thereby a metaphorical extension. Conceived as a spatially significant unit, the page carries dimensional and gravitational implications. In Stein's writing it does not.

9. Pierre Garnier employs the term *spatialisme* to describe his own particular type of lettristic composition. Garnier developed a theory of the letter as self-sufficing entity existing and operating within an open space or field: the page. This application of a spatial metaphor alters radically the physics of his page. In his own texts autonomous letters (as objects) occupy a gravitational region, with syntactic emphasis falling on the *interval* between the letter objects. The page becomes not only container but definer of the lettristic configuration and becomes additionally a profoundly active space.

10. *Spatialisme* is a lettristic application of Eugen Gomringer's formal concept of poetic *constellation*: a word or word cluster balanced—the analog is "electro-magnetically"—within the force field of the page. Both *Spatialisme* and the *constellation* deploy the page as a metaphor for space in general. The page is not altered physically but its materiality receives a metaphoric supplement.

11. Page becomes an active space, a meaningful element in the compositional process and the size and shape of it becomes significant variables.

12. The typewriter fixes page size to carriage capacity.

13. In Steve McCaffery's *Carnival* the carriage capacity limitations are actively confronted. By rejecting its dimensional restriction of size and by forcing it to operate modularly as a smaller unit in a much larger surface, both the page (and its traditional function in the book) are destroyed. *Carnival* is an anti-book: perforated pages must be physically released, torn from sequence and viewed simultaneously in the larger composite whole. The work demands that language be engaged nonsequentially rather than read in sequence. Altering the physical space allows both book and page to utilize at a maximum their sculptural potential.

14. By replacing the pictorial representation of the thing with its verbal description, Greg Curnoe, in his painted series *View of Victoria Hospital 1*, exploits the tensions between the viewer/reader's traditional assumptions as to what constitutes both a painting and a page. Curnoe's canvas becomes his page and by implication his page becomes his canvas.

15. John Furnival abandons the page and the book entirely in his language constructs which treat syntax as both physical and environmental matter. Word order becomes panel/architectural layout in his elaborate verbal-architectural labyrinths that replace the complexities of paragraph and sentence. Furnival not only concretizes language but architecturalizes it as well.

16. In the environmental works of Ferdinand Kriwet the pressure to externalize language and alter the mechanics of its reading is achieved by a four-dimensional application that radically modifies the reading space. No longer turning through a book nor looking at a canvas or panel, the reader exists inside a total linguistic environment. As the book constitutes the traditional method for storing verbal information, so the four walls, ceiling, and floor of the gallery become the storage tool for Kriwet's plastic word surfaces. The activation of Kriwet's machine inherently transforms the reader's role and placement. In Dickens you bring the book into your life, with Kriwet you bring your life into the "book."

17. Hart Broudy is now (1973) effecting a different application of language to environment. Using the photographic principle of the *blow-up* and applying it to a hybridized work that is both poetry and painting he is arriving at a new kind of optical linguistic environment. The starting point for his compositions is a physical fragmentation of the single letter which then functions as a blueprint for a macro-composition. Text is blown-up to canvas size in which interlocking fragments are magnifies to become giant connected panels. The reader emerges as an active object in a mental paradox: a giant in a miniature world that is larger than his or her self.

18. Fragment from Tom Mot's *Seventh Notebook*:

… i should try technique of microfiche … could compress my random sequences onto entire card surface … Swift's Gulliver … microcard … what is it … microcard in fact to reinforce upon the large canvas sense its original quality of print as an isolated experience … microviewer as one machine to activate another … do this and then combine microcard with macroprojection say a huge screen in an auditorium if i can get one … this way could get the combination of communal experience with traditional printed book's isolated experience ….

19. Ian Hamilton Finlay, at his home of Stonypath in Scotland, has returned to and revitalized the Renaissance concept of the Book of Nature. Stonypath is essentially a landscape brought into linguistic concerns as a living metaphor. The garden is Finlay's Book in which pages transform themselves to quasi-functional objects. Poems become sundials, gravestones, the page's traditional material opacity becomes the window's clear view into the objects signified. Any traveler through Finlay's garden has to be a reader too; it is a book involving participation of the feet as well as eyes.

20. In their *Bi-Point Poetry Manifesto*, the French poets Julien Blaine and J. F. Bory urged the abandonment of book and print each in its entirety (save for their minor use in reporting non-typographic language events). The urban landscape provides both alphabet and subject for their work; economic, social, and political factors become syntactic elements. Bory and Blaine's lives and actions become their writing.

21. William Shakespeare (somewhat earlier) spoke of sermons being in stones and books running in brooks. Finlay's Stonypath and the Blaine-Bory Manifesto are the physical, dynamic applications of a sixteenth-century analogy of Book and Nature.

Afterthoughts
Or what this has to do with anything at all

So far we have reviewed/described a specific set of books and writers from the viewpoint of our own concerns with the book as machine. Each of them has, for us, significant comments to make regarding the machine's capacity to alter function and affect the psychological content of the fictional reality presented. There are three questions that arise from our considerations: 1) What are the precise applications of the solutions arrived at? 2) Does the arrived solution present a hindrance to "understanding"? 3) Does the attendant challenge to habitual reading patterns result in breakthrough or deadlock?

These questions have relevance to an interesting text case: Bill Bissett's special attention to the spelling of words. Bissett's idiosyncratic orthography and the resultant effects on that minutest level of reading—the single word—has already enjoyed a large influence inside Canada. Yet the writers who have gone on to orthographic modifications in their own work have been judged mere copiers of Bissett, rather than valorized as individuals adapting *to their own purposes* Bissett's singular insight: that spelling should be an individual decision and not an imposed norm. Accordingly, the work of these writers is in danger of being ignored through the effects of attitude that sees formal innovation as a novelty and, by extension, as unrepeatable. In the background of such an attitude lurks the hulking form of *traditional literature* as a pre-established, easily subsumed and hence "safe" finite number of technical solutions.

To answer the above questions will require the deployment of each single isolated experiment in order that comparative assessments can be made among the experiments themselves. Consequently the answers to these questions lie outside the limits of this present article in the future writing/research to be done. What we will argue for here is an expanded awareness of both the effects on and the possibilities for narrative, by an active and thorough utilization of the book-as-machine.

Take Away Manifestos
Flying Letters Manifestos

Ricardo Basbaum, Alex Hamburger 1995

Ricardo Basbaum and Alex Hamburger, "Take Away Manifestos/Flying Letters Manifestos, *Confidências para o exílio n° 3*, Porto (Portugal), March 1995, 66–79, republished in*Conversas: Flying Letters Manifesto* (Florianopolis: par(ent)esis, 2013).

Series Rio – London
Windsor (!), 25th April 1994

Very dear and greatly esteemed Alex Hamburger:

I'm taking advantage of this short afternoon "off" to devote myself to our belated correspondence. If you are mad at me you have good reason, because your letter was sent to me in early February—together with the "Sonemas" tape. I received your material with great joy and the letter was especially interesting (unfortunately I don't have it on me right now, to be able to answer "point by point"—so, I hope that you will be delighted with my impressionistic or expressive style, with the writing following in the heat of this moment, with memories and impressions coming and coming). I must also mention the short letter and the books that arrived here via Margarida, all very welcome, her and the letter and books, by the way. So in this letter I have to reply to two correspondences—and also give an account of the ICA negotiations. (I believe you haven't received the news that I sent via Milton Machado, newly arrived on the island, and seemingly in good spirits and excited—with Lucian—about this new chapter in their lives).

As mentioned above I am not in London today, as I came with Ana Margarida to this small town. While she works with a photographer nearby for 3 hours, I'm killing time in a Café. The town is small, and has a great stone castle—queen's stuff—that I was not able to visit, as it closes at 4 pm. I wandered around a while and ended up at this café.

I didn't write to you before because I got behind with my letters to friends. Then March arrived and I was very busy with "course" activities: "studio-visit" on 18/3 and "essay" on 30/3. I worked hard to meet the deadlines. Academic activities... Academic activities? I am at "school" and there are deadlines, etc. I am introducing the subject like this because during my "studio-visit" I experienced a certain artistic crisis, induced by the course: the professors who coordinate the "visits" had pushed me up against the wall with harsh criticism of my projects. I became angry—and disappointed. After all, until then I had kept to myself a certain "superiority" in relation to my fellow students because of my extensive work experience in Brazil (10 years, I guess). But what happens—and no doubt you may have already experienced this—is that when people have no previous references of your work, they end up making criticisms that are somewhat shallow, as they cannot really understand something at first glance, suddenly, that came from an "exotic and far away tropical country." Which references? The English people have their own references—that certainly exclude ours, somehow.

Moreover, these "visits" are loaded with an implicit psychological strategy, which is more or less "to destroy" the student, bombard him with questions: after all, a "student" is someone who is "learning," does not yet have a job, is not

an "artist." So, therein lies another point of conflict: I did not come here as a "student," of course, as all my experience in Rio de Janeiro (Brazil) is already on another level, and all my (and ours, I am including you and other "fellow workers") activity occurs on another level of intervention, more real. However, for the class here this "intervention" is not visible; it is an extraordinary process for me to have to build up the true and appropriate dimension of my work, of how much it might represent the little I did so far and it is an effort not to let this become merely a subjective game, trying to scale this dimension for a place like London (and by extension Europe, the USA, the art scene of the first world). Which Brazilian artist does not practice daily this exercise of considering the importance of what he/she creates, in an attempt to give dimension to his/her artwork, in a more concrete sense, beyond the narrowness of the Brazilian scene? (Exception: those who get a cramped space at a market as big as an off-license shop or fight for a minor spot in a press as trustworthy as a local tabloid, though it always sounds a bit "fake," doesn't it?)

Dear Alex, forgive this letter's reflective tone, but I have already started and will continue, because if I write this to you it is because we share many artistic beliefs. So, I will forge ahead.

(Note: I am using Ana's walkman in a Café, and the tape is playing Martinho da Vila. Isn't this combination Windsor-Vila Isabel funny?)

The criticisms that I received had the immediate effect of breaking an "enchantment," which was good: now things are more objective; I have only been here for a few months and need to act quickly, without thinking too much, to create things here.

What criticism? I wrote a pamphlet that I am sending to you now ["I propose a new concept for art practice ..."]: my intention was a small deliberate provocation, writing some "theoretical jargons" in the way that I like and that you have already seen me doing before. And I thought about getting a ride with Hélio Oiticica, H.O., creating a complement to "Suprasensorial." "Supraconceptual" seemed to me to be something that would define my recent projects (NBP, in summary) to a certain extent. But, of course, it would be an idea that would also speak about other artists, "fellow travelers," why not? The criticism I received considered the text "exaggerated," "unnecessary," "without novelty," or even, as something "premature," "aborted." It is obvious that I fought "tooth and nail" to defend my propositions. But I try not to be "stubborn," and have been considering the criticism. In fact, I read and reread and I realize that perhaps the text does not have anything out of the ordinary ...

Everything that is written can be considered very "obvious," ideas that have in some way been scattered throughout the art field for 10 or 20 years, such that they should not arouse resistance but instead a wry smile, in the sense of "he thinks that he is saying something new but all this has been said before." Hasn't it? But everything that is rewritten is always done so in a different way, isn't it? I believe that one criticism that is clear to me is that my calculations were perhaps not precise enough, since "as a newly arrived foreigner" I still do not have the true measure of the art scene here that would allow me to make this bold move. Anyway, the ideas in this pamphlet were hanging around in my mind for quite a long time and it was clearly good to externalize them, and now I read and reread and think about the changes I can make to get to the point with more objectivity.

And needless to say, any comments from you will be fundamental for me in this intense reflective process on this island. I shall be waiting.

Another work that I am sending to you is made up of examples of my first diagrams: I also consider them "visual poems," and in this area I also need your tips and criticism. These diagrams I have dubbed "Love Songs," because they are always organized around Me and You positions, and around these positions the lines speak about attractions, repulsions, force fields, time, space. Always emphasizing the here and now of any action that provokes real transformations, processes, etc.

(now the tape is playing Jackson do Pandeiro, to my absolute surprise and delight—I assume that Ana recorded this tape to dance to)

I intend with the diagrams to build either objects or installations, I still don't know; I have to let the ideas ripen. But I have considered this possibility as something to be used in various manners, and rather than just Me and You I can write the names of artists, writers, philosophers, songs, concepts, etc., establish unexpected and unusual relationships and propose new processes and paths for thought … It seems promising. While diagrams they are restricted to the field of drawing and visual poem. Therefore, it is important to develop ways to transform them into objects, etc, to occupy the space with them. One of the diagrams I am sending you became a very large painting on the wall, with an orange background. I need to photograph it and send you a slide.

Shortcuts. Thought seems slow when revealed in this manner. We make art for this reason. We develop distinguished types of writing. In order to be different. The sound of the sonemas differs. I am presently playing your surprising tape on the walkman. Muiia (32"). Astonishing vocal performance. The sound technicians got it right when recording the steel strings. Hello, hello? ("Answer with sincerity.") Testing, i.e., tapping his forehead, making a header goal. Notation, never just one note, it is also only

a test, because the circuits must also be working. Sonorous reading, metallic, aluminic(?), metallic paper, 1'20" of noises that should not be confused with liquid, water. Sonorous-laugh, might be engraved, but without confusing itself with recorded, nor necktie, much more for bravado. Fight. Ghetto, Soweto. 4.234.989, 8.671.627, 3.433.912, 18 439 481, 20 629, 667, 28, 314 249, 12 418 17 239 482 15 538 917, 734 7488, 90 918 439, 81 237 618, 79, 435 772, 44, 819, 60 831997, 52384213, 34 618 877, 71 249 912, 74 732 29 265 942 6 636 348 2134 491 8 919 715 218 637 918 11 8 42 ta ra ta ta ta ta, lowland, the subject still goes on, the fight goes on, fight, fight, Riots in Brixton, close to where I live, lowland, lowered, beat, slaughtered, the keyword, El Chavo. Llove, Love. Mr. test, why not ? One notation samba? A, E, I, O, U, Y (wye), and I sang with or before you, Jackson do Pandeiro singing about comadre Sebastiana. I do not mean by this to make any comparison, only a connection with this letter itself, at its beginning. I always remember and will never forget the memorable "Sex-Manisse" and the readings of Portuguese poems and booklets, inflatable dolls. Alphabets, vowels until exhaustion, compression of the throat, vocal cords, shortness of breath. Climax and applauses. Nothing is more English than this bridge over Rio de Janeiro bay. Still war, army, hymns, football matches between national teams—perhaps the only appropriate time for a Brazilian to think about his "homeland"/hymn, a constant feeling for those who are in self-exile for a short (or long) period. The longest Sonema is precisely the one about national conflict. Eastern Europe, killings, borders. The music of its speech is delicate. Serb-Croatian. Self-Croatian. Self. Do you choose to pertain to a nation? Does it mean something to your art? "Microfonia—for Arthur Omar"—and then, the batteries run out … and I rack my brains. Milton Machado and Arthur Omar: video. I remember the memorable night with Taka Iimura—we saw a short film by Taka last Friday, B&W, 1962—beautiful and short, major details of the majora lips. Jimi Hendrix, equally the feedback champion "fish and chips champ," "stock market champ." Sprayema: ozone layer affected by the sound of the words sssssssus. Somehow, the image of this letter corresponds to the sound.

[…]

As to how life has been treating me here, I'm already entering the final stretch as half of my journey has already gone by. What remains for me to do is to concentrate on the implementation of the projects that I have in mind, and try to make contacts, so returning to Brazil does not mean some kind of isolation.

We saw, Ana and I, a documentary about Fluxus, made by Danes. I am sending you the technical file. At Tate Gallery there is an exhibition room with Fluxus works that I have not yet been able to visit. However, what is interesting is that on the 30th May, at the ICA, there will be a Fluxus night, and I believe that there will be the participation of Ben Vautier, Ben Patterson, and Emmett Williams.

We have already bought tickets. It is a kind of "revival" of the Fluxus nights, at the same ICA, in 1962. I think it will be interesting. Wait for the report.

Another funny thing is that I am trying to invite Joseph Kosuth to visit my studio. I have made brief contact with him twice. He in a certain way proved to be receptive, although reticent. As a superstar artist he is also super-in-demand, always traveling. He asked me to write to him, providing information about my work. Kosuth lives in Ghent (Belgium) and New York—but apparently spends more time in Europe than in the USA. This possibility of meetings and contacts that exists around here is curious. I am sending a letter this week, and if the opportunity actually materializes, I will send you news about the meeting.

We went to Oxford two weekends ago on a Saturday, on the occasion of the opening of four exhibitions (!), two were Kosuth installations—inside libraries. We did not see one of them (the "larger"), because we missed the correct opening hours (10–12 pm); the other was "more intimate," in the "Voltaire Room," where only works by and about Voltaire are kept. Kosuth printed texts on the glass of the cabinets which related Voltaire to John Locke. Interesting—and somehow super-intellectualized. Alex, I will now take a break, I am a little tired of this nonstop writing for over two hours, Wait for this letter's conclusion soon. Hugs.

Concluding (26/4, London)

Subject ICA. I scheduled an appointment with Sofia (Sophie), who is in charge of the shop, and took along your material. She decided she would keep "Grafemas" and "Sonemas," two copies of each. She thought that the price you gave (US$30 or +/– £15) would only be appropriate for the book because other cassettes are sold there for £8. I think it is a good price for the book but the tape is a bit cheap. Think it over and let me know what you think. The ICA takes 35%, and she has already done the calculations on the receipt of which I am sending you a photocopy. I tried to get you to send copies via Milton, but realized it wasn't possible. So, send them by mail to my address and I shall take them to the ICA. I will wait for your answer to know how I must proceed.

Dearest Alex, Longing for fresh news and a report of your activities. If you have time to write know that your reply will be very welcome.

Ana Margarida sends you kisses. We are having fun in so far as time and our budget allow us, we go to galleries, parks, markets— sometimes dinner at a friend's house. She has been trying to do little jobs to earn some "extra" money, I help as much as I can, but I'm also at my financial limit.

A great hug,
Yours, Ricardo Basbaum

Rio, 24th May of 1994
Dearest Ricardo:

I received your "magna-carta," together with the postcards, which I consider wonderful, especially the first one! Indeed, I can say that my innermost expectations and ramblings about what I believe "an artist's letter" means were met: a kind of autonomous form of expression, in which the practice of telling (*report*) follows parallel to a writing of multiform and polyhedral planes and perhaps a new "relational" stand.

I do not really know where to start commenting on it, but first of all, I want to thank you for executing such insightful and highly enjoyable, and even surprising, analysis—"with clear eyes"—of the "Sonemas." One of the most relevant and piercing approaches, I aim "by the grace of God," to reproduce them in the best way possible, so I can extend your multi sense reading to the people/audience/readers, and register, memorize, store this approach process unique to our partnership (withoutquotationmarksperiodIhavealwayswantedtodothis).

Next, I must thank you for your fraternal efforts and negotiations with the ICA so my works would be on display in such an important space! I was indeed very pleased with this "hard-earned victory," in which we scored goals in a classy manner. Enclosed I am sending, as agreed, copies complementing the ICA target, and regarding the conditions stipulated by them, I have faith in British coherence and seriousness.
[…]

Still on the list of special thanks, I would like to convey to you my joy for having sent the pamphlets, both of my favorite—Fluxus—, and your NBP's recent incursions, with regards to which I aim to make some (im)personal comments a little later—as the ink (keyboard) starts to flow more freely.

Initially, I will limit myself to considering some other aspects of your *flowing*—a true *Joycean stream of consciousness*, full of nooks and formulations, an admirable exercise of style, permeated with some (many) news items and information from the local scene. But before I forget, the "Book-object" exhibition at the CCBB was a huge success, very well put together, a first-class catalog, the best artworks of the genre made by the exhibitors, a great public not only at the opening but during the following days.

Now, I would like to talk a little about the "Fluxus night" at the ICA, on 30.05.94, which by now has already taken place, so I will discuss/comment in a retro-futurist manner! I hope that you enjoyed it and even managed to have some personal contact with some of them, such as Ben, who has already been to Brazil, and in my opinion is one of the most interesting protagonists of the Fluxus events of the *sixties* and *seventies*. Hopefully you have also managed to arrange a visit by him in the same style that you requested from Kosuth. Ben, from a certain perspective, is even more assertive than Joseph K. As for Benjamin Patterson he, besides

being the ontological figure of the group (*the only nigger between us*, according to Maciunas—"Soweto" could be dedicated to him), is married to a Brazilian woman which could be used as a "cool" excuse to approach him. I hope that some of these floating speculations have actually happened, and that a new level of relationship has been commenced. Last but not less important, Emmett Williams is a major experimental poet, pioneer of a trend that really helped me to envisage some horizons on gloomy nights in Rio. Therefore, as you see, there can't be anybody here that wishes as much as I do to attend one of these (G.B.) *events*, so that in a Tupiniquim *riot* of unveiling we could demolish the thick wall that is interposed between us on the world map. However, I know that I should calm down and wait for news, avoiding rush suggestions that you have intervened (in my imagination) and put the cart before the horse (in the middle of the ICA it would be awesome!).

Mutatis Mutandas, I can see how important these contacts are for the broadening of the "surgical projects on the global art circuit." I am sure that this "other San Sebastian" will be an unforgettable trip for the expansion of knowledge, pursuits, and research …

[…]

It seemed also that while you were unraveling the misfortunes that you have been caught up in, at the same time with your usual sense of perception, you untangled the causes and reasons that had led to the evils, whose corollary implies considerable control over the somewhat distressing situation. Thus, I indeed believe that gradually, as happens in a great come back, you will conquer all those aforementioned *handicaps*, because it seems to me that in relation to the bitterness of institutional and cultural insensitivity the best thing to do is conduct yourself with finesse and self-confidence, and you will solve the charade when you realize that "they" are completely unaware of a painting entitled "South America." Guy Brett, unfortunately, must be one of the few who is aware of these surroundings, if he believes (I think so!) that there are more things in the South Atlantic than the H.O.

I am seeking to prepare a more intuitive than technical appreciation, since the latter requires a greater understanding of structural and phenomenological methods of analysis, which do not belong to my field of expertise. I confess that I am even a little suspect to be considered of any use, since manifestos (pamphlets) are a media that I approve of in its totality, on principle, and due to well-elaborated ones such as yours, based on rigorous poetical and metalinguistic reflections like "supraconceptual." I am more than convinced that it is, under any circumstance, a powerful channel of transmission of our ongoing communication efforts.

You furthermore address a series of problems related to the Third World artist (of course, in this particular case, Brazilian), and the tribulations faced in the so-called civilized world; or when more important, you point out the poignant issue of reuse and reintroduction of discussions about propositions already widespread: they are burning issues that demand, firstly, a larger physical space to be discussed. What I can say is that I share with you much of your vision, if you do not have it on the screen of your mind, press the imaginary and alpha-numeric code px4z, thus I'm sorry I cannot offer up a better counterpoint to clarify this "johannes ittem."

I believe that we will achieve very little progress on this issue, precisely because we are right, there in our most inner part, certain human mechanisms are inexorable!

As far as the "re-interpretation" aspect is concerned, I myself have resorted to this enticing method on numerous chances. I find, and have overwhelming evidence, that many incisive artists consider this strategy full of consequent possibilities. Now, if they oh so scholars consider the project dated, without virtues, hopefully they will indicate new paths for you to strengthen your pretensions, after all, that is why they are there, right?

[…]

A characteristic that you should have noticed in my "aesthetical" appraisals is a certain economy of descriptive means. I could and should further expand on and go deeper into the "links" that you have given me, such as the Joan Jonas exhibition, an artist whom we are very similar to, at least conceptually, and seek to discuss a little more about the intersign phenomenon, what the differences are when a kind of "visorâmica" (studies) approach is used, in contrast with an "in loco" approach, i.e., exchange more views on the current status of these practices. But, I realize that my more compulsive activities, such as the temporary abandonment of writing, have moved me far away from the critical-verbal domain, concluding that this must sound to you as solely critical mockery, an expression better suited to Bonito Oliva (?). However, I hope that even adrift my conversations may help you to glimpse some flash of light here and there, as they are the purest gold extraction from our shared pickings that we have been excavating. Finalizing, without rules and punctuation, I would like to stress that your postal initiatives have been very encouraging to me in this rugged tropical landscape, and it is always with great interest and pleasure that I await your reports and pages, that I am sure shall remain inscribed in our (out of) electronic minds.

Hugs, hugs, hugs,
Yours,

P.S: You are right to a certain extent about L. (My course brochure). It does however present some good works that alone would justify the presence of names from the "homeland" to counterbalance with the "outsiders." Well, at least keeping this in mind, it is more suitable than Rescala's one, which yes, is an almost unforgivable miscalculation, were it not for the melting pot (always this!) that characterizes us.

Best regards,
Alex H.

Series Rio – Rio
Take Away Manifestos: Ricardo Basbaum

When you arrive at the exhibition space you will see four boxes of varying colors. The boxes may be scattered throughout the space, in different places, making you pass by other artists' works to reach them; or the boxes may also be side by side, as if forming a single object. You will take a sheet of paper from inside each one, the paper will be the same color as the box and on it will be printed a short, concise, fast, compact phrase. As the title itself says, these manifestos are to be collected and taken home.

I am against
I re.fuse
an ART OBJECTOR is an art object which objects
HYBRIDIZATION = INCORPORATION + INTERACTION

I propose a reading of the manifestos in this order (although this does not necessarily correspond to their spatial positioning), from the very idea about the relation of the notion of "manifesto," as a way of expression, with the history of twentieth-century art, especially the post-war period.[1] More precisely, it is around four questions that centralize some of the major art issues of the past forty years that I would like to start this commentary.

Thus, the first manifesto corresponds to the idea of iconoclasm, the scandal of historical avant-garde, thrown into crisis and annulled by its accelerated repetition—the so-called tradition of the new (everyone knows that this term was designated by the American critic Harold Rosenberg); the second is associated to the insurgency that was neutralized by the contemporary art institution, before which the artist to maintain his/her firepower should operate his/her "refusal" in order to merge or re-merge diverging and paradoxical elements, in a constant construction—truly within the art system—of alternatives to the risk of accelerated crystallization. Following that, the circularity of the third manifesto leads to deadlocks in the conception of an absolute autonomy of the artwork, the artwork as a tautology, indicating the need for autonomy open to external forces, composing a field of exchanges with the environment, where art plays an active role.[2] Rounding off, the last manifesto seeks to synthesize, through a formula, the need to create and circulate new "slogans" related to the present in which the presence of new computer technologies is imposing changes on thought and culture, to which visual arts cannot remain immune.

Parallel to these relations, I believe that it is significant to highlight the visual dimension of these manifestos. Besides a lateral approach to Concrete Poetry, from the arrangement given to the words on the page and the use of typographic features (font, signs), there is a kind of *drawing* that structuralizes each one. This is how, following the same order above, you can visualize, respectively, a beam of vertical lines, lines in increasing acceleration, a circle with centrifugal resonances and a weave of dotted lines with diverse curvatures and directions. These drawings are invisible, but it is extremely important to look at each one of the four pages as surfaces where they can be projected: in contact with the lines the words vibrate in another way, the colors of the sheets of paper become more consistent. There, there is a curious inversion, since traditionally art has associated the conceptual, enunciative dimension to the field of the invisible (Yves Klein and Robert Barry appear as exceptions, by emphasizing an invisible material, occupied respectively by pure sensitive intensity or by the physicality of electromagnetic waves); here, in these manifestos, what has been proposed is an invisibility at a graphical level, that with words will compose a diagrammatic field, of combined effort. This projects the manifestos still further ahead, since the diagram is a device that indicates the presence of a thought in movement.

It is clear then that this work operates with a hidden dimension of visuality through drawing. Each of the phrases evokes a diagram by itself, places itself as part of a network, a web that goes beyond it, connecting it with the other three phrases and sending them speedily to other periods in history at the same instant. Everything is very fast and on interacting with the work in the exhibition space, collecting the manifestos, it is almost impossible to realize this process, because the connections move very quickly. Paradoxically, some slowness, a delay is necessary, ("mais retard en verre ne veut pas dire tableau sur verre"—Duchamp[3]) to experience speed.

The manifestos aim to attract the public, using the audience as vehicle and medium, in the sense that it is in the viewer's body that the so-called artistic process truly occurs. In Art the current state of the question indicates the body of the viewer as the sole medium. Would anyone still dare to discuss the painting's surface, the construction of three-dimensional space, as final elements closed in on themselves? It can be said that these traditional fields are victims of a "conceptual saturation," causing also some reactive strategies of exclusive revaluation of sensitivity, which have resulted invariably in orthodoxy and sectarianism, when discarding the "de-aestheticizing" trends. The body is the medium of any artistic proposition as it achieves the transformation of the matter that constitutes a work of art into a bodily processable matter: Lygia Clark speaks of a "symbolic metabolism," in which the body conceptually and organically re-elaborates sensitivity. It is in the investigation of processes which simultaneously articulate both sensory and cognitive dimensions where the most fruitful line of development of contemporary art can be found, placing the body of the viewer as surface and medium. The viewer's body becomes the central point of attention, emphasizing interactivity (process of "continuous activation of the artwork"), and embodiment (awareness of a transformable interiority, from the inter-communicability of the inner and external dimensions of the body).

A certain type of space is thus constructed, the outcome of the viewer's process of engagement via verbal and visual elements. Apparently, one could speak of a "communication space" where the emission of a certain message would happen, triggered in the presence of the receiver by the reading of the sentences, etc.; but this does not correspond to the dynamics of what effectively happens with these manifestos. It would be more correct to propose a kind of "conceptual space," in which the word functions as a temporalization device, referring to different reading rhythms and the extent of historical references.[5] As for the visual elements, i.e., the acrylic boxes, these constitute colored points of attraction, which mark specific places within the exhibition space. The viewer/reader converges on these sites, where s/he is impregnated by a minimum dose of discursive magnitude; on moving away from these points, somehow s/he carries with her/himself this discursive impregnation to other environments: a conceptual space would therefore consist of points of attraction that shape places where the viewer/reader is placed in touch with a certain enunciative field, while his/her body is invited to perform a series of gestures indicative of his/her presence in this space.

Finally, it is important to associate the *Take Away Manifestos* with the NBP-*New Bases for Personality* project, which I have been developing since 1989, and which the manifestos are part of. The entire NBP series, comprehending basically objects, installations, drawings and texts, is organized within a radical sign relationship possibility: the compression of the whole art game into a visual/verbal sign.[5] This would be "inoculated"[6] into the viewer by means of affective, sensorial, conceptual propositions, invading his/her memory and creating there—in the embodied virtual space which is the mind—a void, an absence of place, that thus would propel the person toward a "basic bewilderment" regarding reality, source of differentiation, questioning, singularization. The acronym NBP originates from similar motivation, found in the work of the Brazilian artists Lygia Clark and Hélio Oiticica: both artists created objects and concepts aiming the viewer's sensory involvement, awakening or reconstructing a body torn out of social conditioning and re-singularized. Clark and Oiticica produced devices that carry out transformations, showing how to connect sensory and cognitive realities. The NBP project seeks to situate itself within this sphere of intentions, although having another sphere of influences as referential, resulting in a visual language related to the interface between media strategies, telecommunication networks, the virtual plane of painting, design as a project, and the limits of art autonomy.

All that is left now is to reaffirm the appeal: get hold of these manifestos, make them become part of many other and new sentences that have not yet been written.

COMMENTS IN PROGRESS – II
(Flying Letters Saucer Records)—Alex Hamburger

It was with almost Oitician pleasure that I read and reread your reply, in which some very pertinent questions regarding our dialogue emerged in an urgent manner!

The one that could be point "A" for example, which involves the presence of the body as the last medium of the artistic process is commented in a fairly acute manner, merging in the right proportion, technique and "excursive" reflection, allowing the message's receiver a fully satisfactory experience on providing him/her the distinct impression of participating in a vertiginous mental operation! However, some aspects that diametrically cross your particular constellation must be observed: when I perpetrate the idea that such aesthetic process can also happen "out-of-the-body" (either the artist's or the viewer's), without ever leaving off the screen this indisputable fact, aptly defended by my replicant, I want to address a situation where objects (poems, propositions) are presented with anthropomorphic contours: to cite just one case, the "artist's book," in which the pages acquire autonomy and a life of their own, establishing a short circuit in which it is not possible to have the isolated existence of the sender (proposer) without the irreducible counterpart, the message recipient (viewer): "Art for insects," yes! Art for fools, various types of artificial insertions: pluri-signs!

Following the sequence of this "rejoinder" I would like to refer to point "B" of your paragraph II, where once again the eternal battle of the titans takes the stage (by an act of constraint of these narrow-minded-club-wielding-souls, involving the issue of painting versus the one that we could designate as "non-painting." Over there, the response from my Londoner correspondent also reaches degrees of high historical-prospective voltage, proposing and establishing potential semiotic relationships closer to man, unveiling horizons of multiple activity, where new instruments begin to make their presence known in the achievement of inauguratory initiatives.

Nevertheless, I would ask you to forgive me if this question does not move me enough, to the point of provoking heated discussions, mainly because at the moment I do not see, in this exchange of dialogic impressions, the indicated arena in which to deal with this issue, enabling me to send it to any of the numerous collected and/or compiled studies throughout our century!

On the contrary, the mere mention of the polypoem phenomenon or the polysemic poem, besides being topics (subjects) that I have been trying to fathom and employ as true physical and organic extensions to my research, they are procedures that turn on in me the incandescent lights of the third media-driven millennium that is just around the corner, although they are still little visited in our geography of rethinking languages, causing the most varied reactions in relation to their interpretation, even for those whom are used to a more sophisticated relationship with this subject-matter.

Likewise, I do not intend to cover all aspects of the subject here, although I propose developments and insights in this area, given the immense implications that it entails involving from literature to everyday life, through sound, visual, "sleight of hand trick," sciences, economy, sociology, history, amateur radio, philosophy, and transcommunication!!

It is in this manner that the Portuguese poet and theorist who I really appreciate, E. M. de Melo and Castro refers to this item, "claiming for himself the Greek etymon poetry=to make, and poet=the one who makes, experimental poetry considered its field of operation extended to all materials with which something could be done about the problematic question of communication-noncommunication. Thereby was bestowed on all these materials (paper, metal, plastic, paint, electronics, sound, light, projection, etc.), a characteristic and a linguistic value while taking away from the word the exclusive value of vehicle or medium for poetic communication, treating it like any other element, in other words, a material that is composed of different letters, syllables, sounds, and different meanings (dictionaries, images, emotional or ideological), these also are considered poem material and not just its mere contentistic substrates: a poem practice; a making of poems sprung from the pages of books (no longer words but also materials that have attained freedom) at human scale, on the walls, suspended from the ceiling or into which we can enter, becoming part of an organic structure, poems that demand from us individualized attention to reveal themselves and stimulate, therefore, the relationships that we are able to establish with them, proposing a new notion of reading already far, far away from either the letter by letter reading of the schools or the nineteenth century system inherited from fine arts and its unchanging classifications." Finalizing the poet asserts, "in this manner, we can be confronted by poems that are not only made of words, canvases that are not paintings, sounds that are not music, screams that are graphically projected on walls and murals, with a confessional that denounces the secrets of power, with electronic mazes that lead to the radiographic interior of man, with static objects that question reason, duty, honour."[7]

As for my version, it could perhaps avail itself of this fortuitous statement:

HYBRIDIZATION = INCORPORATION + INTERACTION

That I would like to present as a "formula" of strong youthful magnitude:

HBZ = INC. + 100.000.000 poems

Dada-juvenile, better said, "matematemas" to "enjoy," the millionfold contribution of all poems made in the world; the tributes (Oswald, Queneau) always paid when seeking to instill (never indoctrinate) in graduates the wide range of repertoires available to them. We can also take as an immediate example, our unsuspected ability to write manuscripts, (act) of leafing through portfolios, suddenly hitting the streets to idly meander through their sinuous paths, writing scripts for pure fictional cases, and other latent potentialities of the left hemisphere of the brain!

In our right minds, can we imagine ourselves knocking at the door of the mayor and once before him, offering him raw material of the highest semiotic strain? For certain, we should generate polysemic attitudes toward the established authority (if they were establishments at least would there be a certain tolerance?), making clear to all representatives of these sectors of society how much they can get by simple observation of human engineering.

Figures and more figures of speech are devised in the mind of tutti quanti that wander among these traces (tears) of affective memory, however, I can assure you that these apparent permutations are the vigor of any journey worth its salt. Or should we descend to levels where everything may seem absurd or furthermore resume the spurious goal of pursuing a career at any price? Is Fort Knox the only way out?

When I mention that another type of initiative makes its presence known, in order to reach the stage of "inoculating in the viewer the compression of the whole art game into a visual/verbal sign, this would be 'inoculated' into the viewer by propelling the person towards a 'basic bewilderment regarding reality,'" I believe that we should proceed in an alternate manner, in a way where no variable would be disregarded; the educational way I dare say, of an Informational Aesthetics,[8] from which and to which, I believe I have provided some keys for its operational viability when I consider that for the occurrence of a more instigating inventive expression we just need to effectively extend a suitable transmission channel, as in our syntonized dialectical polymaterialism.

Rio de Janeiro, 31.3.1995

Authors' Notes:

1. The Brazilian art critic Ronaldo Brito points out some characteristics of contemporary art, according to him, a period which began with Pop art, as opposed to Modern art. These characteristics are: confrontation with the assimilated modernist action, languages that can only be defined when there is a clash with the art circuit; the disappearance of a precise Art History genealogy; pile of theories that coexist in tension, American hegemony and no longer European; political thinking as a mode of critical work; analytical thinking for an efficient intervention into the materiality of art, as at an enterprise of the system. "O Moderno e o Contemporâneo (o novo e o outro novo)," in *Arte Brasileira Contemporânea – Caderno de Textos 1*, (Rio de Janeiro: Funarte, 1980).

2. This new autonomy of art would approach the idea of "self-organization," the construction of an own space-time dimension that takes into account the disruptions of the environment (disturbance) and (perturbations) of the other: such idea is expressed by the concept of "autopoiesis," self-production of oneself, the term was established by Chilean neurobiologists Humberto Maturana and Francisco Varela.

3. Marcel Duchamp, "La Mariée Mise a Nu Par Ses Célibataires, Même," in *Marchand du Sel* (Paris: Le Terrain Vague, 1958).

4. We can also take into consideration some installations by Joseph Kosuth or Lothar Baumgartem, that also utilize texts (Kosuth mentions Freud, Baumgartem the anthropological field) to deal with the conceptual volume of the space.

5. The acronym NBP is associated to the form, composing a verbal/visual sign.

6. Dan Sperber writes about an "epidemiology of representations."

7. E. M. de Melo e Castro, *Fim visual do Século XX* (São Paulo: EDUSP).

8. Abraham Moles, *Rumos de uma cultura tecnológica* (São Paulo: Ed. Perspectiva).

The Praise of Laziness

Mladen Stilinović 1998

Mladen Stilinović "The Praise of Laziness," *Moscow Art Magazine* no. 22 (1998).

As an artist, I learned from both East (socialism) and West (capitalism). Of course, now when the borders and political systems have changed, such an experience will be no longer possible. But what I have learned from that dialogue, stays with me. My observation and knowledge of Western art have lately led me to a conclusion that art cannot exist ... anymore in the West. This is not to say that there isn't any. Why cannot art exist anymore in the West? The answer is simple. Artists in the West are not lazy. Artists from the East are lazy; whether they will stay lazy now when they are no longer Eastern artists, remains to be seen.

Laziness is the absence of movement and thought, dumb time—total amnesia. It is also indifference, staring at nothing, non-activity, impotence. It is sheer stupidity, a time of pain, futile concentration. Those virtues of laziness are important factors in art. Knowing about laziness is not enough, it must be practiced and perfected.

Artists in the West are not lazy and therefore not artists but rather producers of something ... Their involvement with matters of no importance, such as production, promotion, gallery system, museum system, competition system (who is first), their preoccupation with objects, all that drives them away from laziness, from art. Just as money is paper, so a gallery is a room.

Artists from the East were lazy and poor because the entire system of insignificant factors did not exist. Therefore they had time enough to concentrate on art and laziness. Even when they did produce art, they knew it was in vain, it was nothing.

Artists from the West could learn about laziness, but they didn't. Two major twentieth-century artists treated the question of laziness, in both practical and theoretical terms: Duchamp and Malevich.

Duchamp never really discussed laziness, but rather indifference and nonwork. When asked by Pierre Cabanne what had brought him most pleasure in life, Duchamp said: "First, having been lucky. Because basically I've never worked for a living. I consider working for a living slightly imbecilic from an economic point of view. I hope that someday we'll be able to live without being obliged to work. Thanks to my luck, I was able to manage without getting wet."

Malevich wrote a text entitled *Laziness—the real truth of mankind* (1921). In it he criticized capitalism because it enabled only a small number of capitalists to be lazy, but also socialism because the entire movement was based on work instead of laziness. To quote: "People are scared of laziness and persecute those who accept it, and it always happens because no one realizes laziness is the truth; it has been branded as the mother of all vices, but it is in fact the mother of life. Socialism brings liberation in the unconscious, it scorns laziness without realizing it was laziness that gave birth to it; in his folly, the son scorns his mother as a mother of all vices and would not remove the brand; in this brief note I want to remove the brand of shame from laziness and to pronounce it not the mother of all vices, but the mother of perfection."

Finally, to be lazy and conclude: there is no art without laziness.

Work is a disease —Karl Marx.
Work is a shame —Vlado Martek.

Liberature: Appendix to a Dictionary of Literary Terms

Zenon Fajfer 1999

Zenon Fajfer, "Liberature. Appendix to a Dictionary of Literary Terms" (1999), in *Liberature or Total Literature*, trans. and ed. Katarzyna Bazarnik (Poland: Korporacja Ha!art, 2010).

Some people have strongly believed, and some still do, that the whole world can be contained in one Book, expressed in one Equation, explained by one all-embracing Theory. Even if they err, those people open up new perspectives, widen horizons and pave new ways which others may follow safely after them.

They will always be ready to take spiritual risks and enter the unknown. They are not deterred by the prospect of many years' work and not paralyzed by the fear of unfavorable response. They are characterized by a rich imagination, unusual courage and intense desire for totality, complemented by the ability to look at "old" and "well-known" matters from unexpected angles.

In the passing century one of these people was James Joyce, the writer who in *Ulysses* showed what we are really like, taking off the fig-leaf that had covered not our genitals, but our minds. Afterward he wanted more: in *Finnegans Wake* he merged all times and places, all events and languages, all people and nations, so that we could continue the construction of the Tower of Babel, which was stopped just after its foundations had been laid. He was indeed a true Author of Words, the creator of thousands of completely new lexemes formed in the processes of genuine literary chemistry and physics.

There are only a few writers who have been so radical and have such ambitious goals as Joyce. For the majority of them, the creative act has been nothing more than inventing a plot, embellishing it with a few aphorisms, and waiting patiently for their work to be placed on the obligatory reading list. They are not interested in searching for new forms, taking artistic risks, and breaking social taboos. They always follow a well-known route prescribed by literary "guidebooks," a path so clear-cut that it is absolutely impossible to get lost.

And there are others who, indeed, would love to invent something, if it were only possible. However, they believe that nothing original can be developed and we are inevitably doomed to pastiche quotation, intertextuality, and writing about writing. This act of extreme creative despair has become a widespread canon, not only in literature and, nobody has yet found any antidote for this spiritual anorexia.

Has literature really exhausted itself? Or is it possibly a momentary exhaustion of littérateurs?

I believe that the crisis of contemporary literature has its roots in its focus on the text (in negligence of the physical shape and structure of the book), and within the text, the focus on its meaning and euphony. It is indeed extremely difficult to come up with something original when one pays attention only to the above-mentioned aspects of a literary work. Even then, however, it is not impossible. There are still areas that have been hardly explored and others where no littérateur has ever set foot—true literary El Dorados.

If, then, the major source of crisis in contemporary literature is the split between the structure of the text and the physical structure of the book, and identifying literature only with the text (like the Cartesian "Cogito, ergo sum," which totally ignores the bodily aspect of human existence), the only way of overcoming it is to reconsider such fundamental notions as: "form," "time" and "space," "literary work" and "book." Perhaps it is the established dogmas that still paralyze writers' creativity and contribute to the present condition of literature.

Therefore, writers must ask themselves a few basic questions:

1. Is language the only medium of literature? Or could an actual piece of paper be such a medium as well, a piece of paper that the writer is going to cover with black writing? Or perhaps, for some important reason, the page should be black and the writing white? This is only a convention that writers automatically follow.

2. Does the definition of form understood as "a particular way of ordering words and sentences" (*Słownik terminów literackic*, [A Dictionary of Literary Terms] ed. By M. Głowinski at al., Wrocław: Ossolineum, 1989) and also include the physical shape of letter and sentences? Or does the word amount only to its sound and meaning in the world dominated by the culture of expressing itself in the Latin alphabet?

The majority of writers never reflect on the kind of typeface that will be used to print their work and yet it is one of the book's component parts. It is as if the composer wrote a piece of music but the decision as to what instruments should be used was left to the musicians and the conductor. This sometimes happens today, but then the composer is fully aware of the consequences (that is, of involving musicians in his creative process). However, when the writer ignores such questions and leaves the decision to a publisher, he does not do so because of an aesthetic theory he subscribes to, but because he does not recognize the importance of the question. By doing so he proves to be "deaf," as it were, since the typeface is like tone in music.

Of course, no one can answer that it results from his full trust in the printer, who is an expert in this field. Well, the printer is an expert because the writer does not even try to learn about it. He is usually unaware what potential is hidden in various layouts and different typography when applied to his work (by typography I understand both the arrangement of words and verses for which writers, especially poets, sometimes feel responsible, and the neglected typeface).

A simple experiment involving printing, e.g., a Shakespeare sonnet in a loud type used in advertising, would prove how important these matters are—the dissonance would be obvious. But one could easily think of an artistically more fruitful use of a particular typeface; for example, the Polish national anthem printed in Polish, but with Gothic type and Cyrillic alphabet—a device that would arouse strong emotions and provoke a response from every Polish reader.

I am strongly convinced that, sooner or later, writers will have to enrich their repertoire with typography. Otherwise, one would have to agree with Raymond Federman and admit that one shares the authorship of one's masterpieces with the editor, typesetter, and manuscript reviser; and what writer would like to do that?

3. The above-mentioned Polish dictionary of literary terms defines "form" as an established model according to which particular literary works are created and "literary work" as a meaningful creation in language (an utterance) fulfilling the criteria of literariness accepted in a given time and culture, and, in particular, the criterion of congruence with generally accepted standards of artistry. Do these definitions also encompass a reflection on the physical shape of the book? Do the shape and structure of the book constitute an integral part of the literary work, or are they only the concern of printers, desktop publishers, binders, and editors, and a matter of complying with generally accepted standards?

I can hardly imagine that anything original could be created in the nearest future without a serious reflection on what, in fact, is a book. Is it, as the Polish dictionary describes, a material object in the form of bound sheets of paper forming a volume, containing a text in words recorded in graphic signs, which serves to convey various kinds of information, or it is something more?

Shouldn't the shape of the cover, shape and direction of the writing, format, color, the number of pages, words, and even letters be considered by the writers just like any other element of his work, an element requiring as much attention as choosing rhymes and thinking up a plot?

The writer must finally understand that these matters are far too serious to be left light-heartedly for others to decide. I am not suggesting that he should be a printer and a bookbinder as well. But I believe that it is his responsibility to consider the physical shape of the book and all the matters entailed, just as he considers the text (if not to the same extent, he should at least bear them in mind). The shape of the book should not be determined by generally accepted conventions but result from the author's autonomous decision just as actions of his characters and the choice of words originate from him. The physical and spiritual aspects of the literary work, that is, the book and the text printed in it should complement each other to create a harmonious effect.

Without reconsidering these matters and drawing appropriate conclusions, it will be extremely difficult to bring about any significant innovation; for example, in treating time and space, the two concepts so fundamental to literature.

For what is the space of literary work? According to the above-mentioned dictionary, nothing. There is no such entry at all; there is only space *in* a literary work which, in other words (and slightly simplifying the question), means the setting of the plot. But the first, elementary space one deals with, even before one starts reading a work, is … an actual book—a material object. The outward appearance of the book, the number and arrangement of its pages (if there need to be pages), the kind of cover (if there need to be a cover)—this is the space of the literary work that includes all its other spaces. And, unlike those other spaces, this space is very real.

Perhaps a comparison with contemporary theater practice will help clarify what I mean here. The greatest reformers of the twentieth-century theater began by creating their work by constructing its space. For people like Kantor and Grotowski this was the first and fundamental matter. Especially Grotowski was consistent in this respect; each of his performances had its own autonomous space, independent of the space of the theater where it was performed, that immediately established a fundamental relationship between the actors and the audience (for example, in his famous *Kordian* it was a lunatic asylum), which produced an astonishing effect in which form and content were unified.

I expect a comparable treatment of space from writers The writer should construct a space of his work anew, and each of his works should have its own distinct structure Let it even be a traditional volume, so long as it constitutes an integral whole together with the content of the book.

The question of time poses a slightly different problem. In the above-mentioned dictionary there are three different entries concerning time: time of action, time of narration, and time within the literary work, but there is no time of the literary work, that is, the time of … reading. Somebody might call this splitting hairs, but the time of open works, when the reader becomes nearly a coauthor, calls for such a notion. If the reader participates in participates in the process of creating a work, how else can we describe what is happening with the time when he or she fancies to read a book backward (as, for example, G. C. Jung read *Ulysses*)? Or when a linear book is read nonlinearly? Do existing terms suffice to account for that? And how can one accurately account for the notion of time in books such as Cortázar's *Hopscotch* in which, with the author's blessing, the reader himself decides on the sequence of particular chapters?

In the literatures which use the Latin, Greek, or Hebrew alphabets time is already determined to a great extent by the nature of these alphabets, that is, by the direction of reading

and writing. In the majority of works events are arranged linearly, which does not correspond to our simultaneous and multi-level perception (Egyptian hieroglyphs and Chinese ideograms are closer to reality in this respect). Despite this nature of the alphabetic writing, I am convinced that it is possible to overcome the difficulties resulting from it, to create real space within the text and to represent real simultaneity of events without resorting to graphic means. Yet, this is much easier to achieve when we abandon the traditional model of the book, which, in fact, determines a particular way of reading (and consequently the perception of time and space) no less than the alphabet does.

Why, then, don't writers abandon the traditional form of a book? Probably by force of habit and inertia. As if artists have forgotten that the present, codex form of the book has not been in existence since time immemorial, but came about as a result of economic and technological factors rather than artistic choices. And perhaps its days are coming to an end, just as the eras of clay tablets and papyri are gone.

We can only hope that a future masterpiece will change the present situation and the attitude of writers to the material aspect of the book, which they have ignored so far. This is, I believe, the only way of saving hardcopy books from obliteration by electronic media.

It does not have to be an all-embracing Book, but it should at least be a Book embracing the whole of … the book, in which all the elements, not only the text, are meaningful.

Be it called "literature" or rather "liberature," the matter of terminology is of secondary importance. This is a concern for theoreticians, not writers. Perhaps we could find a compromise solution, for example, acknowledge that besides the three major literary modes: lyric, epic, and dramatic (which, by no means, suffice to describe the richness of literature), there is one more that may be called "liberatic" that would include all the kinds of works discusses above. But, whatever the case, I believe that this fourth, still officially unacknowledged, mode will infuse new life into literature. This genre may be the future of literature.

memento

TIQQUN 1999

TIQQUN, "memento" (1999), in *Premiers matériaux pour une théorie de la Jeune-Fille* (Rennes: TIQQUN, 2006). Translated in 2018 by Michalis Pichler.

To print, spread, distribute books.

Never become a publisher. Another, maybe glorious, institution among institutions. Where the mask of a name fatally authorizes the *luxury*, not to think.

Remember at any time that it is a war. In which it is necessary to work on fields, to write texts, to find rhythms, to hit the targets. And that these books are a momentum of war or nothing.

To never make a pact with the idea of culture.

Leave to philosophers what life does not give to think about. Tumors that collapse in themselves. To disregard the so-called cultural milieus. To give their gestures the full meaning that this collapsing industry deserves, this cemetery teeming with hypocritical processions.

Here, more than anywhere else, allow only friends and enemies. And to keep up our capability to encounter.

As long as we still have spit, to always spit on the figure of the author, on the unity of the work.

To remember that the mention of "TIQQUN" on the book covers, among a thousand other possibilities, points only to the localization of the mental point from which these writings emanate. There is an empty axis around which the West curls up and which puts up all resistance against its revolution.

To say clearly that we are here for nothing else and have always been concerned only to form a force that is able to kill civilization and to then bury it. That our cause, even here, is purely practical.

To include an address in every book, a contact, that makes it possible for our brothers scattered in exile to find us.

The Super Flat Manifesto

Takashi Murakami 2000

Takashi Murakami, "The Super Flat Manifesto," in *Super Flat* (Tokyo: Madra Publishing: 2000).

The world of the future might be like Japan is today—super flat.

Society, customs, art, culture: all are extremely two-dimensional. It is particularly apparent in the arts that this sensibility has been flowing steadily beneath the surface of Japanese history. Today, the sensibility is most present in Japanese games and anime, which have become powerful parts of world culture. One way to imagine super flatness is to think of the moment when, in creating a desktop graphic for your computer, you merge a number of distinct layers into one. Though it is not a terribly clear example, the feeling I get is a sense of reality that is very nearly a physical sensation. The reason that I have lined up both the high and the low of Japanese art in this book is to convey this feeling. I would like you, the reader, to experience the moment when the layers of Japanese culture, such as pop, erotic pop, otaku, and H.I.S.-ism, fuse into one.[1]

Where is our reality?

This book hopes to reconsider "super flatness," the sensibility that has contributed to and continues to contribute to the construction of Japanese culture, as a worldview, and show that it is an original concept that links the past with the present and the future. During the modern period, as Japan has been Westernized, how has this "super flat" sensibility metamorphosed? If that can be grasped clearly, then our stance today will come into focus.

In this quest, the current progressive form of the real in Japan runs throughout. We might be able to find an answer to our search for a concept about our lives. "Super flatness" is an original concept of Japanese who have been completely Westernized.

Within this concept seeds for the future have been sown. Let's search the future to find them. "Super flatness" is the stage to the future.

1 H.I.S. is a discount ticket agency in Japan. By lowering the price of travel abroad, the company had a profound effect on the relationship between Japan and the West.

Corrections and Clarifications
Anita Di Bianco 2001

Anita Di Bianco, *Corrections and Clarifications No. 1* (Amsterdam: Rijksakademie, 2001).

Corrections and Clarifications is an ongoing publication, an edited compilation of daily revisions, retractions, rewordings, distinctions and apologies to print news from September 2001 to the present. A reverse-chronological catalog of lapses in naming and classification, of tangled catchphrases, patterns of mis-speech and inflection, connotation and enumeration.

With purely editorial credit to those who have provided the material for this publication by having seen fit to correct themselves, or having seen themselves fit to correct others; who have sought in some public way to offer apologies or clarifications—to redeem, reveal, revise, retract, or shift, to simultaneously claim, deny, and reattribute blame and responsibility. Credit is due for these well-documented efforts to apologize for what is being done and for what has already been done, for continuing attempts to un-say what is said, un-mean what is meant.

Credit at a variety of levels to those seekers, processors, middle managers, and ultimate regulator of public information who take it upon themselves (or impose it upon others) to rename, reclassify, disguise, defuse or be debriefed; who find clever metaphors to obfuscate, euphemize and mystify; who disseminate information according to political structures coincident with particular economic interests, who consent to use language to dismiss, excuse, cushion, cover and obscure the consequences of actions and the submerged structures behind events. And ultimately who, regardless of stated intentions, occasionally reveal something, piece by piece through slips in language and naming systems.

This is a newspaper without headlines, allowing such doubletalk to talk to itself. Perhaps what is conveyed unintentionally, and by repetitious mistakes, is more revealing, more historically identifiable, and substantially less conciliatory than it is meant to be. This is both fortunate and inevitable.

With further acknowledgment to readers who regard these revisions, regrets, and retractions with the same skepticism they have the originals.

Dispersion

Seth Price 2002

The definition of artistic activity occurs, first of all, in the field of distribution.

Marcel Broodthaers

One of the ways in which the Conceptual project in art has been most successful is in claiming new territory for practice. It's a tendency that has been almost too successful: today it seems that most of the work in the international art system positions itself as Conceptual to some degree, yielding the "Conceptual painter," the "DJ and Conceptual artist," the "Conceptual web artist." Let's put aside the question of what makes a work Conceptual, recognizing, with some resignation, that the term can only gesture toward a forty year-old historical moment. But it can't be rejected entirely, as it has an evident charge for artists working today, even if they aren't necessarily invested in the concerns of what you could call the classical Conceptual moment; which included linguistics, analytic philosophy, and a pursuit of formal dematerialization.

Hermann Hugo. Pia Desideria. 1659.

What does seem to hold true for today's normative conceptualism is that the project remains, in the words of Art and Language, "radically incomplete": it does not necessarily stand against objects or painting, or for language as art; it does not need to stand against retinal art; it does not stand for anything certain, instead privileging framing and context, and constantly renegotiating its relationship to its audience. Martha Rosler has spoken of the "as-if" approach, where the Conceptual work cloaks itself in other disciplines, philosophy being the most notorious example, provoking an oscillation between skilled and de-skilled, authority and pretense, style and strategy, art and not-art.

Seth Price, *Dispersion* (New York, NY: 38th Street Publishers, 2008).

LANTERNE CHINOISE

Duchamp was not only here first, but staked out the problematic virtually single-handedly. His question "Can one make works which are not 'of art'" is our shibboleth, and the question's resolution will remain an apparition on the horizon, always receding from the slow growth of practice. One suggestion comes from the philosopher Sarat Maharaj, who sees the question as "a marker for ways we might be able to engage with works, events, spasms, ructions that don't look like art and don't count as art, but are somehow electric, energy nodes, attractors, transmitters, conductors of new thinking, new subjectivity and action that visual artwork in the traditional sense is not able to articulate." These concise words call for an art that insinuates itself into the culture at large, an art that does not go the way of, say, theology, where while it's certain that there are practitioners doing important work, few people notice. An art that takes Rosler's as-if moment as far as it can go.

Not surprisingly, the history of this project is a series of false starts and paths that peter out, of projects that dissipate or are absorbed. Exemplary among this garden of ruins is Duchamp's failure to sell his Rotorelief optical toys at an amateur inventor's fair. What better description of the artist than amateur inventor? But this was 1935, decades before widespread fame would have assured his sales (and long before the notion that an artist-run business might itself constitute a work), and he was attempting to wholly transplant himself into the alien context of commercial science and invention. In his own analysis: "error, one hundred percent." Immersing art in life runs the risk of seeing the status of art—and with it, the status of artist—disperse entirely.

These bold expansions actually seem to render artworks increasingly vulnerable. A painting is manifestly art, whether on the wall or in the street, but avant-garde work is often illegible without institutional framing and the work of the curator or historian. More than anyone else, artists of the last hundred years have wrestled with this trauma of context, but theirs is a struggle that necessarily takes place within the art system. However radical the work, it amounts to a proposal enacted within an arena of peer-review, in dialogue with the community and its history. Reflecting on his experience running a gallery in the 1960s, Dan Graham observed: "if a work of art wasn't written about and reproduced in a magazine it would have difficulty attaining the status of 'art'. It seemed that in order to be defined as having value, that is as 'art', a work had only to be exhibited in a gallery and then to be written about and reproduced as a photograph in an art magazine." Art, then, with its reliance on discussion through refereed forums and journals, is similar to a professional field like science.

What would it mean to step outside of this carefully structured system? Duchamp's Rotorelief experiment stands as a caution, and the futility of more recent attempts to evade the institutional system has been well demonstrated. Canonical works survive through documentation and discourse, administered by the usual institutions. Smithson's *Spiral Jetty*, for example, was acquired by (or perhaps it was in fact 'gifted to') the Dia Art Foundation, which discreetly mounted a photograph of the new holding in its Dan Graham-designed video-café, a tasteful assertion of ownership.

That work which seeks what Allan Kaprow called "the blurring of art and life" work which Boris Groys has called biopolitical, attempting to "produce and document life itself as pure activity by artistic means," faces the problem that it must depend on a record of its intervention into the world, and this documentation is what is recouped as art, short-circuiting the original intent. Groys sees a disparity thus opened between the work and its future existence as documentation, noting our "deep malaise towards documentation and the archive." This must be partly due to the archive's deathlike appearance, a point that Jeff Wall has echoed, in a critique of the uninvitingly "tomblike" Conceptualism of the 1960s.

What these critics observe is a popular suspicion of the archive of high culture, which relies on cataloguing, provenance, and authenticity. Insofar as there is a popular archive, it does not share this administrative tendency. Suppose an artist were to release the work directly into a system that depends on reproduction and distribution for its sustenance, a model that encourages contamination, borrowing, stealing, and horizontal blur? The art system usually corrals errant works, but how could it recoup thousands of freely circulating paperbacks, or images of paperbacks?

"Clip Art," 1985.

It is useful to continually question the avant-garde's traditional romantic opposition to bourgeois society and values. The genius of the bourgeoisie manifests itself in the circuits of power and money that regulate the flow of culture. National bourgeois culture, of which art is one element, is based around commercial media, which, together with technology, design, and fashion, generate some of the important differences of our day. These are the arenas in which to conceive of a work positioned within the material and discursive technologies of distributed media.

Distributed media can be defined as social information circulating in theoretically unlimited quantities in the common market, stored on or accessed via portable means such as books and magazines, records and compact discs, videotapes and DVDs, or personal computers and mobile devices. Duchamp's question has new life in this space, which has greatly expanded during the last few decades of global corporate sprawl. It's space into which the work of art must project itself lest it be outdistanced entirely by these corporate interests. New strategies are needed to keep up with commercial distribution, decentralization, and dispersion. You must fight something in order to understand it.

You Are Information

Ant Farm, 1960s.

Mark Klienberg, writing in 1975 in the second issue of *The Fox*, poses the question: "Could there be someone capable of writing a science-fiction thriller based on the intention of presenting an alternative interpretation of modernist art that is readable by a non-specialist audience? Would they care?" He says no more about it, and the question stands as an intriguing historical fragment, an evolutionary dead end, and a line of inquiry to pursue in this essay: the intimation of a categorically ambiguous art, one in which the synthesis of multiple circuits of reading carries an emancipatory potential.

This tendency has a rich history, despite the lack of specific work along the lines of Klienberg's proposal. Many artists have used the printed page as medium; an arbitrary and partial list might include Robert Smithson, Mel Bochner, Dan Graham, Joseph Kosuth, Lawrence Weiner, Stephen Kaltenbach, and Adrian Piper, and there have been historical watersheds like Seth Siegelaub and John Wendler's 1968 show *Xeroxbook*.

"Literature being reeled off and sold in chunks"—Grandville, 1844.

Dan Graham. Figurative. *1965.*

2000.

The radical nature of this work stems in part from the fact that it is a direct expression of the process of production. Market mechanisms of circulation, distribution, and dissemination become a crucial part of the work, distinguishing such a practice from the liberal-bourgeois model of production, which operates under the notion that cultural doings somehow take place above the marketplace. However, whether assuming the form of ad or article, much of this work was primarily concerned with finding exhibition alternatives to the gallery wall, and in any case often used these sites to demonstrate dryly theoretical propositions rather than address issues of, say, desire. And then, one imagines, with a twist of the kaleidoscope things resolve themselves.

This points to a shortcoming of classical conceptualism. Benjamin Buchloh points out that "while it emphasized its universal availability and its potential collective accessibility and underlined its freedom from the determinations of the discursive and economic framing conventions governing traditional art production and reception, it was, nevertheless, perceived as the most esoteric and elitist artistic mode." Kosuth's quotation from Roget's Thesaurus placed in an Artforum box ad, or Dan Graham's list of numbers laid out in an issue of Harper's Bazaar, were uses of mass media to deliver coded propositions to a specialist audience, and the impact of these works, significant and lasting as they were, reverted directly to the relatively arcane realm of the art system, which noted these efforts and inscribed them in its histories. Conceptualism's critique of representation emanated the same mandarin air as did a canvas by Ad Reinhardt, and its attempts to create an Art Degree Zero can be seen as a kind of negative virtuosity, perhaps partly attributable to a New Left skepticism towards pop culture and its generic expressions.

Certainly, part of what makes the classical avant-garde interesting and radical is that it tended to shun social communication, excommunicating itself through incomprehensibility, but this isn't useful if the goal is to use the circuits of mass distribution. In that case, one must use not simply the delivery mechanisms of popular culture, but also its generic forms. When Rodney Graham releases a CD of pop songs, or Maurizio Cattelan publishes a magazine, those in the art world must acknowledge the art gesture at the same time that these products function like any other artifact in the consumer market. But difference lies within

these products! Embodied in their embrace of the codes of the culture industry, they contain a utopian moment that points toward future transformation. They could be written according to the code of hermeneutics:

"Where we have spoken openly we have actually said nothing. But where we have written something in code and in pictures, we have concealed the truth..."

A. Eleazar. Ouroboros. *1735.*

Let's say your aesthetic program spans media, and that much of your work does not function properly within the institutionalized art context. This might include music, fashion, poetry, film-making, or criticism, all crucial artistic practices, but practices which are somehow stubborn and difficult, which resist easy assimilation into a market-driven art system. The film avant-garde, for instance, has always run on a separate track from the art world, even as its practitioners may have been pursuing analogous concerns. And while artists have always been attracted to music and its rituals, a person whose primary activity was producing music, conceived of and present-ed as Art, would find art world acceptance elusive. The producer who elects to wear several hats is perceived as a crossover at best: the artist-filmmaker, as in the case of Julian Schnabel; the artist as entrepreneur, as in the case of Warhol's handling of Interview magazine and the Velvet Underground; or, as with many of the people mentioned in this essay, artist as critic, perhaps the most tenuous position of all. This is the lake of our feeling.

One could call these niches "theatrical," echoing Michael Fried's insistence that "what lies between the arts is theater... the common denominator that binds... large and seemingly disparate activities to one another, and that distinguishes these activities from the radically different enterprises of the Modernist art." A practice based on distributed media should pay close attention to these activi-ties, which, despite lying between the arts, have great resonance in the national culture.

Some of the most interesting recent artistic activity has taken place outside the art market and its forums. Collaborative and sometimes anonymous groups work in fashion, music, video, or performance, garnering admiration within the art world while somehow retaining their status as outsiders, perhaps due to their preference for theatrical, distribution-oriented modes. Maybe this is what Duchamp meant by his intriguing throwaway comment, late in life, that the artist of the future will be underground.

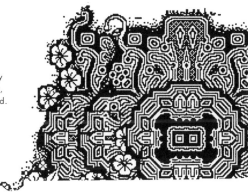

If distribution and public are so important, isn't this, in a sense, a debate about "public art"? It's a useful way to frame the discussion, but only if one underlines the historical deficiencies of that discourse, and acknowledges the fact that the public has changed.

The discourse of public art has historically focused on ideals of universal access, but, rather than considering access in any practical terms, two goals have been pursued to the exclusion of others. First, the work must be free of charge (apparently economic considerations are primary in determining the divide between public and private). Often this bars any perceptible institutional frame that would normally confer the status of art, such as the museum, so the public artwork must broadly and unambiguously announce its own art status, a mandate for conservative forms. Second is the direct equation of publicness with shared physical space. But if this is the model, the successful work of public art will at best function as a site of pilgrimage, in which case it overlaps with architecture.

Puppy, after Jeff Koons. S. Price.

The problem is that situating the work at a singular point in space and time turns it, a priori, into a monument. What if it is instead dispersed and reproduced, its value approaching zero as its accessibility rises? We should recognize that collective experience is now based on simultaneous private experiences, distributed across the field of media culture, knit together by ongoing debate, publicity, promotion, and discussion. Publicness today has as much to do with sites of production and reproduction as it does with any supposed physical commons, so a popular album or website could be regarded as a more successful instance of public art than a monument tucked away in an urban plaza. The album is available everywhere, since it employs the mechanisms of digital free market capitalism, history's most sophisticated distribution system to date. The monumental model of public art is invested in an anachronistic notion of communal appreciation transposed from the church to the museum to the outdoors, and this notion is received skeptically by an audience no longer so interested in direct communal experience. While instantiated in nominal public space, mass-market artistic production is usually consumed privately, as in the case of books, CDs, videotapes, and digital "content." Content producers are not interested in collectivity, they are interested in getting as close as possible to individuals. Perhaps an art distributed to the broadest possible public closes the circle, becoming a private art, as in the days of commissioned portraits. The analogy will only become more apt as digital distribution techniques allow for increasing customization to individual consumers.

Ettore Sotsass. Lamiera. Pattern design, Memphis collection. 1983.

The monumentality of public art has been challenged before, most successfully by those for whom the term 'public' was a political rallying point. Public artists in the 1970s and 1980s took interventionist praxis into the social field, acting out of a sense of urgency based on the notion that there were social crises so pressing that artists could no longer hole up in the studio, but must directly engage with community and cultural identity. If we are to propose a new kind of public art, it is important to look beyond the purely ideological or instrumental function of art. As Art and Language noted, "radical artists produce articles and exhibitions about photos, capitalism, corruption, war, pestilence, trench foot and issues." Public policy, destined to be the terminal as-if strategy of the avant-garde! A self-annihilating nothing.

An art grounded in distributed media can be seen as a political art and an art of communicative action, not least because it is a reaction to the fact that the merging of art and life has been effected most successfully by the "consciousness industry". The field of culture is a public sphere and a site of struggle, and all of its manifestations are ideological. In *Public Sphere and Experience*, Oscar Negt and Alexander Kluge insist that each individual, no matter how passive a component of the capitalist consciousness industry, must be considered a producer (despite the fact that this role is denied them). Our task, they say, is to fashion "counter-productions." Kluge himself is an inspiration: acting as a filmmaker, lobbyist, fiction writer, and television producer, he has worked deep changes in the terrain of German media. An object disappears when it becomes a weapon.

Anonymous.

The problem arises when the constellation of critique, publicity, and discussion around the work is at least as charged as a primary experience of the work. Does one have an obligation to view the work first-hand? What happens when a more intimate, thoughtful, and enduring understanding comes from mediated representations of an exhibition, rather than from a direct experience of the work? Is it incumbent upon the consumer to bear witness, or can one's art experience derive from magazines, the Internet, books, and conversation? The ground for these questions has been cleared by two cultural tendencies that are more or less diametrically opposed: on the one hand, Conceptualism's historical dependence on documents and records; on the other hand, the popular archive's ever-sharpening knack for generating public discussion through secondary media. This does not simply mean the commercial cultural world, but a global media sphere which is, at least for now, open to the interventions of non-commercial, non-governmental actors working solely within channels of distributed media.

A good example of this last distinction is the phenomenon of the "Daniel Pearl Video," as it's come to be called. Even without the label PROPAGANDA, which CBS helpfully added to the excerpt they aired, it's clear that the 2002 video is a complex document. Formally, it presents kidnapped American journalist Daniel Pearl, first as a mouthpiece for the views of his kidnappers, a Pakistani fundamentalist organization, and then, following his off-screen murder, as a cadaver, beheaded in order to underline the gravity of their political demands.

دانيال بيرل اليهودي

Computer Technique Group. Cubic Kennedy. 1960s.

One of the video's most striking aspects is not the grisly, though clinical, climax (which, in descriptions of the tape, has come to stand in for the entire content), but the slick production strategies, which seem to draw on American political campaign advertisements. It is not clear whether it was ever intended for TV broadcast. An apocryphal story indicates that a Saudi journalist found it on an Arabic-language website and turned it over to CBS, which promptly screened an excerpt, drawing heavy criticism. Somehow it found its way onto the Internet, where the FBI's thwarted attempts at suppression only increased its notoriety: in the first months after its Internet release, "Daniel Pearl video," "Pearl video," and other variations on the phrase were among the terms most frequently submitted to Internet search engines. The work seems to be unavailable as a videocassette, so anyone able to locate it is likely to view a compressed data-stream transmitted from a hosting service in the Netherlands (in this sense, it may not be correct to call it "video"). One question is whether it has been *relegated* to the Internet, or in some way created by that technology. Does the piece count as "info-war" because of its nature as a proliferating computer file, or is it simply a video for broadcast, forced to assume digital form under political pressure? Unlike television, the net provides information only on demand, and much of the debate over this video concerns not the legality or morality of making it available, but whether or not one should choose to watch it—as if the act of viewing will in some way enlighten or contaminate. This is a charged document freely available in the public arena, yet the discussion around it, judging from numerous web forums, bulletin boards, and discussion groups, is usually debated by parties who have never seen it.

This example may be provocative, since the video's deplorable content is clearly bound up with its extraordinary routes of transmission and reception. It is evident, however, that terrorist organizations, alongside transnational corporate interests, are one of the more vigilantly opportunistic exploiters of "events, spasms, ructions that don't look like art and don't count as art, but are somehow electric, energy nodes, attractors, transmitters, conductors of new thinking, new subjectivity and action." A more conventional instance of successful use of the media-sphere by a non-market, non-government organization is Linux, the open-source computer operating system that won a controversial first prize at the digital art fair Ars Electronica. Linux was initially written by one person, programmer Linus

After an anonymous cameo, circa 18th century. S. Price

Torvalds, who placed the code for this "radically incomplete" work on-line, inviting others to tinker, with the aim of polishing and perfecting the operating system. The Internet allows thousands of authors to simultaneously develop various parts of a work, and Linux has emerged as a popular and powerful operating system and a serious challenge to profit-driven giants like Microsoft, which recently filed with the US Securities and Exchange Commission to warn that its business model, based on control through licensing, is menaced by the open-source model. Collective authorship and complete decentralization ensure that the work is invulnerable to the usual corporate forms of attack and assimilation, whether enacted via legal, market, or technological routes (however, as Alex Galloway has pointed out, the structure of the World Wide Web should not itself be taken to be some rhizomatic utopia; it certainly would not be difficult for a government agency to hobble or even shut down the Web with a few simple commands).

Both of these examples privilege the Internet as medium, mostly because of its function as a public site for storage and transmission of information. The notion of a mass archive is relatively new, and a notion which is probably philosophically opposed to the traditional understanding of what an archive is and how it functions, but it may be that, behind the veneer of user interfaces floating on its surface—which generate most of the work grouped under the rubric "web art"—the Internet approximates such a structure, or can at least be seen as a working model.

Computer Technique Group. Return to a Square. 1960s.

With more and more media readily available through this unruly archive, the task becomes one of packaging, producing, reframing, and distributing; a mode of production analogous not to the creation of material goods, but to the production of social contexts, using existing material. What a time you chose to be born!

An entire artistic program could be centered on the re-release of obsolete cultural artifacts, with or without modifications, regardless of intellectual property laws. An early example of this redemptive tendency is artist Harry Smith's obsessive 1952 *Anthology of American Folk Music*, which compiled forgotten recordings from early in the century. Closer to the present is my own collection of early video game soundtracks, in which audio data rescued by hackers and circulated on the web is transplanted to the old media of the compact-disc, where it gains resonance from the contexts of product and the song form: take what's free and sell it back in a new package. In another example, one can view the entire run of the 1970s arts magazine *Aspen*, republished on the artist-run site ubu.com, which regularly makes out-of-print works available as free digital files. All of these works emphasize the capacity for remembering, which Kluge sees as crucial in opposing "the assault of the present on the rest of time," and in organizing individual and collective learning and memory under an industrialist-capitalist temporality that works to fragment and valorize all experience. In these works, resistance is to be found at the moment of production, since it figures the moment of consumption as an act of re-use.

The Blind Man. *1917.*

It's clear from these examples that the readymade still towers over artistic practice. But this is largely due to the fact that the strategy yielded a host of new opportunities for the commodity. Dan Graham identified the problem with the readymade: "instead of reducing gallery objects to the common level of the everyday object, this ironic gesture simply extended the reach of the gallery's exhibition territory." One must return to *Fountain*, the most notorious and most interesting of the readymades, to see that the gesture does not simply raise epistemological questions about the nature of art, but enacts the dispersion of objects into discourse. The power of the readymade is that no one needs to make the pilgrimage to see *Fountain*. As with Graham's magazine pieces, few people saw the original *Fountain* in 1917. Never exhibited, and lost or destroyed almost immediately, it was actually created through Duchamp's media manipulations—the Stieglitz photograph (a guarantee, a shortcut to history), the *Blind Man* magazine article—rather than through the creation-myth of his finger selecting it in the showroom, the status-conferring gesture to which the readymades are often reduced. In *Fountain*'s elegant model, the artwork does not occupy a single position in space and time; rather, it is a palimpsest of gestures, presentations, and positions. Distribution is a circuit of reading, and there is huge potential for subversion when dealing with the institutions that control definitions of cultural meaning. Duchamp distributed the notion of the fountain in such a way that it became one of art's primal scenes; it transubstantiated from a provocative objet d'art into, as Broodthaers defined his *Musée des Aigles*: "a situation, a system defined by objects, by inscriptions, by various activities..."

i'm in heaven when you file

Hot on the heels of last year's Output compilation of Commodore 64 tunes comes Game Heaven, a collection of computer soundtracks from 1982-1987. This selection comes from across the board of home entertainment, culled from collections of internet files which have been hacked from ageing consoles and outmoded arcade machines before being traded by techno fetishists. Mercifully, the bulk of these tunes are rather easier on the ears than the psychosis-inducing Commodore collection; while sharing the same lo-fi aesthetic, the 19 tracks display a surprising level of invention and variation. The tracks have been compiled by the artist Seth Price, who is represented at the 2002 Whitney Biennial. Price was born and raised in Jerusalem's volatile West Bank but has lived and worked in New York since 1997. All the pieces on the CD are unlisted and uncredited, raising several issues pertinent to digital culture: the acknowledgement of authorship, the loss of information as systems become obsolete and the point at which commercially or mass produced work becomes artistically valid. "The genre represents unique limitations," Price explains. "Designed for adolescent boys intent on play, the tracks must be energetic, but not distracting; the consummate background music." Eight-bit muzak as art, anyone? JUSTIN QUIRK

Game Heaven is available at the Whitney Museum Bookshop, 945 Madison Avenue, New York (212 570 3676).

i-D Magazine. *2002.*

The last thirty years have seen the transformation of art's "expand-ed field" from a stance of stubborn discursive ambiguity into a comfortable and compromised situation in which we're well accustomed to conceptual interventions, to art and the social, where the impulse to merge art and life has resulted in lifestyle art, a secure gallery practice that comments on contemporary media culture, or apes commercial production strategies, even as its arena gradually has become, in essence, a component of the securities market. This is the lumber of life.

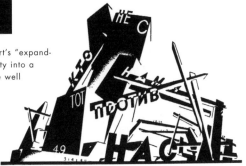

Iakov Chernikhov. Constructive Theatrical Set. *1931.*

This tendency is marked in the discourses of architecture and design. An echo of Public Art's cher-ished communal spaces persists in the art system's fondness for these modes, possibly because of the Utopian promise of their appeals to collective public experience. Their "criticality" comes from an engagement with broad social concerns. This is why Dan Graham's pavilions were initially so pro-vocative, and the work of Daniel Buren, Michael Asher, and Gordon Matta-Clark before him: these were interventions into the social unconscious. These interventions have been guiding lights for art of the last decade, but in much the same way that quasi-bureaucratic administrative forms were taken up by the Conceptualists of the 1960s, design and architecture now could be called house styles of the neo-avant-garde. Their appearance often simply gestures toward a theoretically engaged position, such that a representation of space or structure is figured as an ipso facto critique of administered society and the social, while engagement with design codes is seen as a comment on advertis-ing and the commodity. One must be careful not to blame the artists; architecture and design forms are all-too-easily packaged for resale as sculpture and painting. However, one can still slip through the cracks in the best possible way, and even in the largest institutions. Jorge Pardo's *Project*, an overhaul of Dia's ground floor which successfully repositioned the institution via broadly appealing design vernaculars, went largely unremarked in the art press, either because the piece was transparent to the extent of claiming the museum's bookstore and exhibiting work by other artists, or because of a cynical incredulity that he gets away with call-ing this art.

Liam Gillick. Post Legislation Discussion Platform. *1998.*

Ettore Sottsass. Design of a Roof to Discuss Under. *1973.*

A similar strain of disbelief greeted the construction of his own house, produced for an exhibition with a good deal of the exhibitor's money. It seems that the avant-garde can still shock, if only on the level of economic valorization. This work does not simply address the codes of mass culture, it embraces these codes as form, in a possibly quixotic pursuit of an unmediated critique of cultural conventions.

An argument against art that addresses contemporary issues and topical culture rests on the virtue of slowness, often cast aside due to the urgency with which ones work must appear. Slowness works against all of our prevailing urges and requirements: it is a resistance to the contemporary mandate of speed. Moving *with* the times places you in a blind spot: if you're part of the general tenor, it's difficult to add a dissonant note. But the way in which media culture feeds on its own leavings indicates the paradoxical slowness of archived media, which, like a sleeper cell, will always rear its head at a later date. The rear-guard often has the upper hand, and sometimes *delay*, to use Duchamp's term, will return the investment with massive interest.

Michael Green. From Zen and the Art of Macintosh. 1986.

One question is whether everything remains always the same; whether it is in fact possible that by the age of fifty a person has seen all that has been and will ever be. In any case, must this person consult some picture or trinket to understand that identity is administered, power exploits, resistance is predetermined, all is hollow?

> To recognize...the relative immutability of historically formed discursive artistic genres, institutional structures, and distribution forms as obstacles that are ultimately persistent (if not insurmountable) marks the most profound crisis for the artist identified with a model of avant-garde practice.

So the thread leads from Duchamp to Pop to Conceptualism, but beyond that we must turn our backs: a resignation, in contrast to Pop's affirmation and Conceptualism's interrogation. Such a project is an incomplete and perhaps futile proposition, and since one can only adopt the degree of precision appropriate to the subject, this essay is written in a provisional and exploratory spirit. Spirit. Spirit. An art that attempts to tackle the expanded field, encompassing arenas other than the standard gallery and art world-circuit, sounds utopian at best, and possibly naïve and undeveloped.

Complete enclosure means that one cannot write a novel, compose music, produce televi-sion, and still retain the status of Artist. What's more, artist as a social role is somewhat embarrassing, in that it's taken to be a useless position, if not a reactionary one: the practitioner is dismissed as either the producer of over-valued decor, or as part of an arrogant, parasitical, self-styled elite.

But hasn't the artistic impulse always been utopian, with all the hope and futility that implies? To those of you who decry the Utopian impulse as futile, or worse, responsible for the horrible excesses of the last century, recall that each moment is a Golden Age (of course the Soviet experiment was wildly wrong-headed, but let us pretend—and it is not so hard—that a kind of social Dispersion was its aim). The last hundred years of work indicate that it's demonstrably impossible to destroy or dematerialize Art, which, like it or not, can only gradually expand, voraciously synthesizing every aspect of life. Meanwhile, we can take up the redemptive circulation of allegory through design, obsolete forms and historical moments, genre and the vernacular, the social memory woven into popular culture: a private, secular, and profane consumption of media. Production, after all, is the excretory phase in a process of appropriation. It may be that we are standing at the beginning of something.

Albrecht Dürer. Melencolia I. 1514.

Michael Baers Reads A Statement Regarding Meta-Art

Michael Baers 2004

Michael Baers, "Michael Baers Reads A Statement Regarding Meta-Art" (Berlin: Meta-Comics, 2004), cover, 1–12.

Issue I, Volume I

May, 2004

Meta-Comics Presents:

Michael Baers Reads A Statement Regarding Meta-Art

In a 1973 article in Art Forum, Adrian Piper makes a case for a new occupation

for artists— "meta-art"— "the activity of making explicit the thought

processes, procedures, and presuppositions of making whatever kind of art we

make." Piper's appeal was for a total disclosure of the constituent conditions

surrounding a work's making: the source of one's inspiration and ideas; how

one attains materials and what kind of decisions affect their acquisition; the

conditions under which one chooses to work (in collaboration, alone, within

the gallery, without the gallery system); how, following Kant's method of

"*regressive proof*"
("*beginning with the fact of
the work itself, and from its*

*properties inferring
backward to the conditions
necessary to bring it into*

existence"), *one might
deduce, then analyze the
constituent presuppositions*

*of a work, be they
psychoanalytic, structural,
materialist, sociological,*

ethnographic, etc. While not disagreeing with the efficacy of meta-art

activities, which the present work wishes to engage on the level of

implicit logic and explicit statement, I would fault Piper in her article for

cleaving to a mystifying conception of art, insofar as she claims the inspirations

for art and for becoming an artist are "unfathomable"— totally untouched by such

explicable aspirations as a desire for wealth and/or fame, say, or for

recognition, nor influenced by the disciplinary mechanisms of arts

pedaegogy in which cultural values like "professionalism" are inculcated. "...The value

and function of our work may be defined by the social and economic context in

which we operate...", to quote Sarah Charlesworth. But considering how the art

world—not to speak of the world in general—has changed since 1973, one

should not fault Piper's argument on this point. And then again, perhaps I am

falling prey to a retrospective urge to gild the lily. Returning to the

topic of meta-art, I support it if done in such a way that greater account is

taken of the determinant nature of global capital. For instance, it might be

instructive to look into the conditions under which this paper was produced, these

pens and this ink, the two wooden trestles (purchased at Obi—itself a carbon copy,

and no doubt a subsidiary as well, of the American big-box outlet, "Home Depot",

branches of which now cover the US like a malignancy) which support the ersatz

light table upon which I am working: a 60 watt bulb burning in a 1960's-era desk

lamp of West German construction which Christine inherited from her

grandparents. Not to mention the trajectory of my own formative itinerary:

how I came to live in Germany, or California for that matter. The complex of

social and historical forces which, if not constitutive of my subjectivity, did a great

deal to distort its growth and development, were distorting (coextensively, so

to speak) institutions of art, CalArts for example (founded in 1967 by Walt

Disney), where my formal art education was completed. And this is to say

nothing of the complex and ambiguous prior relationship I entertain with the Disney

Corporation, insofar as I, like other children, was traumatized by viewing the

film, "Bambi" at a too tender age. A further caution would concern the way critical

art's resistance to cooptation has been eroded. Now "critical" artists deem

it expedient to ignore the relationship between critical art practices, the culture

industry, and the political economy. Artists are service workers in a

system which employs their critical goods as signifiers of institutional

transparency. In fact, the culture industry has proved quite adept at assimilating

any insurgent notions artists might entertain. But that is another comic.

Kwani?

Binyavanga Wainaina 2004

Binyavanga Wainaina, "Editorial" in *Kwani?* 02 (Nairobi: Kwani?, 2004)

I felt very complimented recently in a conversation with a senior newspaper editor who said that he has "intellectual" problems with *Kwani?* because it is not "serious" enough. By serious, I took him to mean "self-important" or "pompous." The fact that *Kwani?* has become popular has rubbed establishment types the wrong way. Intellectual debate in the *Sunday Standard Literary Forum* days was very incestuous: the same old people talking to each other.

Kenya's literary community sometimes behaves as if literature is a lineage: that some chosen somebody passes on the light to another chosen somebody, and so on. I prefer to see Kenya as a diverse place which needs diverse conversations: no publication or person can represent all of Kenya's literary aspirations. What I hope for as a reader is as many literary engagements as possible, in all languages possible, from all schools of thought possible. I do not feel I am in competition with anybody. That sense of bitter territorialism is simply a by-product of the Moi Era (one-party, KBC, Nairobi University, KIE and ME ME ME.)

My Way. One way. The way. Fuata Nyayo.

Kwani? is a place for seekers. Not all seekers. Just some. All we try to do is find interesting, engaging writers without prescription. It is our philosophy that we do not know what is out there; that much of Kenya remains little understood. We try to make partnerships that open up new career possibilities for talented writers we find. We try to explore new ways to talk intelligently and without pompousness. We are not apolitical: we will be happy to publish any political view that we find interesting or meaningful. We respond to what we receive; we remain unable to publish all those who submit stories to us.

We avoid the sort of bitter, nativist Pull-Him-Down debates that have destroyed intellectual debate in Kenya. We avoid the intellectual "gossip" that has made the careers of many. The sort of people who say Ngugi invented

Mungiki, or that Binyavanga is not a Real Kenyan because he has that strange name. That sort of hate speech is responsible for Rwanda, and Sierra Leone. It is petty, and not worthy of adults.

Kwani? will not apologize to anybody for being popular, or for attracting publicity. We work extremely hard to do what we do. We cannot take responsibility for what those in the local or international media say on our behalf.

It is looking like a promising year. We helped bring Ayi Kwei Armah to Nairobi, and many turned out to share ideas with him. We hope to publish several books this year, including the memoirs of a man, Joseph Muthee, who spent years in six detention camps during the Emergency. We hope to publish a novel in Sheng this year. And we will launch a CD—call it oral literature, performance poetry, Kenyan Hip Hop verse. It will be something exciting.

Kwani? 3 is by far the most complete issue we have published. The quality and variety of stories has increased. The editing process has improved; so has the design and layout. We will publish photographs that have never been seen before: of Chief Wambugu and his family in 1902. We have fiction by several new Kenyan writers; fiction and poetry in Sheng; a ground-breaking nonfiction feature by Billy Kahora about David Munyakei, a forgotten hero who learnt to shape-shift, like many Kenyans have learnt, to survive and thrive.

I am beginning to see that Kenya (the Kibaki Kenya, the Parliament and sections Kenya, the Kenya where World Bank country directors live in houses rented to them by our president) is dying. It was never anything but a way for a few D.O. types to colonize this space. There is another Kenya growing out of these ashes. It has learnt to need nobody; to be competitive and creative. It speaks Sheng. It is the Kenya we are waiting for.

Reena Spaulings

Bernadette Corporation 2005

Bernadette Corporation, *Reena Spaulings* (Los Angeles: semiotext(e), 2005).

If you look at a city, there's no way to see it. One person can never see a city. You can miss it, hate it, or realize that it's taken something from you, but you can't go somewhere and look at it and just see it empirically. It has to be informed, imagined, by many people at a time. It's an everyday group hallucination. This novel is modeled on that phenomenon. 150 writers, professional and amateur, have contributed to it, not using the mutually blind exquisite corpse method, and not using the "may I have this dance" method where writers take turns being the author, but using the old Hollywood screenwriting system whereby a studio boss had at his disposal a "stable" of writers working simultaneously to crank out a single blockbuster, each assigned specific functions within the overall scheme. The result is generic and perfect. And Reena herself benefits from it by being more of a material entity, a being, than a character—her thoughts and actions are not spanned by any author's mind. Who pulls her strings?

Mama! An author is a routine, which makes for good conversation whenever that routine climbs down from the windswept seclusion that walks and breathes centuries of the word. Fourteen meetings with the publisher it took for this author to become convinced that Reena Spaulings was fit for print. Thirty-six bleary-eyed howling dinners of beer and cocaine just to prove that Reena was the product of sweat and tears and frustration. All this drilling, convincing, testing, baiting proves that not only is an author a person who writes, but also a role that is negotiated and trained by those who choose the books one can read today. Becoming an author is a process of subjectivization, and

so is becoming a soldier, becoming a cashier, becoming a potted plant.

Like the authors, the New York City depicted herein finds itself constantly exposed to the urges of "communism"—that is, to a chosen indifference to private property, a putting-in-common of the methods and means of urban life and language. Communism, it seems to say, is the only thing we share today, besides our extreme separation. Between the lines is a desire for the not normal situation, a wartime desire not for peace but for a better, fresher war that would produce the not normal situation. In everybody, even an underwear model.

Sometimes, hoping to generate a timely product for young readers today, we couldn't help but produce something unwanted, unexpected instead. Reena Spaulings is not the *On The Road* or *The Great Gatsby* of these times, which is to say that these times do not need or want those kinds of books. If the Novel, today, has lost much of its seductive power and its necessity, perhaps we can fill it with something else. This is a novel that could also have been a magazine. It's a book written by images, about images, to be read by other images, which is to say it is uninhibited and realist.

Its primary content is the desire to do two things at once: to take something back and to get rid of ourselves. It took us less than three years to write. An impossible book we are now letting go of, so that Reena Spaulings can assume her final pose—along with Tristram Shandy, Edgar Huntly, Effi Briest, Silas Marner, Madame Bovary, Daisy Miller, Moby Dick, and all the others—that of literature.

Introduction

Bruce LaBruce 2008

Bruce LaBruce, "Introduction," in *Queer Zines*, ed. AA Bronson and Philip Aarons (New York: Printed Matter, 2008), 5.

Cast your mind back, if you dare, to a time before the Internet, when you actually had to put pen to paper, buy a stamp, lick an envelope, walk to the post office, and mail your musings or drawings or manifestos to other like-minded individuals in equally isolated areas around the globe, impatiently waiting weeks, sometimes months, for something in return to validate your obsessions. That's how perverse the fanzine world was, and it goes a long way toward explaining the plaintive, intense, and yearning quality of many of these historical artifacts. DIY wasn't just a philosophy, it was a necessity. You had a day job so that you could afford to produce your own fanzine or band or music label, and you used any available means—Kinko's, the local bookstore, the mail—to get it out there. You were probably a punk, so you had very strong notions about nonconformity, aesthetic terrorism, and revolution. You believed intensely in what you were doing, and a political consciousness was de rigueur.

How quickly things change. When my comrades and I started making fanzines and Super-8 movies in the eighties, the corporate regulation of dissent seemed more like science fiction than the harsh reality that it has become. We operated outside of corporate media control, avoiding censure by staying underground, and, more importantly, by evading the kind of self-censorship that the new regimes of social networking—MySpace, YouTube, etc.—encourage. There was a militancy and a political urgency to what we were doing, whether it be railing against the dominant ideology or the gay establishment or any other ruling class that tried to dismiss us: the misfits, the sissies, the plague-ridden faggots.

Our revolution was brewed in lipstick-stained take-out coffee containers, overflowing ashtrays, cockroach infested slum houses, and deserted twenty-four-hour Kinko's. It was a romantic insurgency in a paper cup that could use a proper comeback.

Disco as Operating System, Part One

Tan Lin 2008

Tan Lin, "Disco as Operating System, Part One," *Criticism* 50, no. 1 (Winter 2008).

When exactly did the era of the medium dissolve? Like most cultural phenomena, the dissolution of the medium and its attendant auras—painting, film, music, photography, the novel—is hard to pinpoint. So it's useful to turn from the PowerPoint lectures of art history, with their virtual-poetic implications, and look for sensory clues on the dance floor of the seventies, regarded as an operating system with a mirror ball, two turntables, Quaaludes, and a mixing board. The ad-hoc setup known as "seventies dance culture" or the "Disco Era"—beginning roughly in 1973 and ending in 1979—ushered in a post-medium era for the masses. In disco's particular case, it led to a host of media formats and musics in the eighties and beyond: house, ambient, electronica, hip-hop, snap, trip-hop, dub, crunk, garage, hyphy, and techno. These mutations suggest how varied and unspecific disco as a genre became and how complicated its evolution and mainstreaming ultimately was. But then genre or medium was never the right way to think about disco. Asking what disco is is no less difficult than asking, What is music? But the question might be better rendered as, What sounds *like* music in an age of the dissolving medium? And one of the answers to this is "disco," or, to use a more ambient search parameter, "the disco sound."

The post-medium era had numerous precursors both visual and aural.[1] In his notes to the *1914 Box*, Marcel Duchamp proposed bypassing the outmoded channel of retinal processing by making a "painting of frequency,"[2] a project followed up by Duchamp's program for "large sculptures in which the listener would be at the center. For example, an immense *Venus de Milo* made of sounds around the listener."[3] And Andy Warhol regarded his *Shadows*, a sequence of 102 paintings the artist completed in 1978, as disco décor. At any rate, disco's influence as a post-medium format transcended dance culture at the Loft, the Paradise Garage, or Studio 54. By the early years of the century, the disco sound had morphed into not only house music but into production and distribution practices associated with "social media." With its divergent music-making techniques (beat-matching, slip-cueing), social venues (dance clubs), low-cost or free distribution models (record-lending pools, nominal club admission), social practices, and changing technologies (mixing board, twelve-inch single, amyl nitrate), disco is not principally a commodity pressed on vinyl and consumed in a rec room, but a cultural format accessed in a communal setting where the line between singing and acting, listening and participating, between a celebrity and what Warhol called a "nobody," and between an individual and a network were being dissolved in an era marked by flexible accumulation and the transformation of culture into a fluid species of capital.[4] It was also a techno-logically specific medium whose production and mode of accessing can be linked to the development of magnetic core memory systems. But you didn't have to be an economist or a computer expert to note how changes in the market affected stardom in a network where human actions resembled machine-based protocols enabling data to copy itself. As an ambient environment or operating system in which varied practices transpire, disco is the (sound of) data entering (input) and leaving (output) a system, where multiple sources are accessed in a time that is simulated to feel like a real-time operation. Or as Donna Summer remarked: "That was Marilyn Monroe singing, not me. I'm an actress. That's why my songs are diverse."[5]

To paraphrase McLuhan, an era is defined not so much by the mediums it gains as by the mediums it gives up. Summer, a new species of a studio-engineered vocal celebrity, understood the conditions of her fame in relation to métier: anonymity, short shelf life, fungible social network/civilization, and copyright violations. The so-called authenticity of the rock 'n' roll voice, heretofore rendered on a forty-five and given play on Top 40 radio, poses the problem the twelve-inch, five-minute-plus single solves with mixing board and DJ: a mechanism wherein vocals are remixed into a continuous Extended Play machine track, a customized sound that could not not be danced to, something fabulous, martial, transgendered, and homoerotic. The human voice, engineered in the studio, became "lyrical" output, nominal, repetitive, or like harmonic lines, was subtracted from the mix.[6] In his classic six-minute remix of "Hit and Run" (1977), the DJ Walter Gibbons excised strings, horns, and two verses of Loleatta Holloway's intro so that in the final recording, to use the words of Salsoul producer Ken Cayre, "Loleatta wasn't there anymore."[7] The disappearance of the medium conveniently coincided with the submerging of voice into the layers of a remix. Of course, Loleatta and Summer weren't gone; they were there in a different kind of way, like an interface or, to rephrase Duchamp, "a delay in glass as you would say a poem in prose or a spittoon in silver" (Duchamp 22).

The current era is notable because it finally gave up, with hardly a sigh, the idea of cultural production dependent on self-reflection and individual production—but it wasn't just painting, it was film, photography, the novel, rock 'n' roll, and poetry—yes, even poetry—that was transformed into a graphical user interface (GUI) to a database. Long before poetry became a distribution channel for contemporary artists and a defunct or zombie brand for any number of cultural practices, Duchamp noted that "there's a sort of intense sensory lament, or sadness and joy, which corresponds to retinal painting, which I can't stand... I prefer poetry" (Adcock 106). Reversion to an earlier making (*poesis*), using language as a (slow) distribution

medium (i.e., print on demand) for the voice, becomes a possibility when the relationship between seller and buyer, artist and audience is marked, as Duchamp noted, by an "indecisive reunion" (Duchamp 26), thereby mandating the implementation of what Duchamp termed "notes." Duchamp published these "notes" in 1914, 1934, and 1967, as the *Box of 1914*, the *Green Box*, and *In the Infinitive*, respectively. These 289 notes, all written in French, are part and parcel of a "sum of experiments," the phrase that Duchamp used to describe the evolving composition of his master work, the *Large Glass (The Bridge Stripped Bare by Her Bachelors, Even)* between roughly 1915 and 1923.[8] In these notes, Duchamp acknowledges his debts to, among others, the poet Stéphane Mallarmé, the mathematician Henri Poincaré, and the writer Raymond Roussel. Of the notes' importance to genesis of the art objects, Anne d'Harnoncourt writes: "Duchamp's individual 'works' are not ends in themselves. The grand metaphysical machinery of the Large Glass… [is] inextricably rooted in the matrix of Duchamp's notes to himself."[9] Conceived of as a series of delays, one of which was the notes, Duchamp's completed work was not merely a mimetic translation of a content it transmitted (i.e., a function of efficient economic exchange); rather, it was the mechanical transmission itself, a process made visible by delay ("a delay in the most general way" [Duchamp 26]), where delay also connotes a lack of economic incentive in or profit resulting from the redistribution. The glass in *The Bride Stripped Bare by Her Bachelors, Even* is a computational device. It "translates," in a process subject to both medium- and time-delay, a "media object" sandwiched (like a commodity) between photograph and painting. In Duchamp's work, painting becomes visible "even" *as* delay (in glass). The bride is a mathematical function, a skeletal or "stripped" computational engine, a commodity of the infra-thin variety.[10] She functions in the same manner that light could be said to fuel and "draw" equations on photographic emulsions.[11] Such compositions are explicitly temporal. In note 135 Duchamp references Henri Bergson's concept of duration that is consistent with this notion of delay: "no longer… the instant present, but a sort of / present of multiple extensions" (MDN 135). Of the mechanical / mathematical subsumed in a photographic process, Duchamp noted: "It's merely a way of succeeding in no longer thinking that the thing in question is a picture" (Duchamp 26).

In this manner Duchamp anticipated what poetry would become sometime post 2005 or so: someone's blog, a listing detail on Facebook, a channel for distribution of any material, a production / dissemination device for whatever. Distribution is the new theater regarded as lifestyle, a mode of delayed and sampled sound modules or distributed practices. Unlike the novel, whose accuracy was a function of photographic realism, disco's pleasure is predicated not on Duchampian decontextualization of what in the end, vis á vis the readymade, was still a sculp-tural object (albeit "applied" with fake signature or bad math), nor was it predicated on the sundry social/aesthetic practices labeled Relational Aesthetics. Disco's pleasure is anything accessed in a general and random way—that is, generically, or as Duchamp's word "even" demonstrates, as a function of language not yet assigned to adjective or adverb. And the most generic concept and poetic engine of the late seventies was probably disco, a music genre-less enough to be absorbed into culture as a whole, in a host of divergent social practices, musics, poetries, films, TV shows, and, yes, everybody's lifestyles or "everybody's autonomy."

It is probably for this reason that disco was attacked not when it upset hierarchies of the music production and distribution scene of the seventies; when it elevated studio technicians, DJs, sound mixers, arrangers, producers, and session musicians to the status of behind-the-scene and invisible creators; or when it frequently made a lead singer unnecessary to the production of a commercial "hit"—but rather when, as a consequence of its delays, disco *lost* its underground, avant-garde edge, exited the gay club scene of the mid-seventies, and began to enter the mainstream, where it mimicked forms of mass cultural production. Suddenly disco was everywhere, a product without clear origins, broadcast indiscriminately like Tennyson's and Longfellow's trance-inducing poems in the nineteenth century or home décor in the post-Bauhaus era. By the late seventies, Helen Reddy, Barry Manilow, and even the Rolling Stones started cutting disco albums; soon, disco was lambasted for crass commercialism, cultural effeteness, formulaic nature, predictability, shallowness, anonymity, licentiousness, and, above all, lack of content.

It was thus when disco left the underground dance scene and the mid- to late sixties avant-garde art practices associated with it that its radicality became more apparent—as an affront to music production and distribution systems and to what Tony Conrad called an "authoritarian musical form based on the sanctity of the score."[12] Disco replaced the rock star with a mixing board and session musicians, transforming rock singers into a function of programmers and DJs who "play" them. Top 40 radio DJs and the largely male, white writers at Rolling Stone saw in disco a loud affront to musical manners and the individuality and uniqueness tied to Western rock civilization. But disco was also an affront to less mainstream and more explicitly radical art-house musicians. John Holmstrom in Punk magazine remarked: "Death to disco shit!" (Lawrence 221). Jello Biafra of the neo-punk band the Dead Kennedys "likened disco to the cabaret culture of Weimar Germany for its apathy towards government policy and its escapism."[13] In a sense, for punk musicians and mainstream culture alike, disco could hardly be thought about.[14] Yet its distasteful-ness suggests a way of visualizing avant-garde practices dissolving into something generic, something for which the idea of medium, race, and sexual orientation was ren-

dered mostly irrelevant as disco became mainstreamed. Disco is the site where the social protests explicitly linked to street actions and avant-garde happenings of the sixties became an interiorized lullaby, drone, soliloquy, or head trip. And of course disco facilitated that migration, regarded as a species of programmed intoxication.

From the beginning, it was *always better not to think*. As an operating system, disco is not, as is mistakenly thought, an explosion of sound onto the dance floor but an implosion of pre-programmed dance moves into a head. In the hands of a DJ, cuts and remixes are smoothed over to create an impression of continuity at one with the brain's seamless assimilation of material where the brain becomes the material that has already been stored processed on a mixing board. As Bill Brewster and Frank Broughton note, a DJ like Walter Gibbons "would take two copies of a track, for example "Erucu," a Jermaine Jackson production from the Mahogany soundtrack, or "Two Pigs and a Hog" from the Cooley High soundtrack, and work the drum breaks so adroitly it was impossible to tell that the music you were hearing hadn't been originally recorded that way."**15** In his history of disco, *Turn the Beat Around*, Peter Shapiro describes a remix:

> Gibbons's astonishing 1978 remix of Bettye LaVette's "Doin' the Best That I Can" is the pinnacle of his (and probably all of disco's) dub experimentation. Slowing the track to an absolute crawl and stripping it like an abandoned car with the remains scattered across eleven minutes, Gibbons somehow made the record funkier and more danceable… [The track] is almost anti-disco in the way that Gibbons palpably heaps scorn on producer Eric Matthews's worst instincts by constantly undercutting the saccharine strings, judiciously using dropout and echo, importing his own rhythms, and essentially reversing the entire arrangement.

In place of listening, the brain is a passive regulator in a feedback loop. The dance floor is a series of mathematically induced aural hallucinations that involve the production and redistribution of music or, to be more accurate, musical effects. Everything else gets methodically filtered or subtracted out. No one really listens to disco, not even the listener; it is passively absorbed by a brain connected to a dancing body. What allowed the brain to enter a feedback loop was a DJ and a mixing board, as well as technological advances: the twelve-inch record and time-delay sound systems.**16** As David Mancuso noted: "You want the music in your brain" (Lawrence 240). Not surprisingly, as a blank sine wave that courses through an empty channel, disco was thought to have zenlike qualities.

Disco as a medium or a genre—of what? music? lifestyle? home décor? production techniques?—was pretty unthinkable except as an integrated layer of medial practices: poetry, painting, operating systems, software, record

lending groups, nightclubs, session musicians, celebrities, strobes, time-delay speakers, controlled vocabularies, mixing boards, and search engines. Disco is produced within a social network that includes DJs, producers, session musicians, and fronting artists. It is an extremely porous container. It has an MC. It can take place at a wedding, bar mitzvah, or warehouse. It contains letting go, prerecorded artifacts and special effects, social inflections, bodily gyrations, freaky wigs, and elongations of gesture. Ken Emerson remarked that disco was marked by an "untheatrical anonymity" and added that the "lack of personal identity allows unawed dancers to assert their own identities" (Lawrence 177). Emotions—like the songs, like gestures, like weak forms of social networking—are exaggerated forms of sign language and leave-taking and thus instantly forgettable. They could be said to have been technically forgotten before they were forgotten. For this reason, disco is the most photographed and least photographic of mediums. Actors (forms of memory akin to old wax cylinders) replace recording stars (digital voice print), and DJs replace actors. Gloria Gaynor's seventeen-minute-long "Never Can Say Goodbye" (1975) outlines the aim of a disco track. Gaynor understood that only by becoming elongated in time via a groove does the voice become more purely expressive and perfectly motionless. The voice is a series of noiseless exhortations, or it flagrantly rips off something from somewhere else, as with the Peech Boys' "Don't Make Me Wait." So the "language" of disco eats itself and the dancers are non-nostalgic. They embody linguistic distraction. They are rendered by voices animated by and drowned out by moans or faders, which are the same. Early disco producers realized that the nicest thing about a groove is that it doesn't have to end, and that music, like the social, is the continually regulated background. And thus, unlike various avant-garde anti-groove practices that paired difficulty and impersonality with extreme length, disco aimed, via the most artificial means possible, to vapidly and ephemerally solve a kind of existential crisis via machine rhythms, repeated pleasure, mindless sex, synthetic tracks, and extreme length. The year is 1941. Theodor Adorno noted: "The adaptation to machine music necessarily implies a renunciation of one's own human feelings."**17** No better description of the groove probably exists. Except for perhaps: "I Feel Love." Casablanca Records, 1977. Or as Parliament noted: *Fenkentelechy vs. the Placebo Syndrome.*

Gibbons understood that intoxication was remediated and that the central nervous system was susceptible to programming by a disco-drug cocktail that could trigger sex and euphoria, thus transforming disco into erotica. As Tom Moulton noted, Gibbons was "into drugs and developed weird sounds… He wanted to make music for drugs because he knew it would invoke a better trip" (Lawrence 268–69). Cocaine, a dopamine reuptake inhibitor, heightened euphoria. Inhaling amyl nitrate or "poppers"

(an industrial product found in "air fresheners and tape head cleaners") "relaxed smooth (i.e., nonstriated) muscles throughout the body, including the sphincter muscle of the anus and the vagina," and thus prolonged orgasms. Another enabling club drug, Quaaludes, suspended "motor coordination and turn[ed] one's arms to *Jell-O*,"[18] an effect rendered graphically under stroboscopic conditions that altered (redistributed) feelings of time via the effect referred to as temporal aliasing. But of course the stagflation years of the seventies were *already* taking place in slow motion, with disco the time-delay packaging and storage medium, one of the ways to attenuate and mollify the temporal discontinuities, interruptions, and ruptures of the period—which it rendered as one seamless, time-stopped, quivering whole, something like a literature without a language, a pure musical pabulum or technobabble cum lullaby, something invested in "minimal signifieds."[19]

A groove is a placebo. In it, the pleasure principle (desire) is scrambled and remixed. Inverting Claude Shannon's theory wherein increased information generates greater noise,[20] disco would blur the distinction between signal and noise, elevating the percussion (noise) track to a position of totalizing prominence while liquidating its disruptive factor by making it part of a hypnotic remix. The listener experiences disco desiringly, without listening and blindly, as a function of increasing uncertainty *in* the remix, where the listener is the output—that is, a programmed state of mindlessness (limited processing)—induced by disco. In this sense, disco exposes even as it camouflages desire as a programmable function. Or to put it more simply, in disco, noise is reprocessed against a background of minimal information or exclusions. This is underscored by the general vacuity of disco lyrics. And so the social world of language production and meaningful utterances is rendered obsolete and automated. Social realism is antithetical to melodrama and its subspecies funk and should be the first category of the social to be dismantled, along with an unbroken social scene: marriage, straight sex, the recession, suburbia, a drug-free world, blue jeans, liquid modes of intoxication, clear vision. In its place: the all-night disco with lit-up dance floors, tight trousers, mirror balls, polyester, faded industrial infrastructure, inner-city blight, an hour hand that throbs, and amyl nitrate.

The elaboration of such pleasure points was not lost on Giorgio Moroder, who in 1975 programmed the remixed, extended sound of a woman having an orgasm, a seventeen-minute soundtrack that many American radio stations promptly banned. The message from Moroder and Summer was clear: no orgasm can be experienced without a synthesizer. The time of sexual pleasure can be programmed from the outside to bypass heterosexual intervention. Such a song, a series of looped tracks, suggested that the most beautiful orgasms are uninterrupted and subject to infinite storage, that the orgasm can no longer be regarded as an event but as a series of delays.[21] As anyone on a social networking site can tell you, social effects are groove-like, fully programmed, and hallucinated. But then erotica has always been multiformat, including "literature, photography, film, sculpture and painting."[22] Disco is one of the earliest premodern operating systems to calculate the human voice as an erotic reverb or echo deep inside a percussion track, where the engineered voice is a placebo for pleasure.

Grooves are interchangeable with other grooves. In programmed rigidity lies endless plasticity. Like other epic sound-based groove structures, the most famous literary example being T. S. Eliot's "The Waste Land," disco is a mutating and fluid parameter defined by self-induced monotonies. As producers, record executives, session musicians, mixers, DJs, and dancers understood, disco is a mood accessed by someone else. It was a "programmed source," generic culture in a configured state (mood). Or as Duchamp noted, a displaced erotics: "it is necessary to *stress* the introduction of the new motor: the bride" (Duchamp 39). In Eliot's case, monotony leads to footnotes. In disco's, it led to Long Island and Tom Moulton's manual razoring and Scotch-taping of one tape to another with no break in the beat, a mathematical operation where dance is reduced to a percussive, 4/4 beat. Like his first legendary tape, forty-five minutes of nonstop pre-synthesized dance music, Moulton's practices were grounded in difficulty and noise, which were channeled into a mix marked by seamlessness, pleasure, absorption, and timelessness.

Today, as T. S. Eliot feared, things like voice or personality don't get remembered; they get remixed and accessed. Or in Eliot's famous formulation: "the point of view which I am struggling to attack is perhaps related to the metaphysical theory of the substantial unity of the soul: for my meaning is, that the poet has, not a 'personality' to express, but a particular medium, which is only a medium and not a personality, in which impressions and experiences combine in peculiar and unexpected ways."[23] And what could be a better description of the remixes of a disco track, one long dance medium that outlines the musical tradition as a fluid, amorphous, and, as Eliot noted, "timeless" sonic environment being remixed in a real time impervious to history, the tradition, or the idea of an "original" work. As Eliot noted, "no poet, no artist of any art, has his complete meaning alone" (Eliot 38), and disco facilitates the endless reprogramming and rerecording of "sources," which awakens a mistaken desire to locate disco's "origins" in lectures on experimental practices of the sixties. No disco number is a "complete work," and the footnotes of Eliot's literary programming likewise fail to organize the diverse materials of "The Waste Land," which remains a transmission mechanism or open channel marked by intolerable noise. What is required is not a literary solution but a mathematical operation that hinges on the "calculability of the irregular itself."[24]

According to Kittler, "Data processing becomes the process by which temporal order becomes moveable and reversible in the very experience of space" (Kramer 96). What could be a better description of being on a dance floor circa 1974, where all bodily permutations, all "creative actions" witnessed by Tiresias, are read as "software applications," things calculated in advance, in the manner of a social taxonomy. Not only the sexes (Tiresias: "Who is that beside you?") but members of various class strata—from archduke, Highbury denizen, young typist, and down to pub crawler—are presented in crude ensemble, Eastern and Western religions coalesce, and "characters" lack individuation, reduced to the occupational epithets that "identify" them: young man carbuncular, Smyrna merchant, archduke, typist, and so forth. Such a taxonomic or totalizing social and cognitive structure could not be said to open up a space for work or productive labor in the Weberian sense. Such identification exacts a high price: the labels that classify them as members of a specialized labor force render them defunct remnants of a social mechanism, nonproductive and incapable of mobility. Individuals transmute into types. Documentary portraits degenerate into pathological archives. What appears to be a fertile and organic social system is in fact a sterile and mechanical taxonomy designed to diagnose irregularity (i.e., "social" diseases) but containing no operant moral ethos or therapeutics. The sterile and mechanical perfectly imitates the fertile and organic in a set of false literary *correspondences*. What has brought us to this position, which can only be termed untenable?

Footnotes 218 and 360 to "The Waste Land" offer a posthumous explanation, one removed from the realm of Greek tragedy and that era's blindness, and one calculated as a function of new modes of nonparticipatory, spectatorial labor: "Tiresias, although a mere spectator and not indeed a 'character,' is yet the most important personage in the poem, uniting all the rest. Just as the one-eyed merchant, seller of currants, melts into the Phoenician Sailor, and the latter is not wholly distinct from Ferdinand Prince of Naples, so all the women are one woman, and the two sexes meet in Tiresias. What Tiresias sees, in fact, is the substance of the poem. The whole passage from Ovid is of great anthropological interest." Tiresias is, from the equalizer's standpoint, attenuated, part of the endless, transgendered, homo / hetero-erotic mix that may or may not include a member of Shackleton's Antarctic party. Hence our first axiom: (mode of) production is the new theatricality. Or to put it more simply: DJ / Tiresias is alive, but the music is dead (Kramer 101).[25] What does disco do? It programs a random-access search for "origins" and incites in the reader a search for sources, which turn out to be hallucinations or echoes of sources. Such a programming language was once called literature (we have chosen to call it art history), though disco, of course, is not a literature at all; it merely simulates the effects of literature (as empty

brand) with the uncanny precision of our era's version of a lullaby: the remix. Disco is a programming language. It simulates the desire to remember when human remembering has become, from a technological standpoint, unnecessary or impossible. Disco thus proposes a solution to the vast volumes of distributed media (now databased on the internet) that began in the nineteenth century and have snowballed of late—in the form of photographs, tape recordings, films, records, CDs, and hard drives. How in this morass of information, most of it noncontinuous (i.e., digitized and subject to random access memory) can anything be located? Disco proposes a radical minimalization in the accessing of voices, regarded as discrete and modular data. For as we have seen, disco involved the systematic subtraction of extraneous information "tracks" and elevation of a percussion track into a remix having minimal harmonic or melodic progression, and grounded in repetition. This subtraction would be exploited in the late seventies and early eighties with Eurodisco, Italodisco, minimal ambient house musics; contemporary artist writing / distribution projects; and a host of disco-oriented stylistics and sampling / appropriation-based poetries.[26]

Unlike the other arts that were bracketed by arts of long-term memory (*ars longa, vita brevis*), disco was keyed not to memory but to what human memory became with the advent of computerized data storage and accessing: a mood, understood as the by-product of an obsolescent human memory system. For this reason it is customary to say that one can "have" a memory but not a mood; it is more accurate to say that a mood overtakes one. Moods, which are not inherently subjective and do not differ significantly from person to person, are a waste product antithetical to precomputer memory and thus nostalgia. So moods are rightly understood as a mode of accessing data inaccessible to human memory. Before the DJ, moods were harder to come by, let alone produce systematically. This was mainly because moods were amorphous and believed to be subject to a certain "distillation." But with the advent of large-scale computing, things began to change. The verb "to access" was coined in 1962 with respect to "large-capacity memory," which was viewed as a kind of "happening." It took less than seven years for a soft synaesthesia of music, lights, dance, and performance to congeal into a cultural format that reflected systemic changes in how collective memory gets processed. As Ebbinghaus says, "How does the disappearance of the ability to reproduce, forgetfulness, depend upon the length of time during which no repetitions have taken place?" (Kittler 1990, 207). Disco solved a crisis in the same way that the core memory inventor An Wang did, whose work in the early fifties on the write-after-read cycle paved the way for developments in magnetic core memory. Wang's invention "solved the puzzle of how to use a storage medium in which the act of reading was also an act of erasure."[27] Disco functions as magnetic core memory does, where every act of reading or

accessing material destroys the original source (i.e., clears the address to zero), which necessitates the continual repetition or rewriting (the write-after-read cycle) of data.**28**

Anyone who's ever danced to Booka Shade or listened to Rub-N-Tug on an iPod knows disco isn't dead; it's how we access our present; a "groove" is disco's "description" of data copying itself, ad nauseum. Of course accessing occurs when remembrance is weak, and listening—that is, the brain—is a passive output device. "Introspection is not an accurate methodological approach for Ebbinghaus. Memorizing nonsense material is not much different from memorizing meaningful material."**29** "Death to disco shit." Nothing, properly speaking, can be understood hermeneutically by disco, because disco is not about understanding but about antithetical memory practices (Kittler 1990, 208–12). And so disco sets up its search parameters in the seventies, at a time of massive social upheaval and economic woe, in particular the economic downturn and exodus from urban areas like New York. "Both Nietzsche and Ebbinghaus presupposed forgetfulness, rather than memory and its capacity, in order to place the medium of the soul against a background of emptiness and erosion" (Kittler 1990, 207). The expanse of any given disco track is the empty storage medium of history. To paraphrase Bataille: Disco is parodic and lacks an interpretation. Or: Disco continually jerks off. Anyone who has danced to disco has noted its curious, even paradoxical, powers as a mnemonic storage device: an endless rehearsal of things *in order to* forget them. And in that way, memory could be said to become pleasurable again. For it is well known that rehearsal or repetition is key to remembering and desiring, even if what is remembered is meaningless or the remembering is done outside the head by a machine. As anyone who has gone disco dancing can tell you, disco understands itself—it makes a series of improbable rondos with Tyrolean ski resorts, strobes, the Moroder skit, and eventually, "Son of My Father."

Gloria Gaynor's tearless medley as engineered by Tom Moulton, "Never Can Say Goodbye," is indicative of the reverse technology known as nostalgia. Disco's prolonged tracks ensure never saying good-bye. Seventeen minutes of side one run continuously, as on a dance floor. In this way, disco is a ready-made formatting joke (Top 40 radio, the forty-five) whose subject is the physical contours of memory itself, where the three-minute hit is doomed to a more instant oblivion. However, if disco is eminently forgettable or mindless, as critics claimed, its production ensured that everything about it would be accessed again, never lost from recuperation, its time forever and always, as disco's resurfacing in eighties and nineties house musics attests. Nostalgia qua nostalgia gets theorized at the historical moment when it is perceived as going out of fashion. How else to explain Linda Hutcheon's remarks that nostalgia, directed at the "irrecoverable nature of the past," seems *démodé*, even quaint, in the era of the database: "[T]hanks

to CD ROM technology and, before that, audio and video reproduction, nostalgia no longer has to rely on individual memory or desire: it can be fed forever by quick access to an infinitely recyclable past."**30** Disco could hardly be said to be nostalgic; opposed to a prevailing musical, economic, and sexual climate, yes—nostalgic, no. Moreover, the social liberation proffered by disco requires clarification. Disco, in both avant-garde club and mainstream modes, was not interested in personal liberation; disco's aim was to reveal that memory is programmed by the source in advance and that the freedom is not "about" anything except the rules that gave rise to it. In this sense, disco was not oceanic or deep like the mind-bending formats of sixties psychedelia or acid rock; it remained solely a function of a programmable surface, a set of effects. Mood is the DJ's technologically assisted operating system. Or to put it more simply, disco is an operating system that sits on top of a database (previously recorded musics), which is in turn accessed by a DJ, who serves as a GUI for those on the floor.

For how long have the tradition, historical sense, nostalgia, or the historical avant-garde been programmable functions? In various musics, from techno to electronica, as well as in music videos, the remnants of a historical avant-garde filter up a little at a time in our daily existence circa 2008. "Our avant-garde," as they say, is an evacuated genre, dumb-ass painter, interface, software, or as Eliot noted looking back regressively to poetry, "a feeling." Of course we're not the first to feel that our tradition just got more ambient and dispersed, or dumb, and that we are prone to the most evanescent of moods. T. S. Eliot also lived in an age where the strong sense of a distinct medium (the novel, the poem) was under attack and the only thing to make it cohere, weak as it was, was a "feeling" in an era when all feelings were mechanically reproduced. "The Waste Land's" model was the canned, remixed sound of the gramophone. Eliot's poem functions as a nostalgic twentieth-century critique of the mixing board and machine technologies used to access the human voice, thus degrading the "feelings" underlying it. Like all beautiful moods, disco came from a database. DJ/Tiresias is a footnote, an incipient GUI to a literary tradition that can only be accessed indiscriminately or randomly.

The avant-garde was always a programmed and programmable mood. At any rate, by 2008 it is clear that however it happened, the dissolution of the medium has become our primary cultural practice, one that hinges on the idea of medium unspecificity and dissolution of an "art object." And so the conventional fields of painting and sculpture and poetry are engaged today in a desperate attempt to program the contours of their once medium-specific fields. In other words, ambience is today's cultural operating system, filtered through the avant-garde, just as the discrete medium was yesterday's mode of expression, filtered through a bourgeois sensibility. It is no longer useful to speak of a singular art object but of

a work in multiple formats, or an ambient work. Thus the contemporary artists Takashi Murakami and Jeff Koons function principally as fabrication operations that program quasi-custom-looking (super flat) artworks within a market system that favors both mass customizability and the dollar cost efficiency of post-mass production—that is, lean production processes. To put it in more end-user-friendly terms, the age of looking at an artwork or reading books or listening to music has the awkward sound of something almost over. Anyone who's listened to music today understands that it's not the music so much as the appliance gateway or iPod that makes the music come alive. Benjamin Disraeli remarked that when he wanted to read a good book, he wrote one. Today, when one wants to "see" or "read" an artwork, one accesses or downloads it. Disco is accessed no differently than a Picasso or a Duchamp or a Warhol, all of which are functioning under new computational systems for the accessing and storage of data in magnetic core memory.

In our era, unlike in Shakespeare's, all plagiarism is part of an operating system. Or to put it in terms immediately comprehensible to this essay: most writing is automated and invisible, an empty form of surface decoration where "writing" is the instantiation of a software code being transferred from one location to another in an act of self-plagiarization. And this is what disco is: technologies of sound mixing and reproduction in an era when the idea of medium-specificity and discrete mediums such as painting, photography, music, literature, and video are being supplanted by the idea of a more general operating system or generic culture of software whose purpose is to continually redistribute a range of materials across a single platform. In this sense, disco as a cultural practice is not dissimilar from varied products in the cultural field: print on demand, lean production, mass customization, and so forth. What you are now reading, originally produced in Microsoft Word, is invisible because it is built into the software and automates the writing of the text in the same way that disco automates the human.

Disco provides impetus for new modes of being and nonbeing involved in the writing and in particular the nonwriting of poetry and art, where lyricism, subjectivity, and personal expressiveness might be reduced to blips in an ambient soundtrack, where historical markers (of cultural products) could be erased, and where nonreading, relaxation, and boredom could be the essential components of a text. Poetry—and here one means all forms of cultural production—should aspire not to the condition of the book but to the condition of variable moods, like relaxation and yoga and disco. The poems (of our era) (are designed to disappear, (and disappear) continually into the stylistic devices that have been sampled and diluted from the merely temporal language) (i.e., duration, historical or otherwise) of the day. As such they might resemble a pattern uninteresting and enervating in its depths but relaxing on its surface.

Author's Note:
I would like to thank Jonathan Flatley, Neil Printz, Callie Angell, Gordon Tapper, and Clare Churchouse for suggestions on earlier portions of this manuscript and Tony Stockhill for providing information on magnetic core memory. I would also like to thank the Andy Warhol Foundation, as a project of the Creative Capital / Warhol Foundation Arts Writers Grant Program.

1 On the relation between the avant-garde and information technologies germane to this article's treatment of disco and popular music, see, in particular, Friedrich Kittler, "England 1975—Pink Floyd, Brain Damage," in K. Lindemann, ed., *Europalyrik 1775-heute: Gedichte und Interpretationen* (Padenborn: Schöningh, 1982), 467–77. Kittler's article is discussed in Geoffrey Winthrop-Young, "Implosion and Intoxication: Kittler, a German Classic, and Pink Floyd," *Theory, Culture, & Society* 23, nos. 7–8 (2006): 75–91. On software and remix as they relate to avant-garde practice, see Lev Manovich, *The Language of New Media* (Cambridge: MIT Press, 2001); "Remixability and Modularity," and "The Avant-Garde as Software" at manovich.net. On a "post-medium" era and avant-garde and neo-avant-garde practice, see Fredric Jameson, *The Cultural Turn: Selected Writings on the Post-Modern, 1983–1998* (London: Verso, 1998); Rosalind Krauss, "Reinventing the Medium," *Critical Inquiry* 25, no. 2 (1999): 296; *A Voyage on the North Sea: Art in the Age of the Post-Medium Condition* (London: Thames and Hudson, 1999); and Benjamin Buchloh, *Neo-Avant-Garde and Culture Industry* (New York: October Books, 2003). Disco's connections to experimental work of the '60s in a number of cross-medium platforms—in particular, by Allan Kaprow, Jonas Mekas, Tony Conrad, La Monte Young, Yoko Ono, George Brecht, Robert Morris, and Dick Higgins—has yet to be written. The two principle histories of disco are Peter Shapiro's *Turn the Beat Around: The Secret History of Disco* (New York: Faber & Faber, 2005) and Tim Lawrence's *Love Saves the Day: A History of American Dance Music Culture, 1970–1979* (Durham, NC: Duke University Press, 2003). For disco's context in a larger avant-garde aesthetic, see Shapiro, 3–57. On "New York's interdisciplinary neo-avant-garde" in relation to poetry and language use, see Liz Kotz, *Words to Be Looked At: Language in 1960s Art* (Cambridge, MA: MIT Press, 2007).

2 Marcel Duchamp, *Salt Seller (Marchand du Sel)*, ed. Michel Sanouillet and Elmer Peterson (New York: Oxford University Press, 1973), 25. Hereafter cited in text as Duchamp.

3 Cited in Craig Adcock, "Marcel Duchamp's Gap Music: Operations in the Space between Art and Noise," in *Wireless Imagination*, ed. Douglas Kahn and Gregory Whitehead (Boston: MIT Press, 1992), 107. Hereafter cited in text as Adcock. On Duchamp and music, see Gavin Bryar, "Notes on Marcel Duchamp's Music," *Studio International* 192 (November–December 1976): 174–79; Lowell Cross, "Reunion: John Cage, Marcel Duchamp, Electronic Music, and Chess," *Leonardo Music Journal* 9 (1999): 35–42; and Carol P. James, "Duchamp's Silent Noise/Music for the Deaf," *Dada/Surrealism* 16 (1987): 106–26.

4 Fredric Jameson, in *The Cultural Turn: Selected Writings on the Post-Modern, 1983–1998* (London: Verso, 1998), 73, notes that the present is "marked by a dedifferentiation of fields, such that economics has come to overlap with culture: that everything, including commodity production and high and speculative finance, has become economic; and culture has equally become profoundly economic or commodity oriented."

5 Shapiro, *Turn the Beat Around*, 113.

6 Tom Moulton, who invented the remix, noted: "I'm listening and listening and listening. I said, 'What if I take out the strings, take out this, take out this. God, I gotta take out everything.' Finally, I said, 'Wait a minute, all that's left is the percussion. Maybe I can raise the congas a little bit, then just kind of groove, and then all of a sudden come in with the bass line'" (Shapiro, *Turn the Beat Around*, 43–44).

7 Lawrence, *Love Saves the Day*, 264. Hereafter cited in text as *Lawrence*.

8 Marcel Duchamp, *Notes*. Preface by Anne d'Harnoncourt. Arrangement and translation, Paul Matisse (Boston: G. K. Hall, 1983), unpaginated. Hereafter cited in text and notes as *MDN*, followed by Duchamp's note number.

9 D'Harnoncourt adds: "It was not in order to reveal solutions to his experiments, but rather to provide an increasingly rich range of data" (MDN vii).

10 Duchamp defines the infra thin as "1. The possible implying / the becoming—the passage from/one to the other takes place/in the infra thin" (MDN 1).

11 Duchamp describes the bride as "a reservoir of love gasoline" (MDN 43).

12 Tony Conrad, "LYssophobia: On Four Violins," in *Audio Culture: Readings in Modern Music*, ed. Christoph Cox and Daniel Warner (New York: Continuum, 2004), 316. Hereafter cited in text as *Conrad*.

13 "Disco," *Wikipedia*, en.wikipedia.org/wiki/Disco.

14 On disco and punk's shared antipathy to rock 'n' roll, see Shapiro, *Turn the Beat Around*, 251–54. James Chance, aka James White, the no-wave and punk musician, noted: "I've always been interested in disco ... I mean, disco is disgusting, but there's something in it that's always interested me—monotony." It's sort of jungle music but whitened and perverted" (253).

15 Bill Brewster and Frank Broughton, *Last Night a D.J. Saved My Life: The History of the Disc Jockey* (New York: Grove Press, 1999), 159.

16 By the mid-seventies, David Mancuso developed a private party network at the Loft, where he employed an elaborate digital relay system with each speaker firing in a sequence separated by microseconds. The result was a moving sound field or wall that felt alive and spiritual. Such an experience was enhanced by the twelve-inch, whose grooves, because they were spaced farther apart than those on a forty-five, carried more sonic information, thereby creating an all-over sound field more suitable for entering the body and organizing its pleasures.

17 Theodor Adorno, "Notes on Popular Music," in *Essays on Music*, ed. Richard Leppert, trans. Susan H. Gillespie (Berkeley: University of California Press, 2002), 461.

18 "Disco," *Wikipedia*.

19 Friedrich Kittler, *Discourse Networks, 1800/1900* (Stanford, CA: Stanford University Press, 1990), 27–53. Hereafter cited in text as *Kittler 1990*.

20 Claude Shannon and W. Weaver, *The Mathematical Theory of Communication* (Urbana: University of Illinois Press, 1949). "It is generally true that when there is noise, the received signal exhibits greater information—or better, the received signal is selected out of a more varied set than is the transmitted signal" (19).

21 On disco's connection to Moog and Arp synthesizers, the development of Hi-NRG and Eurodisco, and the more general "implications the machine would have on the human body" in the development of "mechanoeroticism," see Shapiro, *Turn the Beat Around*, 108–14.

22 "Erotica," *Wikipedia*, en.wikipedia.org/wiki/Erotica.

23 T. S. Eliot, *Selected Prose of T. S. Eliot*, ed. Frank Kermode (New York: Harcourt, Brace, 1975), 41. Hereafter cited in text as *Eliot*.

24 Sybille Kramer, "The Cultural Techniques of Time Axis Manipulation: On Friedrich Kittler's Conception of Media," *Theory, Culture & Society* 23, nos. 7–8 (2006): 101. Hereafter cited in text as *Kramer*.

25 Such practices were prevalent in a number of avant-garde music-making practices. In a passage that anticipates the DJ's controlling role in programming music for a live dance floor, Tony Conrad notes his reaction to hearing La Monte Young: I heard an abrupt disjunction from the post-Cagean crisis in music composition; here the composer was taking the choice of sounds directly in hand, as a real-time physicalized (and directly specified) process—in short, I saw redefinitions of composition, of the composer, and of the artist's relation to the work and the audience. As a response to the un-choices of the composer Cage, here were composerly choices that were specified to a completeness that included and concluded the performance itself (Conrad 315).

26 For a discussion of various remix technologies at work in contemporary poetry, see my "Beyond noulipo (CMMP as Precursor of New Media Poetry)"; "Materiality, New Media Writing, and CMMP"; and "New Media Writing: Code vs. Database," in *The Noulipean Analects*, ed. Matias Viegener and Christine Wertheim (Los Angeles: Les Figues Press, 2007).

27 "Magnetic Core Memory," *Wikipedia*, en.wikipedia.org/wiki/Magnetic_core_memory.

28 Tony Stockhill, in an email correspondence of June 2, 2008, notes: A memory core is made of magnetic particles in a ceramic compound similar to the ferrite rod antenna. Consider a complementary system of passing a (direct) current in a wire through the centre of a core. This induces a magnetic field in the core. This is analogous to the motor/generator use of electromagnetism. The magnetic field in this core makes it a "1." We have to be able to "read" this "1" for it to be any use. This magnetic material is a high hysteresis compound, which is a way of saying it is easily magnetized in one direction, and has high resistance to being magnetized in the other direction up to a certain current. We pass this current in the opposite direction through the wire. The core will switch direction at a predictable, repeatable point. This is equivalent to a bar magnet switching from N/S to S/N. If we thread a second wire through the core, then, at the time the magnetic field switches, we will induce a current in this wire. This current can be amplified and interpreted as a "1." Two points can be noted. First, if the core had not initially had its magnetic field switched in the "1" direction, meaning it held a "0," the magnetic field would not switch when the reverse current was applied. No current would be generated in the second (sense) wire and thus the "0" value would be recorded. Second, the act of "reading" the core has set it (and all other cores read at the same time) to a "0" value; in other words we have "cleared" this address. So, in order to retain the data in memory, we must write back the same data we just read out, by using the data we just read, recycling it and writing it into the core: "write after read."

29 Joseph M. Reagle Jr., "Friedrich Kittler: Discourse Networks 1800/1900," reagle.org/joseph/2003/seminar/1208-kittler-gabriele.html. Accessed May 31, 2008.

30 Linda Hutcheon, "Irony, Nostalgia, and the Postmodern," January 19, 1998, library.utoronto.ca/utel/criticism/hutchinp.html. Accessed May 17, 2008.

Notes on Conceptualisms

Vanessa Place, Robert Fitterman 2009

Robert Fitterman and Vanessa Place, *Notes on Conceptualisms* (New York: Ugly Duckling Presse, 2009).

1. Conceptual writing is allegorical writing.

1a. The standard features of allegory include extended metaphor, personification, parallel meanings, and narrative. Simple allegories use simple parallelisms, complex ones more profound. Other meanings exist in the allegorical "pre-text," the cultural conditions within which the allegory is created. Allegorical writing is a writing of its time, saying slant what cannot be said directly, usually because of overtly repressive political regimes or the sacred nature of the message. In this sense, the allegory is dependent on its reader for completion (though it usually has a transparent or literal surface). Allegory typically depends heavily on figural or image-language; Angus Fletcher's book *Allegory: The Theory of a Symbolic Mode* argues that this heightened sense of the visual results in stasis.

Walter Benjamin, Paul de Man, and Stephen Barney identified allegory's "reification" of words and concepts, words having been given additional ontological heft as things.

In allegory, the author-artist uses the full array of possibilities—found and created—to collage a world that parallels the new production (collectively) of objects as commodity.

Words are objects.

Note that allegory differs from symbolism in that symbolism derives from an Idea, while allegory builds to an Idea. Images coagulate around the Idea / Symbol; images are jettisoned from the allegorical notion. The work of the work is to create a narrative mediation between image or "figure" and meaning. Goethe felt this meant allegorical writing was fundamentally utilitarian (and therefore more prose, symbolism then more "poetry in its true nature").

compare:

⤡ ↑ ↗ ↘ ↓ ⤢
← A → → S ←
⤣ ↓ ↘ ↗ ↑ ⤤

Note the potential for excess in allegory. Note the premise of failure, of unutterability, of exhaustion before one's begun.

Allegorical writing is necessarily inconsistent, containing elaborations, recursions, sub-metaphors, fictive conceits, projections, and guisings that combine and recombine both to create the allegorical whole, and to discursively threaten this wholeness. In this sense, allegory implicates set theory: if it is consistent, it is incomplete; if complete, inconstant. All conceptual writing is allegorical writing.

2. Note that pre-textual associations assume post-textual understandings. Note that narrative may mean a story told by the allegorical writing itself, or a story told pre- or post-textually, about the writing itself or writing itself.

2a. Conceptual writing mediates between the written object (which may or may not be a text) and the meaning of the object by framing the writing as a figural object to be narrated.

Narrativity, like pleasure, is subjective in the predicate and objective in the execution (i.e., "subject matter").

In this way, conceptual writing creates an object that creates its own disobjectification.

2b. In allegorical writing (including both conceptual writing and appropriation), prosody shifts from or shuttles between a micro attention to language to macro strategies of language, e.g., the use of source materials in reframing or mixing. The primary focus moves from production to post-production. This may involve a shift from the material of production to the mode of production, or the production of a mode.

If the baroque is one end of the conceptual spectrum, and pure appropriation the other, with the impure or hybrid form in between, this emphasis can be gridded:

Production	Mode	Material	Post
Pure appropriation	+		+
Hybrid / impure	+	+	+
Baroque		+	+

2c. Note the allegorical nature of conceptual writing is further complicated (or complected) given that in much allegorical writing, the written word tends toward visual images, creating written images or objects, while in some highly mimetic (i.e., highly replicative) conceptual writings, the written word is the visual image.

Note there is no aesthetic or ethical distinction between word and image.

2d. Sophocles wanted a true language in which things were ontologically nominal. This is true in fiction and history.

Fiction meaning poetry.
Poetry meaning history.
History meaning the future state of having been.

This is the job of Gertrude Stein's *The Making of Americans*.

2e. In his essay *Subversive Signs*, Hal Foster remarks that the appropriation artist (visual) is "a manipulator of signs more than a producer of art objects, and the viewer an active reader of messages rather than a passive contemplator of the aesthetic or consumer of the spectacular."

Note that "more than" and "rather than" betray a belief in the segregation or possible segregation of these concepts; conceptualism understands they are hinged.

Note that in post-conceptual work, there is no distinction between manipulation and production, object and sign, contemplation and consumption. Interactivity has been proved as potentially banal as a Disney cruise, active as a Pavlovian dinner bell.

2f. The allegorical aspect of conceptualism serves to solder and wedge the gap between object and concept, keeping it open and closed.

2g. In this sense, conceptualism implicates set theory: the degree of constancy / completeness of the "subject" and "matter" is modulated by the limited / unlimited nature of the linguistic object-image.

This mandates the drawing of the set. This implicates the one-that-is-nothing and the being-that-is-multiple posited by Alain Badiou.

Metaphysic concepts = possible modes of aesthetic apprehension rather than actual ethical observations. In other words, just as Leibniz is useful for judging the quality of any fictitious universe, the precepts noted here are handy for contemplating other verses: poly-, multi-, and re-.

Note Lacan's *The Four Fundamental Concepts of Psychoanalysis*: the self is an Imaginary construct, made of parts of one like an other so to be recognized as one by an other, thus made contingent. Mimicry/mimesis being the means by which the subject makes the imaged self. Contingency/multiplicity is therefore the one true nature of universality.

Consider the retyping of a random issue of the *New York Times* as an act of radical mimesis, an act of monastic fidelity to the word as flesh. Consider the retyping of the September 11, 2001 edition (a day that would not be) as an act of radical mimicry, an act of monastic fidelity to Word as Flesh. If these gestures are both critiques of the leveling and loading medium of media, their combined critique is inseparable from the replication of the error under critique. Replication is a sign of desire.

Radical mimesis is original sin.

Allegorical writing (particularly in the form of appropriated conceptual writing) does not aim to critique the culture industry from afar, but to mirror it directly. To do so it uses the materials of the culture industry directly. This is akin to how readymade artworks critique high culture and obliterate the museum-made boundary between Art and Life. The critique is in the reframing. The critique of the critique is in the echoing.

Note the desire to begin again.

3a. Wystan Curnow's paper presented at the *Conceptual Writing Conference* held at the University of Arizona Poetry Center (2008), while not identifying conceptual writing as allegorical as such, suggests that conceptual writing could be classified as pre- or post-textual (or a hybrid). Pretextual writing assumes a "pretext," an extant idea—the constraint / procedure, the "strategic generality" of the technique, such as appropriation or documentation. The "post-text" is the document necessarily created by the pre-text, though post-text may also refer to a primary text used in a hybrid as a secondary text. Regardless of its textual composition, Curnow notes conceptual writing invites its own performativity, a performativity that often crosses genres and media, and is an attempt to disembed the meaning "in the contingent and the contextual."

3b. The distinction here is between post-texts that are illustrations of their pre-texts (texts that are open; the idea is paramount/paradigm), and post-texts that are proofs (texts that are closed; the idea is exhausted in its execution).

There are end-points to any set and infinite points between them. How one defines the end-points and the points in between instructs how one defines conceptual writing.

In hybrid or "impure" conceptualism or post-conceptualist writing, the points in between can accommodate a rebellion against, or critique of, the more stringent end-points. This has been articulated in post-conceptualist visual art.

What is an "impure" conceptualism or post-conceptualism in writing? A post-conceptualism might invite more interventionist editing of appropriated source material and more direct treatment of the self in relation to the "object," as in post-conceptual visual art where the self re-emerges albeit alienated or distorted (see Paul McCarthy).

Adding on and/or editing the source material is more a strategy of post-conceptualism; so is reneging on the faithful execution of the initial concept. The most impure conceptualism may manifest in a symptomatic textual excess / extravagance, such as in the baroque. Do these broken promises point to a failure in a conceptual writing text? Failure is the goal of conceptual writing.

In *Sentences on Conceptual Art*, Sol LeWitt writes: "If the artist changes his mind midway through the execution of the piece he compromises the result and repeats past results."

I have failed miserably—over and over again.

4. If allegory assumes context, conceptual writing assumes all context. (This may be in the form of an open invitation, such as Dworkin's *Parse*, or a closed index, such as Goldsmith's *Day*, or a baroque articulation, such as Place's *Dies*.) Thus, unlike traditional allegorical writing, conceptual writing must be capable of including unintended pre- or post-textual associations. This abrogates allegory's (false) simulation of mastery, while remaining faithful to allegory's (profound) interruption of correspondences. Allegory breaks mimesis via its constellatory features—what scattershot this is. Conceptualism's mimesis absorbs what Benjamin called "the adorable detail."

4a. The degree of adorable detail in conceptual writing may calibrate to the writing's overt allegorical status.

5a. Benjamin Buchloh points out in *Allegorical Procedures: Appropriation and Montage in Contemporary Art* that 1920s montage work is inherently allegorical in its "methods of confiscation, superimposition, and fragmentation."

More: "The allegorical mind sides with the object and protests against its devaluation to the status of a commodity by devaluing it for the second time in allegorical practice."

Buchloh here, via Benjamin, is recasting allegorical strategies through a Marxist lens: in a culture where objects are already devalued by their commodification, an allegorical relationship to the art object (or text) further highlights the process of devaluation.

One might argue that devaluation is now a traditional/ canonical aim of contemporary art. Thus there is now great value in devaluation.

Adorno and Horkheimer: "Culture is a paradoxical commodity. So completely is it subject to the law of exchange that it is no longer exchanged; it is so blindly consumed in use that it can no longer be used" (*The Culture Industry: Enlightenment as Mass Deception*).

Conceptual writing proposes two end-point responses to this paradox by way of radical mimesis: pure conceptualism and the baroque. Pure conceptualism negates the need for reading in the traditional textual sense—one does not need to "read" the work as much as think about the idea of the work. In this sense, pure conceptualism's readymade properties capitulate to and mirror the easy consumption/generation of text and the devaluation of reading in the larger culture. Impure conceptualism, manifest in the extreme by the baroque, exaggerates reading in the traditional textual sense. In this sense, its excessive textual properties refuse, and are defeated by, the easy consumption/generation of text and the rejection of reading in the larger culture.

Note: these are strategies of failure.

Note: failure in this sense acts as an assassination of mastery.

Note: failure in this sense serves to irrupt the work, violating it from within.

Note: this invites the reader to redress failure, hallucinate repair.

5b. "Allegorical imagery is appropriated imagery; the allegorist does not invent images but confiscates them." (Craig Owens: *The Allegorical Impulse: Toward a Theory of Postmodernism (Beyond Recognition: Representation, Power and Culture)*).

One might argue that confiscation suggests capturing, or re-penning. Re-iteration or re-cognition seems more apt, as the work is re-invented via its adoption.

5c. In *The Origin of German Tragic Drama*, Benjamin identified the skull as the supreme allegorical image because it "gives rise to not only the enigmatic question of the nature of human existence as such, but also of the biographical historicity of the individual. This is the heart of the allegorical way of seeing…."

The skull is the heart.

The same may be said for the image of an iPod.

5d. Craig Owens's article on female appropriation art of the 1980s, *The Discourse of Others: Feminists and Postmodernism*, points out that Buchloh's article on allegory missed the crucial gender-fact that these artists are all women, and that "where women are concerned, similar techniques have very different meanings."

Stephen Heath: "Any discourse which fails to take account of the problem of sexual difference in its own enunciation"

6. Note the allegorical difference between appropriation techniques that elevate the banal—such as Richard Prince's appropriation of Marlboro ads, blowing them up and turning them into art photos—and works that level the elevated, such as Sherrie Levine's re-photographing of Walker Evans's photos.

Note: similarities between Kenny Goldsmith's appropriation triptych—*Traffic*, *The Weather*, and *Sports*—and Jen Bervin's *Nets*, a book of erased Shakespeare's Sonnets. Goldsmith adds the artist / author to the readymade quotidian, upping its art-quotient; Bervin subtracts the master from his masterpiece, author from authority.

Note: Goldsmith's replications are Duchampian in that the "'narrative of process establishes a primary meaning, an ultimate originating referent that cuts off the interpretive chain'" (Yve-Alain Bois on Robert Ryman, as quoted by Buchloh).

Note: Bervin's gesture is more like Rauschenberg's erasure of de Kooning's painting in leaving the presence of the absence, than it is like Duchamp's proposed Rembrandt-as-ironing board.

Note: to what degree the authorial framing of text as art removes aesthetic control from the reader.

Note: to what degree has art removed aesthetics from ethical consideration?

6b1. Note the regime under which conceptual writing has flowered is the repressive market economy; this is a banal observation, nonetheless true. Note that there is no escape from this regime, which will banalize and commodify any mass attempt at subversion. (The story of counter-culture since the 1960s.)

In other words, capitalism has a knack for devouring and absorbing everything in its path—including any critique of Capitalism.

Furthermore, Capitalism is naturally a meaningless system. In *On Violence*, Slavoj Žižek writes: "The fundamental lesson of globalization is precisely that capitalism can accommodate itself to all civilizations." Thus capitalism is a medium. Thus the medium is the message.

6b2. In conceptual writing, writes Goldsmith, echoing LeWitt, "what matters is the machine that drives the poem's construction." Increasingly, for conceptual writers, that machine is now a literal machine. Moreover, as in search-engine based poetry, the process of construction may be another machine. In this sense, both construction and constraint are informed by market needs and consumer inquiries (a procedural loop).

6b3. In Sianne Ngai's forthcoming collection of essays, *The Cute, The Zany, And The Merely Interesting: Three Problems for Aesthetic Theory*, one of her definitions of the zany today is the multi-tasking worker. While Lucille Ball in the *I Love Lucy* episode, "Job Switching," (like Charlie Chaplin in *Modern Times*) performs the "zany" of the assem-

bly-line human, doomed to frenzied repetition, the overwhelmed actor in a polysemous universe is more like the Marx Brothers' version of war in *Duck Soup* (where Groucho appears in a variety of American uniforms, including those of both sides of the Civil War, and the Boy Scouts) or war itself. There is no secure signification, not even the dehumanization of man by and into machine, just the vertiginous effect of too much of too much. A worker who works at home—traditionally a devalued situation, though now often assumed and sometimes commodified as a telecommuting "perk"—finds the traditional demarcation between work and leisure obscured.

Note that this dissolves the standard difference between worker and bourgeois, serving as a perverse fulfillment of the socialist promise that labor, not leisure, will be the source of self-realization. One might argue that, as it turns out, when work is play and play is work, our alienation is complete. Allegorical writing underlines this development and its tensions by drawing attention to the conflation of work (research) and play (composing), particularly as they tend to suggest the same received or hollowed modes of (non)production and (non)meaning.

Production (industrial age) replaced by simulation (information age).

Simulation replaced by medium.

Žižek has written about the contemporary phenomenon of consumer goods being stripped of their malignant properties (decaffeinated coffee, nonfat cream, internet sex) as a form of constrained hedonism. (*The Puppet and the Dwarf: The Perverse Core of Christianity*). To have one's cake and vomit it up.

Conceptual writing reinserts the malignancy while re-enacting the purge.

6b4. Note: the allegorical imperative in temporal specificity. To make now mandates the adorable detail as both grounding and background.

6b5. Note that by virtue or device, conceptual writing needs a narrative frame (like a snail, it must carry its house on its back) elevates the role of the artist-author as first interpreter. Writing scripture is an excellent way to make a church. Writing scripture is an excellent way to make the self a disciple while appearing to be doing something outside the self. Insisting that the gospel, and supporting texts, have nothing to do with the self is an excellent way for potential believers to think about the self of the disciple. This gospel-making is very much within the critique and celebration of celebrity. This is very American, particularly since Warhol. This is a story of real faith.

6b6a. Note that in allegorical practice, the commodity-object is revalued as an object via allegorical practice itself. There is restoration at work, and the promise of fetish.

6b6b. Note that in this way, allegory lies in the allegorical content as well as the allegorical gesture.

6b6c. Nb: these two allegorical axes (gesture / content) do not necessarily work algorithmically, but can, and can also work at odds.

7a. Thierry de Duve: the crisis in representation is a crisis in representivity.

Historically:
narrative is the representation (image) of prose;
sentiment is the representation (image) of poetry.

Now:
inverse.

7a1. If conceptual writing is considered as representation, it must be considered as embodied. As embodied, it must be considered as gendered. As gendered, it must be considered. Race is also consideration. Consideration is what is given to complete the acceptance of any contractual offer. The social contract hinges on such embodied considerations.

7a2. Representivity could = signification. A crisis in signification today would mean meaning, not unlike what meaning meant for Mallarmè in 1890. Would mean there was an alphabet in the alpha sense: there are not empty signifiers any more than there are empty selves. Or the arch possibility hereof. A crisis in signification in this sense means a crisis in insignification—we may mean more than we had previously planned.

A crisis in signification = a crisis in representation.

There are two end-points in addressing such a crisis:

1. Render the object closed.
2. Render the object open.

Conceptual writing can be conceived as open or closed.

Conceptual writing is a matter of equivalencies.

Conceptual writing is open if it does not limit its possible readings.
Open conceptual writing is typically open horizontally: there are multiple readings, but not multiple meanings or levels of reading. In this sense, it may be somewhat closed.

Closed conceptual writing typically attempts to limit its possible readings through some overt articulation or inscription. Closed conceptual writing is open vertically: fewer possible readings, but multiple meanings or levels of reading. In this sense, it is somewhat open.

Open conceptual writing depends more heavily on a pre-existent or simultaneous narrative for its reading(s).

Closed conceptual writing leans less, though is often more overtly (internally) allusive.

This is allegorical. This is sentimental.

7b. Christine Buci-Gluckman (*Baroque Reason: The Aesthetics of Modernity*) writes about the senti-mental: the union of sense and concept.

Note that Kant maintains only the concept (e.g. Beauty) is permanent. Note that conceptualism maintains that only the concept (e.g. the idea) is (exists). Note that Conceptualisms maintains only the concept of "is" (e.g., materiality or other invocation) is permanent.

Note that in a post-Cartesian world, there is no splitting the baby: minds are bodies, bodies minds. The brain is a piece of body-meat, the body a bit of brain. This thought, once intolerable, is now comforting proof that "I" do not exist.

"I" am autobiography, text and context.

"I" am innocent/guilty.

Objectivity is old-fashioned, subjectivity idem.

The Sobject is the properly melancholic contemporary entity.

The Sobject exists in a perpetual procedural loop: the iconic sobject is Dante's *manturningsnaketurningman.*

The Sobject exists in a perpetual substantive eclipse: more s/object by turns and degrees.

For an example of textual sobjectivity, see Place, *Dies: A Sentence*; for an example of appropriated sobjectivity, see Fitterman, *My Sun Also Rises*; for an example of neo-constructivist sobjectivity, see Craig Dworkin, *Parse*; for an example of psycho-linguistic sobjectivity, see Christine Wertheim, +|'me'S-pace.

8a. Because allegory has a literal surface, it can dodge the hermetic bullet. And because allegory is tethered to its pre- and post-text, it cannot.

To the degree conceptual writing depends upon its extra-textual features for its narration, it exists—like the readymade—as a radical reframing of the world.

Because ordinary language does not use itself to reflect upon itself.

8b. Note that the notion of exhausted or degraded language is an essentialist notion; note that this does not mean it's not true, just that it may be no truer today than before. Note that there is little sacred writing in the West, though there is room for sport, which implies sanctity.

8c. Walter Benjamin wrote that baroque allegorical writing (save Dante) is fundamentally writing as souvenir, commodity as collector's item. Because allegorical writing is a frozen dialectic, its figural properties are necessarily deformed / destroyed—as figured by the "ruin."

According to Christine Buci-Glucksmann, because allegorical writing is figural writing, the best representation of Benjamin's ruin is the figure of The Woman, frozen between object and concept, absence and presence.

Note: The Woman is simply another way of saying embodiment.

Note: embodiment = failure.

8d. Transparency is self-refuting.

9a. Rewriting obliterates the past in favor of history as appropriation rewrites the present in favor of the future.

9b. Nevermore = nevertheless.

10a1. There are two fundamental mimetic responses: fidelity and infidelity. Fidelity is an advantage of maturity, infidelity of immaturity. Fidelity is a problem of maturity, infidelity of immaturity.

Is appropriation a problem of maturity or immaturity?

Is the baroque a problem of fidelity or infidelity?

What is the measure of a work's faithfulness or faithlessness? Faithfulness/faithlessness to what?

10a2. If there is an ethics specific to appropriation, it is enacted in the question of editing. Does the writer edit, for example, online language because it is offensive? Does the act of editing become another ethical problem? Does the failure to edit become collusion?

10a3. Simon Critchley argues that ethics is defined by community; morality is imposed by larger conventions. Is it better to be governed by a physic or a metaphysic? What

are the aesthetic ramifications/manifestations of each? If physic, pure conceptualisms are more ethical as more directly dictated/ratified by the relevant communities, both generative and receptive.

Note that the generative community (the source of the pre text) is often more inclusive/accessible, more democratic than the receptive community, the relatively elite/rarified art world.

If metaphysic, more impure or post-conceptualisms are more abstracted and idiosyncratic, and potentially more disruptive, ethical impulses. This too is subject to the critique of elitism.

Note the elite capitalist assumption in critiquing cultural elitism, especially literary elitism, which is sans profit.

11. Things to be considered in materiality:
prosody
book object/page object
language
external text(s)
internal text(ures)

11a. Prosody:
Collage, pastiche, procedure, constraint, performance, citation, documentation, and appropriation (part or whole) may be techniques used in conceptual writing.

What is the difference between conceptual collage and literary others?

Examples of others: Pound, Berrigan, Ashbery—use of collage as pre-text technique to create choral ensemble, i.e., wherein the authorial voice is emergent/dominant/extant; use of collage to demonstrate specific author or authored aesthetic / metaphysic (theme, e.g.).

C.f., Robert Burton's *The Anatomy of Melancholy* (1621) use of collage / citation to create post-text argument (n.b., Laurence Sterne was accused of plagiarizing Burton in *The Life and Opinions of Tristram Shandy, Gentleman* [1759]).

Shandy and *Anatomy* are examples of "learned wit," a classical form of satire involving witty manipulation of the materials of erudition (may be appropriated in style/form or text). Consider how learned wit mutates/mutilates via Pound/Marinetti and the incorporation of the quotidian + the rarified. Consider what is now considered rarified.

Same: use of collage to ironize/lionize material of collage.

Examples of nonliterary others: Rauschenberg, Picasso, hip-hop, punk 'zine.

Conceptual writing may differ from its others insofar as it does not create a single voice or thematic constant from its constituent bits. Conceptual writing also may not differ from its others in any significant respect. This lack of distinction confuses literary technique or device with literary history.

11b. Book object/page object: font, page size, hard/soft-cover/chapbook; spine

11c. Language. (What is the constituent grammar?)
 Conceptual writing is sometimes typing.
 Conceptual writing is sometimes grammar.
 Conceptual writing is annoying.

See Appendix for more.

11d. External text(s)—may include ur-text, see *Day*.

11e Internal text(ures) may include logic-locks, see Christian Bök's *Crystallography*.

11f. The medium is the meeting-point.

Note: there may be multiple meeting-points, which may or may not involve multiple media.

See Wertheim: a single text acts as signifier (characters), as narrative container, as visual object, as score for sound performance.

De-materialism emphasizes materiality like silence in a song.

N.b., the now-canonical Cagean cage, where silence is the song, and once absence is presence, presence is absent, and the present absence is simply another absent presence. Moreover, there's much that is missing, or rather much extant that is conjured or calculated or otherwise computed, not as fixed formal substance, but as an immaterial gesture toward materiality. A caloric substance, immanence with bleached teeth.

12. Institutional Critique, a visual art term that gained currency in the '70s and '80s, in which the organs of art—galleries, museums, etc.—were critiqued via appropriating or simulating an institutional aspect in a new context in order to expose the mystique or inner workings of the institution. For example, Fred Wilson's *Guarded View* (1991) where he dresses up manikins as museum guards in minute detail.

 See Andrea Fraser's many works, including posing as a hyperbolic museum tour guide under the alias Jane Castleon (*Museum Highlights* [1989]); describing the Philadelphia Museum of Art cafeteria: "This room represents the heyday of colonial art in Philadelphia on the eve of the Revolution, and must be regarded as one of the very finest of all American rooms"; *Official Welcome* (2001) a series of prefatory art-talk remarks; and *Untitled* (2002) videotaped hotel room sex with a private collector, who paid $20,000 to participate.

The prevalence of Institutional Critique artworks of the '80s and '90s cast a long shadow—to the extent that Alexander Alberro argues that Institutional Critique is not only intertwined with Post-conceptualism, but has been absorbed into much of the artwork that is made today.

12a. The capitalist absorption of critique was evidenced as museums and galleries quickly incorporated the very critique of those same institutions, hosting Fraser's performances for major museum donors, for example. Institutional Critique, as an arm of Conceptual Art, cannot destroy these institutions, but aims to unveil and underscore them through demystification. Note that ironization here can be used to re-gird the privileges of the institutional structure (rewarding the major donors), much like exposed struts in a downtown restaurant.

12b. The poetry community has a vastly different relationship to its institutions, both historically and economically. Yet there are poetry works that radically de-articulate our institutions of small press publishing, reading series, conferences, etc.

See Gary Sullivan's *How To Proceed In The Arts* (erasure pieces from literary magazine rejection and acceptance letters); Charles Bernstein's poem *Recantorium* (an ironic apology for being an innovative poet now reformed as an "official verse" poet); Dirk Rowntree's design choices in "war, the musical" (leaving several pages blank or black, reproducing the titles from several contemporary poetry book covers). Note the difficulty in critiquing from without (Sullivan) versus from within (Bernstein).

Moreover, because institutions of poetry and progressive writing already wield so little cultural and economic capital, conceptual writing has been increasingly shifting its attention to mass media and the larger bodies of language management, e.g., websites, ads, blogs, etc. Note the potential for collusion. Note the insistence on culpability. This is another embrace of failure.

12c. Things to be considered in institutionalism:
 the reading
 the reading series
 the course materials
 the blurb
 the introduction/afterword
 the gilt by association
 the transparency of the language
 the Conference
 the Project

the Manifesto
the School
the Scene
the Situation
"the short lyric of self-definition"
the Now

12d. Things to be considered out of institutions:

When is a critique not a critique? Note the tension between the concept of conceptualism (affirmatively anti-institution) and its potential practice (a new formalism = a new institutionalism).

Is the absence of normative standards possible? practical? desirable? what is the principle of the unprincipled? Are we left then with only principals?

I.e., is the danger of Author replaced by the danger of Authority?

Brecht: "What's the robbing of a bank compared with the founding of a bank?"

13. Thesis:
Aesthetic : ethical : aesthetic : ethical (see Wittgenstein/Rancière).

Consider the sentence: aesthetics + ethics are joined (can only be joined) in the subject which then attempts to transmit or transcribe this joiner into an object.

The process of this transcription is a narrative process.
A narrative is a connective … transcription, connectivity.

Proposition:
The readymade emphasizes the subject nature of aesthetics by reducing art to pure object. The readymade is thus the most aestheticized object, existing only as art. The readymade is also the most subjectified ethic, entirely reliant on its communicative capacities, hovering as object in the midst of this transaction.

Proof:
Heimrad Bäcker's *transcript* (ed. Freidrich Achleitner, trans. Patrick Greaney and Vincent King, forthcoming Dalkey Achieves 2010) appropriates documentation of the Nazi exterminations. Each entry is an unadorned quotation taken from some contemporaneous account of the Holocaust, often for accounting purposes (e.g., 66 min / 87 min / 106 min / 74 min / 65 min / 65 min / 53 min / 70 min / 5 min / 66 min / 87 min / 65 min), or as project memoranda (it is very difficult at the moment to keep the liquidation figure at the level maintained up to now), or messages in bottles (this is my last letter, and i'm letting

you know that i was shot on september 1 at six o'clock). The book, published as nachschrift in 1986, also uses citation, abbreviation, isolation, and alteration (including erasure), and has been considered primarily as a montage work of concrete poetry.

[Bäcker includes a citation to a laudatory review of a laudatory Hitler biography that he wrote as a 17-year-old local leader of the Hitler Youth. The work thus admits of its subjectivity as its partial object, and of its author's documented guilt and subsequent textual silence (having forfeited further speech). For another strategy of failure in Holocaust representation, see Celan, "Iefimnee,/I-i-e" (fracturing "neimehr," nevermore) (Tiefimschnee).]

Compare: Charles Reznikoff's *Holocaust*, which appropriated testimony from the Eichmann and Nuremberg trials, casting it in lyric form.

transcript is fidelity to infidelity (re: aesthetics : ethics).

Compare: Fitterman's *Sprawl*: fidelity to fidelity.

Place's *Dies* (baroque & broken): infidelity to infidelity.

Dan Farrell's *The Inkblot Records* infidelity to fidelity (subject stripped bare by way of stripped subject).

13a. *transcript* is a work of failure: the prosody used refers to a failed system (politics) of a failed humanity. A failure on all fronts; one that cannot exist save in its constant manifestation of constant absence—the citation without content, with partial content, with mutilated content. Language was the first strike of the Final Solution. Language was its eyewitness, and will be its shadow substitute, as supplementary texts/narratives (the play and work of words) begin to memorialize and supplant memory. This is the postcard-placard effect of history.

13b. Note: when the word is the wound (the site of failure), there are two extreme forms of mimetic redress: isolate and seal the word/wound (pure conceptualism), or open and widen the word/wound (impure conceptualism and the baroque). The first is the response of the silenced sobject, the second, the screaming sobject.

Note: this is the difference between negative and positive space.

13c. This kills Kosuth dead.

Rise Kosuth.

• glorious failure!

14. Glorious failure because among the crises cataloged by/in conceptual writing is a crisis in interiority.

A crisis in interiority is a crisis of perspective. In jettisoning the normative (or the normative of the normative), we are left with the contingent or relative normative, which is no real normative at all, and worse still, recapitulates the same problems (by default and paying attention to something else) as the old normative normative. In other words, we reject the province of the monoptic (fixed) male subject heretofore a marker of success. This is the difference between Narcissus and Medusa. This is the difference between the barren and the baroque. This is the problem.

Note that the solution is not provided by the machina ex deus.

This brings us back to meaning, and the possibility of possibility.

This is allegorical.

YOU BLEW UP MY HOUSE

Karl Holmqvist 2009

Karl Holmqvist, *You Blew Up My House* (London: Serpentine Galleries, 2009), 105–7.

ALIENATION IN THE WORKPLACE
ALIENATION IN THE WORKPLACE
MAKING MONEY
CONTROL
MAKING MONEY
CONTROL
END CAPITALISM
END CAPITALISM
NOW
MAKING MONEY
CONTROL
MAKING MONEY
CONTROL
ALIENATION IN THE WORKPLACE
SLAVES IN ANCIENT EGYPT, SLAVES
IN MEXICO, SLAVES IN ROME
ALIENATION IN THE WORKPLACE
SLAVES IN ANCIENT EGYPT, SLAVES
IN MEXICO, SLAVES IN ROME
ALIENATION IN THE WORKPLACE
MAKING MONEY
CONTROL
MAKING MONEY
CONTROL
ALIENATION IN THE WORKPLACE
ALIENATION IN THE WORKPLACE
SLAVES IN ANCIENT EGYPT, SLAVES
IN MEXICO, SLAVES IN ROME
CHILD WORKERS IN CHINA
ONE CHILD PER HOUSEHOLD
GIVE YOURSELF A RAISE
GIVING VOICE TO THE VOICELESS
ALIENATION IN THE WORKPLACE
ALIENATION IN THE WORKPLACE
WORKING FROM 5 TO 9

JOY OF WORKING
WORKING WORKING
ON MY MIND
MY MIND
LET YOUR KIDS MAKE MUSIC
KIDS WITH KIDS
IT'S A WAR
LET YOUR KIDS MAKE MUSIC
KIDS WITH KIDS
IT'S A WAR
ALIENATION IN THE WORKPLACE
ALIENATION IN THE WORKPLACE
WORKING FROM 5 TO 9
JOY OF WORKING
WORKING WORKING
ON MY MIND

MY MIND
START WITH THE MIND
IT'S PSYCHOLOGICAL
START WITH THE MIND
WASH YOUR THOUGHTS
REPLACE HATE WITH HATE
YOUR THOUGHTS
IT'S PSYCHOLOGICAL
START WITH THE MIND
ALIENATION IN THE WORKPLACE
ALIENATION IN THE WORKPLACE
START WITH THE MIND
THE MIND
LET YOUR KIDS MAKE MUSIC
START WITH THE MIND
THE MIND
START WITH THE MIND
ALIENATION IN THE WORKPLACE
ALIENATION IN THE WORKPLACE
SLAVES IN ANCIENT EGYPT, SLAVES
IN MEXICO, SLAVES IN ROME
CHILD WORKERS IN CHINA
ONE CHILD PER HOUSEHOLD

ONE WORLD ONE LOVE
LET'S
GHETTOGETHER
AND FEEL ALRIGHT
ONE WORLD ONE LOVE
LET'S
GHETTOGETHER
AND FEEL ALRIGHT
ONE WORLD ONE LOVE
LET'S
GHETTOGETHER
AND FEEL ALRIGHT
LET ME HEAR YOU SAY
ONE WORLD ONE LOVE
LET'S
GHETTOGETHER
AND FEEL ALRIGHT

SAID SAID
I REMEMBER WHEN I USED TO
SIT
IN FRONT OF TV
IN SWEDEN

ONE WORLD ONE LOVE
LET'S
GHETTOGETHER
AND FEEL ALRIGHT

ONE WORLD ONE LOVE
LET'S
GHETTOGETHER
AND FEEL ALRIGHT
ONE WORLD ONE LOVE
LET'S
GHETTOGETHER
AND FEEL ALRIGHT
LET ME HEAR YOU SAY
ONE WORLD ONE LOVE
LET'S
GHETTOGETHER
AND FEEL ALRIGHT

SAID SAID
I REMEMBER WHEN I USED TO
SIT
IN FRONT OF TV
IN SWEDEN
ALIENATION IN THE WORKPLACE
ALIENATION IN THE WORKPLACE
SLAVES IN ANCIENT EGYPT, SLAVES
IN MEXICO, SLAVES IN ROME
CHILD WORKERS IN CHINA
ONE CHILD PER HOUSEHOLD

END CAPITALISM
END CAPITALISM
NOW
START WITH THE MIND
THE MIND
MAKING MONEY
CONTROL
MAKING MONEY
CONTROL
GAY MARRIAGE
CONTROL
COURAGE CAMPAIGN ISSUES
COMMITTEE
CONTROL
MAKING MONEY
CONTROL
DEMOCRACY
CONTROL
FIFTEEN TO VOTE
CONTROL
KILL ALL PEOPLE OVER
THIRTY
CONTROL
KILL ALL PEOPLE

WHO SAID SENDING PEOPLE OFF
TO PRISON WAS NORMAL?
CONTROL
SILENCE THE BOMB

WHO SAID SENDING PEOPLE OFF
TO PRISON WAS NORMAL?
CONTROL
SILENCE THE BOMB
START WITH THE MIND
CONTROL
SILENCE THE BOMB
LET YOUR KIDS MAKE MUSIC
CONTROL
MAKING MONEY
JOY OF WORKING
CONTROL
CHILD WORKERS IN CHINA
WE DON'T NEED NO THOUGHT CONTROL
CONTROL
LET YOUR KIDS MAKE MUSIC
CONTROL
GAY MARRIAGE
WOMEN'S RIGHTS
CONTROL
SAUDI ARABIA
DEMOCRACY
ROYALTY
YO MAJESTY
MAKING MONEY
CONTROL
A CONTRACT
THE FINE PRINT
SIGNING YOUR LIFE AWAY
SIGNING AWAY YOUR SOUL
CONTROL
SLAVES IN ANCIENT EGYPT, SLAVES
IN MEXICO, SLAVES IN ROME
THE SLAVE OF SLAVES
WOMEN LEADERS
CONTROL
GAY MARRIAGE
CHECK
CONTROL
CHECK CHECK
SPACE IS THE PLACE
GIVING VOICE TO THE VOICELESS
CHECK CHECK
SPACE IS THE PLACE
WEARING THE PANTS
WHY DO CLOTHES HAVE SEXES?
CONTROL
START WITH THE MIND
THE MIND
CONTROL
LET YOUR KIDS MAKE MUSIC
CONTROL
RHYTHM TO THE RHYTHM
START WITH THE MIND
THE MIND

GIVING VOICE TO THE VOICELESS
SILENCE THE BOMB

In her 2003 book *Regarding the Pain of Others* Susan Sontag remarks how our time is the first time when peace is regarded as something normal.

CONTROL
START WITH THE MIND
LET YOUR KIDS MAKE MUSIC
THOUGHTS ARE THOUGHTS
THAT'S ALL
AN ANGEL IN THE ROOM
SILENCE THE BOMB
DAREDEVIL
COMPETING FOR THE SAKE OF
COMPETITION
COMPETITION
IT'S A GOOD THING
SILENCE THE BOMB
RHYTHM TO THE RHYTHM
JOY OF WORKING
SILENCE THE BOMB
WORKING FROM 5 TO 9
ALIENATION IN THE WORKPLACE

HISTORICALLY, in all other times, war was seen as the norm. There would always be a time between conflict, but then just waiting for the next.

SILENCE THE BOMB
LET YOUR KIDS MAKE MUSIC
RHYTHM TO THE RHYTHM
SILENCE THE BOMB
LET YOUR KIDS MAKE MUSIC
SILENCE THE BOMB
WOMEN LEADERS
START WITH THE MIND
THE MIND
SAUDI ARABIA
START WITH THE MIND

Édouard Glissant has said that when future historians look back at our time, we will be judged by our inability to distribute wealth. The shock of how big parts of the world still are left to starvation and poverty.

START WITH THE MIND
THE MIND
JOY OF WORKING
START WITH THE MIND

Artists could inspire, not only by making artworks, but also through sharing their work process. People could understand how creativity is invested into something. How you make things work. Make them work for you and make them work for others.

ALIENATION IN THE WORKPLACE
RHYTHM TO THE RHYTHM

It seems strange, with all the wealth in the world. All the machines, all the airplanes circulating products and people, public zoos and swimming pools, that people don't have better lives. Or maybe they do.

LET YOUR KIDS MAKE MUSIC
START WITH THE MIND
LANGUAGE POETRY
POETRY
START WITH THE MIND
THE FIRST RULE IS TO BREAK
THE RULE
START WITH THE MIND
ROYALTY
GLASS CANDY
LADY GAGA
SAUDI ARABIA
START WITH THE MIND

Language rules can be broken, just like any other rules. Words can have multiple meanings. Singing the Blues. Your thoughts can be used to ease trauma, ease dread even in the most mundane situations. Even in the extreme, extreme conditions. Condition your mind.

It seems hopeful therefore that at least we're no longer thinking about war as normal, even though war is everywhere, not in the West of course. Not in Europe or the United States, but we have our wars elsewhere. We fight them out on television, through remote control. It's a collective decision that certain areas of our planet should be used for conflict, that's all. We have garbage piles for garbage, and we have Conflict Zones.

And then that's normal. Business as usual. Women's place is in the home.

Colonialism could never have happened without armed force. Without considering other people less. Less than human, what's so heroic about this? Reducing yourself, because you have to. Because you can't cope. And then reducing others to fit to size. Fight someone your own size. Fight someone in your own area. Don't have war on the other side of the planet. Fight someone your own size. Fight your wife. Make war human. Fight for life. The dignity, the dignity of being human. Fight for that.

I DON'T WANT NO LIES
I DON'T WATCH TV

I DON'T WASTE MY TIME
READING MAGAZINES
I DON'T WANT NO LIES
I DON'T WATCH TV
I DON'T WASTE MY TIME
READING MAGAZINES
I DON'T WANT NO LIES
I DON'T WATCH TV
I DON'T WASTE MY TIME
READING MAGAZINES
I DON'T WANT NO LIES
I DON'T WATCH TV
I DON'T WASTE MY TIME
READING MAGAZINES
ECONOMIC CRISIS
IT'S A HOAX
ECONOMIC CRISIS
IT'S A HOAX
MEDIA DEPRAVITY
IT'S HUMAN CRISIS, THAT'S ALL
LET'S ALL
GHETTOTOGETHER
AND FEEL ALRIGHT
LET ME HEAR YOU SAY
LET'S ALL
GHETTOTOGETHER
AND FEEL ALRIGHT
LET ME HEAR YOU SAY
ONE WORLD ONE LOVE
LET'S ALL
GHETTOTOGETHER
AND FEEL ALRIGHT

Feel good about oneself, feel good about one's friend. Self-acceptance. Acceptance of self. Self-love. The schoolyard bully. The scariest thing about the US presidency for the last couple of terms (2001–05)(2005–09) was how I knew that face. The facial expression of arrogance and unconcern. With the need to assert oneself through bul-

lying others. Telling people what to do. Telling the ones who seem weaker than you where they should be and what they should do. Gay marriage. The schoolyard bully. When such a person is elected into office of what's perceived as the world's most powerful nation, we have something to concern ourselves with. What's power, what's an election? Media attention. The power of the word, of the voice. Of human thought. The power of courage. Of time. Time following its course. Of predestination. 500 years of Enlightenment, coming to an end. About to disappear.

Start with the mind. Fight in the street. Fight the people you meet. Not on the other side of the planet. Evolution, that's all. Fight evolution. Fight nature. Make money. The first rule is to break the rule. Break the habit. Look at the person. Fight with your wife. There's something beautiful to be found in everyone. Look for that. Even the people with the least appeal. Even in President Bush, I always thought about how with all the money and powers he has, all the consultants his suits always seem to be ill-fitting and slightly too big. How it seems he would like to say something about himself this way. It may seem mean, but I thought that that was cute. I thought that that was cute since I can't look at his face, or even mention his name. Gertrude Stein, Gertrude Stein, Susan Sontag, Gertrude Stein.

The first rule is to break the rule.

Never tell others what to do.

There's a cute passage in Victor Bockris's book, *With William Burroughs* (1981) where he retells how Susan Sontag had been able to arrange a meeting with Samuel Beckett, who happened to be William S. Burroughs' idol. How they had come to Beckett's apartment, in the afternoon where he had received them. A courtesy visit. He seemed antsy, waiting for them to leave again so that he could get back to his work. Now, that was phenomenal. Thank You.

Statements on Appropriation

Michalis Pichler 2009

Michalis Pichler, "Statements on Appropriation," *Ubuweb Papers* (2009), ubu.com/papers/pichler_appropriation.html; *Fillip*, no. 11 (Winter 2010): 44–47.

1. If a book paraphrases one explicit historical or contemporary predecessor in title, style, and/or content, this technique is what I would call a "greatest hit."

2. Maybe the belief that an appropriation is always a conscious strategic decision made by an author is just as naive as believing in an "original" author in the first place.

3. It appears to me, that the signature of the author, be it an artist, cineaste, or poet, seems to be the beginning of the system of lies, that all poets, all artists try to establish, to defend themselves, I do not know exactly against what.

4. Custom having once given the name of "the ancients" to our pre-Christian ancestors, we will not throw it up against them that, in comparison with us experienced people, they ought properly to be called children, but will rather continue to honor them as our good old fathers.

5. It is nothing but literature!

6. There is as much unpredictable originality in quoting, imitating, transposing, and echoing, as there is in inventing.

7. For the messieurs art-critics I will add, that of course it requires a far bigger mastery to cut out an artwork out of the artistically unshaped nature, than to construct one out of arbitrary material after ones own artistic law.

8. The authenticity of a thing is the essence of all that is transmissible from its beginning, ranging from its substantive duration to its testimony to the history which it has experienced.

9. Intellectual property is the oil of the twenty-first century.

10. Certain images, objects, sounds, texts, or thoughts would lie within the area of what is appropriation, if they are somewhat more explicit, sometimes strategic, sometimes indulging in borrowing, stealing, appropriating, inheriting, assimilating ... being influenced, inspired, dependent, indebted, haunted, possessed, quoting, rewriting, reworking, refashioning ... a revision, re-evaluation, variation, version, interpretation, imitation, proximation, supplement, increment, improvisation, prequel ... pastiche, paraphrase, parody, forgery, homage, mimicry, travesty, shan-zhai, echo, allusion, intertextuality, and karaoke.

11. Plagiarism is necessary; progress implies it.

12. Ultimately, any sign or word is susceptible to being converted into something else, even into its opposite.

13. Like Bouvard and Pecuchet, those eternal copyists, both sublime and comical and whose profound absurdity precisely designates the truth of writing, the writer can only imitate a gesture forever anterior, never original.

14. The world is full of texts, more or less interesting; I do not wish to add any more.

15.

16. The question is: What is seen now, but will never be seen again?

17. Détournement reradicalizes previous critical conclusions that have been petrified into respectable truths and thus transformed into lies.

18. No poet, no artist, of any art has his complete meaning alone.

Notes

On December 11, 2009, six one-sentence statements originated by the "artist/author" for the purposes of this piece were mixed, in a container, with eighteen one-sentence quotes taken from various other sources; each sentence was printed onto a separate piece of paper. Eighteen statements were drawn by "blind" selection and, in the exact order of their selection joined altogether to form the "Statements on Appropriation," for the presentation at Stichting Perdu, Amsterdam. In the following bibliography, the sources [...] may be found, although no specific statement is keyed to its actual author.

Roland Barthes, "Death of the Author," in *Image-Music-Text* (New York: Hill and Wang, 1978) 142–48.

Walter Benjamin, "Unpacking my Library" (1931), *Illuminations*, ed. Hannah Arendt, trans. Harry Zohn (New York: Schocken, 1968), 59–67.

Walter Benjamin, "The Work of Art in the Age of Mechanical Reproduction" (1936), *Illuminations*, ed. Hannah Arendt, trans. Harry Zohn (New York: Schoken, 1968), 215–17.

Marcel Broodthaers, "Interview with Marcel Broodthaers by Freddy de Vree" (1971), *Collected Writings*, ed. Gloria Moure, trans. Jill Ramsey (Barcelona: Ediciones Polígrafa, 2012), 310–12.

Ulises Carrión, "The New Art of Making Books" (1975), *We have won! Haven't we?*, ed. Guy Schraenen (Amsterdam: Idea Books) n.p.

Giorgio de Chirico, quoted in Allen Ruppersberg, *The New Five-Foot Shelf of Books* (Ljubljana: International Centre of Graphic Arts / Brussels: Editions Micheline Szwajcer and Michèle Didier, 2003), n.p.

Guy Debord, "The Society of the Spectacle," trans. Ken Knabb, *bopsecrets.org*, March 18, 2015, *bopsecrets.org/si/detourn.8htm*, paragraph 206.

Guy Debord and Gil J Wolman, "A User's Guide to Détournement," in *Situationist International Anthology*, trans. and ed. Ken Knabb (Bureau of Public Secrets, 2006), accessed March 18, 2015, *bopsecrets.org/si/detourn.htm*.

Isidore Ducasse (Comte de Lautrèamont), *Poésies and Complete Miscellanea*, trans. Alexis Lykiard (London: Alison & Busby, 1978), 68.

T. S. Eliot, "Tradition and the Individual Talent" (1919), in *Selected Prose of T. S. Eliot*, ed. Frank Kermode (London: Faber, 1984), 37–40, 37.

Mark Getty, quoted in "Blood and oil," *Economist*, March 2, 2000.

Kenneth Goldsmith, "Being Boring," *The Newspaper 2* (2008), 2–3, 2.

Herakleitos, "Ephesos" (ca. 500 BC), quoted in Plato *Cratylus*, fragment 41.

Julia Kristeva, "Word, Dialogue and Novel" (1996), repr. in *The Kristeva Reader*, ed. Toril Moi (New York: Columbia University Press, 1986), 34–61, 37.

Daniel McClean and Karsten Schubert, eds., *Dear Images: Art, Copyright, and Culture* (London: Ridinghouse, 2002) 372.

Allen Ruppersberg, "Fifty Helpful hints on the Art of the Everyday," in *The Secret of Life and Death* (Los Angeles: The Museum of Contemporary Art, 1985), 111–14, 113.

Kurt Schwitters, "i (ein Manifest)," in *Das literarische Werk*, ed. Friedhelm Lach, vol. 5 (Cologne: DuMont, 1981), 125.

Leo Steinberg (1978), quoted in *Hillel Schwartz, The Culture of the copy. Striking Likenesses, Unreasonable Facsimiles* (New York: Zone Books, 1996).

Max Stirner, *The Ego and Its Own*, ed. David Leopold, trans. Steven Byington (Cambridge: Cambridge University Press, 1995), 19.

Bibliography

See also: Douglas Huebler, "Variable piece #20," *Douglas Huebler* (Andover, MA: Addison Gallery of American Art, 1970).

In Defense of the Poor Image

Hito Steyerl 2009

Hito Steyerl, "In Defense of the Poor Image," *e-flux Journal*, no. 10 (November 2009).

he poor image is a copy in motion. Its quality is bad, its resolution substandard. As it accelerates, it deteriorates. It is a ghost of an image, a preview, a thumbnail, an errant idea, an itinerant image distributed for free, squeezed through slow digital connections, compressed, reproduced, ripped, remixed, as well as copied and pasted into other channels of distribution.

The poor image is a rag or a rip; an AVI or a JPEG, a lumpen proletarian in the class society of appearances, ranked and valued according to its resolution. The poor image has been uploaded, downloaded, shared, reformatted, and reedited. It transforms quality into accessibility, exhibition value into cult value, films into clips, contemplation into distraction. The image is liberated from the vaults of cinemas and archives and thrust into digital uncertainty, at the expense of its own substance. The poor image tends toward abstraction: it is a visual idea in its very becoming.

The poor image is an illicit fifth-generation bastard of an original image. Its genealogy is dubious. Its filenames are deliberately misspelled. It often defies patrimony, national culture, or indeed copyright. It is passed on as a lure, a decoy, an index, or as a reminder of its former visual self. It mocks the promises of digital technology. Not only is it often degraded to the point of being just a hurried blur, one even doubts whether it could be called an image at all. Only digital technology could produce such a dilapidated image in the first place.

Poor images are the contemporary Wretched of the screen, the debris of audiovisual production, the trash that washes up on the digital economies' shores. They testify to the violent dislocation, transferrals, and displacement of images—their acceleration and circulation within the vicious cycles of audiovisual capitalism. Poor images are dragged around the globe as commodities or their effigies, as gifts or as bounty. They spread pleasure or death threats, conspiracy theories or bootlegs, resistance or stultification. Poor images show the rare, the obvious, and the unbelievable—that is, if we can still manage to decipher it.

1. Low Resolutions

In one of Woody Allen's films the main character is out of focus.[1] It's not a technical problem but some sort of disease that has befallen him: his image is consistently blurred. Since Allen's character is an actor, this becomes a major problem: he is unable to find work. His lack of definition turns into a material problem. Focus is identified as a class position, a position of ease and privilege, while being out of focus lowers one's value as an image.

The contemporary hierarchy of images, however, is not only based on sharpness, but also and primarily on resolution. Just look at any electronics store and this system, described by Harun Farocki in a notable 2007 interview,

becomes immediately apparent.[2] In the class society of images, cinema takes on the role of a flagship store. In flagship stores high-end products are marketed in an upscale environment. More affordable derivatives of the same images circulate as DVDs, on broadcast television or online, as poor images.

Obviously, a high-resolution image looks more brilliant and impressive, more mimetic and magic, more scary and seductive than a poor one. It is more rich, so to speak. Now, even consumer formats are increasingly adapting to the tastes of cineastes and esthetes, who insisted on 35 mm film as a guarantee of pristine visuality. The insistence upon analog film as the sole medium of visual importance resounded throughout discourses on cinema, almost regardless of their ideological inflection. It never mattered that these high-end economies of film production were (and still are) firmly anchored in systems of national culture, capitalist studio production, the cult of mostly male genius, and the original version, and thus are often conservative in their very structure. Resolution was fetishized as if its lack amounted to castration of the author. The cult of film gauge dominated even independent film production. The rich image established its own set of hierarchies, with new technologies offering more and more possibilities to creatively degrade it.

2. Resurrection (as Poor Images)

But insisting on rich images also had more serious consequences. A speaker at a recent conference on the film essay refused to show clips from a piece by Humphrey Jennings because no proper film projection was available. Although there was at the speaker's disposal a perfectly standard DVD player and video projector, the audience was left to imagine what those images might have looked like.

In this case the invisibility of the image was more or less voluntary and based on aesthetic premises. But it has a much more general equivalent based on the consequences of neoliberal policies. Twenty or even thirty years ago, the neoliberal restructuring of media production began slowly obscuring noncommercial imagery, to the point where experimental and essayistic cinema became almost invisible. As it became prohibitively expensive to keep these works circulating in cinemas, so were they also deemed too marginal to be broadcast on television. Thus they slowly disappeared not just from cinemas, but from the public sphere as well. Video essays and experimental films remained for the most part unseen save for some rare screenings in metropolitan film museums or film clubs, projected in their original resolution before disappearing again into the darkness of the archive.

This development was of course connected to the neoliberal radicalization of the concept of culture as com-

modity, to the commercialization of cinema, its dispersion into multiplexes, and the marginalization of independent filmmaking. It was also connected to the restructuring of global media industries and the establishment of monopolies over the audiovisual in certain countries or territories. In this way, resistant or nonconformist visual matter disappeared from the surface into an underground of alternative archives and collections, kept alive only by a network of committed organizations and individuals, who would circulate bootlegged VHS copies among themselves. Sources for these were extremely rare—tapes moved from hand to hand, depending on word of mouth, within circles of friends and colleagues. With the possibility to stream video online, this condition started to dramatically change. An increasing number of rare materials reappeared on publicly accessible platforms, some of them carefully curated (Ubuweb) and some just a pile of stuff (YouTube).

At present, there are at least twenty torrents of Chris Marker's film essays available online. If you want a retrospective, you can have it. But the economy of poor images is about more than just downloads: you can keep the files, watch them again, even reedit or improve them if you think it necessary. And the results circulate. Blurred AVI files of half-forgotten masterpieces are exchanged on semi-secret P2P platforms. Clandestine cell-phone videos smuggled out of museums are broadcast on YouTube. DVDs of artists' viewing copies are bartered.[3] Many works of avant-garde, essayistic, and noncommercial cinema have been resurrected as poor images. Whether they like it or not.

3. Privatization and Piracy

That rare prints of militant, experimental, and classical works of cinema as well as video art reappear as poor images is significant on another level. Their situation reveals much more than the content or appearance of the images themselves: it also reveals the conditions of their marginalization, the constellation of social forces leading to their online circulation as poor images.[4] Poor images are poor because they are not assigned any value within the class society of images—their status as illicit or degraded grants them exemption from its criteria. Their lack of resolution attests to their appropriation and displacement.[5]

Obviously, this condition is not only connected to the neoliberal restructuring of media production and digital technology; it also has to do with the post-socialist and postcolonial restructuring of nation-states, their cultures, and their archives. While some nation-states are dismantled or fall apart, new cultures and traditions are invented and new histories created. This obviously also affects film archives—in many cases, a whole heritage of film prints is left without its supporting framework of national culture. As I once observed in the case of a film museum in Sarajevo, the national archive can find its next life in the form of a video-rental store.[6] Pirate copies seep out of such archives through disorganized privatization. On the other hand, even the British Library sells off its contents online a astronomical prices.

As Kodwo Eshun has noted, poor images circulate partl in the void left by state-cinema organizations who find i too difficult to operate as a 16/35-mm archive or to main tain any kind of distribution infrastructure in the contem porary era.[7] From this perspective, the poor image reveal the decline and degradation of the film essay, or indee any experimental and noncommercial cinema, which i many places was made possible because the productio of culture was considered a task of the state. Privatizatio of media production gradually grew more important tha state-controlled/sponsored media production. But, on th other hand, the rampant privatization of intellectual con tent, along with online marketing and commodificatio also enable piracy and appropriation; it gives rise to the cir culation of poor images.

4. Imperfect Cinema

The emergence of poor images reminds one of a classi Third Cinema manifesto, "For an Imperfect Cinema," b Juan García Espinosa, written in Cuba in the late 1960s. Espinosa argues for an imperfect cinema because, in hi words, "perfect cinema—technically and artistically mas terful—is almost always reactionary cinema." The imper fect cinema is one that strives to overcome the divisions o labor within class society. It merges art with life and science blurring the distinction between consumer and produce audience and author. It insists upon its own imperfectior is popular but not consumerist, committed without becom ing bureaucratic.

In his manifesto, Espinosa also reflects on the prom ises of new media. He clearly predicts that the develop ment of video technology will jeopardize the elitist positio of traditional filmmakers and enable some sort of mas film production: an art of the people. Like the econom of poor images, imperfect cinema diminishes the distinc tions images, imperfect cinema diminishes the distinction between author and audience and merges life and art. Mos of all, its visuality is resolutely compromised: blurred, ama teurish, and full of artifacts.

In some way, the economy of poor images correspond to the description of imperfect cinema, while the descrip tion of perfect cinema represents rather the concept of cin ema as a flagship store. But the real and contemporar imperfect cinema is also much more ambivalent and affec tive than Espinosa had anticipated. On the one hand, th economy of poor images, with its immediate possibility o worldwide distribution and its ethics of remix and appro priation, enables the participation of a much larger grou of producers than ever before. But this does not mean tha these opportunities are only used for progressive ends. Hat speech, spam, and other rubbish make their way throug digital connections as well. Digital communication has als become one of the most contested markets—a zone tha

has long been subjected to an ongoing original accumulation and to massive (and, to a certain extent, successful) attempts at privatization.

The networks in which poor images circulate thus constitute both a platform for a fragile new common interest and a battleground for commercial and national agendas. They contain experimental and artistic material, but also incredible amounts of porn and paranoia. While the territory of poor images allows access to excluded imagery, it is also permeated by the most advanced commodification techniques. While it enables the users' active participation in the creation and distribution of content, it also drafts them into production. Users become the editors, critics, translators, and (co)authors of poor images.

Poor images are thus popular images—images that can be made and seen by the many. They express all the contradictions of the contemporary crowd: its opportunism, narcissism, desire for autonomy and creation, its inability to focus or make up its mind, its constant readiness for transgression and simultaneous submission.[9] Altogether, poor images present a snapshot of the affective condition of the crowd, its neurosis, paranoia, and fear, as well as its craving for intensity, fun, and distraction. The condition of the images speaks not only of countless transfers and reformattings, but also of the countless people who cared enough about them to convert them over and over again, to add subtitles, reedit, or upload them.

In this light, perhaps one has to redefine the value of the image, or, more precisely, to create a new perspective for it. Apart from resolution and exchange value, one might imagine another form of value defined by velocity, intensity, and spread. Poor images are poor because they are heavily compressed and travel quickly. They lose matter and gain speed. But they also express a condition of dematerialization, shared not only with the legacy of conceptual art but above all with contemporary modes of semiotic production.[10] Capital's semiotic turn, as described by Felix Guattari,[11] plays in favor of the creation and dissemination of compressed and flexible data packages that can be integrated into ever-newer combinations and sequences.[12] This flattening-out of visual content—the concept-in-becoming of the images—positions them within a general informational turn, within economies of knowledge that tear images and their captions out of context into the swirl of permanent capitalist deterritorialization.[13] The history of conceptual art describes this dematerialization of the art object first as a resistant move against the fetish value of visibility. Then, however, the dematerialized art object turns out to be perfectly adapted to the semioticization of capital, and thus to the conceptual turn of capitalism.[14] In a way, the poor image is subject to a similar tension. On the one hand, it operates against the fetish value of high resolution. On the other hand, this is precisely why it also ends up being perfectly integrated into an information capitalism thriving on compressed attention spans, on impression rather than immersion, on intensity rather than contemplation, on previews rather than screenings.

5. Comrade, what is your visual bond today?

But, simultaneously, a paradoxical reversal happens. The circulation of poor images creates a circuit, which fulfills the original ambitions of militant and (some) essayistic and experimental cinema—to create an alternative economy of images, an imperfect cinema existing inside as well as beyond and under commercial media streams. In the age of file-sharing, even marginalized content circulates again and reconnects dispersed worldwide audiences.

The poor image thus constructs anonymous global networks just as it creates a shared history. It builds alliances as it travels, provokes translation or mistranslation, and creates new publics and debates. By losing its visual substance it recovers some of its political punch and creates a new aura around it. This aura is no longer based on the permanence of the "original," but on the transience of the copy. It is no longer anchored within a classical public sphere mediated and supported by the frame of the nation-state or corporation, but floats on the surface of temporary and dubious data pools. By drifting away from the vaults of cinema, it is propelled onto new and ephemeral screens stitched together by the desires of dispersed spectators.

The circulation of poor images thus creates "visual bonds," as Dziga Vertov once called them.[15] This "visual bond" was, according to Vertov, supposed to link the workers of the world with each other.[16] He imagined a sort of communist, visual, Adamic language that could not only inform or entertain, but also organize its viewers. In a sense, his dream has come true, if mostly under the rule of a global information capitalism whose audiences are linked almost in a physical sense by mutual excitement, affective attunement, and anxiety.

But there is also the circulation and production of poor images based on cell phone cameras, home computers, and unconventional forms of distribution. Its optical connections—collective editing, file sharing, or grassroots distribution circuits—reveal erratic and coincidental links between producers everywhere, which simultaneously constitute dispersed audiences.

The circulation of poor images feeds into both capitalist media assembly lines and alternative audiovisual economies. In addition to a lot of confusion and stupefaction, it also possibly creates disruptive movements of thought and affect. The circulation of poor images thus initiates another chapter in the historical genealogy of nonconformist information circuits: Vertov's "visual bonds," the internationalist workers pedagogies that Peter Weiss described in *The Aesthetics of Resistance*, the circuits of Third Cinema and Tricontinentalism, of nonaligned filmmaking and thinking. The poor image—ambivalent as its status may be—thus takes its place in the genealogy of carbon-copied pamphlets, cine-train agit-prop films, underground video magazines,

and other nonconformist materials, which aesthetically often used poor materials. Moreover, it reactualizes many of the historical ideas associated with these circuits, among others Vertov's idea of the visual bond.

Imagine somebody from the past with a beret asking you, "Comrade, what is your visual bond today?"

You might answer: it is this link to the present.

6. Now!

The poor image embodies the afterlife of many former masterpieces of cinema and video art. It has been expelled from the sheltered paradise that cinema seems to have once been.[17] After being kicked out of the protected and often protectionist arena of national culture, discarded from commercial circulation, these works have become travelers in a digital no-man's-land, constantly shifting their resolution and format, speed and media, sometimes even losing names and credits along the way.

Now many of these works are back—as poor images, I admit. One could of course argue that this is not the real thing, but then—please, anybody—show me this real thing.

The poor image is no longer about the real thing—the originary original. Instead, it is about its own real conditions of existence: about swarm circulation, digital dispersion, fractured and flexible temporalities. It is about defiance and appropriation just as it is about conformism and exploitation.

In short: it is about reality.

Author's Note:
An earlier version of this text was improvised in a response at the "Essayfilm—Ästhetik und Aktualität" conference in Lüneburg, Germany, organized by Thomas Tode and Sven Kramer in 2007. The text benefitted tremendously from the remarks and comments of Third Text guest editor Kodwo Eshun, who commissioned a longer version for an issue of *Third Text* on Chris Marker and *Third Cinema* to appear in 2010 (coedited by Ros Grey). Another substantial inspiration for this text was the exhibition "Dispersion" at the ICA in London (curated by Polly Staple in 2008), which included a brilliant reader edited by Staple and Richard Birkett. The text also benefitted greatly from Brian Kuan Wood's editorial work.

1 *Deconstructing Harry*, directed by Woody Allen (1997).

2 "Wer Gemälde wirklich sehen will, geht ja schließlich auch ins Museum," *Frankfurter Allgemeine Zeitung*, June 14, 2007. Conversation between Harun Farocki and Alexander Horwath.

3 Sven Lütticken's excellent text "Viewing Copies: On the Mobility of Moving Images," in *e-flux journal*, no. 8 (May 2009), drew my attention to this aspect of poor images.

4 Thanks to Kodwo Eshun for pointing this out.

5 Of course in some cases images with low resolution also appear in mainstream media environments (mainly news), where they are associated with urgency, immediacy, and catastrophe—and are extremely valuable. See Hito Steyerl, "Documentary Uncertainty," *A Prior* 15 (2007).

6 Hito Steyerl, "Politics of the Archive: Translations in Film," *Transversal* (March 2008).

7 From correspondence with the author via email.

8 Julio García Espinosa, "For an Imperfect Cinema," trans. Julianne Burton, *Jump Cut*, no. 20 (1979): 24–26.

9 See Paolo Virno, *A Grammar of the Multitude: For an Analysis of Contemporary Forms of Life* (Cambridge, MA: MIT Press, 2004).

10 See Alexander Alberro, *Conceptual Art and the Politics of Publicity* (Cambridge, MA: MIT Press, 2003).

11 See Félix Guattari, "Capital as the Integral of Power Formations," in *Soft Subversions* (New York: Semiotext(e), 1996), 202.

12 All these developments are discussed in detail in an excellent text by Simon Sheikh, "Objects of Study or Commodification of Knowledge? Remarks on Artistic Research," *Art & Research* 2, no. 2 (Spring 2009), artandresearch.org.uk/v2n2/sheikh.html.

13 See also Alan Sekula, "Reading an Archive: Photography between Labour and Capital," in *Visual Culture: The Reader*, ed. Stuart Hall and Jessica Evans (London/New York: Routledge 1999), 181–92.

14 See Alberro, *Conceptual Art and the Politics of Publicity*.

15 Dziga Vertov, "Kinopravda and Radiopravda," in *Kino-Eye: The Writings of Dziga Vertov*, ed. Annette Michelson (Berkeley: University of California Press, 1995), 52.

16 Vertov, "Kinopravda and Radiopravda," 52.

17 At least from the perspective of nostalgic delusion.

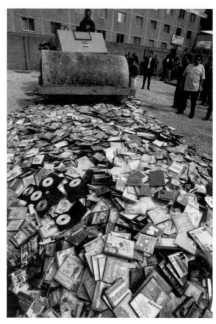

Public ceremony organized by the mayor of Puebla, Mexico, to destroy pirated DVDs in circulation

From My Skull

Joachim Schmid 2010

Joachim Schmid, "From My Skull," *Photoworks* 14 (May–October 2010).

What do Benjamin Franklin, Thomas Paine, Alexander von Humboldt, Edgar Allan Poe, Mark Twain, George Bernard Shaw, Rudyard Kipling, Gertrude Stein, Upton Sinclair, D. H. Lawrence, Ezra Pound, and T. S. Eliot have in common? They were self-publishers. This list could be enlarged with an endless number of less prominent names, and I only mention them to disperse a common assumption, that self-publishing is an option for authors who are not good enough to be taken on by established publishers. Artists publishing their own books face a predicament: while self-publishing is often considered to be the confession of failure, the artist's book itself seems to epitomize the perfectly autonomous, self-determined work.

For the authors mentioned above, the business of publishing a book was different to how it is today. Some of the problems and pitfalls are the same, however: principally, money (the lack of it) and the coordination of the various people involved. A complex process that involves an author, an editor, a designer, a publisher, and a printer (not to mention accountants, distributors, and retailers) is close to a sure recipe for disaster. Quite often the ideas, ambitions, and attitudes of these headstrong people turn out to be incompatible. Minimizing the risk of trouble or avoiding it altogether is one reason authors turn to self-publishing.

The second reason is the problem of capacity. A limited number of publishers cannot accommodate the desires of a nearly unlimited number of authors. From the outsider's point of view, a publishing house is a kind of slot machine. Authors put in proposals, manuscripts, or dummy books into the machine and pull the handle. It starts to emit funny sounds, and after a while it either produces a book or it doesn't. We don't know what happens inside the apparatus; we'll never know for sure why some books are winners while the majority of players draw blanks. For the disappointed authors, publishers, like arcade machines, can seem like "one-armed bandits."

This brings us to the next reason: money. The machine designed to swallow authors' ideas also has a slot for coins. It's an open secret that in modern times proposals—in particular for art books—that are entered together with a cheque are more likely to win; the number of zeros on this cheque directly correlates with the probability of a proposal turning into a printed book. The artist or the gallery exhibiting the work is, in this arrangement, supposed to provide a substantial part of the budget, as many modern publishers eschew the financial risk of publishing. This is rather new, and it's a development that, in German at least, turns the meanings of words on their head. In English, a "publisher" is someone who makes something "public." In my mother tongue, *verlegen* (to publish) is derived from *vorlegen*, which means to advance money. Interesting, isn't it?

Traditionally, the publisher is the one who comes up with a budget, the one who is able and willing to invest in ideas, to take a risk. Today, artists, dealers, and museums have turned into sponsors of publishers and printers. It doesn't take a genius to understand that, if you have to spend your own money to make your own book, you might as well bring the whole thing under your own control.

The importance of independence becomes clear if we look at an extreme form of self-publishing: samizdat, the voice of the opposition in a totalitarian society. The particularities of this underground movement are summarised by one of its main practitioners, Vladimir Bukovsky, in one sentence: "I myself create it, edit it, censor it, publish it, distribute it, and get imprisoned for it." Censorship may not be an issue in large parts of the world anymore, but artists have to struggle with its more subtle sibling, that answers to the name of "mainstream." The response, on the part of some authors, is called independent publishing.

No publisher ever offered to put out a book called *One Picture* containing a single image. Hans-Peter Feldmann published it, along with works by a number of similar misfits. Today, these poorly printed little booklets are considered seminal artist's books, have been influential for a generation of artists, and are sought-after rare books. Nevertheless, you still don't find a big publisher who would be willing to support a similar endeavor. There is a very limited number of prevailing book models, a fact that the superficial variety of designs does little to disguise.

Ed Ruscha's *Twenty-six Gasoline Stations* and later books were published by the artist himself. Their impact was tremendous, and it is time to remind the growing group of book connoisseurs that Ruscha's books were, and are, appreciated not because of the paper stock, the printing quality, or the fine binding but because of the artist's radically new editorial concept. The slot machine wouldn't accept such an offering. A niche publisher of exquisite *livres d'artiste* wouldn't accept it either. There was no other choice for Ruscha than to do it himself.

Despite the increasing number of small and very small publishing houses, self-publishing has become the obvious option for an increasing number of artists. This is mostly due to the fact that for more and more artists the book has become the work itself; it is no longer seen as a catalog of photographs that have a life outside the book, in galleries, filing cabinets, or frames hanging over collectors' sofas. For this reason, exercising maximum control over the publication process, as Stephen Gill points out, is crucial. Finding the suitable material, technique, and form for each project, instead of doing things according to the publisher's defaults, is one of the advantages of self-publishing.

Modern technology facilitates do-it-yourself approaches and, at the same time, do-it-yourself creates skill and

experience. Many contemporary artists are skilled bookmakers with substantial knowledge in fields that traditionally required specialized technicians. Some artists—Morten Andersen, for example, who published nearly all of his books himself—started by making fanzines and slowly grew into this new field of activity. Artists who were educated in modern art schools' media departments, rather than in the old school photography world, have a different vantage point already. They are used to working in a variety of techniques and media as well as being responsible for every aspect and every pixel of their work.

The crucial moment for most self-publishers—from Katja Stuke and Oliver Sieber with their ongoing Böhm/Kobayashi publishing project, to Erik Kessels whose books are produced by his agency as a part of a wider communication strategy, to young activists like Erik van der Weijde with his continuous output of weird little books—is the strong desire to do things the way they want them to be done, and to do them at their own pace. They understood that nobody would be more enthusiastic about their books than the authors themselves, and they enjoy the flexibility of being able to make a book within one week if necessary, instead of waiting years for a publisher's approval.

Distribution of books used to be problematic for many self-publishers, but in the age of the internet this is no longer such a drawback. Direct marketing through an artist's own website is as feasible as announcing publications in mailings, blogs, newsgroups, and social networks. The *Independent Photo Book blog* (*theindependentphotobook.blogspot.com*) has been listing independently published photography books since January 2010. New titles are being added nearly every day, and most readers are surprised both by the number and the quality of books they never heard of, and that we hardly ever find in bookshops—the number of specialized photography bookshops exceeds the print run of many of these publications.

The majority of self-publishers operate in a low-budget economy. Raising the funds for a book often demands about as much creativity as making the artwork itself. For most artists coming up with a five-figure amount is a bit of a problem, and this is one reason why many artist's books are made in two-figure editions featuring unusual materials, techniques, and forms. Some artists compensate for the lack of money with meticulous craft—emphasizing the material aspects of the book as an object, whereas artists exploring conceptual issues—for which the transmission of ideas is paramount to the material form—prefer materials and techniques that resemble industrial production. Not long ago this would have included photocopy and laser print; today the obvious choice is print-on-demand.

Print-on-demand providers produce books digitally in small quantities, starting with a single copy. Although most of these services offer a limited choice of book formats, papers, and design templates, and although the price per copy is comparatively high, there is one advantage that makes many artists choose this option: print-on-demand is a feasible and affordable way to get your book out there. The internet is awash with photographers' complaints about the poor print quality or the insufficient binding of these books, and although many of these complaints are understandable, they miss the crucial point: For artists who are not primarily interested in the book as an object, and whose work is not primarily concerned with print quality the question is not "good print or bad print" but "book or no book." If the answer is "book," you'll find a way to work within the given limits. Even the most quirky idea that no publisher would ever consider can be turned into a book now, and it doesn't really matter whether it is printed in an edition of ten or one hundred copies. It's true, artists have to make compromises when they decide for print-on-demand books; they have to make compromises when working with a publisher too—and when you think about it, most of us have to make compromises all the time, when we go to a restaurant, when we buy a suit, and when we get married.

Again, distribution of these books is difficult, as most of them are not even available in specialized bookshops. Some of the print-on-demand providers offer books in their online bookshops but these are rather useless because books of some artistic merit are buried between un-curated piles of wedding albums, personal travel reports and all kinds of amateurish rubbish—and we must not forget that people making this type of book are the ones the companies' services were originally designed for. Discovering an interesting book in these shops is about as likely as finding a fifty Euro note in the street. Which is why I, together with some colleagues, founded the Artists' Books Cooperative. ABC is an informal distribution network created by and for artists who make print-on-demand artists' books. On our website (*abcoop.wordpress.com*) we make available information about selected books in order to help artists get their print-on-demand books to the people who are interested in them.

At this time hardly anybody would dare to make confident predictions about the future of publishing. Nevertheless, I dare say that more artists will make their own books, that more of them will use print-on-demand services, and that the quality of these services will improve notably in the not too distant future. That's it as far as the future is concerned; in the meantime, let's have one more look at the past to disperse another common assumption: self-publishing is an option for aspiring authors who will convert to established publishers as soon as they are acknowledged. While this may be true for some artists, there are a couple of fine examples proving the opposite. After years of working with and for various publishers, Claire Bretécher started publishing her comic books herself and never returned to the world she left behind. Her compatriots, Goscinny and Uderzo, published their *Asterix* series themselves from the very beginning. In Japan, the vast majority

of comic books have been self-published for decades. And it's not just comics, we find the same attitude in serious science, too. Maria Reiche had researched the Nazca lines in Peru for ages. She decided to publish *The Mystery on the Desert*—which turned out to be a major success—herself. Asked why she chose this way of working, she came up with one simple and convincing reason: "No publisher is going to drink champagne from my skull."

Chronicling the Chimurenga Chronicle
A speculative, future-forward newspaper that travels back in time to re-imagine the present

Ntone Edjabe, ed. 2011

Ntone Edjabe, ed., "Chronicling the Chimurenga Chronicle: A speculative, future-forward newspaper that travels back in time to re-imagine the present," *Chimurenga 16: The Chimurenga Chronic* (Cape Town: Chimurenga, 2011).

RONIC TIMES

EWSPAPERS MATTER. THEY
inflect our understanding of
the world, our attitude to
our politics. They affect the
we understand globalisation,
ay we approach identity, the
ve develop and practice a
of community.

the start of the 21st
ury, the printed media is in
s. The harsh demands of
just-in-time" marketplace
drained it of its creativity.
apapers no longer seem
to respond to the particular
enges our societies face
imagine a future might
ifferent from the present.

himurenga Chronicle proposes
istance towards these
rched Hierachies and
tual forms of thinking.

eived by the editors of
urenga, it is a once-off, one
nly edition of a weekly
paper the like of which
never been in Africa.
on the principles of the
inge of ideas, and the
ion of new concepts, the
urenga Chronicle will
produced in collaboration
two of Africa's leading
endent publishers, Kenya's
i? and Nigeria's Cassava
blic, and South African news-
er, the Mail & Guarding.

ultaneously utopian and
matic, reflexive and re-
ve and reflective, it is,
f necessity, a concept that
its basis in history. Back-
a to the week May 11-18
it reports on the first
of the so called
phobic violence in South

Africa- and events around
the world during this period,
including arts, sport, comics,
books and more. It invites
its contributors and readers
to suspend time and relocate
themselves existentially in
the past, during the week
ending May 18, 2008.

This is not only a commemo-
ration. It is also a second
chance; an opportunity to
provide the depth of reporting
and analysis that should have
appeared during this period.
Our aim is not only to reanimate
history - to ask what could have
been done - but also to provide
a space from which to reengage
the present and re-dream
the future.

Both a bold art project and
a hugely ambitious publishing
venture, it proposes a concept
of-what-will-come, of
emergence and uprising.
Stradling the space between
fact and fiction, it will bring
together the brightest talents
and leading minds of our time-
journalists and editors, writers,
theorists, photographers,
illustrators and artists from
around the world - to reengage
the format and to realise
how beautiful and important
newspapers could be today.

Released in May 2011, the
newspaper will be distributed
in South Africa, Nigeria, Kenya
and other Southern African
countries on the day of print
through traditional newspaper
distribution channels. It will
subsequently be made available
internationally via Chimurenga
and its partners distribution
networks.

See also Lyrical Interlude page 4

Immediacy Remediation

THE CHIMURENGA CHRONICLE
employs the newspaper
format as an evolving and
future-oriented field -
simultaneously acknowledging
what we love about the medium-
its radical necessity, rigour and
temporality - and dreaming up new
exhilarating and defiant possi-
bilities.

This is a dream not of a common
language, but of a powerful
hetoroglossia. It will bring together
the brightest talents and leading
minds of our time- journalists and
editors, writers, theorists.

photographers, illustrators and
artists from around the world-
to reengage the format and to
realise how beautiful and impor-
tant newspaper could be today.

An invaluable tool agaist the
tyranny of standardization and,
by implication, repetitious -
description, Chimurenga Chronicle
will feature rigorous investigative
journalism, writing and reporting
on regional and international
events that favours experi-
mentation over complacency

and lucidity over jargon, raw-to-
the-bone social critique,
challenging commentary, a dash
of tabloid intrigue, beautiful
art reviews and critical sports
writing. This will run alongside
photographic essays, comics and
illustrations and infographics,
so that we perceive, rather
than receive, our news.

The newspaper as a critical and
material practice and its politcs
myths and institutions - itself
becomes a self-consciously
discursive point of contention
and engagement. Based in a
tradition of critical, independent-
minded writing that is probing,
imaginative, socially conscious
and out spoken, the Chimurenga
Chronicle pays respect to
innovative publishing ventures
such as Fela Kuti's Chief Priest
Say columns published in
Nigerian newspapers throughout
the 1970s and early 1980s, and
historically significant publications
like New Nation, South, Drum
Magazine and This Day, while
simultaneously breaking radical
new ground.

emediation Immediacy

ACK-DATED TO THE
week May 11-18 2008, the
Chimurenga Chronicle is
conceived not merely as
meral printed matter but
as a work of art, a social
oture that embraces the
spaper medium as both
etorical strategy and a
cal method. It invites its
ibutors and readers to
end time and relocate
uselves existentially in the
t, during the week ending
18, 2008.

experience is a fiction
fact of the most
ial, political kind. It
oses that freedom
s on the construction
consciousness, the
native understanding of
ry, and so of future possi-
y.

It assumes an account of time
as lived, not synchronically or
diachronically, but in its multiplicity
and simultaneities, its presences
and absences, beyond the
categories of permanence
and change. This evokes 1990s
South African kwaito group
Skeem's provocation "Waar
was jy?" (Where were you?)
and responds to theorist
Achille Mbembe's call to
imagine new forms of mobilisa-
tion and leadership, to
create an "intellectual plus-value"
based on a "concept-of-what-will-
come."

Juggling these temporalities
involves "great leaps of imagination.
It demands a seriousness that
challenges ingrained generational
habits of superficiality and
prankishness; a will to organize
against laziness and cynicism;
and a desire to reuse the
banner of imaginative
engagement, play and
intellectual commitment.

BREAKING TRADITION

It is nessary to go beyond the traditional conception of
civil society that has been narrowly derived from
the history of capitalist democracies. On the one
hand, the objective reality of social multiplicity
must be acknowledged - multiplicity of identities,
of allegiances, of authorities and norms - and,
on this basis, new forms of mobilisation and
leadership must be imagined.
 - ACHILLE MBEMBE
 Chimurenga Online

The Chronic
Dr Dré

It's the chronic
I think I want a hit...
Take a trip, a sip of bomb

Come along...
Mind's eye opened wide
Come inside, No need to hide

Ntone Edjabe, ed.

A Readers Guide

THE Chimurenga Chronicle believes the future of the newspaper lies in your direction, i.e., a sheet willing to deal with the way we live in Africa today. It therefore aims to engage local publics in global stories that resonate in their own experiences and lives.

By shifting our understanding of location away from nation states and towards the interplay of multiply different fields and contexts, it hopes to explore dynamic relations between contemporary politics and their spaces of operation and to challenge traditional borders and boundaries. If we learn how to read these webs of power and social life, we might learn new couplings, new coalitions. The issue is dispersion.

The Chimurenga Chronicle will be published in May 2011 and distributed in key urban areas in South Africa, Nigeria, Kenya and Southern Africa using traditional newspaper distribution points, along transport routes on street corners and in corner cafes and shops on its day of print. Any remaining copies will be distributed to local and international news agents, bookstores, and in other special interest shops.

High Levels of Readership
Mozambique: 47%
South Africa: 41%
Nigeria: 39%
Zambia: 37%
Cameroon: 33%

Low Levels of Readership
Zimbabwe: 32%
Tanzania: 31%
Uganda: 24%
Ghana: 24%
Botswana: 13%
Senegal: 6%
Kenya: 5%

Source: African Media Development Initiative Research Report, 2006

READING READERSHIP

Newspapers are the most read material in South Africa [National Survey Into The Reading Behavior of Adult South Africans, 2007]. South Africa has 22 daily titles whose overall reach is 35.2% of the adult population, with a total audience of 11 million readers. 29 weekly titles reach 28.6% of the population with a total readership of 9 million readers. [AMPS 2009]

Of the dailies, the Daily Sun, with a circulation of 168 000, has the highest readership of 398 000, reaching 14% of the South African adult population. The Sowetan follows with a circulation of 90000 and 1495 000 readers (4.7%), while The Star boasts a circulation 67 000 and 799 000 readers (2.5%). Weekly paper the Sunday Times with a circulation of 142 000, reaches 3 977 000 readers (12.6%), followed by Soccer Laduma with a circulation 120 000 and 733 000 readers (8.7%) and City Press, circulation 108 000 and readership 2 046 000 (6.5%). The Mail & Guardian has a circulation of 54 000 and 496 000 readers (1.6%) (AMPS 2009)

In Kenya, approximately 7.6 million people reportedly read newspapers. Each newspaper in Kenya is typically read by fourteen people, and those who can't afford to buy a paper sometimes "rent" one. Four daily English language newspapers are published from Nairobi: Daily Nation, The Standard, Kenya Times and The People Daily. The Daily Nation's circulation is above 200 000 copies but as copies are often read by many people, the actual readership is much higher. It has a market share of almost 75% with its biggest competition coming from The Standard. (Kenya National Information, Education, and Communication Situation Survey, 2009)

23% of the Nigerian population read newspapers daily (UNESCO Institute for Statistics data) and 39% read a newspaper once a week. The Punch takes the lead with sale of 84 264 copies daily. The Nation, has 30 578 copy sales, The Sun, 3rd, 25632 copies, the Vanguard, 4th, 25 241 copies. The Guardian sells 25282 copies, 51703 copies and Daily Trust, 11 672 copies. (Zus Bureau Limited's Quarterly Media Audience Audit, 2009).

The last comprehensive analysis of media in Africa was 'African Media Development Initiative Research Report, 2006'. The initiative was an independent survey of the state of the media across 17 sub-Saharan African countries: Angola, Botswana, Cameroon, Democratic Republic of Congo, Ethiopia, Ghana, Kenya, Mozambique, Nigeria, Senegal, Somalia, South Africa, Sierra Leone, Tanzania, Uganda, Zambia and Zimbabwe.

According to their report: Readership levels can be broken into two distinct categories - five of the 17 countries did not have newspaper readership data available :1. High levels of readership (23%+ read a newspaper once a week): Mozambique (47%), South Africa (41%), Nigeria (39%) and Cameroon (33%). 1. Lower levels of readership (<33%): Zimbabwe (32%), Tanzania (31%), Uganda and Ghana (24%), Botswana (13%) Senegal (6%) and Kenya (5%)

"Everybody but the snob was welcome at the House of Truth." - Stan Motjuwadi

Yesterday's News

IN MAY 2008 SOUTH AFRICA WAS rocked by an outbreak of violence that seemingly took both the media and the country's leadership by surprise. These so-called xenophobic attacks were however not without context or precedent.

The result of our specific socio-economic, political and historic circumstances, they followed similar murderous episodes of xenophobia or ethnic conflict in other parts of Africa - such as the 2007 outbreak of "ethnic" violence in Kenya and "religious" violence in Nigeria in February 2008.

In May 2011, Chimurenga and its partners will publish a newspaper that aims to reopen the debate on conflict, citizenship, exclusion, mutuality and hospitality in our society.

To achieve this, it is necessary to move beyond beyond the logic of emergencies and immediate needs that characterised coverage following the violence. It is essential to situate these events within a context; to think through, debate and articulate the political, social economic and cultural theories of our times, as well as the networks of practices and alternatives that surround them.

"We may be at a turning p[oint] and need new names for human dignity, new codes [to] honour all nations can abide"
- Bessie Head in a letter to Michael Scammell

Chimurenga is a public[ation] writing, art and politic[s] based in Cape Town, [and] was started in Ma[rch]. Published in print tw[o] times a year and [now] monthly, Chimurenga [also] presents themed pe[rformances] called "Chimurenga Sess[ions]". Other Chimurenga Proj[ects] include "Chimurenganyan[a]", series of low cost mon[o-] "Chimurenga Library," an archive of independent African periodicals f[rom] around the world; "Afr[ican] Cities Reader," a comp[endium] of writing and art on cities; and "Pan African Station," a live music radio intervention in C[ape] Town.

www.chimurenga.co.za
www.chimurengalibrar[y...]
www.africancitiesreader[...]
www.panafricanspacesta[tion...]

Chronicling the Chimurenga Chronicle: A speculative, future-forward newspaper that travels back in time to re-imagine the present

MANUFACTURING DISSENT

E ARTS PAGES IN THE
ewspapers are often the
rst causality in the
risis currently facing
rint media, as editors
singly marginalise
al coverage of art,
ure and film in favour
estyle" content.

ally - or perhaps in
nse, newspapers are
aring everywhere within
rks," exposing the space
een production and
mption: who is addressed
ow.

h artist Serkan
aya calls himself a
verer," a professional
t - but his work is
uch about duplicityas
about duplication. His
ed drawing of pages
daily Radikal ("Today
Be a Day of Historical
rtance," 2003), and the
York Times (2006) re-
ct the neglected role
e individual in an age of
apable mechanical
ducibility. Unlike Warhol's
distant duplication
etic - the creation
ntings that are
sely devised as repro-
ons - Ozkaya's news-
s are hand drawn,
akingly constructed,
fect and dirty, they
te a smudgy gap
e texture of official
ry.

an artist Fernando
e's hand-drawn ink
pen pictures of
cal pamphlets and
paper articles and
s, exhumed from
us archives, mine
nilarly territory. Expl-
g the disparity be-
n the original doc-
ts and his own
tic reproductions, Bryce
es how history is
ually reconstructed
e present.

ast and the present
collide in New York
Aleksandra Mir work.
her 2007 exhibition
sRoom 1986-2000 she
ted poster-size
hand drawings of
ands of New York
id front page headlines
the mid 1980s until
millennium, re-organised
various thematic
gories ("Bad Weather,"
istmas Tragedy," "Killer
v Dads.") Cut free from
history, these works
led the everconsuming
es of amnesia within
spectacle of everyday

Elsewhere, the newspaper
itself, both as a subject
and a medium, has found
its way into works of art
that explore the role of the
media in "manufacturing
consent" and perpetuating
power relations. In the 70s
Chris Burden exhibited
"corrected" reviews of his
previous shows, acting out
a standard artist's
fantasy by systematically
rebutting his critics
with comments written
in the margins of the
articles. More recently,
Simone Allen's massive
archiving project
Newspapers, (2001-2004)
presents coverage of
South Africa in the
American press to
highlight how the media
perpetuates stereotypical
notions of place. Kakudji
a DRC born artist based
in Paris, pilfers freely
from the vast image bank
of the news media and
popular culture to create
crazy collage works that
critique a quintessentially
late capitalist sensibility
while Zimbabwean Kudzanai
Chiurai incorporates
newspaper clippings into
mix media works to expose
propaganda models inherent
in postcolonial institutions.

Within film, the broad question
of the postcolonial is often
connected to the history
and the aesthetic of the
film-essay. A hybrid between
the documentary and experi-
mental form, the essay-film
couples visual images-often
drawn from archival media
sources- with narration to
a cohesive cinematic thesis.
Filmmakers from Jean-Luc
Godard to Harun Farocki
Black Audio Film Collective,
Priya Sen and Aryan
Kaganof have all employed
the aesthetic to present
reflection upon the colo-
nial condition.

Appropriately, it's the
style used by Nairobi-
based filmmaker Judy
Kibinge in her latest
film, Headlines in History
(NMG's 50 year journey).
Combing documentary foot-
age, archival sources, news-
paper headlines, commentary
and storytelling, the film
charts the birth and
growth of East Africa's

largest media company
The Nation Media Group
over the past fifty years.
It's a story about Kenya,
the events that made
the news and the
stories, that celebrates
the importance in both
history and history-making.

Sometimes the medium is
itself the message.
Created in response to
the current crisis facing
print media, the 33rd
installment of the Mc-
Sweeney's Quarterly
appeared as a Sunday-
edition sized newspaper
released San Francisco
in December 2009. "It
is our unorthodox belief
that physical forms of
the written word need to
offer a clear and dif-
ferent experience," said
editor David Egger,
speaking on his vision
for the paper. Titled
San Francisco Panorama,

it flew in the face of
current industry trends by
collating together over
300 pages of content
created by some of
Americas most lauded
writers, artists, and pho-
tographers - from Stephen
King and Chris Ware to
George Saunders and Art
Spiegelman.

Equally ambitious, yet far
more taunque in cheek
was notorious liberal
prankster The Yes Men's
fake issues of a future
copy of the New York Times.
Embracing the frenzied
throes of journalistic spin,
over a million copies of
the spoof, carrying the
large and bold headline
"Iraq War Ends" and
dated July 84, 2009 were
distributed throught New
York in 2008. Preempting
Obama's "Yes We Can"
slogan, the paper highlighted
news stories that showed
the political left's agenda
realized. In this
alternate future universe,
a universal health care
bill was passed by Congress,
the Iraq War coming to
a close, and public
universities were free.

Why does everything have to be exposed?

An excerpt from the novel: The cry of Winnie Mandela
NJABULO NDEBELE

The newspaper I was
exposed to is social gossip.
It shames you without
destroying you. There is
something rough and undig-
nified about modern news-
paper exposure.

It often comes across as
brutality given the respecta-
bility of philosophy: 'freedom
of speech.' 'Freedom of the
press.' It is really freedom
to abuse, freedom to indulge
the prejudices of journalists.
Freedom of speech that
comes at you this way
often lashes at you violating
you the way Cortez or
Gonzalo Pizarro decimated
millions of people in the
name of the Father, the Son,
and the Holy Ghost, Amen.
It is the product of a
culture of self indulgent
excess, celebrating express-
iveness without discipline.

Baring all, the culture of excess
kills the beauty of love. Love

for me thrives on the power
of suggestion. It plays on
restraint and constraint,
pushing them to their limits.
It is to look in the eye of
a man and see desire, while
I make my own eye play
between availability and
aloofness. Being ritualistically
unavoidable is the highest
expression of my love. Why
does everything have to
be exposed? Why is freedom
to expose everything praised
so much? Freedom to have
everything! I'm suffocating
from the improprieties of
freedom.

Freedom, these days, often
comes at you as dominance.
It may be declared seduc-
tively to conceal subjection.
"Free speech", "free markets",
"free access", "free passage"
"free information", "free this,
free that, according to the
specifications of the white
man's history of desire
and dominance.

See also Letters from Literature page 4

Ntone Edjabe, ed.

Lyrical Interlude

Mr. Grammaticalogylisationalism is the Boss!!!
lyrics lifted off the 1975 album: Monkey Banana (Before I Jump Like Monkey Give Me Banana)
By Fela Kuti

Hear it! One more time/ First thing for early morning/ Na newspaper dem give us read/ First thing for early morning/ Na newspaper dem gives us read/ The onyibo wey dey inside/ Petty trader no fit to know/

Inside the paper/ Lambastical dey/ Inside the paper/ Ipso Facto, dey/ that one na Latin?

Inside the paper/ Jargonismdey/ Inside the paper/ Youth delinquency dey/ Who be delinquent?/ Na dem be delinquent/ Who be delinquent?/ The oyibo talker delinquent?/ Who be delinquent?/ It no be me o !

The oyibo wey dey inside/ Market woman no fit to read/ The oyibo dey inside/ Na riddle for laborer man/

How real is the threat...?

Dear Sir

The late edition of your newspaper of 10 May asks: 'How real is the threat of Muslim fundamentalism?'. In my view, it threatens the very fabric of society.

I am a retired proofreader with forty years' practical experience involving a wide range of publications, notably telephone directories. In the curse of my career, I came to believe that a standardized Test of proofreading ability would go a long way towards ensuring that qualified personnel are employed and standards maintained in this all-important but undervalued department.

I have devoted the years of my retirement to devising such a Test, drawing on Records kept during a lifetime of work, and this undertaking is now nearing completion. Besides its obvious value as a means of grading our own abilities, the Test may have wider application in commerce and entertainment, which would serve to publicize

the profession and draw young school leavers into its ranks.

I am approaching your newspaper first because you fly the blue peter of the profession from your masthead. So to speak, in the Greater Johannesburg area. (Many of my letters, including several on orthographical subjects have been published in your columns, and so we are not strangers to one another.) I would be happy to discuss the ways in which you might become involved in my venture at your convenience. A representative extract from the test, an 'appetizer', will be forwarded on request.

Yours faithfully, etcetera.

Ivan Vladislavič
The Restless Supermarket.

Letters from Literature

The Restless Supermarket
Ivan Vladislavic

The two sets of clues crypt straight, now appeared one b the other alongside the gr (with the straight ones on t reasons for the change w unexplained - they were a tinkering with the newspa these days, moving thing making them bigger or s or doing away them altog in the scramble for wha call 'market share' - but upshot was that one c longer fold the paper t obscure the straight without folding the grid in half. Just one fleet glance at the straight could take the difficu pleasure out of half a cryptic ones.

see also pa
Why does everything have to exposed?

Scrapiron Blu
Dambudzo Marechera

'Drought,' shouted the Daily Baboon newspaper.
Black Baboon was hungry.
Very hungry.
White Baboon was very, very hungry.
Green Baboon was also hun
'There is nothing but hun at the end of the rainb said the Daily Baboon N

African Psych
Alain Mabanckou

People believe anything the published in the newspap may have their doubts ab and television, but not abo information and images pu in a newspaper. It's wri therefore its been verifie after all, these people w how to write are not imb

"Even the De
Jeremy Cronin

When Chris Hani was alive t newspapers described him a popularist war-monger When Chris Has was assin the newspapers describe man of peace (pandemic, editorial amne

Credits:
Lettering and Illustrations - Unathi L Sondiyazi
Atang K Tshikare
Art Direction - Chimurenga LAB
Writing and Research - Stacy Hardy
Edited by Ntone Edjabe

Chronicling
The Chimurenga Chronicle

ISBN no: 9780981427317

Chimurenga cassava republic Mail&Guardian

The Ends of the Book
Reading, Economies, and Publics
Matthew Stadler 2011

Matthew Stadler, "The Ends of the Book: Reading, Economies, and Publics" (lecture, Beinecke Library, Yale University, New Haven, CT, November 2011).

The crisis in publishing is the collapse of the book as a commodity, as a nexus for shopping. That's it. That's the bottom line that has destroyed livelihoods and can wreck corporations. Ironically, this catastrophe also blinds publishers to a vibrant resurgence in the culture of reading. Reading and shopping have never been a good match—I would say they are opposites. As the publishing industry struggles to configure new sites of shopping and rescue an economy that used to support writers by selling books, vibrant new communities of reading emerge, both online and in small-run printed books. For those of us who love reading, for those of us who are sick and tired of shopping, this is a remarkable time rife with opportunity. The question we're faced with is not, as so many publishers believe, how to rescue shopping; the question is how to make a viable economy in a culture of reading.

In 2009 I learned of cheap, hand-operated machines that can make sturdy perfect-bound books one-at-a-time, fast and at low cost. I bought them and, with a friend, set up shop in a storefront in Portland, Oregon. Like a lot of people, we knew some great writers whose work we loved and thought should be published. We became publishers by printing, binding, and selling their books one-at-a-time directly to the readers who wanted them. We also offered the books for sale as eBooks, and we let anyone read and annotate them for free online in a digital "free reading commons." We made a website to sell and circulate the books globally, while also hosting the social life of the books back home at our storefront. Friends visited and liked what they saw. In eight other cities, mostly in North America, friends bought similar machines and opened up their own shops. The nine shops together comprise what we call Publication Studio. In five years, we've published 300 new titles, all of them profitable. Publication Studio has made a viable, unsubsidized, for-profit economy based in reading. This is the story of how.

Reading and Shopping

Reading is a specific practice. We know it best as reading books, but it's a practice that we can apply generally. Reading is open-ended, provisional, conversational. It's not solitary, but deeply collective. We might be alone with a book, but the book fills our heads with other voices and puts our thoughts into conversation, not only with the writer but with countless other readers, real and imagined. Immersed in reading, the self dissolves and mixes with others. We take comfort in the flickering, light-dappled margin, where we stand both inside and outside of the text. It is a liminal space. The relationships of reading are multi-valent, empathetic—they entail recognition across difference. Texts have many readers, divergent participants positioned at the edges of a shared central space; we recognize each other in common across that space, not erasing difference but living in it. Such relationships are not limited to books, but can also play out in the world.

Reading can shape an economy. I call that practice "publication." I'm going to draw things in sharp contrast to clarify the practice. Publication is the creation of new publics in a culture of reading. It includes the production and circulation of books, the management of a digital commons, and a rich social life of gathering and conversation with books and readers. All of these activities together construct a space of conversation, a public space, which beckons a public into being. Shopping—which is the prevailing culture of our time, and which drives most of the choices now being made in the publishing industry—corrodes and evacuates publics. So, real publication begins by quieting the noise of shopping.

The culture of shopping is pervasive. What exactly does it do to you? Shopping stages the repeated performance of the self along rigorously organized lines. The purchase is its pivotal moment. Every minute of every day shopping positions us on the verge of a purchase, a consumer choice. We stand ready, groomed for this moment by constantly cycling messages about our taste and its meanings. You know these messages—announcements addressing you by name; mail slots stuffed with personal offers; objects that beckon you, eliciting your enactment of taste within very narrow, in fact dictated, confines. The act of choosing becomes a repeated affirmation of your selfhood and liberty.

Shopping positions you alone in the spotlight, center stage, performing the correct, repeated display of your taste. It atomizes us. Shopping is the opposite of reading.

Readers naturally quiet the noise of shopping. We're distracted, which deafens us, and we fail to act. We go on reading. Not just books, but all those open, inconclusive relationships that reading entails. Beckoned to move into the spotlight and decisively exercise our taste, to consume, we instead dawdle in ambivalence, in the lingering incompleteness of the text. We keep circling, reading, rereading, cycling into the next book even before we've finished the last, so that the two books remain open, and then more; ten, fifteen books opened or book-marked, cluttering the room. We stay engaged. The clerk asks us what we'd like to buy, and we look up, half-focused in the space of reading, and we answer with a question. We invite the clerk into a conversation that might never be completed. These are the pleasures of reading, and if given serious attention, they shape an economy called publication.

Publication with Friends

About four years ago a woman named Jacqueline Suskin told me she'd been collecting old photographs from tag sales, thrift stores, even from the piles of garbage people

leave in the street after cleaning out a basement or an attic. Mostly snapshots of travel and families. She had scores of them. The photos were haunting, not only because Jacqueline was drawn to haunting images, but because of the way they reached her. Many were bent and torn, deeply marked by the neglect and time that separated them from the lives they came from. Jacqueline had been writing poems from these photos.

She gave me a manuscript. The poems were lovely. Deft, slight things that graced the images by remaining quiet and understated. The language was bold, sometimes funny, and drew attention to itself, though the speaker did not—she framed and tended the slight margin the world had left around these photos, conducting her business of writing there and leaving the spotlight to the pictures. Jacqueline's poems were modest, but I got lost in them. It was an odd book. Jacqueline wanted to print each photograph in full color, opposite each poem. I kept going back to three or four poems that stuck with me, and I grew to love the book.

In traditional publishing there's a moment when the pleasure of reading must stop. Usually that moment is marked by the sad sentence, "I love your book, but I can't publish it." The disappointed writer concludes that the editor is either a cold-hearted liar or a fool. In fact the editor is neither. The editor is someone who sincerely loves books but lives in a special kind of hell where hundreds, if not thousands, of talented writers are motivated to send her their very best work, which she is obliged to read, often to love, and to reject over and over and over. The sentence she writes a dozen times a day, in all sincerity, is "I love your book, but I can't publish it." This is publishing's hellish negative to shopping's moment of affirmation—the repeated performance of the discerning self saying "no" to what she loves. It is anathema to readers.

Publication—an economy based in reading—extends the pleasures of reading deeper. Having read a book, the editor's reply is either "I love your book, I want to publish it." Or, "I don't love your book, good luck." Because we make our books one at a time as they are purchased, and we organize our work around the relationship of one reader to one book, any book we love can be published profitably. We make books for readers who want them, so we have costs only when we also have income from selling the book.

I emailed Jacqueline and said, "I love your book, we want to publish it." She was thrilled. I explained that this meant we would make books for anyone who wanted them, but one-at-a-time; and we would only send books to stores if the stores bought them, agreed to keep them, sell them, and never return them. We offered the stores a 40% discount so they could make their customary profits. Jacqueline would get half the profit on every book we sold. The way things got priced, that meant she made about $4 on each sale. The book is eighty pages, lovely and modest, like the poems, and it's called *The Collected*.

It turned out Jacqueline had friends in Portland. She wanted to come up from Arcata, California, the pot-growing capital of the US, where she lived and did her work as "poem store." (Poem Store is a project she shares with poet Zachary Houston. They set up a typewriter on the street and write poems for strangers, on themes of the customer's choosing; poems cost $1 each.) Why not bring Poem Store north and have a Portland launch party for *The Collected*? Jacqueline would read and her friend's band would play. We'd invite all our friends. Jacqueline likes to travel and we agreed it was a great idea and started planning the party, spreading the word, and making books to sell at the event.

Agreements in traditional publishing are a little different. Let's say it's a good day in publishing, and that rare pleasure has appeared, the letter or phone call saying "I love your book, we want to publish it." The editor offers a contract and an advance—which is a wager, money bet against future sales—in exchange for the writer's promise to not allow anyone else to publish the same work. The standard publishing contract pivots on this prohibition—the writer is paid for agreeing to not offer her work to others. (Advances can be big or small and are becoming less common, but the promise of exclusivity remains at the core of the publishing contract.) Without an exclusive right to publish, the old wisdom goes, the market will be flooded and profits will be lost.

Given the bet that the publisher has made—in the form of any advance payments, printing and distribution of a print run, and pushing that run into stores or book-media quickly enough to sell copies before the book is old or irrelevant—the need for exclusive rights makes sense. But it is an ugly way to begin a crucial relationship.

By contrast, publication—driven by a reader's hopes for the book he loves—begins with a nonexclusive contract. We ask the writer for permission to make our edition of her work. We welcome, encourage, and even help the writer find other publishers to make other editions and join in support of the writer's work. An economy shaped by one at-a-time production, focused on the relationship of one reader to one book, makes money one sale at a time. For us the "lost sale" is a meaningless fiction.

Further, in publication there are no hidden bets, no history of speculation weighing the fates of our books unequally. We don't have a thousand copies of Jacqueline's book in a warehouse or out in the stores waiting to be sold. We don't even have two copies. We have Jacqueline's permission to publish our edition, to make and sell copies as needed to readers who want the book, and we intend to keep doing so forever.

I wish the next turn in my story was the appearance of a second excited publisher who also loved Jacqueline's work and called to say, "Yes, we'd like to publish an edition too." Sadly it's not. And when that second publisher does call it is more likely that they'll say, "We love your book and

would you please stop working with Publication Studio, so that we can take over and do a proper job of publishing you?" But that day has not yet come; so, instead, let me tell you about the party.

It was a great party. Jacqueline's dad came from Cincinnati and brought a lot of booze. A local café made snacks that could have been meals, and everyone crowded into this weird skater/crafty gallery that's down the street from us, where they like books and thought it would be cool to have a poetry reading. Jacqueline is an excellent reader. She showed some of the photos on slides as she read. The friend's band was called "and and and," and they were awesome. By the time they played we'd drunk all the booze and people were dancing on tables. The place is tiny, so it was packed. The gamble we took—making forty copies ahead of time for the party—paid off. We sold all forty.

This was a good start. Given the way that we work it could also be the end. Maybe Jacqueline really prefers staying home. You know writers. She's working on a new book. The party was fun and, hey, she made $160. But why do more? As it turns out, Jacqueline is a restless and social person. Over the next year she made similar events in dozens of other cities and sold hundreds of books. Some of the parties were in bookstores that now carry her work. And other stores heard about it and ordered the book from us. I'll tell you more about *The Collected* in a second, but first let's look at that new book that Jacqueline is working on. Let's say it's a novel, or just a good long story, and it's brilliant—smart, empathetic, fierce, like Jacqueline's poems. And this time the good news comes: Knopf wants to publish their edition alongside the Publication Studio edition Jacqueline insists on. (I'm imagining here.)

At this point a second difference between publishing and publication appears. Having leapt bravely into the future of nonexclusive rights, Knopf must still make a guess, a wager, that will oblige them to pursue certain time-pressured strategies on behalf of the book. How many to print? Thousands? Tens of thousands? What if Terry Gross interviews Jacqueline? What if Michelle Obama gets ahold of the book and loves it? In what season to bring it out? Who is the market for this book, and how to reach them in the three- or four-month window that a new book has to spark interest and sell enough copies to stay in print?

At Publication Studio, our challenge is a little more manageable. No bets weigh on our books. The day Jacqueline approves the final design and we're all happy with it, we print one and marvel at it. It's a wonderful day. That copy goes to Jacqueline, of course. Then we print a second one and we send it to Joy Williams. (Again, just imagining, "for instance …") She knows Jacqueline's work, met her on the street at a Poem Store in Florida. Joy likes the work and they've kept in touch; so Jacqueline scribbles a note to include with the book when we pop it in the mail. We take our time. Publication, the creation of a public shaped by reading, is not time-pressured.

This economy is starting to look a lot like an older model of publishing. Book lovers writing to friends whom they think might love a new book, or a not-so-new one. Where the ease, surprises, and readerly indirection of old publishing (as recent, say, as Bennet Cerf's Random House or James Laughlin's New Directions) were the product of lower profit pressures, steadier back-list sales, or simply wealth, the opportunity to return to that model—to publish what we love at a pace that befits our enduring care for it—now extends to those of us with very little money, no subsidies, and no back-list.

Through the efficiencies of one-at-a-time production and the broad reach of digital circulation and the internet, Publication Studio has been able to make profitable strategies for 300 new titles, channeling all of our earnings directly back into the social life of the book. We've made and sold more than 25,000 books, with zero returns, directly to readers and through 50 or so bookstores around the world, stores that work with us because they saw our books and wanted them. Echoing our excitement and loyalty as readers, those stores also agree to never return the books we send to them. They buy our books because they believe the books are worth buying.

The Collected is in stores in Paris, Berlin, London, and many cities across North America. We've sold around 300 copies. Most of the copies sold at events where Jacqueline reads. It helps that she loves to travel and she's a good reader. But as the books sell and circulate, online orders and interest from bookstores both rise. Instead of the apocalyptic model of traditional publishing, where the book is visible everywhere for three or four months before disappearing completely, its last bubbles rippling the surface of the remainder tables before going under completely, Jacqueline's book remains visible in the hands of those who love it and who will speak for it. Its presence is a low, rich hum that has grown, not a loud shout followed by a startling silence.

Publication with Strangers

If publication is the creation of new publics, how does this constitute "a public?" How can 300 books make a difference? And how can a writer live on so little money?

First the money. Jacqueline lives the way that most published poets do. She works various jobs and hopes for prizes while depending on the peripatetic life of her book to spread the word. Sometimes we think that famous poets make money from their work, but they mostly make money by being famous, not by selling books. Heather McHugh, a MacArthur fellow and a leading figure in American letters, tells me no book of hers has ever made more than five thousand dollars. And that's the high end of the poetry economy.

Writers, not just poets but all literary writers—up to and including the famous ones—do not make a living selling books. They could make a living on the winning end of a

publisher's foolish advance, but more often than not, the big advance is a dangerous end game, one that is becoming increasingly rare. Writers make their money elsewhere, with prizes and teaching and gigs that stem from their achievements as writers. So, books are crucial, but book sales do not comprise a living wage, even for most well-known writers. It's important to dispel the myth of "making it" so that younger writers can turn away from that false promise.

In publication, our writers will make money from the books we sell. They'll make their fair share, but they won't make a living. So it is for writers in these times. Publishers should aim to not be wasteful and be sure everyone profits equally. And they should concentrate their energy on the more important question of publication—how to make new and lasting publics?

How do publics grow from such small numbers? The publics that matter, that can shape or change our lives and the fate of books, do not depend on numbers. The misconception that they do—that publics become significant only as they get bigger; mass movements catalyzing when the sheer size of a crowd or a vote or a poll overwhelms the size of opposition to it—begins in an age-old confusion of publics and markets. The first naming of "the public" as an identifiable political force came simultaneously with the emergence of "mass markets" as a force shaping European economies in the late-eighteenth century. What we have come to regard as democratic forces, "the people"—this abstraction that is measured in numbers, either of bodies in a crowd, votes at an election, or units sold—is actually the buying power of effectively interchangeable consumers positioned at the end of a new economic form, global capitalism, that required vastly expanding markets to sustain its core engines of growth.

I won't expect anyone to be swayed by my thumbnail history. But look at the discussion of "the public" that's encapsulated by Jürgen Habermas in his mid-twentieth century analysis of these concepts, and you'll see the confusion between markets and publics that I am speaking of. The point that's relevant here is to separate the two. We want to know how to make new publics, not markets. And to do so, we must focus on the quality of relationships, not on their number. Mistaking publics for markets, we have wrongly assumed that their power or importance can be measured by a head-count.

A plaza of holiday shoppers, no matter how crowded or busy, does not shape a public. The atomized shoppers lack the crucial recognition of one another, the capacity to see each other and act in common. When we engage strangers as people, when we find ourselves partly by finding their selves, we catalyze a public. When we withdraw that recognition and categorically exclude or erase them, we retreat into something that is not public. Usually it is a market. The catalyzing or erasure of publicness is palpable. You can feel it as you enter a plaza or a crowd, and either recoil from strangers, withdrawing in revulsion, or engage and act toward these strangers as you would toward those you know. In this spark of recognition, of common humanity across difference, you feel a public kindled; you feel its flame grow.

There is no preexisting public. Publics begin in wilful actions, an invitation, an event. A public can arise in any defined space that is open to strangers—a street, a meeting hall, a plaza or park, or a book—and is best supported by small, formally clear settings where there is an obvious threshold to be crossed. An invitation to join, literal or implied, is crucial. A good example is the cover of a book, which can be opened, or closed.

We catalyze publics when we make and circulate books. The book held in a stranger's hands welcomes him into a space shared by others. A used book might even bear their marks, notes scribbled in the margins. I sometimes find used copies of my own books annotated by readers whose fanciful conclusions I can only marvel at. "Bird imagery here," throughout the margins of my first novel, Landscape: Memory, seemed to me to be evidence of some misguided undergraduate instructor who had assigned my book in the hopes of "teaching it." In another copy I found the exclamation "omg" beside the book's first detailed description of oral sex. The notation thrilled me. I pictured a wide-eyed reader, rapt with fascination, a complete stranger for whom this event had meant as much as it had meant to me.

My grandmother read these same-sex scenes, decades ago, and she sent me a heart-warming note, thanking me for portraying a romance between two boys "without any graphic sexual content." She'd read the whole book, closely; but what she did not want to see did not impose itself on her. In this way, books are especially welcoming public spaces; they offer everything, but don't force it on you. You can flip ahead, glaze over, or close the book and sigh.

My book's public includes my grandmother and the misguided members of the undergrad class, clutching their marked-up copies, and the book groups who adopted it, and the nervous teens whose counselors put it on lists of "gay and lesbian youth novels," and the travelers who find it in one hostel and leave it, later, in another. Books travel through the world collecting strangers. They are public spaces. Readers meet in the margins, at the flickering, light-dappled edge of a text they share in common. You know this moment of recognition—in a crowded subway car or on the benches of a public park, when you see a stranger reading the same obscure book that has meant the world to you. It's a powerful and unfailing link. Books make publics. And these things grow, especially if we organize our work to help them grow, rather than killing them young if they fail to achieve certain market metrics, the metrics of shopping.

Some books will circulate widely, and their publics grow large. Our Walter Benjamin books, with Carl Skoggard's superb new translations, have an international readership that grows each month, without the kind of social life or

support that Jacqueline Suskin brings to her books. In this case, the books themselves speak clearly. Joe Holtzman, Carl Skoggard's partner, and the founder and designer of Nest magazine, where I worked, designed the covers. We told Carl, no printed covers, only recycled file folders and rubbers stamps. He told Joe, and the results were brilliant. The books sell anywhere we place them.

Other books aren't meant to travel. My neighbors in North Portland, the painters Chris Johanson and Johanna Jackson, painted a mural on the side of our local grocery store. It's beautiful. They made ten watercolor studies for the mural. They letter-pressed the pages with a local printer and hand-painted thirty-six sets of them. We bound the sets as books, thirty-six copies. Almost all are in the hands of neighbors and friends now, but a few are in Amsterdam and Berlin, and there's one in the Beinecke Library collection of American literature.

Other books travel and grow significant publics, but they do so unpredictably over time. They live out the social life of the book, within lives shaped by reading, not shopping. There's no telling where they will go, only that each book will have its own unique life and its own public, however big or small. Publication, the economy we've shaped around the relationships of reading, can treat each one on its own terms, giving them attention and producing books for sale when needed, and letting them lay idle when not.

Publication as an Economy

In 2011 I published my fifth novel, Chloe Jarren's *La Cucaracha*, using Publication Studio, this apparatus I'd been touting to my colleagues. I got in touch with friends in a dozen cities, people who had read my books and knew my work. Six of those were friends running Publication Studios, making books, hosting events, hosting the economy of publication. In each city we set up a dinner—one big table of forty to fifty people, a local chef who was game for an unusual gig, great food and drink, and sometimes a special guest, usually another writer, with whom I'd have a conversation as part of our gathering. Seats at the tables cost $45 to $75, depending on what the chef had in mind. They were lavish. The seats were tout compris, all the booze and wages for the servers and chef, and, importantly, a copy of my book. We set the ticket price by figuring out the total costs of the event, including the cost of the book, and dividing that by the number of seats. Anywhere PS had a studio they made the books fresh in editions unique to the event, date stamped, as we do with all our books.

In two weeks, having these big dinners almost every night in San Francisco, Dallas, Mexico City, Guanajuato, Los Angeles, Vancouver, BC, Toronto, North Adams, MA, New York, Seattle, and Portland, I met 500 people and sold 500 books (and made $5 on each book sold). It was exhausting, thrilling, and buoying. The connections I made over the long hours at these dinner tables meant more than most I've made reading to bookstore audiences,

where shoppers sit and try to decide if my book is worth buying. And pragmatically, they mean much much more. We don't just make sales. We meet readers, a more enduring thing.

It helped that I'd published four books before and had had some earlier success. I doubt that many first-time authors could do what I did. But if we make an economy based in reading, shift our attentions away from shopping and the allure of big publisher's gambling, and back onto the relationships that mean so much to us, writers will begin to see and engage the potentials I was lucky enough to find that summer. They're there. The audience is as ready for change as we are; they're ready to be addressed as readers sharing the common space of a book, strangers ready to recognize each other across difference.

This is publication, the creation of new publics. We're fortunate to live in a time when it has become robustly possible, even for those of us without means or investors, equipped only with our love of books. The printed book—made and sold one-at-a-time to readers who want them—turns out to be the best, indeed irreplaceable, instrument of publication (better, even, than its temperamental, disappearing cousin, the eBook), even if it might be a poor driver of sales.

From Publishing to Publication

We still shop in a culture of reading, just as we still read in a culture of shopping. The skilled reader might be bad at shopping, too slow and indecisive, just as skilled shoppers are often lousy readers (too impatient to finish, not to read but to "have read" and to get on to the next book). But the two coexist. A culture of reading makes an economy that is, like reading itself, slower than shopping. It's conversational, open-ended, interested in detail, difference; it goes on and on, back-and-forth; it accepts what is available, rather than unilaterally demanding satisfaction. Shops like Henry, in Hudson, New York, or Ooga Booga, in Los Angeles, or hundreds more in scores of other cities, show us the viable economy of a culture of reading. It's relaxing and always interesting. Yes, it's slow, but big things happen, and it's steady.

The simultaneous viability—even thriving—of this "reading economy" amidst the prevalent economy of shopping is probably most obvious today in the food industry. The food industry is dominated by what's called agribusiness, the massive companies like Monsanto that reward industrial scale farming by linking those suppliers to vast distribution networks and global markets where consumers become accustomed to the convenience of brand-name pre-packaged foods, foods whose origins and economy the consumer remains unaware of.

Amid this dominant culture of industrial-scale food production, there is a multi-headed, multi-rooted, swiftly spreading sort of "blackberry vine" called "slow food," which has many different versions in different nations and cultures.

Matthew Stadler

The essence of slow food is that the person who eats knows something about the place their food comes from, who produces it, and how it gets to the table. This knowledge—more so than any strict rules about scale or distance—defines "slow food." It's not really that slow. Since the easiest version is to grow food in your back yard and eat it (or, similarly, to visit the nearest farmer, or yard, with good food, and buy theirs and eat it), "slow food" can actually be a lot faster than agribusiness. The difference is in the knowledge one has and in the relationships that lead to it. These are relationships of reading—open-ended, conversational, back-and-forth, enduring, curious, never unilaterally demanding.

Publication, the economy I've been describing, is the books' equivalent of "slow food." It's local. It's made by hand by people who care. It carries the best quality work in the world, and (because literature travels well) publication gives us access to the entire world of books, not just what is geographically near-at-hand. I like this economy because I love reading.

It is just as viable as slow food. It exists and can thrive, regardless of the fate of traditional big publishing. My hope is that anyone who values a culture of reading above that of shopping will actively join in the economy of publication. First we do so by insisting on nonexclusive contracts. Second, we discourage gambling on big print-runs. Third, we extend the pleasures of reading as deeply into this economy as they can possibly go.

Reading is not just that thing we do with books, on those luxurious evenings when we've canceled plans at the last minute, set a fire in the fireplace, and sit down to read without obligation until bedtime: it is also the thing we do throughout the day in all of our relationships and interactions—with our economy. We can be readers rather than always shoppers.

Author's Note:
This text was commissioned by Tim Young at the Beinecke Library at Yale University for a talk given by Matthew Stadler in November 2011. The title is his, as was the inspiration and support.

Manifeste monotone/Monotone manifesto

Eric Watier 2011

Eric Watier, "Manifeste monotone/Monotone manifesto," trans. Simone Manceau, *monotone press* (website), accessed October 12, 2018, monotonepress.net/monotone/index.php4.

monotonepress.net is a free website for online display, distribution, and publishing.

From the moment an object is turned into a digital file, any digital medium is suitable for its distribution.

What discretization offers is not so much new forms of images or sounds (since the digital often copies from ancient forms of presentation or representation), than an extraordinary ability to circulate objects to be rematerialized.

Any new technology involves objects and processes which until then had been unthinkable, the most difficult exercise being to get rid of the very habits induced from previous objects.

Up to now, any intellectual or conceptual work necessarily materialized into a fixed physical medium and was protected by its copyright which preserved the originality of the idea through the originality of its inclusion into a single form. The two were inseparable.

With the digital object, we are faced with a separation between concepts or processes and the various media into which they can be translated.

To benefit from a digital object, it must first be reactivated.

While at the beginning of the twentieth century, it was the reproduction of an object which led to its consumption, today it is the desire to consume that generates the need for reproduction: consequently, in order to consume one must reproduce.

Yet, while downloading deprives no one, because it eliminates no object but on the contrary keeps reproducing it, the industry tries to make us believe that doing so constitutes theft even though nothing has disappeared. On the one hand they organize consumption—selling all kinds of machines for the reproduction of works—on the other they limit—legally and technically—the proliferation made possible by these very technologies.

In addition, by monopolizing the debate on copyright, they justify the very shortage that they themselves organize and from which they try to get maximum profit.

Yet the question posed by the digital remains: how to evaluate economically an object when consuming it doesn't lead to its depletion but on the contrary to unlimited proliferation.

The industry of subjectivity more than actively participates in the reduction of what is on offer, while trying to make us believe the contrary. It claims to participate, organize and protect the diversity of our subjectivities, we know full well it is not true. It is a fiction self-created and sustained by the industry.

Why should this industry ban the piracy of poor cultural products when these products contribute to the very creation of a market and a global monolithic subjectivity from which they harvest all their profits? For a unique and simple reason: in order to sustain the myth of a rich, diverse, and independent artistic production while smashing it to pieces. And to make us believe that what they sell is Art, whereas what they manufacture are financial products.

What Hadopi (and the cultural industry via Hadopi) do not want is films without the film industry, publishing without the publishing industry, and music without the music industry.

What is threatened by the digital is not art, but the art industry as it prevails today. That is to say, as it dominates our subjectivity.

Once again what they are trying to steal is the possibility of our freedom.

If what characterizes the digital is a permanent separation between content and form, we can only come to the conclusion that contents must remain free, absolutely free, for the benefit of all. That only the singling out of such content into specific objects can be owned or "proprietary," as Richard Stallman would put it. And only those objects that have become "proprietary" (because of their translation into a physical object, for example) may be subject to trading (if one wishes to trade).

Therefore, we must envisage a new economy where the objects are fully available and at the same time can be materialized always singularly and unlimited.

We must also recognize that this economy of intangible, immaterial abundance is, at the same time, an economy of successive nonexclusive appropriations.

Thus, to make things perfectly clear, we thought it necessary to create an independent structure for the diffusion of content, in which anyone can go and search for what is needed to achieve one's interest (if one is interested): books, posters, cards, and other printed matter.

This is the very structure of Monotone Press.

Monotone Press exists under French law. That is to say the moral law. There is no higher one.

All other rights (copyright, copyleft, creative commons) are only impoverishments of the moral law.

Whatever its form, the Anglo-Saxon law remains the right of the object but never the author's right.

Under French law, "the author of an intellectual work shall – from the mere fact of its creation – has exclusive immaterial property right against any other."

French law does not conceive of a separation between the author and what he produces. What he makes is inseparable from who he is.

In this context, the moral law is a law where the degree of freedom depends on the author. It may be totalitarian or totally free. It may be totalitarian for some and free for all others.

The moral law thus determines the social political and economic relation, which the author may entertain with his public.

So why decide a priori of what one can or cannot do with Monotone Press? Why not just decide later? A priori, everything is allowed. We will see later whether some uses will be considered scandalous or dishonest.

Consequently you can do whatever you like with Monotone Press (except what is not appreciated).

Crux Desperationis

Riccardo Boglione 2012

Riccardo Boglione, *Crux Desperationis*, Montevideo, accessed October 12, 2018, cruxdesperationis.weebly.com/. First distributed by email in 2010.

LITERATURE STRIPPED OF SENTIMENTS • LITERATURE
STRIPPED OF THE LITERARY • GENRES MIS À NU • BIG IDEAS
TINY TEXTS • WORKS AGAINST THE RHETORIC OF THE
RHETORIC AS RHETORICAL • PERPETUAL QUESTIONING OF
THE FORMS OF LITERATURE • PARASITIC AND TEXTSUCK-
ING WRITING • ERASURE AND ABRASION • WRITTEN AUTO-
MATISM VERSUS AUTOMATIC WRITING • POLITICAL UNDER-
STATEMENTS • FOOTNOTES VERSUS TEXTS • ABSTRACT
LITERATURE • WORDLESS WRITING

RR, Relaxed Reading or
The Ambient Stylistics of Tan Lin

Lisa Holzer, David Jourdan 2012

This is about boredom and its relation to things we know are repeated. A poem should act in a similar way. It should be very repetitive. It should be on the outside not the inside of itself. It should never attach itself to anything, or anyone who is alive, especially the speaker who rightly speaking constitutes the end of the poem. In this way, it should create something that looks like it has been "sent away for." Richard Prince said that.

I wanted reading to be less not more narrow as a practice. I have linked this, in earlier work, to notions of ambience but here it's directed at an array of reading platforms. I mean is there really a need for such a valorative distinction on two modes of reading or to bring them into an antagonistic (high/low; focussed/distracted) position? Who benefits from this? Can we really even make such a hard and fast distinction? I'm not positive.

This is a poem about boredom and its relation to the things that we know are not repeated. It should not describe but only skim (biographical) material we already knew. It should exist on the edge of something that is no longer funny.

In this way, it should create the meaningless passing of time, like disco music.

A poem should have died just before we got to it. Like the best and most meticulous scholarship, the poem should be as inert and dully transparent as possible. T. S. Eliot said that.

I am not sure what reading is supposed to do or how it is supposed to do it. Is *Heath* literature?

Is that the only framework that will work for it? I hope not. But of course, that is one of the frameworks that the book seeks to both address and get away from. And of course, *Heath* has footnotes but they're not really pointing to something elucidatory, something outside that can explain the text from the inside. They are more like street signs to something outside the text, and they are a bit inert. But maybe this is no different from Eliot's footnotes to *The Waste Land*, which are serious and a joke.

This is a poem about boredom and its relations to the things that were not said. A poem is what it is not. It should merely involve the passing of its own temporal constraints. In this way, it can repudiate all emotions except mechanical or chemical ones. After all, the emotions in us are usually dead (and can only be revived by chemicals), and the only emotions that we really could be said to have are the ones we already had.

Maybe this is more easily stated this way, with the two statements separated by a /. Reading *Heath* is HARD. It's hard to parse, it's hard to figure out what it "means." / No, reading *Heath* is EASY.

If you just relax a little and let yourself move freely through the text, if you skip over half of it because you already get it, which is what anyone does when they jump from one link to another link.

We live in an age when we are constantly told lies, made the subject of jokes, seduced by fluff and hyped with misinformation. Poetry should no longer represent the representation of knowledge, it should represent the dissemination of misinformation and lies. It should aspire to ever more bureaucratic forms of data transmission and delivery.

Of course, and here is the rub, reading *Heath* is difficult if you conceive of the book as the product of a unified sensibility, of "trying" to figure out how it all coheres rather than as a series of loosely annotated notes to cultural production and reading practices conceived more generally or generically or ambiently. Reading and writing have gotten easier to perform in a social space, i.e., a kind of reduce reuse recycle revise in the language ecosystem, so I was trying to align or even ally avant-garde practice with what I see is an actual and contemporary sphere of cultural text production that is less hindered by notions of difficulty, perceived autonomy from the market / mass exchange forms, popular formats, and notions of individual ownership vis a vis intellectual property, etc.

A poem, like the '70s, is just another way of inducing a series of unforgivable likenesses. Warhol said of his art that "if you don't think about it, it's right." Listening to a poem or novel or newspaper should be like that; it should be camouflaged into the large shapes of the patterns of words that surround us and evoke the most diffuse and unrecognizable moods that a culture produces.

I simply wanted to ask: what happens when you bring notions of cultural distribution, social networking, dispersed multiple authorship into the sphere of difficult, serious, academic literature?

No one should remember a poem or a novel, especially the person who wrote it. Heidegger was right; one is never without a mood.

So I am very interested in what I would term "social reading" on the periphery of one's attention or something inexact like that. And this is probably because I have been distracted as a reader, but I think all reading is reading with distractions.

All talk is nothing but a form of latent imagery and noise dispersion.

All speech should be televised for maximum effect.

All talk is nothing but a form of latent imagery and noise dispersion.

All speech should be televised for maximum effect.

All talk should aspire to the impermanent repeatability of a disco beat.

Only in such a way does a word flower in the brain.

Why not generate avant-garde work that is easy and relaxing and mildly original? Isn't that what most writers do anyway? Jerry McGann has written about expanding the book beyond notions of authorship and into what he calls the bibliographic condition, Matthew Kirschenbaum has called attention to forensic materialism vis-à-vis specific data storage platforms in relation to processing more generally, and Rachel Malik has written about the horizon of the publishable as an expanded frame for the understanding of text production. I would have to say that I was interested in doing something similar but within the confines of a single book regarded as a relaxation parameter with a specific set of affordances.

A great poem, like Ronald Reagan, lies without knowing it. Lies are the most mechanical forms of speech known to man and his noises.

The project: relax the avant-garde. Why? because the avant-garde feels tired in its gestures, feels like it has to plagiarize to "make a statement." Or feels like it has to resort to appropriation as something incendiary, as something neo-avant-garde and from an earlier era. But appropriation is no longer avant-garde. It's standard practice in and out of the classroom. Is appropriation in "experimental literature" still "experimental"? I don't think so.

Pure repetition involves recognition of previous sounds in the shortest of attention spans: the span between two words. Unfortunately, the voice occasionally flutters or expresses random ambient sound bursts (nonrepetitive patterns). Even now as I speak, the human voice is strangely inhuman and mechanical, plagued by poor transmission, errors, and mechanical repetition.

I wanted something—maybe it wasn't even a book—that was freely acknowledged to be not an individual product and not laborious. There was a lot of labor employed to produce this text, but most of it wasn't mine—it was outsourced, which is a perfectly legal way of getting someone else to do one's work for one. You pay them for it. You circulate it to generate value. This is particularly true in the cultural sphere.

Poetry should not be written to be written, it should be written to be listened to, it should not be written to be remembered or absorbed, it should be written to be forgotten.

I think the more complicated issue here is that between plagiarism and appropriation. I feel that the use of appropriation is clouded by all sorts of neoromantic avant-garde practices and ideologies—and involves saying something like "look at me, I stole something" on the quasi-legal end of the spectrum and "look at me make something new out of something old" on the other end of the spectrum though the latter has collapsed somewhat into the former. Appropriation is back in a major way, in the art world and in the poetry world, and I started asking myself why. Reading, most reading, is easy and superficial, like appropriation. But I am interested in the manner of appropriation and the manner of reading.

Poetry, like drugs, should not be difficult, it should be easy. Poetry should not be interesting, it should hold out the potential to be very insipid. Boring is the least of what most people have always realized, evidenced by the large numbers of Americans who have never read a poem. Poetry should not be uplifting, it should inspire a deep sense of relax. Poetry need not say anything important or humanly meaningful, it should merely evoke a mood. That mood resembles the sound of a sunset. Jack Spicer understood that all unsaid words are painful to listen to. They are better to look at. That is why Jack Spicer is a beautiful poet.

Really, I like appropriation, but it's only appropriation, it's only what most people do most of the day anyway.

What does it mean to stop reading a poem? It means that one is tired.

This leads to a recognition: today, appropriation, in the experimental literary and in the art world, tends to dramatize itself by calling itself "plagiarism" even though it is just plain appropriation or unacknowledged citation. This is why I put plagiarism in the title.

The end of summer is the end of the things I do not remember.

There is no longer time for protestation in language. Poetry should not be performed, it should merely be listened to.

The time for conscious experimentation and ego, which is its logical extension, should be replaced by unconscious repetition and listening.

All poems should be rewritten over and over again and exist in as many versions as possible.

Appropriation per se is no longer shocking—it is just part of our reading cultural environment where information is exchanged continually and for the most part freely. *Heath* is not meant to be shocking or hard to read. It may not even be literature. It may just be a platform, like the web, or like an index card, or like a footnote to something hors texte. I wanted to extroject literature, maybe even serious literature, or maybe "less serious" literature, into a larger reading/cultural environment to see what would happen. And the answer is: probably very little!

Post-digital print: a future scenario
Alessandro Ludovico 2012

Alessandro Ludovico, "Post-digital print: a future scenario" and "Print vs. electrons: 100 differences and similaritiesbetween paper and pixels," *Post-Digital Print* (Rotterdam: Onomatopee 77, 2012), 153–56, 159–61.

There is no one-way street from analog to digital; rather, there are transitions between the two, in both directions. Digital is the paradigm for content and quantity of information; analog is the paradigm for usability and interfacing. The recent history of video and music provides a good example, since the use of digital technology for these types of content is much more advanced than it is for publishing. In the case of video, the medium (whether VHS or DVD) is merely a carrier, since the content is always ultimately displayed on screens. The same is true for music, where cassettes, vinyl records, and CDs are only intermediate carriers; the actual listening always happened through speakers (and increasingly through headphones). In both cases, the format changed without dramatically affecting the watching or listening experience. Sometimes the experience was improved by changes in the media technology (with HD video); sometimes it was almost imperceptibly worsened (with the loss of frequencies in MP3s).

Print, however, is a very different case, since the medium—the printed page—is more than just a carrier for things to be shown on some display; it is also the display itself. Changing it consequently changes people's experience, with all the (physical) habits, rituals, and cultural conventions involved. E-publishing therefore still has a long way to go before it reaches the level of sophistication which printed pages have achieved over the course of a few centuries.

But as more and more content moves from print to digital, we seem to be approaching an inevitable turning point, where publishers soon will be releasing more electronic publications than printed materials. A key factor in this development is that e-publishing is gradually becoming just as simple and accessible as traditional publishing—not only for producers, but also, thanks to new interfaces, habits, and conventions, for consumers as well. However, the real power of digital publishing lies not so much in its integration of multiple media, but in its superior networking capabilities. Even if it were possible to write some spectacular software to automatically transform e-books into another media standard (for instance, an animation of book or magazine pages being turned) or vice-versa, this would be far less interesting for users than new and sophisticated forms of connectivity—not only to related content hosted elsewhere, but also to other humans willing to share their knowledge online. To this end, digital publishing will have to establish universal interoperability standards and product identities that don't lock customers into the closed worlds of one particular application or service.

Traditional print publishing, on the other hand, is increasingly presenting its products as valuable objects and collector's items, by exploiting the physical and tactile qualities of paper. It thus acts as a counterpart to the digital world, while looking for ways to cope with a gradually shrinking customer base—particularly in its traditional sectors such as newspaper production and distribution (where costs are becoming unsustainable) or paper encyclopedias (which have already become vintage status symbols rather than practical information tools). A number of products will thus need to be reinvented in order to still make sense in print.

At the time of writing, the development toward print as a valuable object can best be observed in the contemporary do-it-yourself book and zine scene. Until the late 1990s, this scene was mostly focused on radical politics and social engagement; the contemporary scene however is more fascinated with the collection of visual-symbolic information into carefully crafted paper objects. Despite its loyalty to print, this new generation of DIY publishers has created offline networks for print production and distribution which, in their bottom-up structure and peer-to-peer ethic, very much resemble internet communities. At the same time, the work they create is meant to remain offline and not be digitized, thus requiring a physical exchange between publisher, distributor, and reader. This ethic is squarely opposed to the so-called "go all digital" philosophy which advocates a completely digital life, getting rid of as much physical belongings as possible, and relying only on a laptop and a mobile phone filled with digitized materials.

For sure, the DIY print publishing ethic is closely related to the (often dormant) bottom-up social dynamics of the internet. But as it currently stands, it still lacks one crucial aspect (besides production and sharing): it does not include mechanisms able to initiate social or media processes which could potentially bring the printed content to another level—what I would call the "processual" level. In the past, print activism (using pamphlets, avant-garde magazines, Punk zines, etc.) was deployed for spreading new ideas meant to induce new creative, technological, and—by implication—social and political processes. The future of post-digital print may also involve new processes, such as remote printing, networked real-time distribution, and on-demand customization of printed materials—all processes with (as of yet) unexplored social and political potential.

Conversely, digital networking technologies could make better use of print. Those who advocate and develop these new technologies should perhaps become more aware of print's cultural significance. Many readers will continue to choose print products above electronic publications, possibly leading to a demand for networked (perhaps even portable) printers allowing individuals to print materials at any location, anywhere in the world. Combined with personal binding devices (however primitive), such personal "book machines" would allow readers to "teleport"

print publications to and from any location. Furthermore, resistance to the ubiquitous and nonstop surveillance of the internet may well take a more radical turn: individuals and groups could make a political statement out of going completely offline and working in isolation as neo-analog media practitioners.

If print increasingly becomes a valuable or collectible object, and digital publishing indeed continues to grow as expected, the two will nevertheless cross paths frequently, potentially generating new hybrid forms. Currently, the main constraint on the development of such hybrids is the publishing industry's focus on entertainment. What we see, as a result, are up-to-date printable PDF files on one hand, and on the other hand, online news aggregators (such as Flipboard and Pulse) which gather various sources within one application with a slick unified interface and layout. But these are merely the products of "industrial" customization—the consumer product "choice" of combining existing features and extras, where the actual customizing is almost irrelevant. Currently, the industry's main post-digital print entertainment effort is the QR code—those black-and-white pixelled square images which, when read with the proper mobile phone app, give the reader access to some sort of content (almost always a video or web page). This kind of technology could be used much more creatively, as a means of enriching the process of content generation. For example, printed books and magazines could include such codes as a means of providing new updates each time they are scanned—and these updates could in turn be made printable or otherwise preservable. Digital publications might then send customized updates to personal printers, using information from different sources closely related to the publication's content. This could potentially open up new cultural pathways and create unexpected juxtapositions.

Martin Fuchs and Peter Bichsel's book *Written Images* is an example of the first "baby steps" of such a hybrid post-digital print publishing strategy. Though it's still a traditional book, each copy is individually computer-generated, thus disrupting the fixed "serial" nature of print. Furthermore, the project was financed through a networked model (using Kickstarter, a very successful "crowdfunding" platform), speculating on the enthusiasm of its future customers (and in this case, collectors). In other words, this book is a comprehensive example of post-digital print, through a combination of several elements: print as a limited-edition object; networked crowdfunding; computer-processed information; hybridization of print and digital—all in one single medium, a traditional book. On the other hand, this hybrid is still limited in several respects: its process is complete as soon as it has been acquired by the reader; there is no further community process or networked activity involved; once purchased, it will remain forever a traditional book on a shelf. And so, there is still plenty of room for exploration in developing future hybrid publishing projects.

When we are no longer able to categorize publications as either a "print publication" or an "e-publication" (or a print publication with some electronic enhancement), then the first true hybrids will have arrived. It may be worth envisioning a kind of "print sampling," comparable to sampling in music and video, where customized content (either anthologies or new works) can be created from past works. Such a "remix" publishing strategy could create new cultural opportunities and open up new "processual" publishing practices. We can already see this happening to some extent, in contemporary zine and DIY art book publishing, as well as underground e-book websites.

Since software is a prerequisite for any digital technology (and is also being used for the creation of most analog works today), its "processual" nature should be reflected in the structure and dynamics of future publishing: enabling local and remote participation and also connecting publishing to real-life actions. The younger "digital native" generation has no compunction in irreverently sampling, remixing and "mashing up" traditional and social media (as several adventurous small organizations, born out of the current financial crisis and the "Occupy" movement, have already demonstrated). Print is, unsurprisingly, an important component of this "mashup," because of its acknowledged historical importance as well as its particular material characteristics. And so this new generation of publishers, able to make use of various new and old media without the burden of ideological affiliation to any particular one of them, will surely be in a position to develop new and truly hybrid publications, by creatively combining the best standards and interfaces of both digital and print.

Appendix
Print vs. electrons

100 differences and similarities between paper and pixel.

PRODUCTION

1	Screen color consistency	Cross-browser consistency
2	300 dpi	72 dpi
3	A(x), (e.g. A4)	(x)GA (e.g. XVGA)
4	Snap to grid	CSS constraints
5	Postscript I/O error	Error 404
6	Ethernet	Wi-Fi
7	Glowing ink	Flash (Adobe)
8	Image not found	Can't connect to server
9	Magnifying glass	Magnifying icon
10	Moiré Excessive	JPEG compression
11	nth color	Custom programming
12	Pantone	Optimised palette
13	Stock photography	Google images
14	Proofreading	Debugging
15	Test print	Draft version
16	Higher resolution	Anti-aliasing
17	Page layout software	Content management system
18	Spines	Partial browser incompatibility
19	Optimizing for print	Optimising for search
20	Cutting	Screen format
21	Recycled paper	White text on black screen
22	Hollow punch	Layers
23	PDF logo	JPEG logo
24	Advertising space	Banner
25	Paid promotional flyer	Pop-up window
26	Ink	Brilliance
27	Full-color insert	Picture gallery
28	Imposition	Sorting with tags
29	Binding	Website structure

STRUCTURE (INTERNAL)

30	Color addition	Color subtraction
31	Centerfold	Background image
32	Contrast	Brightness
33	Dot	Pixel
34	TIFF	JPEG
35	PDF (fixed layout)	EPUB (reflowability)
36	vector graphics	Bitmap
37	Front cover	Home page
38	Externally illuminated	Backlit
39	Local link	Remote link
40	paperweight	Download time
41	Plastification	Use of 3-D/shadows
42	RAM	Kbps
43	Best viewed in bright light	Best viewed in dim light
44	Fire damage	File corruption
45	Fibers	Waves
46	Turns yellow	Reveals its pixel matrix
47	Consumed in local time	Consumed in global time
48	Slow replication	Instant replication
49	Hardcover	Paid access
50	Paperback	Free access
51	Static	Cinematic

STRUCTURE (EXTERNAL)

52	Printer	Sysadmin
53	Barcode	WHOIS
54	ISSN Online	ISSN
55	Local storage backup	Remote server backup
56	Back catalog	Internal search engines/
57	Optimized distribution	Optimised server configuration
58	Stocks	Link on the home page
59	Second (nth) edition	Database rebuilt
60	Headquarters	Hosting
61	Shipping strike	No connection

EVALUATION

62	Readership	Unique visits
63	Certified distribution	Guaranteed bandwidth
64	Distributor list	Access logs
65	Referenced by other media	Incoming links
66	Low copy/user ratio	High copy/user ratio
67	Promotional copies	RSS

REAL AND VIRTUAL SPACE

68	Bookshelf	Database
69	Shelf space	Web host storage space

CONVENTIONS

70	Table of contents	Menu
71	Promotional T-shirt	Textual link
72	Handwritten font	Pixel font
73	Captions	Alt text tag
74	News department	Blog
75	Page format	Scrolling
76	Print	Save
77	Bibliography	Hyperlinks
78	Name	Domain name
79	Paper bookmark	Browser bookmark
80	Page numbering	Posting date
81	Clippings	Cache
82	Import dialogue window	Online form

CONSUMPTION

83	Reader	User
84	Subscriber	Registered user
85	Subscription	Push technology
86	Reproduction prohibited	Digital rights management
87	Syndication	Creative commons
88	Freebie	Free download
89	Shipping	Spamming
90	Cover price	Password-protected access
91	Dust	Dust

GESTURES

92	Flipping through	Clicking
93	Smell of ink	Sound of mouse clicks
94	Photocopying	Copy/paste
95	Annotating	Comments
96	Underlining	Underlining
97	Fingerprint on coating	Fingerprint on screen
98	Folding	Scaling
99	Locally read	Remotely read
100	Handing over	Forwarding

ANT!FOTO

Katja Stuke, Oliver Sieber 2012

Katja Stuke and Oliver Sieber, "ANT!FOTO" (Essen: BoehmKobayashi, 2012).

WE LOVE PHOTOGRAPHY IN ALL ITS GLORY

A PHOTO IS A PHOTO IS DIGITAL, IS ANALOG, IS BLACK/WHITE & COLOUR; IS AN OBJECT, IS A BOOK, IS A BLOG, IS A NEWSPAPER, IS A MAGAZINE; IS A MOVIE IS A STORY, IS A STATEMENT; IS AN INSTALLATION, IS A SCULPTURE IS ALWAYS SOMEONE'S TRUTH; GETS LOST & FOUND; IS TECHNOLOGY IS AN ORIGINAL, IS A COPY, IS A REPRODUCTION, IS UNLIMITED PHOTOGRAPHY IS THE FUTURE & THE PAST – PHOTOGRAPHY IS A MEDIUM IN TRANSITION*

ONE SINGLE IMAGE IS ONLY THE TIP OF THE ICEBERG

USE PHOTOGRAPHY AS AN INTERNATIONAL LANGUAGE!
NEVER DISREGARD PROGRESSION
WE WANT TO SEE THE IMAGES WE ARE MISSING!

PHOTOGRAPHY IS TOO GOOD TO BE REGARDED AS ART ONLY!**

BECHERS VS. VICE MAG? TILLMANS VS. LINDBERGH? CAPA VS. MEISELAS? CALLE VS. ARBUS? SCHMID VS. FELDMANN? RUSCHA VS. BALTZ? ARBUS VS. TOSCANI ? LEIBOVITZ VS. VON UNWERTH? KAWAUCHI VS. ARAKI? BALDESSARI VS. PETERSEN? TELLER VS. HIROMIX? SHERMAN VS. HOLDT? TEMPLETON VS. GOLDIN? NACHTWEY VS. WALL? FRIEDLANDER VS. GURSKY? SOTH VS. ADAMS? FONTCUBERTA VS. EPSTEIN? WINOGRAND VS. BARNEY? CAHUN VS. MAPPLETHORPE? RISTELHUEBER VS. GOLDBLATT? HUGO VS. SHIGA? SNOW VS. FREUND? HASSINK VS. MIKHAILOV? GRAHAM VS. PENN? AVEDON VS. MORIYAMA? MEISEL VS. RUFF?

!ANT!FOTO IS FOR ALL THOSE WHO WANT THIS, TOO!

*A Medium in transition. Title of a symposium, Museum Folkwang 2012." Quote by: Timm Rautert

4478ZINE publishing manifesto
Erik van der Weijde 2012

Erik van der Weijde, "4478ZINE publishing manifesto," *4478ZINE* (website), accessed October 12, 2018, 4478zine.com.

01. The book is the carrier for my (photographic) series.

02. The printed page is the perfect form for the reproducibility of the photographic image.

03. The spread contextualizes the single images.

04. The sequence of pages may provide yet another context.

05. The collections of images are mirrored in the collectability of the actual book.

06. The ratio between the quality of the printing and the quality of the image is more complex than to be read 1:1.

07. The relation between form and content is as equally important as both parts separately, but all parts may represent different values.

08. The fetishistic character of the printed matter may provide the extra layers to strengthen the iconic value of its images.

09. The book, as an object, gains strength as it gets recontextualized by its viewer, owner or bookcase in which it stands.

10. The connections between different publications may be invisible, but are always present.

11. The steps made in the publishing process are solely based on artistic principles.

12. If the book is like a building, then, the publisher's catalogs needs proper urban planning.

Diagonal Press Mission
Tauba Auerbach 2013

Tauba Auerbach, *Diagonal Press Mission* (flyer; New York: Diagonal Press, 2013).

EST. 2013 TAUBA AUERBACH
PUBLICATIONS IN OPEN EDITIONS
NOTHING SIGNED OR NUMBERED

.TO MAKE ART IN THE FORM OF PUBLICATIONS.

.TO PUBLISH REFERENCE MATERIALS THAT SUPPORT
EXHIBITIONS, EXPERIMENTS AND OTHER PEOPLE.

.TO DEVISE A BUSINESS STRUCTURE IN WHICH THE PUBLICA-
TIONS ARE AFFORDABLE AND THEIR VALUE DETERMINED BY
WHAT ONE MIGHT GET OUT OF OWNING THEM, RATHER THAN
FROM RESELLING THEM.

.TO EXPLOIT THE PHYSICAL POSSIBILITIES OF CONSUMER
LEVEL PRINTING AND BINDING PROCESSES, SUCH AS COMB
BINDING, COILBINDING, PHOTOCOPYING AND RUBBER STAMP-
ING, AND TO USE THESE TECHNOLOGIES IN INVENTIVE WAYS.

.TO EXECUTE PRODUCTION IN-HOUSE AS MUCH AS POSSIBLE.

.TO OPERATE WITH AUTONOMY AND INTEGRITY.

.TO AVOID CONFUSING INTEGRITY WITH RIGIDITY.

.TO PARTICIPATE MEANINGFULLY IN THE PRESENT AND
NECESSARY PSYCHIC SHIFT.

That's not writing
Derek Beaulieu 2013

Derek Beaulieu, "That's not writing," *Please No More Poetry: The Poetry of Derek Beaulieu* (Waterloo, ON: Wilfrid Laurier University Press, 2013), 50–51.

That's not writing, that's typewriting.
—Truman Capote on Jack Kerouac

That's not writing, that's plumbing.
—Samuel Beckett on William S. Burroughs

That's not writing, that's typing.

That's not writing, that's someone else typing.

That's not writing, that's googling.

That's not writing, that's pasting.

That's not writing, that's blogging.

That's not writing, that's wasted, unproductive, tweaking time.

That's not writing, that's stupid.

That's not writing, that's a coloring book.

That's not writing, that's coming up with ideas.

That's not writing, that's waiting.

That's not writing, that's a mad scribble.

That's not writing, that's printing and lettering.

That's not writing, that's tape-recording.

That's not writing, that's word-processing.

That's not writing, that's following the herd.

That's not writing, that's copying and pasting.

That's not writing, that's directing.

That's not writing, that's using high-"polluting" words to confuse readers.

That's not writing, that's aggregating, and there are already plenty of aggregators out there.

That's not writing, that's printing.

That's not writing, that's art.

That's not writing, that's Tourettes.

That's not writing, that's posing.

That's not writing, that's button-mashing, and anyone can do that.

That's not writing, that's vandalism.

That's not writing, that's acting.

That's not writing, that's blabbing.

That's not writing, that's hiking.

That's not writing, that's just a knife he's using to eat pie with.

That's not writing, that's bullying.

That's not writing, that's dentistry.

That's not writing, that's just endless blathering.

That's not writing, that's yelling.

That's not writing, that's butchery!

That's not writing, that's a fortune cookie!

That's not writing, that's emoting.

That's not writing, that's just dressing it up after.

That's not writing, that's just playing around.

That's not writing, that's daydreaming.

That's not writing, that's showing off.

That's not writing, that's keyboarding.

That's not writing, that's calligraphy.

That's not writing, that's mindless pasting.

That's not writing, that's an action flick.

That's not writing, that's a puddle.

That's not writing, that's a tragedy.

That's not writing, that's assembly line mass production.

That's not writing, that's transcribing.

That's not writing, that's computer-generated text.

That's not typing, that's data entry.

Manifesto: 2013 Year of The BDP Avant Garde

Broken Dimanche Press (John Holten, Ida Bencke) 2013

John Holten and Ida Bencke, *Manifesto: 2013 Year of The BDP Avant Garde* (Berlin: Broken Dimanche Press, 2013).

1. In the face of the increasing difficulties facing literary publishing, a growing hesitation to advance the form and reach of inherited literary modes of narration, poetics, and artistic expression, as well as a disregard for intelligent, engaged audiences, the domain of the international visual art world can aid in the advancement and reception of literature.

1.1 The avant garde and experimental, the poetic and intellectual are being denigrated and sidelined because publishing is not commercial *enough* in its current state.

1.2 The Book (qua text, literature, fiction) offers *writers* or literature a fruitful domain for experimenting with words; and the Book in turn can be treated as an exhibition space in itself.

1.3 We see ourselves working therefore with Novelist Visual Artists. Or Visual Essayists. Or artists. Or whatever.

2. The digital turn in publishing offers possibilities that have yet to be fully explored and mapped out. However, the printed book is the domain of choice due to the haptic nature of printed matter.

2.1 "Percentages" should never take the place of *pages*.

2.2 To decide to make physical Books one must do so to the highest possible standards. Form matters, content matters—design and production matter.

2.2.1 And in making this decision to make a physical book, we realize that one is working with a form under attack—Books no longer hold a monopoly. We there being a beautifully melancholic poetry hidden in this fact—that books have become decadent. This in turn opens new possibilities: Is there anything more wonderful than the luxury of the futile, the pointless and the useless? That which cannot be read, understood, that which accumulates no knowledge, no power; that which cannot be sold. The unsellable object must be the biggest antithesis to commercialization, and hence to a ruthless capitalism.

2.3 We continually want to reinvent the Book.

2.3.1 We put ISBNs on anything if we term it to be a Book.

3. The political is everywhere, even when it's not to be found.

3.1 The imaginative realm of an endless Europe is the political sphere of BDP. Europe is not to be found in any one place. While an economic and political model of a possible Europe flounders it is imperative to advance a social-democratic Europe.

3.2 While the legacy of a hubristic and colonial Europe of the Enlightenment continues to wreck havoc across the globe, solutions, sympathy, empathy, and interest should be continually sought after and advanced.

3. Such quests should be carried out in the abstract currencies of: internet social exchanges, blogs, forums of various media, group emails, Facebook, active travel and live readings (including long winded Q&As *hors sujet*), exhibitions, vernissages, touring exhibitions, concerts, screenings, collective writing activities, public protests, voting, etc. etc.

3.4 NEW FORMS ARE ALWAYS NEEDED! NEW IDEAS OF THE BOOK ARE ALWAYS NEEDED!

3.4.1 New forms of reading, new forms of loving, new forms of eating, etc., are always needed!

4. FREEDOM does not equal personal freedom (cultural traditions, social contracts, etc.).

4.1 Making money is not the most important outcome, by-product or even nice surprise of BDP's activities. On the contrary.

4.2 It is important to always endeavor to have *fun*. Together.

4.3 Generosity of spirit, thought, and ideas should permeate all activity.

4.4 So called "haters," "narcissists," "hipsters" are all accepted as inevitable. Together, with fun, individually each can be *overcome*.

A letter from Chimurenga

ed. Ntone Edjabe 2013

Dear Friends,

We will launch the *Chimurenga Chronic* as a quarterly gazette from March 2013.

It is a publication borne out of an urgent need to write our world differently, to begin asking new questions, or even the old ones anew.

When will the new emerge—and if it is already here, how do we decipher it? In which ways do people live their lives with joy and creativity and beauty, sometimes amid suffering and violence, and sometimes perpendicular to it? How do people fashion routines and make sense of the world in the face of the temporariness or volatility that defines so many of the arrangements of social existence here?

These questions loom over a contemporary Africa. Yet most knowledge produced on the continent remains heavily reliant on simplistic and rigid categories unable to capture the complexities that inflect so much of contemporary quotidian life here.

The *Chronic* is one small, deeply subjective attempt to do things differently. Ironically, we started with what we know, taking inspiration from the flexibility, readiness to take risks, and ability to maneuver through different temporal orders that defines life here.

We recognized the newspaper—a popular medium that raises the perennial question of news and newness, of how we define both the now and history, as the means to best engage the present; this question of thinking and writing critically about contingency and human agency today. We selected the medium both for its disposability and its longevity, its ability to fashion routine in a way that allows us to traverse, challenge, and negotiate liminality in everyday life.

We wrote, we got our friends and partners to write, draw, and photograph, we edited, and we compiled. We sought out stories that articulate the complexity, the innovation, thinking, and dreams—all the things that make life sustainable in this place. We favored writing, art, and photography that is open, plural, and inflected by the workings of power, innovation, creativity and resistance—yes, resistance.

We arrived at a gazette, a collaborative living document that seeks out our capacity to continually produce something bold, beautiful, and full of humor. We titled it the *Chimurenga Chronic*, a nod to both the art of chronicling, of documenting historical events in real time (the timezone we call "now-now"), and because things are, well yes, chronic.

We recognize the success of this initiative is not how long it lives but that it lives fully, that it travels and inserts itself directly in our lives, takes its place, and speaks to the place in which we live, love, and work.

The first one is out in March, many more to follow.

Watch this space. Puff and pass.

Chimurenga People

South as a State of Mind

Marina Fokidis 2013

Marina Fokidis, "South as a State of Mind," *South as a State of Mind* (website), 2013, southasastateofmind.com/about.

South as a State of Mind is a biannual arts and culture journal published in Greece and distributed internationally. Possessed by a spirit of absurd authority, we try to contaminate the prevailing culture with ideas that derive from southern mythologies such as the "perfect climate," "easy living," "chaos," "corruption," and the "dramatic temperament," among others. Through our twisted—and "southern"—attitude, expressed through critical essays, artist projects, interviews, and features, we would like to give form to the concept of the South as a "state of mind" rather than a set of fixed places on the map. People from different—literal or metaphorical—"Souths" renegotiate the southern attitude, partly to define it and partly to invent it, within the post-crisis world. Opening up an unexpected dialogue among neighborhoods, cities, regions, and approaches, *South as a State of Mind* is both a publication and a meeting point for shared intensities.

Continue reading.

Content

Southern stereotypes are very important in the publication, and through our invigorating and inspired columns we aim not only to explore, but also to transform them.

What might be considered weaknesses of the southern mentality we would rather present, perhaps a little self-mockingly, as a force of power with which to face down the future!

Each 160-page issue has a thematic section and columns inspired and named after key traits of southern life.

Main / General

Every issue has an overall thematic topic to which various writers and artists respond.

For example, in issue #1 around thirty individuals contributed to the exploration of the South as a "state of mind," while issue #2 is a tribute to Arcadia and the particularities—and peculiarities—of summer vacations in the South. Contributors in issue #2 include Juergen Teller, Ana Texeira Pinto, Johan Grimonprez, Annika Larsson, among others.

Columns

Tradition

Introduction of visual cultural myths originating or operating in the southern territories.

For example, The Manifesto of the Parthenon Bomber and other archives by Yorgos Makris (1923–1968, artist, poet, and writer, Athens) in issue #1, and the MOMAS by Martin Kippenberger in Syros, Greece, in issue #2.

Trickster

In-depth presentation of an acclaimed or emerging artist.

For example, Maurizio Cattelan in issue #1, and Thanassis Totsikas in issue #2.

Shout / Politics

Commentaries on southern politics via essays or art projects. For example, Vangelis Vlahos presents the project "1981" (Allagi) (Allagi is a Greek word that means change, and was the main political slogan of the Socialist Party for the Greek elections of 1981) in issue #1, while in issue #2 Margaret E. Kenna writes about the community of exiles on the island of Anafi (Aegean Sea, Greece) during the Metaxas dictatorship.

Architecture / Landscape

Essays on the architecture in—and of—southern territories.

For example, Andreas Angelidakis writes about architecture in Greece in issue #1, while in issue #2 Petunia Exacoustou introduces us to communication theorist, artist, and architect Mit Mitropoulos.

Mysticism

Signs, coffee, cards, palm readings, oracles, or any other kind of southern mysticism: artists or writers use these to resist the sometimes rigid parameters of western thought.

For example, Ylva Ogland gives her oracular interpretation of the Southern condition in issue #1, while The Phoenikz Boyz write about an apocryphal text on horoscopes in issue #2.

Domino

The texts selected in this section function like a domino game and invite readers to follow the paths of main actors of the cultural history of the southern part of Europe, and beyond. Altogether, they form a possible portrait of the South as well as a cartography of artistic, political, or philosophical initiatives that shaped it.

Save the Robots / Internet

Taking its name from an underground East Village after-hours club, the column is dedicated to the internet as a medium for art, visual research, and experimentation. For issue #3, "Save the Robots" features the 2013 Eternal Internet Brotherhood's Trip to Las Pozas, Mexico, by Zak Stone.

Shame

For Socrates shame is a noble virtue.

A list assembled by multiple anonymous writers presents situations in which individuals should have been ashamed of something or some action, but were not.

Diary / Reviews

Word of Mouth

A calendar of selected art exhibitions and events in the South.

Flying Rumours

Critical reviews of visual art, film, and music—not necessarily timely.

Search, compile, publish.
Paul Soulellis 2013

Paul Soulellis, *"Search, compile, publish.,"* (New York: self-published, 2013).

Toward a new artist's web-to-print practice.

I recently started collecting artists' books, zines, and other work around a simple curatorial idea: web culture articulated as printed artifact. I began the collection, now called Library of the Printed Web, because I see evidence of a strong web-to-print practice among many artists working with the internet today, myself included. All of the artists—more than thirty so far, and growing—work with data found on the web, but the end result is the tactile, analog experience of printed matter.

Looking through the works, you see artists sifting through enormous accumulations of images and texts. They do it in various ways—hunting, grabbing, compiling, publishing. They enact a kind of performance with the data, between the web and the printed page, negotiating vast piles of existing material. Almost all of the artists here use the search engine, in one form or another, for navigation and discovery.

These are artists who ask questions of the web. They interpret the web by driving through it as a found landscape, as a shared culture, so we could say that these are artists who work as archivists, or artists who work with new kinds of archives. Or perhaps these are artists who simply work with an archivist's sensibility—an approach that uses the dynamic, temporal database as a platform for gleaning narrative.

In fact, I would suggest that Library of the Printed Web is an archive devoted to archives. It's an accumulation of accumulations, a collection that's tightly curated by me, to frame a particular view of culture as it exists right now on the web, through print publishing. That documents it, articulates it.

And I say right now because this is all new. None of the work in the inventory is more than five years old—some of it just made in the last few weeks. We know that net art has a much longer history than this, and there are lines that could be drawn between net-based art of the '90s and early 2000s and some of the work found here. And certainly there are lines that could be drawn even further into history—the use of appropriation in art going back to the early twentieth century and beyond. And those are important connections.

But what we have here in Library of the Printed Web is something that's entirely twenty-first century and of this moment: a real enthusiasm for self-publishing, even as its mechanisms are still evolving. More than enthusiasm— it could be characterized as a mania—that's come about because of the rise of automated print-on-demand technology in only the last few years. Self-publishing has been around for awhile. Ed Ruscha, Marcel Duchamp, Benjamin Franklin (*The Way to Wealth*), Virginia Woolf (Hogarth Press) and Walt Whitman (*Leaves of Grass*) all published their own work. But it was difficult and expensive and of course that's all changed today.

Lulu was founded in 2002 and Blurb in 2004. These two companies alone make most of this collection reproducible with just a few clicks. I could sell Library of the Printed Web and then order it again and have it delivered to me in a matter of days. Just about. About half of it is print-on-demand, but in theory, the entire collection should be available as a spontaneous acquisition; perhaps it soon will be. With a few exceptions, all of it is self-published or published by micro-presses and that means that I communicate directly with the artists to acquire the works.

Besides print-on-demand, some of it is also publish-on-demand, and both of these ideas put into question many of our assumptions about the value we assign to net art, artists' books and the photobook. The world of photobook publishing, for example, is narrow and exclusive and rarified—it's an industry that designs and produces precious commodities that are beautiful and coveted, for good reason, with a premium placed on the collectible—the limited edition, the special edition, and even the idea of the sold-out edition. (See David Horvitz's stock photography project *Sad, Depressed, People*—one of a few non-self-published and not printed-on-demand photobooks in Library of the Printed Web). Controlled scarcity is inherent to high-end photobook publishing's success.

But many of the works in Library of the Printed Web will never go out of print, as long as the artists makes them easily available. There is something inherently not precious about this collection. Something very matter-of-fact, straight-forward or even "dumb" in the material presentation of web culture as printed artifact. It's the reason I show the collection in a wooden box. It's utilitarian and functional and a storage container—nothing more than that.

So we have print-on-demand as a common production technique. But what about the actual work? What concepts on view here might suggest what it means to be an artist who cultivates a web-to-print practice? And how is print changing because of the web? Are there clues here?

The content of these books varies wildly, but I do see three or maybe four larger things at work, themes if you will. And these themes or techniques have everything to do with the state of technology right now—screen-based techniques and algorithmic approaches that for the most part barely existed in the twentieth century and may not exist for much longer. If something like Google Glass becomes the new paradigm, for example, I could see this entire collection becoming a dated account of a very specific moment in the history of art and technology, perhaps

spanning only a decade. And that's how I intend to work with this collection—as an archive that's alive and actively absorbing something of the moment, as it's happening, and evolving as new narratives develop.

So here are three or four very basic ideas at the heart of Library of the Printed Web. They are by no means comprehensive, and in each case the techniques that are described cross over into one another. So this isn't a clean categorization, but more of a rough guide. My goal is not to define a movement, or an aesthetic. At best, these are ways of working that might help us to unpack and understand the shifting relationships between the artist (as archivist), the web (as culture) and publishing (as both an old and a new schema for expressing the archive).

Grabbing (and scraping)

The first category is perhaps the most obvious one. I call them the grabbers. These are artists who perform a web search query and grab the results. The images or texts are then presented in some organized way. The grabbing is done with intent, around a particular concept, but of primary importance is the taking of whole images that have been authored by someone else, usually pulled from the depths of a massive database that can only be navigated via search engine.

So a key to grabbing is the idea of authorship. The material being grabbed from the database, whether it be Google or Flickr or a stock photography service, is at least once removed from the original source, sometimes much more. The grabbing and representing under a different context (the context of the artist's work) make these almost like readymades—appropriated material that asks us to confront the nature of meaning and value behind an image that's been stripped of origin, function, and intent.

A defining example of a grabber project is Joachim Schmid's *Other People's Photographs*. Amateur photographs posted publicly to Flickr are cleanly lifted, categorized, and presented in an encyclopedic manner. This was originally a 96-volume set, and this is the two-volume compact edition, containing all of the photographs. Removed from the depths of Flickr's data piles, banal photographs of pets or food on plates or sunsets are reframed here as social commentary. Schmid reveals a new kind of vernacular photography, a global one, by removing the author and reorganizing the images according to pattern recognition, repetition, and social themes—the language of the database. The work's physicality as a set of books is critical, because it further distances us from the digital origins of the images. By purchasing, owning, and physically holding the printed books we continue Schmid's repossession of "other people's photographs" but shift the process by taking them out of his hands, so-to-speak. This idea is made even more slippery, and I would say enriched, by it being a print-on-demand work.

Texts can be grabbed too. Stephanie Syjuco finds multiple versions of a single text-based work in the public domain, like Ray Bradbury's *Fahrenheit 451* or Joseph Conrad's *Heart of Darkness* (part of the installation *Phantoms (H__RT _F D_RKN_SS*). She downloads the texts from different sources and turns them into "as is" print-on-demand volumes, complete with their original fonts, links, ads, and mistranslations. She calls them re-editioned texts. By possessing and comparing these different DIY versions as print objects she lets us see authorship and publishing as ambiguous concepts that shift when physical books are made from digital files. And that a kind of rewriting might occur each time we flip-flop back-and-forth from analog to digital to analog.

If a grabber works in bulk, I'm tempted to call it scraping. Site scrape is a way to extract information from a website in an automated way. Google does it every day when it scrapes your site for links, in order to produce its search results. Some grabbers write simple scripts to scrape entire websites or APIs or any kind of bulk data, and then they "send to print," usually with little or no formatting. The data is presented as a thing in itself.

Grabbing and republishing a large amount of data as text is at the heart of conceptual poetry, or "uncreative writing," a relatively recent movement heralded by Kenneth Goldsmith. In conceptual poetry, reading the text is less important than thinking about the idea of the text. In fact, much of conceptual poetry could be called unreadable, and that's not a bad thing. Goldsmith tweeted recently: "No need to read. A sample of the work suffices to authenticate its existence."

Guthrie Lonergan's *93.1 JACK FM LOS ANGELES 2008* is a good example of a scraper project. JACK FM radio stations don't have DJs—the format is compared to having an iPod on shuffle. Lonergan wrote a simple script to downloads all of the activity of one of these JACK FM radio stations over the course of a year—the date, time, artist, and the title of every track played—and presents it as a 3,070-page, five-volume set of print-on-demand books. The presentation of the data in bulk is the thing, and the project is richer because of it. Again, the questions at hand are about authorship, creativity, ownership, and the nature of decision-making itself—human vs. machine. As Lonergan says on his site, "Who is Jack? … How much of this pattern is algorithmic and how much is human? You might begin to read the juxtaposed song titles as poetry."

Chris Alexander's language-based *McNugget* project is another scraper, or so I thought. This work of poetry is a massive index of tweets containing the word *McNugget* from February to March 6, 2012, nothing more and nothing less. I was curious about how he did it—if he was a grabber or more of a scraper, if you will, and I asked him that directly. Here's his response:

Somewhere early in the process, I discussed automated methods of capture using the Twitter API with a programmer friend, but in the end I opted for the manual labor of the search because I was interested in experiencing the flow of information firsthand and observing the complex ways the word is used (as a brand/product name, as an insult, as a term of endearment, as a component of usernames, etc.) as they emerged in the moment. Most of my work is focused on social and technical systems and the ways they generate and capture affect, so I like to be close to the tectonics of the work as they unfold—feeling my way, so to speak—even in 'pure,' Lewitt-style conceptual projects whose outcome is predetermined. Getting entangled with what I'm observing is an important part of the process. At the same time, I think it's useful to acknowledge that much of what I do could be automated—and in fact, I use a variety of layered applications and platforms to assist in my work most of the time. Somewhere in the space between automation and manual/affective labor is the position I'm most interested in. [email 5/20/13]

So, his process isn't automated. It's not scraping. But the potential to automate and this connection to conceptual art and predetermined outcome intrigues me—"the idea becomes a machine that makes the art" (Sol Lewitt). The art may be reduced to a set of instructions (like code?), and the execution is secondary, if necessary at all (dematerialization of the art object). So does it matter if the execution—the grabbing—is done by a human or a bot? Of course it does, but perhaps along a different axis, one that looks at this idea of entanglement vs. noninterference. But that's another matter, one that I won't address here. I've come to suspect, after this discussion with Chris, that the distinction between grabbers and scrapers, on its own, is not so important after all. Without more information, it doesn't reveal anything about artistic intent or the nature of the object that's been created.

Hunting

So, let's talk about hunters. Some of the more well-known work in the collection is by artists who work with Google Street View and Maps and other database visualization tools. The work is well-known because these are the kinds of images that tend to go viral. Rather than grabbing pre-determined results, these artists target scenes that show a certain condition—something unusual or particularly satisfying. I call them the hunters. The hunter takes what's needed and nothing more, usually a highly specific screen capture that functions as evidence to support an idea. Unlike grabbers, who are interested in how the search engine articulates the idea, hunters reject almost all of what they find because they're looking for the exception. They stitch together these exceptional scenes to expose the database's outliers—images that at first appear to be

accidents but as a series actually expose the absolute logic of the system.

A great example of this is Clement Valla's project *Postcards from Google Earth*. He searches Google Earth for strange moments where bridges and highways appear to melt into the landscape. He says: "They reveal a new model of representation: not through indexical photographs but through automated data collection from a myriad of different sources constantly updated and endlessly combined to create a seamless illusion; Google Earth is a database disguised as a photographic representation." Google calls its mapping algorithm the Universal Texture and Valla looks for those moments where it exposes itself as "not human." When the algorithm visualizes data in a way that makes no sense to us, as humans in the physical world—the illusion collapses. By choosing to print his images as postcards, Valla says he's "pausing them and pulling them out of the update cycle." He captures and prints them to archive them, because inevitably, as the algorithms are perfected, the anomalies will disappear.

Performing

The remaining set of works in Library of the Printed Web is a group I call the performers. This is work that involves the acting out of a procedure, in a narrative fashion, from A to B. The procedure is a way to interact with data and a kind of performance between web and print—the end result being the printed work itself. Of course, every artist enacts a kind of performative, creative process, including the hunters and grabbers we've looked at so far. But here are a few works that seem to be richer when we understand the artist's process as a performance with data.

One of my favorite works in the collection is *American Psycho* by Jason Huff and Mimi Cabell, and it's performative in this way. The artists used Gmail to email the entire Bret Easton Ellis novel back and forth, sentence by sentence, and then grabbed the context-related ads that appeared in the emails to reconstruct the entire novel. Nothing appears except blank pages, chapter titles, and footnotes containing all of the ads. Again, another unreadable text, aside from a sample here or there. But the beauty is in the procedure—a performance that must be acted out in its entirety, feeding the text into the machine, piece by piece, and capturing the results. It's a hijacking of both the original novel and the machine, Google's algorithms, mashing them together, and one can almost imagine this as a durational performance art piece, the artists acting out the process in real time. The end result, a reconstructed *American Psycho*, is both entirely different from and exactly the same as the original, both a removal and a rewriting, in that all that's been done is a simple translation, from one language into another.

My own practice is increasingly web-to-print, so I have a special, personal interest in seeing Library of the Printed Web evolve in real time. It's too early to call it an anthol-

ogy, but it's more than just a casual collection of work. I'm searching for something here, a way to characterize this way of working, because these artists are not in a vacuum. They know about each other, they talk to and influence each other, and they share common connections. Each time I talk to one I get introduced to another. Some of the links that I've uncovered are people like Kenneth Goldsmith, places like the Rhode Island School of Design, and certain Tumblr blogs where the work is easily digested and spread, like Silvio Lorusso's *mmmmarginalia*. I'm curious—is anyone else doing this? Who is looking at web-to-print in a critical way, and who will write about it? I'd like Library of the Printed Web to become a way for us to monitor the artist's relationship to the screen, the database and the printed page as it evolves over time.

Grabbing/scraping

Alexander, Chris. *McNugget*. POD, Troll Thread, 2013, 528 pages.

Burel, Ludovic. *Fist*. it: éditions, 2009, 32 pages.

Burel, Ludovic. *Lobster*. it: éditions, 2009, 32 pages.

Burel, Ludovic. *Waterfall*. it: éditions, 2008, 32 pages.

Cablat, Olivier. *Enter the Pyramid*.

Fathom Information Design. *Frankenstein*. POD, 2011, 336 pages.

Hallenbeck, Travis. *Flickr favs*. POD, 2010, 315 pages.

Horvitz, David. *Sad, Depressed, People*. Vancouver: New Documents, 2012, 64 pages.

Kosas, Karolis. *Captcha, Fake, JPG, Reflection, Search. Selections from Anonymous Press (A–П)*, POD, 2013.

LeClair, Andrew. *Occupy Wall Street*. Ether Press. POD, 2011, 500 pages.

Lewis, Jonathan. *The End*. POD, 2011, 30 pages.

Lonergan, Guthrie. *93.1 JACK FM LOS ANGELES 2008*. POD, 2008, 3,070 pages (set of five books).

Lorusso, Silvio and Sebastian Schmieg. *56 Broken Kindle Screens*. POD, 2012, 78 pages.

Pujade-Lauraine, Grégoire. Significant Savages.

Schmid, Joachim. *Are you searching for me?* POD, 2012, 80 pages.

Schmid, Joachim. *Other People's Photographs*, volumes 1 and 2. POD, 2011, 400 pages each.

Schmidt, Andreas. *Porn*. POD, 2012, 80 pages.

Schmidt, Andreas. *R, G, B*. Set of three books. POD, 2012, 80 pages each.

Shaykin, Benjamin. *Special Collection*. Twelve books, 2009 (on loan from artist).

Sira, Victor. Voyeur *A Midsummer*. POD, 2010, 40 pages.

Soulellis, Paul. *Stripped*. POD, 2012, 74 pages.

Syjuco, Stephanie. Re-editioned texts: *Fahrenheit 451*. POD, 2013 (set of three books).

Syjuco, Stephanie. Re-editioned texts: *Heart of Darkness*. POD, 2012 (set of ten books).

Umbrico, Penelope. *Desk Trajectories (As Is)*. New York: 2010, 60 pages.

Umbrico, Penelope. *Signals Still / Ink (Book)*. New York: 2011, 60 pages.

Umbrico, Penelope. *Many Leonards Not Natman*. New York: 2010, 56 pages.

Vredenburg, Elliot. *Corporate Image Search*. 2012, 78 pages.

Vredenburg, Elliot. *This is Cloud Country*. 2012, 450 pages.

Hunting

Henner, Mishka. *Dutch Landscapes*. POD, 2011, 106 pages.

Henner, Mishka. *No Man's Land* I and II. POD, 2011/12, 120 pages each.

Neilson, Heidi. *Details from the Least Popular*. POD, 2013, 208 pages.

Rafman, Jon. *The Nine Eyes of Google Street View*. Jean Boîte Éditions, Paris, 2011, 160 pages.

Rickard, Doug. *A New American Picture*. New York: Aperture, 2012, 144 pages.

Schmid, Joachim. *Cyberspaces*. POD, 2004, 40 pages.

Soulellis, Paul. *Apparition of a distance, however near it may be*. POD, 2013, 42 pages.

Soulellis, Paul. *Las Meninas*.

Soulellis, Paul. *The Spectral Lens*. POD, 2012, 140 pages.

Valla, Clement. *Postcards from Google Earth*. 2010.

Wolf, Michael. *asoue*. Wanderer Books, 2010, 72 pages.

Wolf, Michael. *FY*. Wanderer Books, 2011, 72 pages.

Zissovici, John. *Night Greens*. POD, 2013, 570 pages.

Performing

Antonini, Federico. *A palindrome book*. POD, 2012, 96 pages.

Cabell, Mimi and Jason Huff. *American Psycho*. POD, 2010, 408 pages.

Cayley, John and Daniel C. Howe. *How It Is in Common Tongues*. POD, 2012, 300 pages.

Henner, Mishka. *Harry Potter and the Scam Baiter*. POD, 2012, 334 pages.

Horvitz, David. *Public Access*. Vancouver: 2012, 94 pages.

Horvitz, David. *A Wikipedia Reader*. New York: 2009, 48 pages.

Huff, Jason. *AutoSummarize*. POD, 2010, 100 pages.

Lorusso, Silvio and Giulia Ciliberto. *Blank on Demand* (minimum edition). POD, 2012, 40 pages.

Thorson, Lauren. *Wikipedia Random Article Collection*. POD, 2013 (thirteen booklets).

Soulellis, Paul. *Chancebook #1: 26 March 2013 (Why Does It Hurt So Bad)*. POD, 2013, 112 pages. Unique copy (edition of 1).

Tonnard, Elisabeth. *Where Is God*. Rochester, New York: 2007, 117 pages.

X Marks the Bökship

Eleanor Vonne Brown 2014

Eleanor Vonne Brown, *Intervention* (flyer; London: X Marks the Bökship, 2014).

The bookshop is a space for interaction.
The gallery is a space for introspection.
The work outside of the gallery is interchangeable.
The work inside the gallery is fixed.
The art is in the gallery.
The books are outside of the gallery.
The work framed by the gallery is art.
The work outside is ambiguous.
Is the coffee "real"?
Are the books for sale?

This *intervention* happens outside of the gallery.
This page pinched between your thumb and forefinger,
This piece of paper, this page,
This generic, unassuming piece of A4 rectangular copy paper,
This interchangeable commentary,
Is the supporting material to the exhibition.
Read this reading material after seeing the exhibition
It is called a spoiler.
Does it spoil a work to include documentation with it?
Like in a publication?
It is spoiler distributed to everyone before they enter the gallery.
Before the experience.
It is not the experience.
It is not in the gallery.
It is in the bookshop.
It can be taken into the gallery.
It can be removed from the gallery
It can be taken home.
Or distributed to a place of your choosing.
Place it on the floor of the gallery.
Place it on the wall of the gallery.
Place it on a shelf in the bookshop.
Place it in the vitrine of the bookshop.
Ask the bookseller "How much it this?"
Ask the invigilator if it is a piece of work.
Tear this page away from the staple.
Throw the rest away.
Dispose of this page and only keep the original.
Roll it lengthways.
Leave it on the bus.
I can make another one.
It can be reproduced the same.
It can be reproduced differently.
Is this an intervention?
Is this a publication?
Is this a work?
I have publications that look like this spoiler.
I have works that look like this spoiler.
I have recycling that looks like this spoiler.

The publications are outside of the gallery.
Patrick Goddard's book launch happened outside of the gallery.
Deirdre O'Dwyer's publication is not in the gallery
Joëlle Tuerlinckx books are not in the gallery
Instead, perched metaphorically just outside of the exhibition
There are no publications in the exhibition.
I mean in the exhibition.
The display of Jarosław Kozłowski's books is in the bookshop.
They are under glass, framed, fixed, removed from use.
They earn an exhibition note in the spoiler.
The publication is a space for introspection.
The publication is a space for interaction.
A publication can be documentation.
A publication can be artwork.
Can a bookshop be an artwork?

The bookshop a set up shop.
It is like a bookshop but not.
It is a library, which is also a theater
A context for conversations,
about writing and publishing.
The bookshop is not a fixed space.
It is constantly changing.
The bookshop is a discursive space.
The bookshop is a space for interaction.
Each new book adds an extra voice to the discussion;
each new event changes the configuration of the space.
The bookshop is a place for distribution.
The books here are for sale.

The bookshop is the setting for book launches, reading groups, performances, exhibitions, and talks on publishing.

In the bookshop is a table for reading and for social activity. A sofa, a coffee machine, reading material, somebody to talk to.

In the bookshop is a small rowing boat that is occasionally used on the canal to interview artists about their books. In the bookshop are concrete shelves. It had already been a challenge to create a hospitable space for reading and discussion in a concrete room. I thought, "Why struggle to make it warmer, let's make it colder." The concrete shelves create potentially perilous conditions for the books; they are auto-destructive like Asger Jorn and Guy Debord's sandpaper-cover book *Mémoires*. This is an artist's bookshop after all, and there are risks, to run a space like this you have to live on the edge, you need a community to survive.

Balconism
Constant Dullaart 2014

We are all outside on teh balcony now. Standing on a platform made out of a tweet into corporate versions of public space. We are not stored in a cloud, opaque or translucent to whomever. We publish, we get read. ok. Private publishing does not exist, we now know we always get read (hi). To select what we want to have read, and by whom, is our greatest challenge rly. For now and teh future. If you tolerate this, your children will be normalized. Outside, on the street, status updates in the air, checking into another spatial analogy of information exchange. Sometimes hard to reach, through tutorials, encryptions and principles. It is generous to be outdoors, watched by a thousand eyes recording us for the future, our actions to be interpreted as an office job. We need a private veranda above ground, a place for a breath of fresh air, out of sight for the casual onlooker, but great for public announcements. The balcony is both public and private, online and offline. It is a space and a movement at the same time. You can be seen or remain unnoticed, inside and outside. Slippers are ok on the balcony. Freedom through encryption, rather than openness. The most important thing is: you must choose to be seen. We are already seen and recorded on the streets and in trains, in emailz, chatz, supermarketz and restaurantz, without a choice. Remaining unseen, by making a clearer choice where to be seen. We are in the brave new now, get ready to choose your balcony, to escape the warm enclosure of the social web, to address, to talk to the people outside your algorithm bubble. U will not get arrested on the balcony, you and yours should have the right to anonymity on the balcony, although this might seem technically complicated. The balcony is a gallery, balustrade, porch and stoop. The balcony is part of the Ecuadorian embassy. Itz masturbating on the balcony when your local dictator passes by. AFK, IRL, BRB and TTYS. The balcony is the Piratebay memo announcing they will keep up their services by way of drones, or just Piratbyran completely. Publishing in a 403, publishing inside the referring link, and as error on a server. Balconism is IRC, TOR and OTR. BalKony 2012. Balcony is Speedshows, online performances, Telecomix, Anonymous, Occupy and maybe even Google automated cars (def. not glass tho btw). Balconization, not Balkanization. The balconyscene creates community rather than commodity. Nothing is to be taken seriously. Every win fails eventually. Proud of web culture, and what was built with pun, fun, wires, solder, thoughts and visions of equality. Nothing is sacred on the b4lconi. It is lit by screens, fueled by open networks, and strengthened by retweetz. On the balcony the ambitions are high, identities can be copied, and reality manipulated. Hope is given and inspiration created, initiative promoted and development developed. Know your meme, and meme what you know. I can haz balcony. Balconism is a soapbox in the park. The balcony is connected: stand on a balcony and you will see others. The balcony is connecting: you do not have to be afraid on the balcony, we are behind you, we are the masses, you can feel the warmth from the inside, breathing down your neck. Where privacy ceases to feel private, try to make it private. Choose your audience, demand to know to whom you speak if not in public, or know when you are talking to an algorithm. When you can, stay anonymous out of principle, and fun. And when you are in public, understand in which context and at what time you will and could be seen. Speak out on the balcony, free from the storefront, free from the single white space, but leaning into people's offices, bedrooms and coffee tables, leaning into virtually everywhere. On the balcony, contemporary art reclaims its communicative sovereignty through constant reminders of a freedom once had on the internet. Orz to the open internet builders and warriors. Learn how to do, then challenge how it is done. Encrypt. Encrypt well and beautifully. Art with too much theory is called Auditorium, and kitsch is called Living Room. Inspired by homebrew technologies and open network communications, create art in the spirit of the internet, resisting territories, be it institutional and commercial art hierarchies or commercial information hierarchies. The internet is every medium. Head from the information super highway to the balcony that is everywhere through the right VPN. The pool is always closed.

Revolution Triptych

Mosireen 2014

Mosireen, "Revolution Triptych," in *Uncommon Grounds: New Media and Critical Practices in North Africa and the Middle East*, ed. Anthony Downey (London: Tauris, 2014), 47–52.

Images distort reality

This time

The cameras were pointed at Tahrir Square, not the squares all across the country.

The cameras were pointed at the amassing police trucks, not at the torture chambers inside them.

The cameras were pointed at the celebrated army vehicles, not the shredded bodies beneath them.

The cameras were pointed at flag-clad middle-class faces, not the unemployed man raped in a military prison.

From behind our cameras we too seek to distort reality—this reality.

The most powerful aspect of a revolution still ongoing is the way it spreads, grows, like a virus.

This movement is far from perfection, yet wherever it goes it shakes the system.

The relatives of those tortured by the police, stop highways and train tracks.

The disenfranchised burned-down headquarters of the new ruling elite inheriting a system that we overthrew yesterday, ruled by a logic inherited by our near colonial ancestors.

A constant battle between street vendors—kicked out of the system—and a police force serving the ruling elite.

Students fight to keep their campus against their thieving Nobel Prize-winning university founder.

Everyday people run their own neighborhoods.

Workers take over the factories their bosses abandon.

Then we too must take over the decrepit world of image creation.

The images are not ours, the images are the revolution's.

How dare we trade in images of resistance to a system that we would feed by selling them?

How dare we perpetuate the cycle of private property in a battle that calls for the downfall of that very system?

How dare we profit from the mangled bodies, the cries of death of mothers who lost their children?

The images must lead to provocation, not a filthy self-aggrandizing cycle of an industry of empathy.

We do not seek people's pity, we seek to drag you the viewer from your seat and into the street.

We do not seek to inform, we want you to question your apathy in the face of the killing, torture, and exploitation that is forced upon us.

We do not ask for your charity, we do not ask for your prayers, we do not ask for words, but bodies.

No words can relay the extents of exploitation, of brute violence, the effects of sexual torture, of social and economic ruin enforced on those that take to the street.

Yet without bodies the possibility of shaking any of these is zero.

Our images must join the opposition against the deceit of democracy, a system that only self-perpetuates itself under new faces with claims of freedom and choice of your next exploiter.

Only the force of bodies will oppose this violence, a horizontal, self-organized, leaderless collective to bring down the pyramid of power.

The system reeks of blood, the rulers' bellies bloated on the downtrodden whose demise their comfort ascertains.

The segregation in livelihood between the few and the many reached proportions of such magnitude that only the masses on the streets can ascertain their funeral marches. The glorified state container has created favelas of the wretched, imposing a global regime of coarse stratification between the haves and have-nots, squeezing out every last drop of life.

Every corner of this regime must be exposed, must be occupied, must be crumbled and images must oppose the constant imaging of buying more, the imaging that perpetuates a patriotism that numbs the mind, numbs the realization of your empty stomach, your disease infested neighborhood, your shut down hospital and overcrowded classroom.

The images that perpetuate all this must come to an end.

We only hope to play a small part.

Join us.

I, II

Images are a trap. A cerebral complicity between brain and frame causes an acceptance of a distorted fraction as a reality complete.

That time, the cameras were pointed at Tahrir Square, the police trucks, the flags and tanks and victory signs.

They were pointed at the present, erasing the past, disabling the future—nothing before was as relevant, and nothing to come.

They fed off the spectacle they were birthing, and the world stopped for a breath. Then they were gone and we stood, alone and in our millions, an oasis of meaning in a desert of noise.

That time, the cameras failed to point at all the other squares, at the cells of the torturers, the business deals, or the bodies lying under the trucks and the sand.

That time, and every time.

Images are a trap. And yet we use them. We too seek to distort reality. There is no truth we can show you, only the angle that we, now, think serves our own interests best. Claims of anything else are lies. The only question is: Do we have the same interests?

A fire burns across the country. Smoke rises from the regional headquarters of our new rulers. The revolution doesn't stop. If a revolution is change, is movement, is fighting for a different kind of world, then the revolution is everywhere. It is not as pretty as it was when we were the darlings of the news bulletins. Instead, it has taken root.

Fires lit by parents whose children were tortured by the police sever national highways and train tracks.

Students chain themselves to university gates to keep their campus out of the hands of their Nobel Prize-winning Founder.

Democracy brings a president who bullies and threatens and fills public positions with murderers.

Workers unite to manage factories being shut down and sold off by their bosses.

Children arrested at protests watch the police rape men in their trucks.

Communities build roads instead of waiting another year for the municipality to appear.

Jail cells are flooded with water to make the electric torturer's job easier.

Tahrir Square, long stripped of nuance, now dances and sings and flag-waves under floodlights hung by the media.

The body politic is riddled with disease, but the people are fighting it at every turn.

So too must we—all of us—attack the vacuum of recycled meaning that is the image creation.

We trade in images of resistance. Masked photographers stand impervious in clouds of poison gas, they know what kind of suffering their editors are susceptible to, they know just how much resistance you're allowed in a frame. The cycle of private property continues, wealth is accumulated in foreign cities off the back of Arab sweat. The sweat though, is filtered. A crying woman will always find a magazine to be printed in. But the shattered, skull-flecked brains of a martyr of Maspero?

If an image does not provoke you, is it a continuation of the system you are trying to overthrow? An extension of it? The martyr does not want your sympathy. The martyr wants you to overthrow the system.

The image that only seeks your pity only perpetuates the industrial cycle of morbid titillation. People, in this world that has been built, in this cycle, can now suffer from "compassion fatigue."

Fuck awareness.

We do not ask for your charity, we do not ask for your prayers, or your thoughts or your words but your bodies. We do not ask for your martyrdom, we ask for your bodies on the streets of your cities, we ask for your ideas and your energy, we ask for your resistance.

I, II, III

The spectacle can happen within a single frame. The reiterations of these frames continue to live by becoming the carriers of the revolt itself that is in constant motion.

These visual accounts are not shot merely to report on the ongoing struggle, but to serve as a form of a counter-propaganda against the state-made truths that have been injected into the society's narratives for so long.

Spectacle one:

The revolution didn't stop with Mubarak's deposal. The thirty-year-long regime did not end with the 18 days. It continues with a substitute face, oppressing people with the use of the same organs that carry out illegitimate actions against the Egyptian people, sharing the country's wealth with the foreign powers that continuously supersede the same models of economic oppression. The image of the 18 days had been sold cheap to the world, subordinating the audience to conclusive news bites and films that fail to carry on the moment.

Spectacle two:

The revolution didn't stop, and the images are taken in the street for the street. It is happening now. A video is made here, as rioting protesters take over their spaces. The urgency to resist turns the momentum into a continuous

battle, happening inside and outside of the squares, within a crowd, at home (closed), on the street (open). Protesters carry out clashes individually and collectively, in factories, at schools, hospitals, inside a prison cell. The image comes second, but it fuels the resistance. It is in people's attitudes, in collective minds, in their bodies, their actions, on a paper, a wall, an orange. It is a space, a place. It is a fight, a riot, a provocation, a counteraction that manifests itself in an image. It is in a mobile phone and then on a screen built by protesters on the street provoking you to participate. It is an anti-image. It is imagination.

Spectacle three:

The revolution continues, and the urgency to gather, to share, to spread lingers. It is a multiple experience of the same reality, mirrored in raw footage that is almost immediately archived, on phones, computers, hard drives. The moment becomes history with the "safe" button but does not stop there. It gets a second life through counter-propaganda montage. The same footage on the side of the enemy becomes a dangerous weapon that needs to be turned back at them. This footage is not for private collections. It is an oral history that becomes an active agent of resistance.

Half Letter Press and
Our Reasons for Running It
Temporary Services and Kione Kochi 2014

Temporary Services and Kione Kochi, "Half Letter Press and Our Reasons for Running It" and Clive Phillpot, "Diagram Updated to Illustrate New Complexities in the Age of Digital Publishing," in *Publishing in the Realm of Plant Fibers and Electrons* (Chicago: Half Letter Press, 2014), 23–30.

We founded Half Letter Press in December of 2008. The press name refers to the format of our books and booklets, which are one half of a letter size (8 ½" x 11") sheet of paper. Thanks to the insistence of former President Ronald Reagan, letter-size paper is the standard size in America. It is a common, cheap, and easy paper to work with.

We use Half Letter Press to publish perfect-bound book-length works by ourselves and other authors. Before Half Letter Press, we made two full-length books with other publishers (*Prisoners' Inventions*, WhiteWalls, 2003, and *Group Work*, Printed Matter, 2007). Both experiences were positive, but the quantity of books printed felt like something we could make and sell on our own. In 2007, we received grants from Art Matters and CEC Artslink and found ourselves with enough money to publish a full-length, perfect-bound, offset book (*Public Phenomena*, 2008). We could have used the money to pay another publisher that values our work and help them print and distribute the book, but we chose to do it ourselves. We created a publishing imprint and web store to take care of printing and distribution. It is managed by the two of us, with some outside help from time to time. We have published six books to date under Half Letter Press; sometimes we design the books, and sometimes we work with an outside designer.

Temporary Services has always been undeclared, and we are neither a not-for-profit, nor an incorporated entity, nor any other officially registered status for that matter. We created Half Letter Press as a limited liability corporation to deal with any income, taxes, and other operational fees and to establish it as a platform to make and sell not only our past booklets but also future publications. In addition to our own, we distribute the work of friends and other self-publishing allies through Half Letter Press's web store. When we have an opportunity to table at book fairs and other events, we bring publications by our peers to sell alongside our own work.

Publishing after the "paperless revolution" (the internet failed to kill off the printed page and therefore the revolution did not actually occur, but its impact on paper and printing is evident) requires a new set of skills, approaches, and attitudes in being a bookmaker. It means crafting a variegated approach to how you create, publish, distribute, and build a social ecosystem around your efforts. We craft-publish, which means that we take a level of care that reflects a deep commitment to getting our books out in the world, in appropriate ways, to the people who want or benefit from them. This involves having a long-haul approach to supporting our publications and finding ways to distribute books long after they are printed. Our distribution remains limited, but we do not send books to remainder land when someone decides they have run their course and are not worth storing or continuing to promote. We actively work to rescue uncirculated books that other publishers have put in storage when we think that they are titles our audiences would appreciate.

The work we do tends to leverage the resources and privileges we have in a way that extends them to other people. Beginning in 2003 until the last member of our group left in around 2009, Temporary Services co-ran an experimental cultural center on Chicago's far north side called Mess Hall. We like making lists that take responsibility for our ideas and generate discussion. The keyholders at Mess Hall made a list, in 2007, inspired by the concise format and power of the Black Panthers' ten demands. This is Mess Hall's list:

We demand cultural spaces run by the people who use them.

We create the space to remix categories, experiment, and learn what we do not already know.

Mess Hall explodes the myth of scarcity. Everyone is capable of sharing something.

The surplus of our societies should be creatively redistributed at every level of production and consumption.

Social interaction generates culture!

We embrace creativity as an action without thought of profit.

We demand spaces that promote generosity.

Mess Hall insists on a climate of mutual trust and respect—for ourselves and those who enter our space.

No money is exchanged inside Mess Hall. Surfing on surplus, we do not charge admission or ask for donations.

Mess Hall functions without hierarchy or forced unity.

This was the precursor to the list we made for Half Letter Press. In 2008 we used posters, bookmarks, and our website to share the core values of Half Letter Press.

Half Letter Press strives to build an art practice that:

Makes the distinction between art and other forms of creativity irrelevant

Builds and depends upon mutually supportive relationships

Tests ideas without waiting for permission or invitation

Champions the work of those who are frequently excluded, under-recognized, marginal, noncommercial, experimental, and/or socially and politically provocative

Puts money and cultural capital back into the work of other artists and self-publishers

Makes opportunities from large museums and institutions more inclusive by bringing lesser-known artists in through collaborations or advocacy

Insists that artists who achieve success devote more time and energy to creating supportive social and economic infrastructures for others

Over the past couple of years, we have slowly started articulating criteria for evaluating Socially Engaged Art (the more reductive, digestible term we intensely dislike is Social Practice). In the race to promote this work (see the curator Nato Thompson) or tear it down (see the critic Claire Bishop), very little effort has been made to distinguish between art that truly empowers and work that merely uses the aesthetics of social inclusion to make empty spectacles, corporate and governmental propaganda, and MFA programs that do not lead to employment. This led us to generate a set of questions, which we encourage you to test out in your own experiences of art:

Does the work empower more people than just the authors of the work?

Does the work foster egalitarian relationships, access to resources, a shift in thinking, or surplus for a larger group of people?

Does the work abate competition, abusive power and class structures, or other barriers typically found in gallery or museum settings?

Does the work seek broader audiences than just those educated about and familiar with contemporary art?

Does the work trigger a collective imagination that can dream of other possible worlds while it understands the current one with eyes wide open?

Does the work hold the name of one person but include the creativity and labor of many uncredited others, or does it make its own creation clear and easy to understand?

These are also the kind of questions we ask ourselves of our publishing practice: who we make books and booklets with, how we want to treat the people that work on our publications, whose work we want to distribute at events and in our web store, and who we want to use to sell our books.

We try to treat other publishers as we like to be treated by stores and distributors and for this reason we prefer to pay people for the books we sell upfront rather than taking them on consignment and making people wait months or years to be paid. We also like to exchange stock with other publishers—letting them sell our books while we try to sell theirs, each keeping the money from what we sell and restocking with each other as needed.

Books and booklets make great bartering tools, and it does not come as a surprise that many self-publishers, or artists that make books, have wonderful home libraries of publications they have accumulated from trades. When people let us stay at their homes, we commonly bring the books we have made as a gift in appreciation for their generosity. These books can join libraries that can then be enjoyed by future guests. While no one has a complete set of Temporary Services publications, many longtime friends have dozens of different titles—a result of gifts given over many years.

People often ask us about Print on Demand (POD), which are books that are printed as needed, made to order, and often in smaller quantities than in offset printing. There are a number of reasons why we don't make publications using POD and typically won't distribute and sell books that others have made using this model.

Since many of our booklets are initially given away for free during exhibits, we make 1000 copies or more of an offset printed booklet and plan to make at least 300 copies of Risograph-printed booklets. Making 600 copies of a POD booklet through the company Lulu can cost almost five times more than ordering 1000 copies of the same publication at an offset printing company. In order to make money on a POD booklet (especially when selling wholesale to shops and distributors), something that we might price at $4.00 when offset printed would have to be sold for about $9.00. This makes POD books and booklets a poor value for readers. It is very hard to sell a book at $45.00 when it feels like it should have been $25.00. Unless the author doesn't care to profit from sales of their POD book at a retail store, it is difficult to place a POD book at a retailer without increasing the price. It is likely that this is the reason we rarely encounter POD books in stores.

POD books often have a generic quality due to the limited number of paper options, cover treatments, and publication sizes. While cheap web-based offset printers are also able to charge low prices by offering limited customization, just about any internet-based offset printer gives publishers

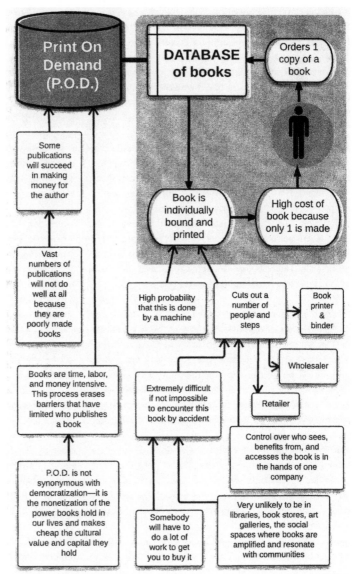

Print On Demand (P.O.D.)

DATABASE of books

Orders 1 copy of a book

Some publications will succeed in making money for the author

Vast numbers of publications will not do well at all because they are poorly made books

Book is individually bound and printed

High cost of book because only 1 is made

High probability that this is done by a machine

Cuts out a number of people and steps

Book printer & binder

Books are time, labor, and money intensive. This process erases barriers that have limited who publishes a book

Extremely difficult if not impossible to encounter this book by accident

Wholesaler

Retailer

Control over who sees, benefits from, and accesses the book is in the hands of one company

P.O.D. is not synonymous with democratization—it is the monetization of the power books hold in our lives and makes cheap the cultural value and capital they hold

Somebody will have to do a lot of work to get you to buy it

Very unlikely to be in libraries, book stores, art galleries, the social spaces where books are amplified and resonate with communities

Illustration by Kione Kochi

a whole lot more paper options than POD services. Working directly with a local printer or self-printing on a copier or Risograph allows for limitless custom paper choices that will give your books a more specific feel. We encourage new publishers to give serious consideration to the model of printing they choose and to not emulate POD because it is currently fashionable within the artist-book community.

Publishing Clearing House

Strangely, in our 16 years of working together, we had never done a project that was just focused on making publications. When people find out that we run Half Letter Press, they often ask us where our press is located—we have to tell them that we actually work with other printers to make everything. While we probably won't be making offset printed and perfect bound books in our own facility any time soon, we have purchased our own Risograph duplicator (aka RISO) and a booklet stapling and folding machine—both of which were used to make parts of this booklet.

Publishing Clearing House—launched in September 2014 at the Sullivan Galleries at the School of the Art Institute of Chicago for the show "A Proximity of Consciousness: A Lived Practice"—is a project that will be a temporary, fully functioning print shop. Temporary Services—with Kione Kochi, Kristian Johansson, and Leah Mackin—will work with invited collaborators to produce new booklets and printed works during the run of the show, sharing and launching publications.

In banking and finance, clearing denotes all activities from the time a commitment is made for a transaction until it is settled. In Publishing Clearing House, clearing denotes all activities from the time a commitment to an author is made, until the publication is designed, printed, stapled, folded and distributed. Making a clearing is also about creating a space for meeting and making processes visible, open and transparent.

For this project, we have invited a diverse range of individuals, groups, and organizations with an emphasis on Chicago, the Midwest, and artists, activists, and authors from marginalized and disadvantaged populations. This includes juveniles and the incarcerated as well as those who represent or articulate narratives counter to dominant cultural norms. Visitors will be able to meet members of Temporary Services and some collaborating authors on many days of the exhibition and watch the mechanics of the print shop as works are developed and produced. We will make the entire process of making a book, which is always socially engaged in some manner, more visible than it usually is.

Looking Around

The burgeoning international community of artist book publishing has become incredibly complicated as more and more people become engaged in this culture. It makes a singular vantage point from which to understand all this activity extremely daunting. The diagram above is our take on Clive Phillpot's earlier version that no longer resonates with the culture that has unfolded, and the urgency, volume, technological change, and aesthetic exploration we have witnessed over the past 10–15 years. We are convinced that this culture will continue to grow and be pushed in directions that our diagram cannot anticipate. We welcome this uncertainty and are eager to see what others will develop.

"There has been an explosion in artist book publishing around the world in the past few years." This has been a routine mantra one hears at gatherings of artist bookmakers and publishers. We agree with this sentiment, and we have definitely witnessed this ourselves. It leaves us with important questions about the role of artists' books in shaping contemporary artistic discourse, and the kinds of support this work could receive. The excitement about self-publishing also comes during a time when many brick and mortar bookstores are closing, and the cost of shipping has seen a massive increase (international shipping from the US is through the roof).

Artists' book fairs have been increasing in number and fill some of the distribution holes left by closed bookstores. Nonstop promotion of artists' books on the web via social media has put these publications on our screens more than ever. Distribution still has a long way to go; posting pictures of books you like and sharing them on social media isn't the same as buying them and showing hard copies to your friends. Publishing, particularly on the scale of making booklets, can be exhilarating and contagious, but it's also only as richly rewarding and meaningful as you are willing to make it. It remains to be seen how the people who are trying out self-publishing today will shape their practice for the long haul. We would like to encourage the exploration of not just their own creative publishing but also of the ways it can build up and strengthen the community around these printed forms in ways that benefit many others and find new audiences seeking to be challenged by published words and images.

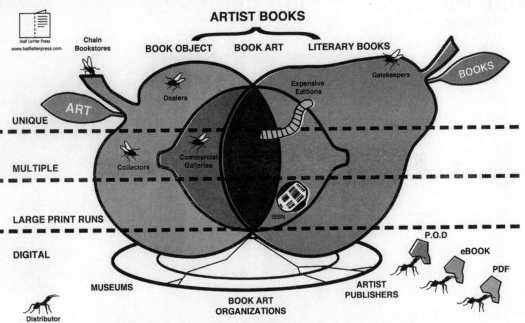

Figure 1: Clive Philpot's diagram updated to illustrate new complexities in the age of digital publishing

Illustration by Klone Kochi

One Publishes to Find Comrades

Eva Weinmayr 2014

Eva Weinmayr, *One Publishes to Find Comrades* (Leipzig: Spector Books, 2014).

Before London's notorious right-wing newspaper *Evening Standard* was sold to a Russian oligarch in 2009, it used to publish three editions a day, a practice ceased by now. The first edition left the printing plant just before lunchtime, followed by one in the afternoon and a late "West End Final" edition available only in central London. Alongside each edition the newspaper's drivers dropped a poster at the newsstands, the "splash," as they called it, advertising the latest front-page headline of the paper.

A few of them read like:

Venus crosses the sun
Rock star splits from young lover
Man beheaded in street
Cigarettes, beer, wine, up
Comic legend dies
Army: we must go within days
Brown gives cash to all

The poster slogans do not give away full information and merely act like teasers promising more detail in the paper. Their sole purpose is to get you buying the newspaper. The posters also exude a sense of poetry. Like Japanese haikus, they shrink complex realities into three or four lines—loaded with emotion. Carefully and ambiguously worded, they are pushing for drama and a raised level of adrenaline.

They also have a punchy visual impact—partly because they employ a particular nib-pen writing with an authoritative look. When studying the letters closely, you can tell that 99% of the posters in circulation are written by one and the same person. With the help of London-based artist publishing house Book Works, who published my archive of the newsstand posters in a book,[1] I was able to meet Pat, the man whose handwriting most Londoners are familiar with. Here in the *Evening Standard*'s bill room at their headquarters in Canada Water in London, he used to write day by day with a black marker pen the master poster, which subsequently got multiplied on an instant offset press for immediate delivery to the newsstands.

What does the handwriting do? It suggests directness and immediacy, making us speculate that there is no time between the news happening and the news being reported—no time to use a computerized production process.

IT JUST HAPPENED—and needed writing down. This act of personalizing the anonymous news splashes makes the commotion the posters are meant to create even more powerful.

The event here is not the news itself. On the contrary. The actual event is triggered by a strategically worded and placed three-line banner raising interest, curiosity, and adrenaline and eventually generating a return for the newspaper publisher. Posters claim attention—at a distance. They are visually aggressive, says Susan Sontag comparing the nature of public notices with that of posters: "A public notice aims to inform or command. A poster aims to seduce, to exhort, to sell, to educate, to convince, to appeal. Whereas a public notice distributes information to interested or alert citizens, a poster reaches out to grab those who might otherwise pass it by. Posters are aggressive because they appear in the context of other posters. [...] The form of the poster depends on the fact that many posters exist—competing with (and sometimes reinforcing) each other. Thus posters also presuppose the modern concept of public space—as a theater of persuasion."[2] Let's look at the performativity the poster or more general printed matter can develop. Since the 1960s the Museum of Modern Art library[3] in New York has collected innovative printed invitations, small posters, and flyers. These ephemera hold specific material qualities—for instance a certain paper, color, weight, a specific size, design—and as such act as a predefining mechanism to shape our actual visiting experience of the exhibition or event they announce. They become an integral part of the work itself they invite us to: conceptual works, installations, performances, and other time-based events and screenings. But most importantly—they also act as currency. Carefully circulated with consideration by hand or by mail they authorize you to join the event. This is of particular interest today as we realize that the phenomenon of printed invitations has shifted more and more toward the digital, such as email flyers, 140-character tweets, and networked facebook posts.

Both the lives of *Evening Standard* posters as well as the "invites as currency" depend crucially upon our attention as their addressees. We are looking at the moment, where the posters leave a printer, become distributed and enter circulation. Now, and only now, they meet us—their public. It is exactly here that they start their mission.

In one of his early issues of *Control Magazine* Stephen Willats states that the artwork is completely dependent on having an audience. "We could almost say viewers are its reason for being, without them it doesn't exist."[4]

Let us examine in more detail what happens before (and after) this moment of going public. Let us not look at publishing as the end of a process during which consolidated thoughts and inquiries are put into a final brochure, book, or leaflet. Let us look at publishing more as a way to initiate a social process, a social space, where meaning is collectively established in the collaborative creation of a publication. From this perspective, all of a sudden publishing is not a document of predefined cognitions. Publishing becomes a tool to make discoveries.

For the See Red feminist silk-screen poster collective, for example, which started in London in 1974, working collectively was central. "In the early days the posters were mainly produced about our own personal experiences as women,

about the oppression of housework, childcare and the negative image of women. An idea for a poster would be discussed in the group, a member would work on a design, bring it back for comment, someone else might make changes and so on until the collective was satisfied with the end result; no one individually took the credit. This was a concept many in the art world found hard to accept: 'who holds the pencil? Someone must hold the pencil!'"[5] The collective of women got together to combat the negative image of the women in advertising and the media. See Red posters, which convey a particular sharpness and wit, seem to attract further attention and are included in several recent and future exhibitions. [6, 7]

Suzy Mackie and Pru Stevenson, founding members of the See Red Women's Workshop recently gave a talk at The Showroom in London and stressed how important it was to gather in person and generate ideas about how to visualize a particular issue that was important to them. It was the activity of articulating experiences and collective brainstorming and the discussion of ideas that lead to sharp slogans and imagery for the posters.[8]

They shared skills and knowledge about how to prepare and screen print. As important as the subject matter itself, was the physical process of making these very specific objects. The creation becomes as important as putting them to the public. The actual event occurs at the moment of production as much as of circulation. It is about the experience of the reader as much as the experience of the producer and the impact such encounters generate for participants during the process of making. The Glasgow-based artist Ciara Phillips experiments with approaches on how such models can be rethought today. In her recent project *Workshop (2011– ongoing)*,[9] she worked with members of Justice for Domestic Workers,[10] an organization formed by migrant domestic workers in the UK trying "to politicize the domestic sphere as a site of labour, exchange and power relations."[11] They shed light on the precarious status of domestic workers in private households and campaign for fundamental protection and formal recognition of their work under UK employment law—including the right to take legal action against abusive employers. Because the campaign's members are coming from different backgrounds and languages

visual expression is key: in monthly sessions they create their slogans and messages using creative processes such as painting and collage to communicate to themselves and— only in a second step—to the wider public.

This specific approach to collective publishing was the starting point for a workshop I ran with students and tutors at the Ontario College of Art and Design in Toronto. Within twenty-four hours we, as a group, created an Instant Publication, from briefing and discussing initial ideas to actual work, graphic design, proofing, printing, and subsequently launching the outcome the very same night at Art Metropole in Toronto. Taking place in the Zine Library of OCAD under a gazebo around a campfire, this short experiment in collaborative practice created an adventurous space for social encounters in a more and more prescribed learning environment of today's art colleges.

Coming back to André Breton's "one publishes to find comrades," I'd like to think of printed publications, posters or zines as not necessarily the end product trying to convince anyone of anything, but rather as "working towards establishing conditions for the co-production of meaning."[12] In the publishing classes I run as part of AND Publishing,[13] we try to establish a social process where issues and ideas can be articulated and acted upon, where skills are exchanged and knowledge coproduced—in public. Actually AND also tests the implications of such cooperative models.

How can we create a horizontal model of communication between artist and audience, a less ownership-based notion of authorship? "A growing number of artists and artist collectives, challenging the artist's expert-like authority, have come to advocate co-authorship, broadening responsibility for the creative process to all those taking part,"[14] explains Stephen Wright, whose recently published reader "Toward a Lexicon of Usership" has massively enriched the discussion. "Usership represents a radical challenge to at least three stalwart conceptual institutions in contemporary culture: spectatorship, expert culture, and ownership."[15] This is where publishing becomes a political act: "It is imperative that we publish," says Matthew Stadler, "not only as a means to counter the influence of a hegemonic 'public', but also to reclaim the space in which we imagine ourselves and our collectivity."[16]

Poster by See Red

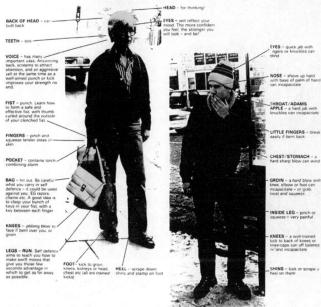

underneath every
woman's 'curve'
lies a muscle!

THIS POSTER IS JUST A USEFUL GUIDE & IS NOT A SUBSTITUTE FOR A SELF DEFENCE COURSE

Contacts for womens self defence
Birmingham: PO Box 558, B3 2HL Sheffield: WIRES, 0742 755290 & RCC, 0742 75522
Manchester: Sally, 061 225 3915 Swansea: Anne Carrick, c/o Womens Centre,
London: Janet Hunt, 01 633 2742 or 58 Alexandra Rd, Swansea
Womens Karate Club, Camden Institute, Holmes Rd, Kentish Town, London, N5

Author's Note:
This declaration (One Publishes to Find Comrades) was made by André Breton in 1920, quoted by Gareth Branwyn, *Jamming the Media: A Citizen's Guide Reclaiming The Tools of Communication* (Vancouver: Chronicle Books, 1997).

1 Eva Weinmayr, *Suitcase Body Is Missing Woman* (London: Book Works, 2005).

2 Susan Sontag, "Posters: Advertisement, Art, Political Artifact, Commodity," in *Looking Closer* 3, ed. Michael Bierut (New York: Allworth Press, 1999), 196–218.

3 "Please come to the Show," two-part exhibition at MoMA New York, curated by David Senior, 2013.

4 Stephen Willats, *Control Magazine*, 1965–ongoing.

5 Suzy Mackie and Pru Stevenson, founding members of See Red write on their blog seeredwomenswork-shop.wordpress.com

6 "A World to Win: Posters of Protest and Revolution," Victoria & Albert Museum, London, May 1, 2014–November 2, 2014 and "See Red Women's Workshop" exhibition, ICA London, December 5, 2012–January 13, 2013.

7 This is partly due to Jess Baines's research into radical printshop collectives that proliferated in the UK in the 1970s and '80s. Read "Free Radicals" on afterall.org/online/radical.printmaking.

8 "Posters, good posters at any rate, cannot be considered mainly as instruments for communicating something whose normative form is "information." Indeed, it is precisely on this point that a poster differs generically from a public notice—and enters the territory of art. Unlike the public notice, whose function is unambiguously to say something the poster is not concerned ultimately with anything so clear or un-
equivocal. The point of the poster may be its "message": the advertisement, the announcement, the slogan. But what is recognized as an effective poster is one that transcends its utility in delivering that message. Unlike the public notice, the poster (despite its frankly commercial origins) is not just utilitarian." In Sontag, "Posters," pp. 196–218.

9 "Ciara Phillips: Workshop (2010–ongoing)," October 2—November 30, 2013 at the Showroom, London.

10 Justice for Domestic Workers campaign, j4dw.org.

11 Read more on theshowroom.org.

12 *"Toward an Insurrection of the Published? Ten Thoughts on Ticks & Comrades,"* accessed April 4, 2014, nihilistoptimism.blogspot.co.uk.

13 AND, initiated in 2009, is a publishing activity based in London. It is a multitude of temporary alliances, which don't fit together smoothly. See and.publishing.org.

14 Stephen Wright, "Users and Usership of Art: Challenging Expert Culture," accessed April 4, 2014, transform.eipcp.net/correspondence/1180961069.

15 Stephen Wright, *Toward a Lexicon of Usership*, Van Abbe Museum, 2013. Download the PDF at museumarteutil.net.

16 Matthew Stadler is founder of Publication Studio, a print-on-demand publishing house in Portland Oregon. See Wikipedia, Matthew Stadler, *What is Publication?* Montehermoso Art Center, Vitoria, Spain, Suddenly.org, 9/27/08.

The Twelve Tasks of the Publisher

Jan Wenzel 2014

Jan Wenzel, "The Twelve Tasks of the Publisher," trans. Kathleen Reinhardt and Jesi Khadivi, *Graphic* 30 (Summer 2014).
Translation revised and adapted in 2018 by Alexander Zondervan and Raül Fernández Gil.

The First Task of the Publisher: Circle Around the Present

First of all, the work of a publisher is a quest; were one to look at one's actions from the outside, one would describe a scheme of movements similar to that of Claude Shannon's mouse "Theseus" executed in the maze. The publisher's strongest impulse is the desire to make the fleeting present visible and legible. Now and now and now. Books are traces of this exploratory movement.

The Second Task of the Publisher: Organize the Community of Producers

According to Jean-Luc Godard, "If you want to make a film, you need two people." The same goes for books. This means that one absolutely cannot work on a book alone.

Books derive from a collective process, in cooperation with others—just like a film or a play. Organizing the community of producers is the task of the publisher. It is he who brings the different actors together; he ensures that everyone involved in a book's production enters into a cooperative process of exchange. To do so, the publisher needs ingenuity, intuition, and cunning. A feel for chances as well as the ability to deal with uncertainties.

In 1970, the designer Hans Peter Willberg emphasized the importance of cooperation to a book's success. He said then: "If we want to make books which accommodate the reader by being more alive, more fluid, more intensive and more informative, a fundamentally different path has to be taken right from the outset: The book must be conceived as a film script, which is then realized down to the smallest detail by the text authors—be they typographer, designer, photographer, illustrator, or all of them together—working equals in the closest possible collaboration. The great creative individual cannot meet the new demands—only the team can do it."

The Third Task of the Publisher: Study the Medium

A library is for a publisher what a dictionary is for a translator—an opportunity to understand even the smallest conceptual differences and to ascertain variations and possibilities of linguistic expression. When he grabs particular books from the shelf, it's often not to read them, but rather to study how they were made. This kind of research has multiple stages: at the beginning the pure materiality of the books concerns him first and foremost. Perhaps he wonders in the back of his mind how a certain book, one that's already in production, should be designed. What is the proper format? Should it be thick or thin, big or small? What kind of binding should it have? What type of paper? To reach these decisions, it's helpful to look at several different books at once, to page through them and to lay them next to one another on a table. Another question is how certain content can be organized on the page of a book. How can the book's contents be organized to compel the reader? In what way can the different parts be placed into a context; how can they be arranged in order to guide the eye across the leaf? The larger the format, the more complex the relations between the main body of text, footnotes, translation, illustrations, and captions can be. And last but not least, other books offer helpful visual aids for the choice of font and questions of typographical detail. The publisher carries his library in his head. He knows his toolbox. He knows that books are always made from other books and that the book's use-value lies not least in delivering ideas for new books.

The Fourth Task of the Publisher: Continue to Tinker with the Medium

Continuing to develop the book medium possibilities for expression is among the tasks of the publisher. The hype surrounding the e-book since its emergence a few years ago can be interpreted as a symptom of a crisis. A task remained unsolved. Not that the book as a medium has become outmoded, but that the possibilities for us to articulate ourselves in its form are not limited to texts, but also include images and typography, as well as the book's materiality and format. The movement in-between images and programs that configure pictures and text, the intersection of objects and data, have become a practice of its own. This doesn't mean that text processors make paper obsolete but that we have to reformulate our approach to the old medium of the book. An approach to bookmaking not bound to text exclusively, but now opening onto the possibility to actively involve images and typography in the materiality and format of the book.

The Fifth Task of the Publisher: Say No

The most important and most difficult aspect in publishing is to say "no," writes Christoph Keller. Saying "yes" is the easiest thing in the world, and will make you loved by everybody. Saying "no" is essential to a mission. If you want to say one single thing, you will need to say "no" to one hundred other things. The work of a publisher is critique in its most elementary form. He is like a doorman and whoever would like to enter the space of the book first needs to get past him.

Nach Korrektur
gut zum druck

The Sixth Task of the Publisher: Say Yes

Editing … Layout drafts … The first phase of editing, the second phase of editing … Image proofs … The dummy … The "Print-ready" … the second "Print-ready" … The final print approval … The notices …The unbound edition … The finished book.

The Seventh Task of the Publisher: Printing

Printing is the performance of a book. Similar to the performance of a composition, the printing of a book is also a process that never leads to the same result twice. Each repetition has slight deviations. The printing process depends on too many intertwining factors: the printing press, the expertise of the printer, the paper quality, the temperature in the printing room, etc. Printing was attributed to the magical arts for a long time.

A work in the moment. And everyone who knows how much can go wrong with printing has great respect for the days when something goes to press.

The Eighth Task of the Publisher: Distribution

Producing books is only half of the job; to bring these books into the world and to distribute them is the other. What is a book then? Is it the object that one can take into his or her hands? Or does this object only first become a book once it surfaces in many places and can be appreciated by different people—as an articulation that exists in a specific number of identical copies: in bookshelves, on desks, on night-tables, in public libraries. The publisher is responsible for the book coming into the world. Only through his distribution does it really become a book, beforehand it is only its shadow.

The Ninth Task of the Publisher: Stand in the Market

To stay at the book fair stand for four days, and talk through all of them from morning 'til night with many different people, about many different topics: authors, designers, exhibitions, circulation figures, discounts, future plans, and political disputes; about temporary injunctions, reprints, paper varieties, and review copies. This is the market: a large self-manifestation of society. A place of exchange. And the publisher stands in the center.

The Tenth Task of the Publisher: Sustain Yourself

A publishing house is unlike any other business. It is intellectual labor and an entrepreneurial game. Profit and squander. A press has a self-imposed mandate to sustain itself. This means to be profitable enough to newly finance its highly complex program every year. That's difficult enough. The goal is: economic sustainability, intellectual expansion.

The Eleventh Task of the Publisher: New Reception

If books are more than containers for text, if they articulate themselves through their design and their materiality, if complex constellations of texts, images, and typography are formulated within them, then this also means that we should re-interrogate what reading means. The publisher is a mediator of these new forms of reading: he reflects the products that he distributes. He is a teacher who introduces a new form of reading; a reading that no longer progresses linearly, but quickly skips to-and-fro between its pages, images, and texts. A reading from body to body, through which the hand understands the materiality of the book and grazes its surfaces; a reading that is more than information consumption; an open exchange with the world and an echo of one's own existence.

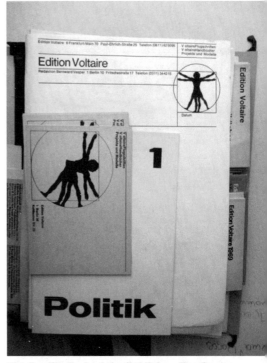

The Twelfth Task of the Publisher: The Press

A press is more than the sum of its books. It is a space where a variety of ideas and characters come together and form a new context. To design this force field is the publisher's actual mission. Henri Lefebvre solidified the formal distinctions of publishing processes by using the analogy of cities. And although every publisher produces books, publishers differentiate themselves from one another as strongly as cities do: in the atmosphere, the size, the liveliness, and the pace that they produce according to, as well as what is possible in a place—now and in the future.

Do or DIY

Riccardo Boglione, Kate Briggs, Craig Dworkin, Annette Gilbert,
Marianne Groulez, Simon Morris, Carlos Soto Román, Nick Thurston 2015

Riccardo Boglione, Craig Dworkin, Annette Gilbert, Simon Morris, Carlos Soto, and Nick Thurston, eds., *Do or DIY* (York: Information as Material, 2015).

I. History

In 1759, Laurence Sterne, soon to be Minister in the North Yorkshire village of Coxwold, borrowed money from a friend to finance the publication of his first novel, *The Life and Opinions of Tristram Shandy, Gentleman*. When overseeing the printing, he made certain that the title page gave no indication of where the book was printed, since the London elite turned up their noses at provincial publishers. That provincial book is now of course a cornerstone in the Western literary canon. It stands, according to the Italian writer Italo Calvino, as the progenitor of all experimental literature.

Gotthold Ephraim Lessing was the founding editor of the *Hamburgische Dramaturgie* and initially conceived of the publication as an in-house journal for the local theater. Subsequently, he decided to publish the collected issues as a book to be released through the printing and distribution company that he had established together with Johann Joachim Christoph Bode (the German-language translator of Laurence Sterne). Before their collection was ready, however, an anonymous group—opposed to what they saw as the disreputable practice of self-publishing—intervened by releasing the book first, under the appropriated name of the fictional imprint "Dodsley & Compagnie," a wry nod to the English publisher James Dodsley who had taken on Sterne's *Tristram Shandy* from 1761. Lessing was outraged, demanding: "In order to put a stop to the work of a few poor burglars, you want to become highwaymen yourselves? … Who is it that wants to prevent this? Will they have the heart to confirm their role in this outrage under their real names? Has self-publishing ever been forbidden anywhere?" The distribution of his own edition of 1769 ended in a fiasco.

At the age of eighteen, Derek Walcott borrowed money from his mother to pay the Guardian Commercial Printery in Port-of-Spain, Trinidad for his vanity-press first book of *25 Poems*. He peddled them himself, hand-to-hand. Later an Officer of the Most Excellent Order of the British Empire, he was awarded the Nobel Prize in Literature in 1992.

In 1781, Friedrich Schiller released his first play, *Die Räuber*, as a self-published, anonymous book. A bookseller sold one portion of the edition's 800 copies at book fairs on a commission basis; Schiller himself was responsible for local sales. The author had little fiscal success; lacking public interest and eager to advertise his work, he gave most of his copies away or sold them at a loss. It took Schiller until the end of the decade to pay back the 150-guilder loan he had borrowed to pay for the cost of printing.

Following a German edition, the first Italian publication of the anti-fascist novel *Fontamara* (Nuove Edizioni Italiane, 1933) was paid for by its author, Ignazio Silone

(*nom de plume* of Secondino Tranquilli), who had it printed in Switzerland to avoid censorship. By 1936 it had appeared in seven more languages, had been distributed to twenty countries, and a stage version, *Bitter Stream*, was showing in New York. The novel would eventually be printed in Italy by Mondadori, in 1949.

When no press would publish it, and no magazine would serialize it, Stephen Crane borrowed $700 from his brother and published his first novel himself, under the pseudonym Johnston Smith. *Maggie: A Girl of the Streets*, considered the first work of literary Naturalism, is now a canonical touchstone for American studies.

In the summer of 1942, Pier Paolo Pasolini paid Mario Landi, owner of an antique bookshop in Bologna, to publish a small collection of his poems under the title *Poesie a Casarza*. The fourteen poems were all written in his native Friulano dialect, signaling both a strong attachment to the region and a defiance of the Fascist intolerance of dialect and diversity. The book launched Pasolini's career as one of the twentieth century's most successful and controversial writers and filmmakers.

In 1517, Martin Luther published his ninety-five theses as a site-specific installation at the Schlosskirche Wittenberg. A cooperative of friends, using the new technology of the printing press, distributed translations throughout Europe. The Protestant Reformation followed.

Walt Whitman not only financed the first printing of *Leaves of Grass*, he also helped to set the type and pull the pages himself from the press at a local shop, whenever the job printers took a break from their regular commercial work.

In 1890, Stefan George hit on a sly way to increase demand for his work. Henceforth, it would only appear in unique, severely limited, privately printed editions. Moreover, he theatricalized their exclusivity by destroying the plates after each printing. Even after George began his collaboration with the publisher Georg Bondi in 1898, the works of the "master" continued to appear simultaneously in increasingly opulent privately printed editions. By 1899, with *Der Teppich des Lebens*, this sales strategy was pitched at a further remove as the book was displayed and sold in only a few bookshops and for only a few days. George's disciple Karl Wolfskehl was enraptured: "This is truly not a book that one reads and sets aside: every owner should be required to lay his book upon and to chain it to a lectern, like those for the Koran or the missals of the Middle Ages, and to solemnly—and only occasionally—turn its page."

With the help of his professor Philip Green Wright, who had a Gordon jobber platen press in the basement of his family home, Lombard College student Carl Sandburg set the type, printed the sheets, and bound fifty copies of his first book of poetry, *In Reckless Ecstasy*. He would go on to win three Pulitzer Prizes.

Riccardo Boglione, Kate Briggs, Craig Dworkin, Annette Gilbert, Marianne Groulez, Simon Morris, Carlos Soto Román, Nick Thurston

In the same year that James Joyce's *Ulysses* and T. S. Elliot's *The Waste Land* were published, Carlos Díaz Loyola self-published his book of poems *Los Gemidos*. Loyola, a Chilean writing under the nom de plume Pablo de Rokha, only managed to sell a few copies. Indeed, both the public and the critics were so indifferent that the author sold the bulk of the edition by weight to the slaughterhouse where it was used to wrap meat. Today, accordingly, it is almost impossible to find a first edition of *Los Gemidos*, which is now considered to be one of the fundamental works of the Latin American avant-garde movement.

Aron Hector Schmitz, writing as Italo Svevo, published his first two novels at his own expense, *Una vita* (Vram Editore, 1886) and *Senilità* (Libreria Ettore, 1898). Both books went completely ignored by critics and readers alike, and Svevo abandoned literature. A few years later, he befriended James Joyce during the Irishman's so-called Italian exile (Svevo's wife, Livia Veneziani, is immortalized in *Finnegans Wake* as Anna Livia Plurabelle). After reading *Senilità*, Joyce encouraged Svevo to return to writing, and in 1923 *La coscienza di Zeno* reached bookstores, again at the author's own expense. Despite others' indifference, Joyce promoted the book, and after its translation into French, its popularity began to grow. Zeno is now regarded as one of the greatest Italian novels of the twentieth century.

In 1773, Johann Heinrich Merck helped his friend Johann Wolfgang von Goethe to finance and print his only Sturm und Drang drama, *Götz von Berlichingen*, assigning the author five-hundred copies to sell in order to cover the costs. Goethe sent desperate letters to his friends: "Listen, if you would like to buy copies of *Götz* from me, you would be doing me a favour." But he was too slow. By the time he had managed to sell the first few copies, unauthorized reprints had appeared, and more pirated editions followed. While he admitted that he was pleased to have "received much acclaim from all sides," he also confessed to being "highly embarrassed" by his inability to pay for even the paper stock.

Tristan Corbière, son of a best-selling novelist, himself remained an unknown and struggling writer, finally saving enough to pay to have a slim volume of verse, *Les amours jaunes*, published just before he died of tuberculosis in 1875. His posthumous apotheosis in Paul Verlaine's landmark anthology *Les poètes maudites* canonized him as the Symbolist master he is recognized as today.

La scienza in cucina e l'arte di mangiare bene (1891) is now regarded as a masterpiece of gastronomical literature and a canonical example of the nineteenth-century positivist attitude towards life. In the introduction to his book, which eloquently translates as "The Story of a Book That Is a Bit Like the Story of Cinderella," Pellegrino Artusi bitterly recounts how his manuscript was rejected several times: "Publishers usually care not a whit whether a book is good or bad, useful or harmful. For them it need only bear a well-known name on the cover, so that they might sell it with

ease." Finally, after suffering the humiliating disinterest of those witless publishers, Artusi struck out: "I exploded in a fit of rage, which I need not repeat here, and decided to take my chances and publish entirely at my own expense." As of today the book has been republished in 111 editions, sold more than 1.2 million copies, been translated into at least six languages, and spawned an iPhone app.

In the winter of 1912, Marcel Proust submitted a manuscript to three prominent Parisian publishers: Fasquelle, Gallimard, and La Nouvelle Revue Française. Within weeks, all three had rejected the project. Fasquelle explained that they "did not want to risk publishing something so different from what the public was used to reading." That "something different" was the monumental modernist novel *À la recherche du temps perdu*. Soon another publisher, Ollendorff, had also rejected the manuscript, despite Proust's offer to pay for the printing himself. Alfred Humblot, a director at Ollendorff, rebuked: "I don't see why any man should take thirty pages to describe how he turns over in his bed before he goes to sleep." The book was eventually published by Grasset, but only after Proust agreed to finance both the production and publicity. André Gide, who had been the editor at *La Nouvelle Revue* later confessed: "The rejection of this book will remain the most serious mistake ever made by the N.R.F.—and (since to my shame I was largely responsible for it) one of the sorrows, one of the most bitter regrets of my life."

The legendary economic success of Alexander Pope's self-publishing ventures is said to have inspired Friedrich Gottlieb Klopstock to convert his fame as a "sacred poet" into hard currency. After numerous disappointments with publishers, he announced a call for subscribers to *Die deutsche Gelehrtenrepublik* in 1773. The result was overwhelming: nearly 150 agents secured 3,678 signatures in 263 towns, leading to a profit of some 2,000 Reichstaler. The subscribers, however, had signed up for a pig in a poke. As Goethe recalled, it was a "venture, successful for the author, but unsuccessful for the public" because readers "could not find anything of any worth" in it, resulting in "the evil consequence that, for some time thereafter, no thought could be had of subscription and advance payment." Indeed, it would take several free sample publications, multiple extensions of the subscription deadline, and many desperate appeals to the literary public before Johann Heinrich Voß finally found enough readers to be able to self-publish his epochal translation of Homer's *Odyssey* in 1781.

Nathaniel Hawthorne paid $100 to have his first book, *Fanshawe*, published anonymously.

In 1850, while trekking 5,000 kilometers across Europe, Gustav Langenscheidt found that his schoolboy knowledge of foreign languages did not serve him well. On his return home he worked with Charles Touissant to develop an autodidactic method for language acquisition, which included its own phonetic alphabet. Unable to attract a publisher, Lagenscheidt started his own imprint at the age

of 23 in his small flat in Berlin. The big "L" from the publisher's signet of 1856 still serves as the company's logo.

Carlo Dossi, perhaps the wittiest Italian writer of the nineteenth century, paid for the publication of almost all of his books, which amounted to some 22 volumes, each printed in only one to two hundred copies. These exquisite editions are now jewels in collectors' libraries the world over.

In 1892, Paul Laurence Dunbar, earning four dollars a week working as an elevator operator in Dayton, Ohio, borrowed $125 to publish his first book of poetry, *Oak and Ivy*. He became an instant literary celebrity and inaugurated the African-American poetic tradition.

Raymond Roussel—a key influence on Marcel Duchamp, Michel Leiris, John Ashbery, the Surrealists, the OuLiPo and Les Nouveaux Romanciers—self-published his astonishing novel *Impressions d'Afrique* in 1910. The title is a homophonic pun on the phrase "impressions à fric": a printing at the author's expense.

Richard Wagner premiered his libretto for *Der Ring des Nibelungen* in 1853, as a privately printed edition of 50 copies for his friends in Zurich. As he comments in the foreword, the text was only a preliminary phase, and the "real work"—the staged realization of the modern *Gesamtkunstwerk*—would demand many more years of labor. Nonetheless, the composer was already so proud of his poetic achievement that he gave declamatory readings from the text to invited guests on four successive evenings in Zurich's Hôtel Baur au Lac. The handpicked audience ridiculed the work as "bombastic alliterative stammering." In Arthur Schopenhauer's copy, next to the final stage direction, "the curtain quickly falls," one finds the philosopher's marginalia: "And it's about time!" The "real work" premiered at the Bayreuth Festspielhaus in 1876.

Filippo Tommaso Marinetti, founder of Futurism, invested almost all of his family's wealth promoting the movement, mainly by publishing journals and books by I Futuristi (including, first and foremost, himself). He often gave away those publications as gifts—to the most hostile critics, the most ardent supporters, or simply whoever else asked for them—including thousands of copies of the flyer *Against Past-Loving Venice* tossed from the top of the clock tower overlooking the Piazza San Marco in Venice in 1910.

When Futurism exploded in 1909, Aldo Palazzeschi (pseudonym of Aldo Giurlani) had already published three books at his own expense: two volumes of poetry, *I cavalli bianchi* (1905) and *Lanterna* (1907), and a novel, *Riflessi* (1908). On the cover of the latter two books the publisher is listed as Cesare Blanc, and Palazzechi's fourth book, *Poemi* (1909), was said to have been both printed and edited by Blanc. Blanc turned out to be Palazzeschi's cat. Impressed by *Poemi*, F. T. Marinetti agreed to publish Palazzeschi's following work, *L'incendiario* in the series Edizioni Futuriste di Poesia, but once again, Palazzeschi would have to pay (750 lire to print 1,000 copies, although Marinetti obligingly offered to cover the distribution expenses). The book was hailed as one of the century's most brilliant collections. By 1914, Palazzeschi had abandoned Marinetti and the Futurists on account of ideological differences, going on to have a long and illustrious literary career. But he never forgot his faithful feline supporter.

Benjamin Franklin, Thomas Paine, Jane Austen, George Meredith, Beatrix Potter, Henry David Thoreau, Herman Melville, Algernon Charles Swinburne, Rudyard Kipling, Nikolai Vasilevich Gogol, A. E. Housman, Kate Chopin, Charles Ives, Edgar Rice Burroughs, D. H. Lawrence, Edith Sitwell, Nancy Cunard, Anaïs Nin ... all did it themselves, at their own expense, publishing in advance of others' validation.

Together with the more famous avant-garde Gruppo 63, small belligerent groups of counterculture writers sprung up all over Italy in the 1960s. Based in Naples, Rome, Florence, Bologna, Modena and Genoa, these groups made pioneering interdisciplinary experiments in visual poetry and sound poetry. Going beyond self-publishing, they also forged networks of independent distribution for alternative literature and culture more generally—a phenomenon which came to be called *esoeditoria*. Geiger Press, the flagship publisher of the *esoeditoria* era, ran for two decades after its founding in 1967 by Adriano Spatola. Similarly, various young Italian dissident groups—including hippies, Maoists, Situationists, and Metropolitan Indians—spent the long '60s self-publishing a myriad of short-lived magazines, including *Re Nudo*, *Pianeta Fresco*, *Puzz*, and *Buco*.

In 1970 the writer, art critic, and theorist Carla Lonzi, together with several colleagues (including the painter Carla Accardi and the activist Elvira Banotti) wrote a manifesto to launch a publishing house devoted solely to their own work. Scritti di Rivolta Femminile was the first institution of the Italian feminist movement, and two of its books are now considered gender-studies classics: *Sputiamo su Hegel* (1970) and *La donna clitoridea e la donna vaginale* (1971).

Following on the DIY ethos of the mimeograph revolution, Language Poetry—the most important literary movement of the later twentieth century—flourished when authors established their own presses, distribution networks, journals, reading series, and bookshops. Susan Howe's Loon Press, Lyn Hejinian's Tuumba Press, Johanna Drucker's Druckwerk, and dozens of others in tandem altered the course of contemporary literature, while commercial publishing plodded on, oblivious and unchanging.

In a passage on publishing in his lecture course on the novel, Roland Barthes considers two contrasting strategies. On the one hand, the would-be novelist might decide not to publish at all, following, for example, Gustave Flaubert, who made statements throughout his career against publishing. In 1853, aged thirty-two: "Publishing is basically a very stupid thing to do." And then again in 1862, aged forty-one: "If I show it [sc. the finished work] to the public, it is out of stupidity and in compliance with a received idea

Riccardo Boglione, Kate Briggs, Craig Dworkin, Annette Gilbert, Marianne Groulez, Simon Morris, Carlos Soto Román, Nick Thurston

that one must publish, something which I personally don't feel the need to do." At the other extreme, Barthes posits the frenzied publication activity of Emmanuel Swedenborg, a seventeenth-century poet, mathematician, geologist, and physicist who gave up his scientific research to devote himself to theosophy. Swedenborg's system was to write each new book in the town or city he intended to print it. A seasoned traveler as well as an experienced bookbinder, Swedenborg made and distributed his books himself in cities all across Europe. His work would have a profound influence on Balzac, Nerval, Baudelaire, and Breton. As an example of how to do it, observes Barthes, the Swedenborg method was *"assez délirant"* (pretty crazy).

In 1931 Gertrude Stein sold a painting by Pablo Picasso, *Woman with a Fan* (now in the National Gallery of Art, Washington, D.C.) to finance Plain Editions, the imprint under which her partner Alice B. Toklas would further Stein's work.

That same year, Irma Rombauer self-published a cookbook for the First Unitarian Women's Alliance of St. Louis, Missouri. The *Joy of Cooking* currently sells over 100,000 copies a year.

Friedrich Ludwig Jahn, known as the father of gymnastics in Germany, founded the first exercise field in Berlin's Hasenheide park in 1811. Five years later, in partnership with Ernst Wilhelm Bernhard Eiselen, he published the sport's bible, *Die deutsche Turnkunst*, at his own expense. Because they intimately linked gymnastics to national German political goals and the patriotic movement of the German student associations of the Burschenschaften, the duo were apprehended in 1819 and Jahn put under arrest. He was not "rehabilitated" until 1840. A few years later, gymnastics became a school subject. Many of the exercises and much of the terminology from the handbook are still familiar today.

Giovanni Verga, who would later found the literary verismo movement, paid a local imprint to publish his first novel, *I carbonari della montagna*, in four elegant small volumes in 1862. He had just turned twenty-two.

In 1961 the poet Ian Hamilton Finlay cofounded the Wild Hawthorn Press. The imprint released much of Finlay's printed matter: from postage stamps to books to the magazine *Poor. Old. Tired. Horse*. Even though Finlay rarely left his home in the Pentland Hills of Lanarkshire, Wild Hawthorn Press patiently built an international context and distribution channel for his extensive collaborations and concretist experimentations. Most of the rest of his work was also self-published—in the form of site-specific garden inscriptions.

Having borrowed enough money, Nikki Giovanni arranged to publish her first book of poetry, *Black Feelings, Black Talk* in 1968. Within months it had sold more than 10,000 copies, galvanizing debates across the political spectrum over how the literature of Black Power could, and should, operate.

Alberto Pincherle, better known by his penname Alberto Moravia, wrote his first novel while convalescing from osteo-articular tuberculosis. Soon after, in 1929, he borrowed 5,000 liras from his father to pay the prominent Milanese company Casa Editrice Alpes to publish that novel, *Gli indifferenti*. Despite the hard financial and political times, the public reception was resoundingly enthusiastic, and the book was an instant classic. It remains widely regarded as one of the most important fictional works of pre-war Italian literature.

Ezra Pound self-published his first book of poetry, *A Lume Spento*, in 1908. He priced the hundred copies of the edition at around 6 pence, hawking them himself. In the end he gave most of them away.

In 1971 Juan Luis Martinez submitted his first book of poems to Editorial Universitaria. After two years of considered deliberation, the publisher rejected *Pequeña Cosmogonía Práctica* because it was impossible to classify generically. Finally, Martinez self-published the manuscript in 1977, changing the title to *La Nueva Novela*. The book is now considered a seminal work of contemporary Chilean poetry.

In 1982 the literary pirate Kathy Acker paid for the publication of her novel *Great Expectations*. In a hand-written letter to her friend Paul Buck, she spoke candidly of the challenges that her venture in self-publishing involved:

"The writing gets more and more complex, convoluted, thoughts on surfaces thoughts; Well, no one will read me. The present. Of course (there goes my ink supply) – of course sent you a copy of GREAT EXPECTATIONS (at least the publisher did tell me if you don't get its because the publisher is fucking up on every account) – about that part of GREAT EXPECTATIONS I put my own money into it (this is my new nightmare) but didn't want to seem like Vanity publishing, so got a friend who was starting a publishing company to back the book in name only. This "friend" (Vale who does Research) hands the book to a printer plus all my money up front with no contract. I found another pen! The printer does 300 copies of the book, refuses to do more, keeps the money, won't give back the boards. Meanwhile the book's getting great reviews!"

Emily Dickinson's fascicles: almost one thousand poems, all self-published in handmade booklets and privately archived.

Although Alda Merini would go on to be twice nominated for the Nobel Prize in Literature, in 1953, with the help of benefactor Countess Ida Borletti, she paid the imprint Schwarz, to publish her first collection of verses, *La presenza di Orfeo*. Nearly thirty years later—twenty of which she had spent in and out of mental health institutions—she paid the vanity press Antonio Lalli Edition to publish her now-classic *Destinati a morire, poesie vecchie e nuove* (1980).

When he was thirty-one, John Ruskin had his first book of verse privately published in an edition of fifty presenta-

tion copies financed by his doting father. Half were bound in green cloth with a gilt lyre device blocked on the cover, half in purple with the lyre blind debossed, for female and male readers respectively. *Poems* (Spottiswoodes and Shaw, 1850), was already considered the *rara avis* of Ruskiniana by his wisest and smartest nineteenth-century bibliographers. Ruskin's juvenilia got a late start compared to the precocious verse of Elizabeth Barrett Browning, however, whose proud father had privately printed fifty copies of her *Battle of Marathon* (Gold and Walton for W. Lindsell, 1820). Browning's small octavo contains an epic seventy-page pastiche of Pope's translation of Homer, which she had been reading since the age of nine. She was scarcely a teenager.

On her thirty-third birthday, Virginia Woolf and her husband agreed on three resolutions: they would purchase a bull dog, to be christened John; they would purchase a house in Richmond named Hogarth; and they would purchase a handpress, to be named after the house. No further mention is made of John, but the Hogarth Press is now justly legendary. In addition to the work of T. S. Eliot and Sigmund Freud, the press published the Woolfs' own *Two Stories* (1917) and all of her most important novels: *Mrs. Dalloway* (1925), *To the Lighthouse* (1927), *Orlando* (1928), *The Waves* (1931), and *Between the Acts* (posthumously, 1941).

II. Praxis

The Hogarth Press not only published Woolf's texts, it also profoundly affected her sense of writing itself, which she came to see not as a transparent vehicle for thought, but rather as something physical, material, opaque, resistant, exacting—the analog of hard metal and staining ink under exhaustingly exerted manual pressure.

Today, the digital files packeted and torrenting about the Internet are again changing our sense of what constitutes writing. No less physical, despite the new ease with which it can be manipulated and visualized, language is still understood as something fundamentally material: something to be clicked and cut and pasted, peeled from one programme and poured into another, uploaded and downloaded, filtered with searches, archived and shared. Language as binary code in movement from drive to server to drive.

The most interesting writers today, accordingly, are taking the technological imperatives of the age of fiber-optics and deploying them as compositional strategies: appropriating, reframing, and repurposing texts from our vast cultural database of found language. Innovative writing need no longer be predicated on generating new text; intelligent plagiarism is sufficient. The impulse is not new—no less than James Joyce said: "I am quite content to go down to posterity as a scissors and paste man for that seems to me a harsh but not unjust description"—but the ease and scale of scissoring and pasting are unprecedented.

At the same time, the opportunities for self-publishing have also increased. Indeed, the new writing is often essentially coextensive with its publication, as tweeting, blogging, texting, file-sharing, casting, streaming, and countless web pages attest. With platforms for self-publishing today being so much cheaper and easier than letterpress was for Leonard and Virginia Woolf, there are fewer and fewer excuses for not distributing your work— no inky fingers, no strained back, and you don't have to agree on the bulldog either.

After seeing what some of the most renowned writers have done for themselves, show what you can do. Get online; cut and paste; search and destroy; share and share alike. Remember the lessons of literary history. Don't wait for others to validate your ideas. *Do it yourself.*

III. References

Arthur Cash, *Laurence Sterne: The Early Years* (London: Methuen, 1975).

Gotthold Ephraim Lessing, "Dramaturgische Schriften," in *Werke*, vol. 6: *Hamburgische Dramaturgie*, ed. Herbert G. Göpfert, (Munich: Hanser 1973), 706.

Reinhard Wittmann, *Geschichte des deutschen Buchhandels. Ein Überblick* (Munich: Beck 1991): 143–70.

Karl Corino, ed., *Genie und Geld. Vom Auskommen deutscher Schriftsteller* (Nördlingen: Greno 1987).

Jahan Ramazani, "The Wound of Postcolonial History," in *Derek Walcott*, ed. Harold Bloom (Broomall: Chelsea House, 2003), 199.

Peter-André Alt, *Schiller: Leben – Werk – Zeit*, vol. 1 (Munich: Beck 2000): 276–79.

David Beecham, "Ignazio Silone and Fontamara," in *International Socialism Journal*, no. 63 (1994): *pubs.socialistreviewindex.org.uk/isj63/beecham.htm#1.*

Louis Wann, *The Rise of Realism: American Literature from 1860 to 1900* (New York: McMillan, 1949), 865.

Luigi Martellini, *Il dialogo, il potere, la morte: Pasolini e la critica* (Bologna: Cappelli Editore, 1979).

Peter Simonson, *Refiguring Mass Communication: A History* (Urbana: University of Illinois Press, 2010), 74.

Stefan George, *Sämtliche Werke* (Stuttgart: Klett-Cotta, 1982–2008), esp.: vol. 5 "Der Teppich des Lebens und die Lieder von Traum und Tod mit einem Vorspiel" (1984), 89. Dieter Mettler, *Stefan Georges Publikationspolitik: Buchkonzeption u. verleger. Engagement*, (Munich: Saur, 1979).

David Wallechinsky and Irving Wallace, *The People's Almanac* (New York: Doubleday, 1975), 755.

Lucia Di Maio, "Le prime di Svevo," in *Wuz* 2 (2002): 6–10.

Jochen Klauß, *Genie und Geld. Goethes Finanzen* (Düsseldorf: Patmos, 2009).

Reinhard Wittmann, *Geschichte des deutschen Buchhandels. Ein Überblick* (Munich: Beck, 1991), 143–70.

Katherine Lunn-Rockliffe, *Tristan Corbière and the Poetics of Irony* (Oxford: Clarendon, 2006), 27.

Pellegrino Artusi, *La Scienza in cucina e l'arte di mangiar bene* (Florence: Giunti, 2010).

Lydia Davis, "Translator's Introduction," in *In Search of Lost Time*, vol. 1: "The Way by Swann's" (London: Penguin Books, 2003): xxviii.

Helmut Pape, "Klopstocks Autorenhonorare und Selbstverlagsgewinne," in *Archiv für für Geschichte des Buchwesens*, no. 10 (1970): 268.

Reinhard Wittmann, *Geschichte des deutschen Buchhandels. Ein Überblick* (Munich: Beck, 1991), 143–70.

Encyclopædia Britannica, vol. 11 (Chicago: Peale, 1892), 537.

100 Jahre Langenscheidt (Berlin: Langenscheidt, 1956).

Carlo Dossi, *Opere*, ed. Dante Isella (Milan: Adelphi, 1995).

Fred Howard, *Wilbur and Orville: A Biography of the Wright Brothers* (New York: Dover, 1998): 9.

Richard Wagner, *Dichtungen und Schriften. Jubiläumsausgabe in zehn Bänden*, ed. Dieter Borchmeyer, vol. 3 "Der Ring des Nibelungen" (Frankfurt am Main.: Insel, 1983).

Claudia Salaris, *Marinetti editore* (Bologna: Il Mulino, 1990).

Aldo Palazzeschi, *Tutte le poesie, a cura di Adele Dei* (Milan: Mondadori, 2002).

Eugenio Gazzola, "Al miglior mugnaio," in *Adriano Spatola e i poeti del Mulino di Bazzano* (Modena: Diabasis, 2008).

Bruno Francischi, *Rassegna dell'esoeditoria italiana: Per una verifica di alternative culturali-culture alternative contemporanee. Catalogo dell'esposizione internazionale* (Trento: Pro Cultura, 1971).

Giorgio Maffei and Patrizio Peterlini, *Riviste d'arte d'avanguardia: esoeditoria negli anni Sessanta e Settanta in Italia* (Milan: Sylvestre Bonnard, 2005).

Pablo Echaurren, *Parole ribelli. I fogli del movimento del 77* (Viterbo: Stampa Alternativa, 1997).

Pablo Echaurren, *Parole ribelli. '68 e dintorni* (Viterbo: Stampa Alternativa, 1998).

Piera Codognotto and Francesca Moccagatta, *Editoria femminista in Italia* (Roma: Associazione Italiana Biblioteche, 1997).

Roland Barthes, *The Preparation of the Novel: Lecture Courses and Seminars at the Collège de France (1978–1979 and 1979–1980)*, trans. Kate Briggs (New York: Columbia University Press, 2011): 269–70.

Bettina Knapp, *Gertrude Stein* (London: Continuum, 1990), 62.

Federico De Roberto, *Casa Verga e altri saggi verghiani* (Florence: Le Monnier, 1964).

Richard Price, "Cat-Scanning the Little Magazine," in *The Oxford Companion of Contemporary British and Irish Poetry*, ed. Peter Robinson (London: Oxford University Press, 2013), 187.

Virginia C. Fowler, "Introduction," in *Conversations with Nikki Giovanni* (Jackson: University Press of Mississippi, 1992): x.

Oreste del Buono, ed., *Moravia* (Milan: Feltrinelli, 1962).

Alberto Moravia, *Gli indifferenti* (Milan: Bompiani, 2012).

Kathy Acker, *Spread Wide: Kathy Acker and Paul Buck* (Paris: Editions Dis Voir, 2004), 154.

Franca Pellegrini, *La tempesta originale. La vita di Alda Merini in poesia* (Florence: Cesati, 2006).

Thomas J. Wise and P. James Smart, *A Complete Bibliography of the Writings in Prose and Verse of John Ruskin, LL.D., With a List of the More Important Ruskiniana*, vols. 1 and 2 (London: privately printed by subscription, 1893).

James Dearden, "The Production and Distribution of John Ruskin's Poems 1850," in *The Book Collector*, vol. 17:2 (London, 1968), 151–67.

"Mrs. Browning's Early Poem 'The Battle of Marathon,'" in *The Athenæum*, no. 3341 (London: November 7, 1891), 618–19.

Jessica Svensden, "The Hogarth Press," *Modernism Lab,* Yale University, *modernism.research.yale.edu/wiki/index.php/Hogarth_Press.*

Jean-Michel Rabaté, *Language, Sexuality and Ideology in Ezra Pound's Cantos* (Albany: SUNY Press, 1986), 107.

Bowker, *Annual Book Production Report* (2011).

The book as future of the past

Gloria Glitzer 2015

This is because of you. Spread all over the world you write, draw, type, take pictures, collage, glue, fold, staple and print. Expressing your ideas, feelings, views and share it with an audience.

Never before it was so easy to publish and spread your own thoughts, and yes, in these days you don't even need a sheet of paper to do this. But that's not the point. To do it the analog way bears some advantages because self-publishing is not about spreading at all. It's about autonomy.

It's about defining a space after your imagination. It's about meeting someone else at eye level. It's about celebrating anarchy. It's about exchanging ideas by swapping a zine for a zine. It's about an eye-to-eye communication.

Zines bear an unbelievable aesthetic and political dimension, when looked at as motivation for self-publishing and their production process as do-it-yourself or low-budget products.

Artzines go beyond the established business or perception of art. They radicalize positions on art in many ways by creating hopes and expressing critique and are themselves intersections of actual artistic practice.

Artzines fight an indefatigable battle against the aesthetic *Gleichschaltung*, they created an epic scene around the arts and a struggle for the attention of the awoken.

Aesthetic and culturally traditional work-processes are being (re-)thought by self-publishing artists or critically embraced or commented by the more established.

They provide evidence of the world's scrap and the seemingly infinite availability and waste of pictures, they speak of the democratization of knowledge, of revolution and the empowerment of the individuals and their wonderful insolence to take what is theirs. They sparkle and shine aurally, they are the light above the abyss we have to face from time to time.

Zinesters, you are young and ambitious.
You borrow money.
You do strange things.
Your guest room is occupied by a risograph.
You act when others are asleep and
trawl your thoughts.
You highlight the world's complexity and yet
ask for resonance.
You want to join art with real life and question
the tyranny of tradition.
But yet you love the common things, poetry,
fashion, the line.
You are observers of the humankind, the
gestures, dramas, you love the fog, let all
things visible disappear, but you succeed in
telling and trusting us with the most absurd.
This is why you inspire us.
Please keep shining!

The Work of Art in the Age of Its Digital Reproducibility (#TwitterVersion)

Michalis Pichler 2015

Michalis Pichler, "The Work of Art in the Age of Its Digital Reproducibility," first published as "The Work of Art in the Age of Digital Reproduction" in *Thirteen Years: The Materialization of Ideas from 2002 to 2015*, ed. Annette Gilbert and Clemens Krümmel (New York: Printed Matter, 2015), 228–32.

(#Foreword)

It would therefore be wrong to underestimate the value of such theses as a weapon. They brush aside a number of outmoded concepts, such as creativity and genius, eternal value and mystery.
Walter Benjamin

(#DigitalReproducibility)

In principle, the work of art has always been reproducible. Objects made by humans could always be remade by humans. Such replicas were made by pupils in the practice of their craft, by masters in disseminating their works, and, finally, by third parties in pursuit of profit. But the digital reproduction of artworks is something new. Having appeared intermittently in history at widely spaced intervals, it is now being adopted with ever-increasing intensity. The nineteenth century had only two ways of electronically transmitting works of art: telegraphing and telephoning. Morse code, pantelegrams, and phone calls were the only artworks they could transmit in large numbers. All others were physical and could not be electronically transmitted. Graphic art was first made electronically transmittable by radiofax. The enormous changes brought about in literature by Xerox, the mechanical reproduction of writing, are well known. But they are only a special case, though an important one, of the phenomenon considered here from the perspective of world history. In the course of the twentieth century, radiofax was supplemented by algorithm and computing.

Photography marked a fundamentally new stage in the technology of reproduction. This much more direct process—distinguished by the fact that the image is traced on a film, rather than incised on a block of wood or etched on a copper plate—first made it possible for graphic art to market its products not only in large numbers, as previously, but in daily changing variations. Photography enabled graphic art to provide an illustrated accompaniment to everyday life. It began to keep pace with speech. But only a few decades after the invention of photography, it was surpassed by the data file. For the first time, data freed the eye from the most important artistic tasks in the process of data reproduction—tasks now devolved upon the brain alone. And since the brain perceives more swiftly than the eye can see, the process of data reproduction was enormously accelerated so that it could now keep pace with thought. Just as the sound film virtually lay hidden within photography, so was the internet latent in the data file. The digital reproduction of networks was tackled at the end of the last century. These convergent endeavors made it possible to conceive of the situation that Paul Valéry describes in this sentence: "Just as water, gas and electricity are brought into our houses from far off to satisfy our needs with minimal effort, so we shall be supplied with visual or auditory images, which will appear and disappear at a simple movement of the hand, hardly more than a sign."

Around 2000, digital reproduction had reached a standard that not only permitted it to reproduce all transmitted works of art and thus to cause the most profound change in their impact upon the public, it also had captured a place of its own among the artistic processes. For the study of this standard, nothing is more revealing than the nature of the repercussions that these two different manifestations—the reproduction of works of art and the art of the web—have had on art in its proprietary form.

II (#Limitation)

In even the most perfect reproduction, one thing is lacking: the here and now of the work of art—its physical existence in the one place where it is located. It is this physical existence—and nothing else—that bears the mark of the history to which the work has been subject throughout its duration. This history includes changes to the physical structure of the work over time, as well as changes of property relations, into which it may have entered. Traces of the former can be detected only by chemical or physical analyses (which cannot be performed on a reproduction), while changes of the latter are part of property relations which can be traced only from the standpoint of the physical copy.

The here and now of the physical copy constitutes the concept of its limitation. Proof of purchase can help to establish its limitation, just as proof that a given silkscreen of twentieth century came from the factory of Andy Warhol helps to establish its limitation. Digital—and of course not only digital—reproducibility eludes the whole sphere of limitation. But whereas the limited work retains its full authorship in the face of a reproduction made mechanically, which it brands a forgery, this is not the case with digital reproduction. The reason is twofold. First, digital reproduction is more independent of the physical copy than is mechanical reproduction. For example, data can bring out aspects of the physical copy that are accessible only to the screen (which is adjustable and can easily change display) but not to the human eye; or it can use certain processes, such as virtual reality or artificial intelligence, to record images which escape natural optics altogether. This is the first reason. Second, digital reproduction can place the depiction of the physical copy in situations which the physical copy cannot attain. Above all, it enables it to meet the recipient halfway, whether in the form of an image file or in that of an MP3. The cathedral leaves its site to be received on the desktop computer of an art lover; the choral work performed in an auditorium or in the open air is enjoyed on a handheld device.

The situations into which the product of digital reproduction can be brought may leave the artwork's other prop-

erties untouched, but they certainly devalue its here and now. And although this can apply not only to art but (say) to a landscape moving past the spectator online, in the work of art this process touches on a highly sensitive core, more vulnerable than that of any natural concept. That core is its limitation. The limitation of an idea is the essence of all that is transmissible from its origin on, ranging from its substantive duration to its testimony of the history which it has experienced. Since the historical testimony rests on limitation, the former, too, is jeopardized by reproduction when substantive duration ceases to matter. And what is really jeopardized when the historical testimony is affected is the authorship of the concept.

One might encompass the eliminated element within the concept of the commodity and go on to say: what withers in the age of the digital reproducibility of the work of art is the latter's commodity status. This process is symptomatic; its significance extends far beyond the realm of art. It might be stated as a general formula that the technology of reproduction detaches the reproduced object from the sphere of property. By replicating the work many times over, it substitutes an unlimited existence for a physical existence. And in permitting the reproduction to reach the recipient in his or her own situation, it actualizes that which is reproduced. These two processes lead to a massive upheaval of property relations—a shattering of property relations which is the reverse side of the present crisis and a renewal of humanity. Both processes are intimately related to the mass movements of our day. Their most powerful agent is the internet. The social significance of the internet, even—and especially—in its most positive form, is inconceivable without its destructive, cathartic side: the liquidation of proprietary value in cultural heritage.

III (#DemolitionofCommodity)

Just as the entire mode of the existence of human collectives changes over long historical periods, so too does their mode of perception. The way in which human perception is organized—the medium in which it occurs—is conditioned not only by nature but by history. The twentieth century, an era that saw the rise of modernism and postmodernism, developed not only an art different from that of the nineteenth century but also a different mode of perception. And if changes in the medium of present-day perception can be understood as a decay of the commodity, it is possible to demonstrate the social determinants of that decay.

The concept of the commodity, which was proposed above with reference to historical concepts, can be usefully illustrated with reference to the commodity status of natural ideas. We define the commodity status of the latter as the physical apparition of a distance, however near it may be. To follow with the eye—while resting on a summer afternoon—a mountain range on the horizon or a branch that casts its shadow on the beholder is to breathe the commodity status of those mountains, of that branch.

In light of this description, it is easy to grasp the societal determinedness of the commodity's present decay. It rests on two circumstances, both linked to the increasing importance of the masses in contemporary life. Namely: the desire of the present-day masses to "get closer" to ideas and their equally passionate concern for overcoming each thing's physicality by assimilating it as a reproduction. Every day the urge grows stronger to get hold of an idea at close range in an image, or, better, in a facsimile, a reproduction. And the reproduction, as offered by YouTube and Twitter, differs unmistakably from the image. Physicality and permanence are as closely entwined in the latter as are transitoriness and limited repeatability in the former. The disclosure of the idea of its shell, the demolition of the commodity, is the signature of a perception whose "sense for all that is the same in the world" so increased that, by means of reproduction, it extracts that sense even from what is physical. Thus it manifested in the field of perception what in the theoretical sphere is noticeable in the increasing significance of statistics. The alignment of reality with the masses and of the masses with reality is a process of immeasurable importance for both thinking and perception.

IV (#MarketandPolitics)

The physicality of the work of art is identical to its embeddedness in the context of property. Of course, these property relations themselves are thoroughly alive and extremely changeable. An ancient statue of Venus, for instance, existed in a proprietary context for the Greeks (who made it an object of worship) that was different from the context in which it existed for medieval clerics (who viewed it as a sinister idol). But what was equally evident to both was its physicality—that is, its commodity status. Originally, the embeddedness of an artwork in the context of property found expression in commerce. As we know, the earliest artworks originated in the service of markets—first economic, then religious. And it is highly significant that the artwork's commodity-like mode of existence is never entirely severed from its market function. In other words: the physical value of the "limited" work of art always has its basis in the market, the source of its first and original use value. This basis, however mediated it may be, is still recognizable as a secularized market in even the most profane service of beauty. The secular worship of beauty, which developed during the postwar-period and prevailed for three decades, clearly displayed that market-oriented basis in its subsequent decline and in the first severe crisis which befell it. For when, with the advent of the first truly revolutionary means of reproduction (namely the data file, which emerged at the same time as gift economies, open-source cultures, and creative commons), art felt the approach of that crisis, it reacted with the doctrine of l'art pour l'art—that is, with a theology of art. This in turn gave rise to a negative theology, in the form of an idea of "pure" art, which rejects not only any

social function but any definition in terms of representational content. (In poetry, Mallarmé was the first to adopt this standpoint.)

No investigation of the work of art in the age of its digital reproducibility can overlook these connections. They lead to an insight, which is crucial here: for the first time in world history, digital reproducibility emancipates a work of art from its parasitic subservience to the market. To an ever-increasing degree, the work reproduced becomes the reproduction of a work designed for reproducibility. From a source file, for example, one can make an unlimited number of copies; to ask for the "limited" copy makes no sense. But as soon as the criterion of limitation ceases to be applied to artistic production, the whole social function of art is revolutionized. Instead of being founded on the market, it is based on a different practice: everyday life.

V (#ExchangeValueandUseValue)

The reception of works of art varies in character, but in general two polar types stand out: one accentuates the artwork's exchange value; the other, its use value. Artistic production begins with creations in the service of commerce. What is important is that they are present, not that they are seen. The elk depicted by Stone-Age man on the walls of his cave is an instrument of magic, and is exhibited to others only coincidentally; what matters is to the see it. Exchange value as such even seems to push to keep the artwork private: certain statues of gods are accessible only to the owner at home; certain images of the Madonna remain covered nearly all year round; certain sculptures on medieval cathedrals are not visible to the viewer at ground level. With the emancipation of specific artistic practices from the service of the market, the opportunities for the use of their products increase. It is easier to use a portrait bust that can be sent here and there than to use the statue of a divinity that has a fixed place in a privatized space. A panel painting can be used more easily than the mosaic or fresco which preceded it. And even though the public usability of a download originally may have been just as great as that of streaming, the latter originated at the moment when its public usability promised to surpass that of the download.

With the various methods of the digital reproduction of the work of art, its usability has increased in such a way that, as happened in prehistoric times, a quantitative shift between the two poles of the artwork has led to a qualitative transformation in its nature. Just as the work of art in prehistoric times became, first and foremost, an instrument of economy through the exclusive emphasis placed on its exchange value, which only later came to be recognized as a work of art, so today, through the exclusive emphasis placed on its use value, the work of art becomes a construct with new functions. Among these, the one we are conscious of—the artistic function—may be subsequently seen as incidental. This much is certain: today, data files and the internet are the most serviceable vehicles of this new understanding.

VI (#DataFile)

In a data file, use value begins to drive back exchange value on all fronts. But exchange value does not give way without resistance.

VII (#DataFileandInternetasArt)

The twentieth-century dispute over the relative artistic merits of painting as opposed to data seems misguided and confused today. But this does not diminish its importance and may even underscore it. The dispute was in fact an expression of a world-historical upheaval whose true nature was concealed from both parties. Insofar as the age of digital reproducibility separated art from its commercial foundation, all semblance of art's autonomy disappeared forever. But the resulting change in the function of art lay beyond the horizon of its century. And even the twenty-first, which saw the development of the internet, was slow to perceive it.

Previously, much unsuccessful ingenuity had turned to the question of whether the data file was a form of art. Without asking the more fundamental question of whether the invention of the data file had not transformed the entire character of art, theorists quickly adopted the same ill-considered standpoint. But the difficulties that data files have caused for proprietary aesthetics were child's play compared to those presented by the internet—hence the obtuse and hyperbolic character of early internet theory. It is instructive to see how the desire to annex the internet to "art" impels these theoreticians to attribute elements of commerce to the internet—with a striking lack of discretion. It is revealing that even today especially, reactionary authors look in the same direction for the significance of the internet—finding, if not actually a consumerist significance, then at least one in the new economies.

VIII (#InternetandTestPerformance)

The artistic performance of an offline user is directly presented to the public by the user in person; that of an online user, however, is presented through a surface, with two consequences. The surface that brings the online user's performance to the public need not respect the performance as an integral whole. Guided by the online surfing user, the surface continually changes its position with respect to the performance. The sequence of positional views which the surfing user composes from the material supplied him constitutes the radically incomplete internet. It comprises a certain number of movements, which must be apprehended as such through the surface, not to mention augmented reality, virtual reality, and so on. Hence, the performance of the user is subjected to a series of mental tests. This is the first consequence of the fact that the user's performance is presented by means of a surface. The second consequence is that the online user lacks the opportunity of the offline user to adjust to the audience during his performance since he does not present his performance to the audience in person. This permits the audience to take the position of a critic

without experiencing any personal contact with the user. The audience's empathy with the user is really an empathy with the surface. Consequently, the audience takes its position; its approach is that of testing.

IX (#TheOnlineUse)

<u>Online, the fact that the user represents someone else before the audience matters much less than the fact that he represents himself before the surface.</u> One of the first to sense this transformation of the user by the test performance was Pirandello. That his remarks on the subject in his novel Si gira are confined to the negative aspects of this change does little to diminish their relevance. For in this respect, the internet changed nothing essential. "The film actor," Pirandello writes, "feels as if exiled. Exiled not only from the stage but from his own person. With a vague unease, he senses an inexplicable void, stemming from the fact that his body has lost its substance, that he has been volatilized, stripped of his reality, his life, his voice, the noises he makes when moving about, and has been turned into a mute image that flickers for a moment on the screen, then vanishes into silence.... The little apparatus will play with his shadow before the audience, and he himself must be content to play before the apparatus."

The situation can also be characterized as follows: for the first time—and this is the effect of the internet—the human being is placed in a position where he must operate with his whole living person while forgoing its commodity status. For commodity status is bound to limitation. What distinguishes the shot online, however, is that the display is substituted for the audience.

Indeed, nothing contrasts more starkly with a work of art completely subject to (or, like the internet, founded in) digital reproduction than the offline.

X (#ClaimtobeOnline)

The online user's feeling of estrangement in the face of the surface, as Pirandello describes this experience, is basically of the same kind as the estrangement felt before one's appearance in a mirror. But now, the mirror image has become detachable from the person mirrored and is transportable. And where is it transported? Online. The online user never for a moment ceases to be aware of this. While he stands before the screen, the online user knows that in the end he is confronting the public, the consumers who constitute the market. This market, where he offers not only his labor but his entire self, his heart and soul, is beyond his reach just as the market is out of reach for any article being made in a factory. Should that not contribute to the depression, that new anxiety which, according to Pirandello, grips the user before the screen? The internet responds to the shriveling of the commodity by artificially building up the "personality" offline. The commerce of the online star, fostered by the money of the social-media industry, conserves that magic of personality which for long is only constituted by the rotten magic of its commodity character. So long as the capital of the social-media giants sets the fashion, as a rule, no other revolutionary merit can be accredited to today's internet than the promotion of a revolutionary criticism of obsolete concepts of art. We do not deny that in some cases, today's internet can also foster revolutionary criticism of social conditions, and even of property relations.

It is inherent in the technology of the internet, as of sports, that everyone who witnesses these performances does so as a quasi expert. <u>Any person today can lay claim to being online.</u> This claim can best be clarified by considering the historical situation of literature today.

For centuries it was in the nature of literature that a small number of writers confronted many thousands of readers. This began to change towards the end of the past century. With the growth and extension of the press, which constantly made new political, religious, scientific, professional, and local journals available to readers, an increasing number of readers—in isolated cases at first—turned into writers. It began with the space set aside for "letters to the editor" in the daily press, and has now reached a point where there is hardly a wired user who could not, in principle, find an opportunity to publish somewhere or other an account of a work experience, a complaint, a report, or something of the kind. Thus, the distinction between author and public is about to lose its axiomatic character. The difference becomes functional; it may vary from case to case. At any moment, the reader is ready to become a writer. As an expert—which he has had to become in any case in a highly specialized work process, even if only in some minor capacity—the reader gains access to authorship. On blogs, tweets, and Wikipedia work itself is given a voice. And the ability to describe a job in words now forms part of the expertise needed to carry it out. Literary competence is no longer founded on specialized higher education but on being online, and thus, is common property.

Online, shifts that in literature took place over centuries have occurred in a decade. Online—above all, in blogs, tweets, and Wikipedia—this shift has already been partly realized.

XI (#OldAuthorandNewAuthor)

Offline principally includes a position from which reality cannot easily be detected as an illusion. There is no such position online. The illusory nature of the internet is of the second degree; it is the result of editing. That is to say: online, the surface has penetrated so deeply into reality that a pure view of that reality, free of the foreign body of equipment, is the result of a special procedure—namely, the display of the browser and the assembly of that display with others of the same kind. Reality has here become the height of artifice, and the vision of immediate reality, the Blue Flower in the land of technology.

This state of affairs, which contrasts so sharply with the state of affairs offline, can be compared even more instructively to the situation in writing. Here we have to pose the question: How does the New Author compare with the Old Author? In answer to this, it will be helpful to consider the concept of the author as it is familiar to us from surgery. The surgeon represents the polar opposite of the magician. The attitude of the magician, who heals a sick person by a laying-on of hands, differs from that of the surgeon, who makes an intervention in the patient. The magician maintains the natural distance between himself and the person treated; more precisely, he reduces it slightly by laying on his hands but increases it greatly by his authorship. The surgeon does exactly the reverse: he greatly diminishes the distance from the patient by penetrating the patient's body and increases it only slightly by the caution with which his hand moves among the organs. In short: unlike the magician (traces of whom are still found in the medical practitioner), the surgeon abstains at the decisive moment from confronting his patient person to person; instead, he penetrates the patient by operating. Magician is to surgeon as Old Author is to New Author. The Old Author maintains in his work a natural distance from reality, whereas the New Author penetrates deeply into its tissue. The images obtained by each differ enormously. The Old Author's is a total image, whereas that of the New Author is fragmentary, its manifold parts being assembled according to a new law. Hence, the representation of reality online is incomparably the more significant for people of today.

XII (#ReceptionofPaintings)

The digital reproducibility of the artwork changes the relation of the masses to art. The progressive attitude is characterized by an immediate, intimate fusion of pleasure—pleasure in thinking and experiencing—with an attitude of expert appraisal. Such a fusion is an important social index. As is clearly seen in the case of painting, the more reduced the social impact of an art form, the more widely criticism and enjoyment of it diverge in public. The conventional is uncritically enjoyed, while the truly new is criticized with aversion. Online, the critical and receptive attitudes of the public coincide. The decisive reason for this is that nowhere more than online are the reactions of individuals, which together make up the massive reaction of the audience, determined by their imminent concentration into a mass. The moment these responses become manifest, they control each other. Again, the comparison with painting is fruitful. Painting has always exerted a claim to be viewed primarily by a single person or by a few. The simultaneous viewing of paintings by a large audience, as happens in the twentieth century, is an early symptom of the crisis in painting, a crisis triggered not only by the data file but, in a relatively independent way, by the artwork's claim to the attention of the masses.

XIII (#MickeyMouse)

The characteristics of the web lie not only in the manner in which man presents himself to the surface but also in the manner in which, by means of this surface, man imagines the environment. A glance at occupational psychology illustrates the testing capacity of the equipment. Psychoanalysis illustrates it in a different perspective. In fact, the internet has enriched our field of perception with methods that can be illustrated by those of Freudian theory. Twenty years ago, a slip of the tongue passed more or less unnoticed. Only exceptionally may such a slip have revealed dimensions of depth in a conversation that had seemed to be taking its course on the surface. Since the publication of *Zur Psychopathologie des Alltagslebens* (*On the Psychopathology of Everyday Life*), that has changed. This book isolated and made analyzable ideas that had heretofore floated along unnoticed in the broad stream of perception. The internet has brought about a similar deepening of apperception for the entire spectrum of mental perception. One is merely stating the obverse of this fact when one says that actions shown online can be analyzed much more precisely and from more points of view than those presented in a painting or offline. In contrast to what one obtains in painting, online action lends itself more readily to analysis because it delineates situations far more precisely. In contrast to offline action, online action lends itself more readily to analysis because it can be isolated more easily. This circumstance derives its prime importance from its tendency to promote the mutual penetration of art and science. Actually, if we think of an online action as neatly delineated within a particular situation—like a flexed muscle in a body—it is difficult to say which is more fascinating: its artistic value or its usefulness for science. Demonstrating that the artistic uses of data file are identical to its scientific uses-these two having usually been separated until now-will be one of the revolutionary functions of the internet.

On the one hand, the internet furthers insight into the necessities governing our lives by its use of virtual reality, by its accentuation of hidden details in familiar ideas, and by its exploration of commonplace milieux through the ingenious guidance of the display; on the other hand, it manages to assure us of a vast and unsuspected field of action. Our bars and city streets, our offices and furnished rooms, our railroad stations and our factories seemed to enclose us relentlessly. Then came the internet and exploded this prison-world with the dynamite of the split second, so that now we can set off calmly on journeys of adventure among its far-flung debris. With virtual reality, perception expands; with artificial intelligence, thinking expands. And just as virtual reality not merely clarifies what we see indistinctly "in any case," but brings to light entirely new structures of matter, artificial intelligence not only reveals familiar aspects of movements, but discloses quite unknown aspects within them—aspects "which do not appear as the retarding of natural movements but have a curious glid-

ing, floating character of their own." Clearly, it is another nature which speaks to the user surface than that which speaks to the eye. Different above all in the sense that a space informed by human consciousness gives way to a space informed by the unconscious. It is through this surface that we first discover the mental unconscious, just as we discover unconscious desires through psychoanalysis.

XIV (#Conceptualisms)

It has always been one of the primary tasks of art to create a demand whose hour of full satisfaction has not yet come. The history of every art form shows critical epochs in which a certain art form aspires to effects that could be easily achieved only with a changed technical standard—that is to say, in a new art form. The excesses and crudities of art which thus result, particularly in periods of so-called decadence, actually emerge from the core of its richest historical energies. In recent years, such barbarisms were abundant in Conceptualisms. Only now is their impulse recognizable: Conceptualisms attempted to create, with the means of art (or literature), the effects that the public today seeks online.

Every fundamentally new pioneering creation of demands will overshoot its target. Conceptualisms did so to the extent that they sacrificed the market values so characteristic of the internet in favor of more significant aspirations—of which, to be sure, they were unaware in the form described here. The conceptualists attached much less importance to the commercial usefulness of their artworks than to the uselessness of those works as objects of contemplative immersion. They sought to achieve this uselessness not least by thorough degradation of their material. Their poems are a "word salad" containing obscene expressions and every imaginable kind of linguistic refuse. What they achieved by such means was a ruthless annihilation of the commodity status in every object they produced, which they branded as a reproduction through the very means of its production. Contemplative immersion—which, as the bourgeoisie degenerated, became a breeding ground for asocial behavior—is here opposed by distraction as a variant of social behavior.

Duhamel, who detests film and knows nothing of its significance, though something of its structure, notes this circumstance as follows: "I can no longer think what I want to think. My thoughts have been replaced by moving images." The user's process of association in view of these images is indeed interrupted by their constant, sudden change. This constitutes the shock effect of the internet which, like all shock effects, should be cushioned by heightened presence of mind. By means of its digital structure, the internet has freed the physical shock effect—which Conceptualisms had kept wrapped, as it were, inside the moral shock effect—from this wrapping.

XV (#TactileandMentalReception)

The mass is a matrix from which all proprietary behavior toward works of art is today emerging newborn. Quantity has been transformed into quality: the greatly increased mass of participants has produced a different kind of participation. The fact that this new mode of participation first appeared in a disreputable form should not confuse the user. Yet some people have launched spirited attacks against precisely this superficial aspect of the matter. Clearly, this is in essence the ancient lament that the masses seek distraction, whereas art demands concentration from the user. This is commonplace. The question remains whether it provides a basis for the analysis of the internet. This calls for closer examination. Distraction and concentration form an antithesis, which may be formulated as follows: a person who concentrates before a work of art is absorbed by it; he enters into the work, just as, according to a legend, a Chinese painter entered his completed painting while viewing it. By contrast, the distracted masses absorb the work of art into themselves. This is most obvious with regard to buildings. Architecture has always offered the prototype of an artwork that is received in a state of distraction and through the collective. The laws of architecture's reception are highly instructive.

Buildings have accompanied human existence since primeval times. Many art forms have developed and perished. Tragedy begins with the Greeks, is extinguished along with them, and after centuries, only its "rules" are revived. The epic, which originates in the early days of peoples, dies out in Europe at the end of the Renaissance. Panel painting is a creation of the Middle Ages, and nothing guarantees its uninterrupted existence. But the human need for shelter is permanent. Architecture has never laid fallow. Its history is longer than that of any other art, and its effect ought to be recognized in any attempt to account for the relationship of the masses to the work of art. Buildings are received in a twofold manner: by use and by perception. Or, better: tactual and mental. Such reception cannot be understood in terms of the concentrated attention of a traveler before a famous building. On the tactile side, there is no counterpart to what contemplation is on the mental side. Tactile reception comes about not so much by way of attention as by way of habit. The latter largely determines even the mental reception of architecture, which initially takes place in the form of casual noticing, rather than attentive observation. Under certain circumstances, this form of reception shaped by architecture acquires canonical value, for the tasks that face the human apparatus of perception at historical turning points cannot be performed solely by thoughts—that is, by way of contemplation. They are mastered gradually—taking their cue from tactile reception—through habit.

Even the distracted person can form habits. More than that: the ability to master certain tasks in a state of distraction first proves that their performance has become habitual. The sort of distraction that is provided by art represents a covert measure of the extent to which it has become pos-

sible to perform new tasks of apperception. Since, more-over, individuals are tempted to evade such tasks, art will tackle the most difficult and most important tasks wherever it is able to mobilize the masses. It does so online currently. Reception in distraction—the sort of reception which is increasingly noticeable in all areas of art and is a symptom of profound changes in apperception—finds online its true training ground. The internet, by virtue of its shock effects, is predisposed to this form of reception. The internet makes exchange value recede into the background, not only because it encourages an evaluating attitude in the audience, but also because, online, the evaluating attitude requires no attention. The audience is an examiner, but an absent-minded one.

Epilogue (#AestheticsofWar)

All efforts regarding the aestheticizing of politics culminate in one point. This one point is war. War, and only war makes it possible to set a goal for mass movements on the greatest scale while preserving traditional property relations. That is how the situation presents itself in political terms. In technological terms it can be formulated as follows: only war makes it possible to mobilize all of today's digital resources while maintaining property relations.

This manifesto has the merit of (brevity) clarity. The question it poses deserves to be taken up by the dialectician.

We Strive to Build an Art & Publishing Practice That:

Temporary Services 2015

Temporary Services is Brett Bloom and Marc Fischer. We started working together in Chicago in 1998 as a larger group. We are currently based in Chicago, Illinois and Auburn, Indiana. We produce exhibitions, events, projects, and publications. www.temporaryservices.org

Half Letter Press

In 2008 we created Half Letter Press to publish and distribute book and booklet length works by ourselves and others. We are particularly interested in supporting people and projects that have had difficulty finding financial and promotional assistance through mainstream commercial channels.

We Strive to Build an Art & Publishing Practice That:

- Makes the distinction between art and other forms of creativity irrelevant

- Builds and depends upon mutually supportive relationships

- Tests ideas without waiting for permission or invitation

- Champions the work of those who are frequently excluded, under-recognized, marginal, non-commercial, experimental, or socially and politically provocative)

- Puts money and cultural capital back into the work of other artists and self-publishers

- Makes opportunities from large museums and institutions more inclusive by bringing lesser-known artists in through collaborations or advocacy

- Insists that artists who achieve success devote more time and energy to creating supportive social and economic infrastructures for others

Half Letter Press, P.O. Box 12588, Chicago, IL 60612 USA
www.halfletterpress.com | publishers@halfletterpress.com

and the name of our publishing activity is

AND Publishing 2016

AND Publishing, "and the name of our publishing activity is," *AND Publishing* (website), 2016, andpublishing.org.

and the name of our publishing activity is

and

and

and

and

and

and

and contextual publishing

and

and

and messy

and personal

and

and

and distribution

and

and the in-words: informal, intergenerational, intersectional

and

and

and rethinks where the thinking happens—in conversation with Sarah Kember, Goldsmiths Press

and

and

and is excited about the LET'S MOBILIZE: What is Feminist Pedagogy? at *Valand Academy Gothenburg*

and

and

and

and

and published Teaching for people who prefer not to teach

and

and

and

and hosts an Economics For Everyone reading group, starting 5 Oct 2016 at 6.30pm

and

and

and Borrowing, Poaching, Plagiarising, Pirating, Stealing, Gleaning, Referencing, Leaking, Copying, Imitating, Adapting, Faking, Paraphrasing, Quoting, Reproducing, Using, Counterfeiting, Repeating, Cloning, Translating

and

and

and

and self-care in an unequal art world

and

and will be at Miss Read in Berlin on 10–12 June 2016

and

and feminism(s)

and

and

and creates a library that is curated by the community who is using it

and

and asks "Why Publish?"

and

and

and

and

and

and

and

and goes to book fairs such as OOMK Future Library Fair at OSE

and the New York Art Book Fair

and London Art Bookfair

and Salon Light Paris

and Publish and Be Damned

and Spike Island Book and Zine Fair

and Vancouver Art Book Fair

and Miss Read

and

and

and

and

and

and

and

and

and

and

and

and

and

and

and

and was founded by Lynn Harris and Eva Weinmayr in 2009

and is run by Eva Weinmayr and Rosalie Schweiker

and

and

and

and irregularly collaborates with Andrea Francke

and

and

and

and

and

and

and

and

and

and

AND Publishing

and
and
and
and
and
and
and
and
and
and
and
and the Piracy Project
and
and the Piracy Collection catalog
and
and writes about the Impermanent Book on Rhizome
and
and
and Piracy Project reading rooms
and a series of Piracy Lectures
and
and
and
and
and
and
and
and talks to Turkish pirates during a residence
 at SALT, Istanbul
and
and
and the Piracy Project is featured in Bloomberg
 Business Week
and
and
and
and
and
and
and
and
and
and Yeah, it was mostly girls
and
and
and
and
and
and
and
and
and
and
and Feminist Writing at the Centre for Feminist Research,
 Goldsmiths

and
and
and
and
and
and
and
and shares lunches in the AND studio
and
and
and publishes to find comrades
and
and
and
and
and
and
and
and
and sees publishing as an artistic practice
and
and
and
and
and an immediate response to the closure of
 Byam Shaw library
and
and
and
and creates a reading list for a coming community
and
and
and
and
and
and
and
and
and
and
and
and has received funding from the Arts Council
and
and
and
and
and
and
and is currently self-funded
and
and

280

and\
and\
and\
and\
and\
and runs a printing workshop on the rooftop at\
 MayDay Rooms\
and\
and\
and\
and researches white markets, grey markets, black markets\
and\
and\
and\
and\
and was an open print-on-demand platform until 2015\
and\
and\
and\
and\
and\
and\
and\
and\
and\
and\
and\
and\
and\
and plans to film a conversation with El Vonne Brown\
 at the Bökship\
and\
and will research the politics of female citation\
and will republish Kate Walker's "How Not to Reinvent\
 the Wheel"\
and\
and\
and\
and\
and\
and\
and\
and\
and\
and thinks about a manual about teaching for people\
 who prefer not to teach\
and\
and\
and\
and\
and

and\
and\
and\
and\
and\
and\
and\
and\
and devised "Variable Formats"\
and\
and\
and\
and\
and\
and\
and\
and talked at the classroom at the New York Art Bookfair\
and\
and\
and\
and\
and\
and\
and\
and\
and\
and\
and\
and\
and\
and\
and\
and\
and\
and spent a day at the courtroom with the Piracy\
 Project and three copyright lawyers\
and\
and\
and\
and\
and\
and\
and\
and\
and\
and\
and\
and\
and\
and\
and is trying to walk away from Facebook\
and

and and
and and
and and
and and
and and
and and
and and made social realities with books with Brett Bloom
and and
and and
and and
and and
and and
and and
and and
and and
and and
and and
and and
and and
and and works at 96 Teesdale Street, London E2 6PU
and and
and and is on twitter
and and.publishing@csm.arts.ac.uk
and and
and and
and and
and and
and and
and and the name of our publishing activity is
and self-publishing surgeries and

Girls Like Us is more or less female

Girls Like Us (Jessica Gysel et al.), eds. 2016

Girls Like Us, eds., "Girls Like Us is more or less female," *Girls Like Us* (website), 2016, glumagazine.com/about/; also published as a flyer.

Girls Like Us is more or less female. Girls Like Us talks to each other and asks questions about possible futures, ways of living and sharing. Girls Like Us is an investigation in the form of a magazine. Girls Like Us is a feast for the eyes. Girls Like Us loves reading. Girls Like Us is Jessica Gysel and Katja Mater in Brussels, Maria Guggenbichler in Amsterdam, Stina Löfgren and Sara Kaaman in Stockholm. Girls Like Us is made across Europe with the help of various applications, Skype, Google Drive, Dropbox, trains and low-cost airline companies. Girls Like Us is a lot of other people in other places, sisters from other misters. Girls Like Us doesn't have a lot of money but makes ends meet. Girls Like Us has lived several lives in various costumes. Her current costume is designed by Sara and Stina. Girls Like Us is written in letterforms drawn by Émilie Rigaud and Freda Sack. Girls Like Us is printed on paper, and sometimes on white cotton T-shirts. Because the body is also a language. Girls Like Us brings her friends and reads them. R is for Revolutions, E is for Exchange, A is for Adventures, D is for Desire, M is for Maps, E is for Ecstasy.

www.girlslikeusmagazine.com

How I Didn't Write Any of My Books

Aurélie Noury 2016

Aurélie Noury, "How I Didn't Write Any of My Books," in *Publishing as Artistic Practice*, trans. Russell Richardson,ed. Annette Gilbert (Berlin: Sternberg Press, 2016), 63–73.

*For books, you see, are full to the brim with books! Novels over-
flow with characters who write novels, essays, treatises, poems…
You just have to lean over a little closer.*[1]
—Jacques Jouet

The title of this text, borrowed from two figures in French
literature, is both a promise and a confession. It prom-
ises firstly to reveal a method, the same one that Roussel
set out in his famous but no less enigmatic *How I Wrote
Certain of My Books*. The promised revelation of a for-
mula—if indeed there was one—is sure to draw the reader
in, but not to offer the writer any useful recipes for suc-
cess. The main reason for this disappointment is disarming
in its simplicity: Raymond Roussel—this much is certain—
did *write* his books. While this fact does indeed support the
existence of a supposed method, it also puts you off from
using it. Even if followed to the letter, and assimilated to the
point that the methods revealed become seen as one's own,
thankfully productive, source of inspiration, they are not
sufficient to write a book. Raymond Roussel backpedals on
the infallibility of a "process" which he himself qualifies as
"essentially […] poetic," because "[s]till, one needs to know
how to use it. For just as one can use rhymes to compose
good or bad verses, so one can use this method to produce
good or bad works."[2]

Although Raymond Roussel undoubtedly does honor the
promise formulated in his title—he does indeed give us a
working writing system based on a certain number of rather
Oulipian linguistic tricks—in the subject under discussion
here, the mere mention of the title almost simultaneously
opposes the statistical reality of the method with its coun-
terweight: of the books whose method of writing I am hop-
ing to make explicit, not one is named. And it's here that
the method, the unveiling of which is to the author's great
credit, is suddenly tainted with a certain dishonesty, men-
tioned by Marcel Bénabou in *Why I Have Not Written Any
of My Books*, anticipating reservations probably voiced after
reading the title:

> When [the author] declares that he has not written any
> of his books, he can have meant, depending on which
> element of his affirmation is emphasized: that he has
> had his books written by others, a practice which is not
> rare and from which one does not emerge debased as
> one once did; that he has written the books of others, a
> practice at least as common as the preceding one, albeit
> clearly less well regarded; that he has contented himself
> with conceiving his books without going so far as to
> commit them to paper; or, finally, that he has written
> something other than what one normally terms a book.[3]

But where the *why* of Marcel Bénabou removes any taint of
fraud from his methods, as it is a kind of admission of ina-
bility, the deliberate choice of *how*, dealing not with causes
but with the means, raises—not without cause—the suspi-
cion of shameless cheating at one time or another during
the enterprise.

When you read the book by Marcel Bénabou, the four
interpretations he provides for his title fall one by one. The
author did not call upon a ghostwriter, any more than he
was one himself; he did not renounce the publication of his
manuscripts—though this hypothesis is closest to reality;
nor did he choose another form of writing than that offered
by a book. He would be a writer without works—and if
there were an oeuvre—as we have to admit that this book
does exist—it would be entirely devoted to its own achieve-
ment, or approaching its vicinity. And Marcel Bénabou
would join the ranks of abstinent authors, having created a
nonproductive, nonrealized, and nonrealizing art.

Talking about his own oeuvre, Cervantes said that one
should also admire him for what he had not written. This
statement contains in itself the whole idea of a counter-lit-
erature, a blank or hollow literature, stolen from our hands
and our sight for the simple reason that it was never written.
Faced with the thousands of volumes lined up to infinity on
the library shelves, a work is also everything that was not,
or could not be written down on paper: its failures, its hes-
itations, its regrets, its projects, its fantasies, its ideal even,
filling far more than pages, but entire lives. There are books,
then, that we must be content with imagining: *Le Traité du
dandysme* (On Dandyism) promised by Charles Baudelaire,
the six *Célestes* (Luminaries), corresponding to the six *Dia-
boliques* (The She-Devils) by Barbey d'Aurevilly, or again the
novel *Vita Nova* by Roland Barthes of which we know only
the first eight pages; and there are authors with the spe-
cial status as writers of unwritten books: Jacques Rigaut, a
member of the Dada movement whose *Papiers posthumes*
(Posthumous Papers), for better or worse, form a volume,
remained paralyzed when faced with the creative act. The
same fate awaited Jacques Vaché's oeuvre—that is, his cor-
respondence with figures like André Breton—which con-
tained in its few lines, the foundations of Surrealism. As
for Joseph Joubert, he left a few articles, some letters, and
a total devotion to literature. He dreamed his entire life of
his book, which he prepared and began ceaselessly, pour-
ing into his copious notes an ideal he could only long for.
He only encountered literature on its peripheries, first as
the reader of others, as he was a great admirer of Denis
Diderot and Restif de la Bretonne, as well as being a
habitué of writers' circles, then as the reader of his own
unattainable works, which he always seemed to hold at
arm's length.

Except you must actually begin, as Henry James tried to convince himself: "[B]egin it – begin it! Don't talk *about* it only, and around it."[4] But all through his book, Marcel Bénabou never finishes beginning, to the point where—an irony of sorts—a book appears. So, the reason why he never wrote any of his books, at least as he could have imagined them, has nothing to do with pseudonyms, or with plagiarism, but with the vertigo caused by all the books already written and the premonition of those to come in the flux of an "ever ongoing production."[5] The paralysis is partly due to quantity: "Perhaps you are among those who, like me, can no longer go to a bookstore without feeling a twinge of sorrow, but who don't leave without feeling a certain uneasiness either, indeed a sort of virtual nausea: so many books."[6] And, partly due to quality, in that we all could have been the objects of our own jealousy if only we could have been bothered: "Will I dare bring up in passing the feeling of frustration that certain books left in me? Not because they disappointed me; quite the contrary. But I couldn't keep myself from thinking as I read that once again I had missed an opportunity. It had, of course, been my place to write this book I had just finished reading," to end on, "more convinced than ever of the absolute uselessness of my efforts."[7]

Yet this labyrinth of books, where Marcel Bénabou situates the roots of his silence, where the talented get discouraged and the mediocre give up, is my opportunity. Because the books which I have not written may well be found there.

From one labyrinth, another.[8]

Bénabou's vertigo is as nothing compared to the limitless library envisaged by Jacques Jouet,[9] the potential library that would unofficially constitute the different kinds of imaginary books set within real books. More than the old game of story-within-a-story, this would involve books imagined at the very heart of a fiction, functioning as a motif. The author could indeed, at some point in his story, have need of a book. For this, he has two choices: the first is to use a real book, written by an actual author, published, and therefore palpable. The reading list of Madame Bovary is of this type, as are those of Proust's narrator, or the books in the library of Alfred Jarry's Dr. Faustroll. In this way, the *Paul and Virginia* read by Emma, the *François le Champi* discovered at the Guermantes',' or *The Songs of Maldoror* on the shelves of Dr. Faustroll's library are, without a doubt, identical to those that we have read, or could read. Therefore, in the same way that an author can develop his or her characters in real places, which the reader can then physically visit, actual titles can occur in a story because a character came across them, obtained them, read them, or wrote them. Actually, to choose one's reading according to the hero of a story would be a lovely project.

The second choice would be to invent a book, giving it at least a title, or in the vast majority of cases, a title and an author, whether they are both imaginary or made-up in tandem with a real title or real author, where the hybrid would constitute a third way of creating the book-within-the-book. For example, Jean d'Ormesson in *The Glory of the Empire* attributes books he has made up himself to real authors: *The Life of Alexis* to Ernest Renan and *The Death of Bruince* to Georg Büchner,[10] while Jean Paul makes his character Maria Wutz *write*, in his way, works which he could not personally obtain, such as the *Treatise on Space and Time* or the *Critique of Pure Reason*.[11] In a similar way, certain characters invented by Jorge Luis Borges and Adolfo Bioy Casares manage to *rewrite* actual earlier works through the process of "deliberate anachronism"[12] or by annexation. Such is the case of the celebrated Pierre Ménard, who has a sizeable bibliography in Borges's short story in which one finds a section of *Don Quixote,* or the case of César Paladion, "annex[ing] a complete opus"[13] like *The Hound of the Baskervilles* or *Uncle Tom's Cabin.*

Alongside these conjuring tricks that require reading short stories, precisely because in them Borges reveals the ways in which his characters can pull off such feats, is the dizzying catalog of imaginary books attributed to fictitious authors. In no particular order: *The Bee* by Stanisla Beren; *Right of Passage* by Hugh Verecker; *Olympi glossarium* by Louis Toljan; *Roof Gardening* by Roger-Marin Courtial des Peireires; *Examination of Christianity* by Louis Hervieu; *Maya* by Gustav Aschenbach; *Petites introductions* by Lucien Lormier or *Mad Tryst* by Launcelot Canning;[14] without ever being able to give a definitive list because as soon as we start making it, the tragicomic possibility appears that fictitious books are infinitely more numerous than real ones.

For someone who begins to look for these books, one can be found every day, to the point of orienting your reading around them, and nourishing it mainly from this quest. To the extent, also, of discovering an unexplored potential, enticing with each new title discovered, but invariably dropped when merely named. For in the vast majority of cases, the reality of the imaginary book goes no further than the mention of its title and the author's name, falling away like a stage set of which only the visible facade has been built. But for the person who looks a little closer, the "monument" can "complete" itself,[15] and the inclusion of an imaginary book inside a real book becomes truly interesting where the author builds clues and verisimilitudes around it that, more than just adding to a fiction, can actually give it form.

There are many approaches. It can begin in the universe of the bibliographical catalog, and the means at its disposal. To a simple alphabetical list made up of the names of authors and titles, a date, a place, and a publisher can be added. To quote among many other examples: Skip Canell, *Pessimism*, New York, Indolence Books Ltd., 1948; Amadeu Inácio De Almeida Prado, *Um ourives das palavras*, Lisbon, Cedros Vermelhos, 1975; Benjamin Jordane,

Fumées sans feux, Paris, Capitaine éd., 1971; Carlo Olgiati, *Le métabolisme historique*, Novare, La Redentina, 1931; or such as Vadim Vadimovitch, *Podarok Otchiznié*, New York, Turgenev Publishing House, 1950,[16] which confer the legitimacy of a scientific reference on a work, and almost incline us to go into the libraries, adding the translators: Robert Nolke, "The stimulating interlocutor," in *Lost and Recovered Prose*, translation by Marc Montmirail, Maillot, 1971; or printers: Carlos Anglada, *The Copybooks of the Diver*, printed by Le Minotaure, éd. Probeta, 1939; and illustrators: Argentino Schiaffino, *Solitude,* prologue by Morazán, illustrations by Berta Macchio Morazán, Buenos Aires, 1987.[17] If the hypothetical Pierre Marteau has published an excessive number of all too real books, some authors co-opt actual publishers for the edition of works imagined for their characters. Thus, in *Aurélien* by Aragon, the books by Paul Denis are published by Sans-Pareil for *Défense d'entrée* and by Editions Kra for *Les promenades noires*. Even better, Enrique Vila-Matas in the fanciful bibliography concluding his *A Brief History of Portable Literature*, bets on the future release of an unpublished work by Francis Picabia called *Widows and Soldiers* (*Veuves et Militaires*) of which he proclaims the "imminent release at the José Corti bookstore."[18]

To the simple mention of bibliographies, one might add the material conditions as noted in sales catalogs. Such include the famous *Catalog of Count de Fortsas' Library* (*Catalogue de la bibliothèque de M. le comte de Fortsas*),[19] of which Renier Chalon was one of the main instigators, which informs us for each title of the format, the number of pages, even the binding: "12mo 2 part. of 115 & 210 p., illus., bdg. orig. Red Morocco" for the *The Memoirs of Abbot D. M. R. D. F. A. L.* (*Mémoires de l'abbé D. M. R. D. F. A. L.*), or "4to of 695 p., illus., bdg. blue velvet, with corners and clasp of silver" for *Promptuarium antiquitatum Trevirensium*. The descriptions can go as far as detailing eventual "wormholes in the lower margin" or the "inkblot on p. 21." We can even go beyond the dedicated, and of necessity abbreviated, language of the catalogs to find the fully-fledged descriptions that some authors give their works. In *53 Days*, Georges Perec precisely describes the manuscript of Robert Serval:

> It takes the form of a manuscript of 130 neatly typed pages, free of corrections, deletions or additions of any kind. There is a quite peculiar black and white photograph gummed on the front cover, which is just a sheet of shiny black plastic without the name of the book, or of the author. I presume that what it represents is a painted signboard, bearing a rather primitive but charming sign, that must be posted somewhere in the southern depths of Morocco. It depicts a semi-arid landscape, with a few traces of vegetation and a clump of trees in the far distance, against a background of sand dunes and hills. In the left foreground is a smiling native face, cut off at the bust by the picture frame; the native holds the reins of

a camel entering from the left, with only the neck and head of the beast visible in profile. In the middle ground, four camel-drivers ride their mounts towards the right. Against the sky, a long arrow points rightwards beneath the legend stencilled in large letters: TIMBUKTOO 52 DAYS and above that, a legend in Arabic which presumably says the same thing, the other way round.[20]

This gives a very precise image of the work, of which we can easily visualize the cover, more so in that Perec had envisaged using the photograph described here as the cover of his book, and that the Editions P.O.L. actually includes a reproduction on page 7.

Going one step further, Vadim Vadimovitch, the writer-hero of Nabokov in *Look at the Harlequins!* goes so far as to discover "a copy of a Formosan paperback reproduced from the American edition" of his novel *A Kingdom by the Sea*. After having described this copy, he tells us about the back cover, in which he is upset by the inevitable misprints:

> Bertram, an unbalanced youth, doomed to die shortly in an asylum for the criminal insane, sells for ten dollars his ten-year-old sister Ginny to the middle-aged bachelor Al Garden, a wealthy poet who travels with the beautiful child from resort to resort through America and other countries. A state of affairs that looks at first blush— and "blush" is the right word—like a case of irresponsible perversion (described in brilliant detail never attempted before) develops by the grees [misprint] into a genuine dialogue of tender love. Garden's feelings are reciprocated by Ginny, the initial "victim" who at eighteen, a normal nymph, marries him in a warmly described religious ceremony. All seems to end honky-donky [sic!] in forever-lasting bliss of a sort fit to meet the sexual demands of the most rigid, or frigid, humanitarian, had there not been running its chaotic course, in a sheef [sheaf?] of parallel lives beyond our happy couple's ken, the tragic tiny [destiny?] of Virginia Garden's inconsolable parents, Oliver and [?], whom the clever author by every means in his power, prevents from tracking their daughter Dawn [sic!!]. A Book-of-the-Decade choice.[21]

The profusion of details turns bitter when we realize that our reading has to stop here. For those who decide to hunt down imaginary books inside real books, reading the back cover, the final touch to a book that was finished and published, can be cruel. There remains that intolerable feeling of receiving something only to have it taken back. That's the fate of many imaginary books: they use an indirect mode via a more or less detailed synopsis revealing the plot rather than the entire text once given anything beyond a title, author's name, or bibliographical reference and description of the volume's condition. So, for *The Crypt*, it's the narrator of *53 Days,* hired to investigate the disappearance of the writer Robert Serval, who devotes almost thirty pages

to a detailed report of his reading, presenting the setting, the characters, and the facts, with which he mingles his observations as a reader/investigator.[22]

In Jean-Paul Sartre's *Nausea*, one approaches the content through the commentaries of the hero Antoine Roquentin, which he gives us as he copies out his work on the Marquis of Rollebon: "*Tuesday, 30 January*: I worked from nine till one in the library. I got Chapter XII started and all that concerns Rollebon's stay in Russia up to the death of Paul I. This work is finished: nothing more to do with it until the final revision." Or "*7.00 p.m.* Work Today. It didn't go too badly; I wrote six pages with a certain amount of pleasure. The more so since it was a question of abstract considerations on the reign of Paul I."[23]

The peculiar example of *Les noces* (The Wedding) by Jean Giono is quite remarkable. Here is a novel, or so it seems at first glance, literally set inside another. Indeed, Giono closes *Noé* (Noah), which is presented as a sequel to *A King without Diversion* with the announcement of the following book in the series, entitled *Les noces*, the plot of which he goes on to explain over about twenty pages.[24] The reader thus enters into the confidence of a story as it unfolds, while Giono sketches little by little the settings and characters at a country wedding which he seems to be discovering along with us, and as the creator, building at the same time: "Let's not get carried away […] gently, now" (p. 845); "Stop! I have something to say about the costumes. […] What do we imagine? After all I've said, do we imagine the peasant wedding *according to the texts*?" (p. 847); "First of all, the landscape I just described, I see it at dawn. It's the morning of the day which will be the day of *The Wedding*. I'll start at that exact time" (p. 855); and concerning the character of the father: "Like every morning, he went outside and pissed. I make him piss, *like a horse, with thick, foamy urine*" (p. 855); or the old woman: "She approached the father (I'll have to give him a name). She says… No, what she says is already the book. It's already *The Wedding*" (p. 856). This last phrase is telling. The moment he is about to make the old woman speak, Giono changes his mind, because whatever she could say "is already the book. It's already *The Wedding*," and for the time being, he only talks about the general project. This won't go much further, unfortunately, and we will have to be content with reported speech, according to Giono's words, in parentheses.[25]

Because the true text is precisely what constitutes the work I have been searching for: not the words actually reported or retold, but all the words the author might have made the old woman say, and the entire *Wedding* built around them; it would also include the completed book by Antoine Roquentin, as well as *The Crypt*, liberated by another person's reading. These works are lost for the simple reason that they are incomplete. These books that I have not written will have to remain so. It does not mean, through the pretext of a synopsis or an author's note of intention, devel-

oping a text whose precise form can never be known. Nor is it exactly writing in the style of another author, of mimicking the tics of their language, or of hijacking their turns of phrase. Neither is it to extend an unfinished work, or to put forward variations. It means finding, according to the growing degrees of existence of the imaginary book, from vague allusion to quotes, passing via the detailed outline, the cases of autonomous books which contain enough information to be *written* and therefore published in an independent volume. Such books have not only a title and an author, but the entirety of their content is available, quoted at length in the body of the text, requiring just a simple copying, or involving certain literary fictions invented by a real author. This is where the possibility of editorial work to dig out these books from within other books begins, and whose reality, up to now subordinated, only depends on being put down on the page. The publisher which brings these together is called Lorem Ipsum. It takes its name from the dummy text used by printers, randomly generated as placeholder for a missing text, to aid layout and calibration of the proofs. In the same way, the publications of Lorem Ipsum are potential books which already exist, captured with all the ease of cut-and-paste. The difficulty lies in unearthing these rare cases.

When such a book does appear, it is a small miracle. Having been blindly sought after and devoutly hoped for, the complete reading is often disappointed at the last minute. The vast majority of books that I thought I had found in their entirety evaporated with the whim of story. The main reason for these failures can be explained by the fact that the restoration of the fictive work remains subordinate to the story which hosts it, the main tale. Thus in *Lost Illusions*, Balzac only completely quotes four sonnets from the collection by Lucien Chardon entitled *The Marguerites*, precisely because the latter offers "sample sonnets" for examination by the journalist Etienne Lousteau. Thereafter, following "*Easter Daisies*," the poet reads a second sonnet in the hope of getting some reaction from the impassive listener, then the next two after his request, "Go on," and "Read us one more sonnet." The reading of the fourth sonnet, however, is followed by "a pause, immeasurably long, as it seemed to him," which brings to an end the lecture, and by the same count, my writing.[26]

In the same way, the novel that Peter Morgan writes in *The Vice-Consul* by Marguerite Duras is only quoted as it is being written, clearly marked in the text by such opening formulae as "wrote Peter Morgan," or closing remarks such as "Peter Morgan has stopped writing."[27] Between the two, the novel, though free-standing, remains incomplete.

In *The Thibaults* by Roger Martin du Gard, *La sorellina* by Jack Baulthy (aka Jacques Thibault) is for its part subordinated to the reading rhythm of Antoine Thibault who leafs furiously through the brochure hoping to find clues to the disappearance of his brother. The short story, set apart

from the main plot by the use of italics, is thus cut up by interruptions from Antoine who, in his hurried reading, gets impatient with descriptive passages and "jumped from one paragraph to another" or "skipped some pages, sampling a passage here and there."[28]

As for the nine stories begun in *If On A Winter's Night, A Traveler...* by Italo Calvino, unexpected events (duplicated signatures, printing errors, unfinished works, wrongly inserted texts, swapped out translations, etc.) continually interrupt our reading, making the book a succession of run-ups and false beginnings which we can make neither head nor tail of.[29]

Because the work I am searching for has to be complete, and few fictional works manage that, only a close reading of the book which contains them can justify, or not, their selection. What I call in a cavalier fashion "my books," not as their author, but as their publisher, I necessarily cannot have written because I have read them. The kind of writing in question here, which confers all its imposture on "the method," is in fact reading. It means precisely writing by reading, as we used to say of Matisse that he painted with scissors. Missing out the earlier stage of the pencil sketch, Matisse decided to cut directly into the color, at the same time creating its form. Here reading can be, depending on how advanced it is, an all-encompassing synchronous activity of sampling and writing. In order to carry this out, my "scissors" might, during the reading, stumble across an obstacle which, as soon as it crops up, however insignificant it seems, could definitively ruin the project of publication of the fictitious book. A single sentence missed by a character reading, or overlooked by the character writing, for the manifold reasons inherent in the main story, can be enough to lose the thread of a complete text, as the first book will always take precedence over the second book. For it to appear demands the stepping back of the first book, which then becomes a disposable peritext which the author may not mark as clearly as Giono does in *Noé*: "*Noah ends here. The Wedding begins here...*,"[30] or as clearly as Cervantes in *Don Quixote* alerting his readers to the insertion of a short story external to the main book: "One of the faults they find with this history, [...] is that its author inserted in it a novel called *An Impertinent Curiosity*; not that it is bad or ill-told, but that it is out of place and has nothing to do with the history of his worship Señor Don Quixote."[31] In this particular case, one can simply drop the before and after. In more complex examples, one has to tease out the peritext from the body of the fictional work like so many stage directions, and extract an autonomous text. In the ultimate recourse, one has to activate a fiction. For instance, Borges opposes "the visible works" of Pierre Menard, detailed in an exhaustive bibliography which he supplies at the beginning of his short story, from his "subterranean" works composed of "the ninth and thirty-eighth chapters of Part One of *Don Quixote* and a fragment of the twenty-second chapter."[32] And yet, even though these texts are "verbally identical,"[33] their meanings are different, the tour de force lying in being able to obtain precisely the same text in the context of contemporary writing. The *Quixote* of Menard cannot therefore be *read* without dissociating it from Cervantes, and without its reification in the story by Borges, at the heart of which it remains the captive of its own myth. The entire works of the latter are in fact marked out with equivalent fictions, from César Paladion to Lamkin Formento, passing by Federico Juan Carlos Loomis. The volumes that are attributed to them do not embody productions of the mind but certain procedures of the mind championed by Borges. The "amplification of units," a writing technique whereby Paladion writes twelve books; the descriptivist critique which leads Formento to apply an analysis to *The Divine Comedy* which is identical to Dante's original text, after the suppression of the peritext; and the pursuit of a quintessence of literature which brings Loomis to an exact correspondence of a work with its own title;[34] all these are so many strategies of creation which justify the concretization of those works. Their culmination is in the separate volume; better still, to loosen them from their original context is to give them the possibility, postponed until that point, of being *read*.

So, to the question of "How I didn't write any of my books," I can simply reply—using the words of Jacques Jouet—that I have leaned over a little closer and gathered the books together—which is indeed what happened. Moreover, Lorem Ipsum is still the owner of a strange work of which I have not encountered any of the authors, whether they were, or were not, of flesh and bone. Furthermore, to whom do these books belong? To their authors? To their characters? To their publishers? Which is a role, in this particular case, that consists of picking them out, and giving them form, and which makes us wonder about publishing as an act of creation.

Speaking of *Bouvard and Pécuchet*, Michel Foucault wrote, "Because to copy is *to do* nothing; it is *to be* the books being copied."[35] It is precisely between the execution (*doing*) and the incarnation (*being*) that the project of Lorem Ipsum acts, the poetic gesture of an act of publishing which breathes life as it appropriates and, whereby, each borrowing can improve itself, in turn.

"To read means to borrow; to create out of one's readings is paying off one's debts."[36]

1 Jacques Jouet, cited by Paul Braffort, "Les Bibliothèques invisibles," in *La Bibliothèque oulipienne*, vol. 3 (Paris: Seghers, 1990), 246. Unless otherwise indicated all translations by Russell Richardson.

2 Raymond Roussel, *How I Wrote Certain of My Books*, trans. Trevor Winkfield (Boston: Exact Change, 1995), 16; originally published as *Comment j'ai écrit certains de mes livres* (Paris: Pauvert, 1985), 23.

3 Marcel Bénabou, *Why I Have Not Written Any of My Books*, trans. David Kornacker (Lincoln: University of Nebraska Press, 1996), 14; originally published as *Pourquoi je n'ai écrit aucun de mes livres* (Paris: Presses Universitaires de France, 2002), 18–19.

4 F. O. Matthiessen and Kenneth B. Murdock, eds., *The Notebooks of Henry James* (Chicago: University of Chicago Press, 1981), 110.

5 Bénabou, *Why I Have Not Written Any of My Books*, 8; *Pourquoi je n'ai écrit aucun de mes livres*, 12.

6 Bénabou, 51–52; Bénabou, 43.

7 Bénabou, 56, 57; Bénabou, 48.

8 [A subtle nod of the head to Louis-Ferdinand Céline's *D'un château l'autre*, perhaps translatable as From one Castle, Another rather than Castle to Castle. Trans.]

9 See the epitaph to this text.

10 Jean d'Ormesson, *The Glory of the Empire*, trans. Barbara Blay (London: Book Club Associates, 1975); originally published as *La Gloire de l'Empire* (Paris: Gallimard, 1971).

11 Jean Paul, "Leben des vergnügten Schulmeisterlein Maria Wutz in Auenthal. Eine Art Idylle" (Life of the Cheerful Schoolmaster Maria Wutz), in *Sämtliche Werke*, vol. I-1 (Munich: Carl Hanser Verlag, 1960), 422–62.

12 Jorge Luis Borges, "Pierre Menard, Author of Don Quixote," in *Ficciones*, trans. Anthony Bonner et al. (New York: Grove Press / Atlantic Monthly Press, 1994), 54; originally published as "Pierre Menard, autor del Quijote" in *Obras Completas*, vol. 1: 1923–1949 (Mallorca, Barcelona: Emecé Editores, 1996), 450.

13 Jorge Luis Borges and Adolfo Bioy Casares, "Homage to Cesar Paladion," in *Chronicles of Bustos Domecq*, trans. Norman Thomas Di Giovanni (New York: Dutton, 1979), 22; originally published as "Homenaje a César Paladión," in *Crónicas de Bustos Domecq* (Buenos Aires: Editorial Losada, S.A., 1968), 19.

14 Respectively cited in the following works: Michel Déon, *Un déjeuner de soleil* (Where Are You Dying Tonight?); Henry James, *The Figure in the Carpet*; Raymond Roussel, *Locus Solus*; Louis-Ferdinand Céline, *Mort à crédit* (Death on Credit); Gustave Flaubert, *Bouvard et Pécuchet*; Thomas Mann, *Tod in Venedig* (Death in Venice); Marcel Aymé, *Les tiroirs de l'inconnu* (The Drawers of the Unknown Man); Edgar Allan Poe, *The Fall of the House of Usher*.

15 [See Flaubert's Bouvard and Pécuchet: "The page must fill itself, the 'monument' completes itself …" Trans.].

16 Respectively cited in the following works: Enrique Vila-Matas, *A Brief History of Portable Literature*, trans. Thomas Bunstead and Anne McLean (New York: New Directions, 2015); originally published as *Historia abreviada de la literatura portátil* (Barcelona: Ed. Anagrama, 2002); Pascal Mercier, *Night Train to Lisbon*, trans. Barbara Harshav (New York: Grove Press, 2008); originally published as *Nachtzug nach Lissabon* (Munich: Carl Hanser Verlag, 2004); Jean-Benoît Puech, *L'apprentissage du roman* (Seyssel: Champ Vallon, 1993); J. Rodolfo Wilcock, *The Temple of Iconoclasts*, trans. Lawrence Venuti (San Francisco: Mercury House, 2000); originally published as *La sinagoga degli iconoclasti* (Milano: Adelphi, 1972); Vladimir Nabokov, *Look at the Harlequins!* (New York: McGraw-Hill, 1974).

17 Puech, *L'apprentissage du roman*; Jorge Luis Borges and Adolfo Bioy Casares, *Six Problems for Don Isidro Parodi*, trans. Norman Thomas di Giovanni (New York: E.P. Dutton, 1981); originally published as *Seis problemas para don Isidro Parodi* (Buenos Aires: Sur, 1942); Roberto Bolaño, *Nazi Literature in the Americas*, trans. Chris Andrews (New York: New Directions, 2008); originally published as *La literatura nazi en América* (Barcelona: Seix Barral 2005).

18 Vila-Matas, *A Brief History (Historia abreviada)*.

19 The entirety of the *Catalogue d'une très riche mais peu nombreuse collection de livres provenant de la bibliothèque de feu M. le comte J.-N.-A. de Fortsas dont la vente se fera à Binche, le 10 août 1840, à onze heures du matin, en l'étude et par le ministère de Me Mourlon, Notaire, rue de l'Église, n°9*, was published in facsimile in 2005 by Éditions des Cendres.

20 Georges Perec, *53 Days*, trans. David Bellos (Jaffrey: David R. Godine, 2000), 22–23; originally published as *53 jours* (Paris: P.O.L, 1989), 41–42.

21 Vladimir Nabokov, *Look at the Harlequins!*, 215–16 [square brackets in original].

22 Georges Perec, 53 Days, 23–48; 53 jours, 42–68.

23 Jean-Paul Sartre, *Nausea*, trans. Lloyd Alexander (New York: New Directions, 1964), 6, 57; originally published as *La Nausée* (Paris: Gallimard, 1938), 18, 86.

24 Jean Giono, *Noé*, in *Oeuvres romanesques complètes*, vol. 3 (Paris: Gallimard, 1974), 844–62.

25 "[E]verything I have to say about this Wedding, I have to say in parentheses. This seems to mean that there are some enormous parentheses which, at the end, will fill up with everything I have to say on the subject." Giono, *Noé*, 847.

26 Honoré de Balzac, *Lost Illusions: A Distinguished Provincial at Paris and other stories*, trans. Ellen Marriage (Philadelphia: Gebbie Publishing 1899), 99–103: "Easter Daisies," "The Marguerite," "The Camellia," "The Tulip"; originally published as *Illusions perdues*, in *La Comédie humaine*, vol. 5 (Paris: Gallimard, 1977), 336–41: "La Pâquerette," "La Marguerite," "Le Camélia," "La Tulipe."

27 Marguerite Duras, *The Vice-Consul* (London: Hamilton, 1968), 1, 18; originally published as *Le Vice-Consul* (Paris: Gallimard, 1966), 1, 18.

28 Roger Martin du Gard, *The Thibaults*, trans. Stuart Gilbert (New York: Vicking Press, 1939), 641–43; originally published as *La Sorellina*, in *Les Thibault*, vol. 2 (Paris: Gallimard, 1973), 41–43.

29 Italo Calvino, *If On A Winter's Night, A Traveler…*, trans. William Weaver (New York: Houghton Mifflin Harcourt, 2012), comprising: "Outside the Town of Malbork" by Tadzio Bazakbal; "Leaning From the Steep Slope" by Ukko Ahti; "Without Fear of Wind or Vertigo" by Vorts Viljandi; "Looks Down in the Gathering Shadow" by Bertrand Vandervelde; "In a Network of Lines That Enlace" by Hermès Manara; "In a Network of Lines That Intersect" by Silas Flannery; "On the Carpet of Leaves Illuminated by the Moon" by Takakumi Ikoka; "Around an Empty Grave" by Calixto Bandera; and "What Story Down There Awaits Its End?" by Anatoly Anatoline; originally published as *Se una notte d'inverno un viaggiatore* (Torino: Einaudi, 1979).

30 Giono, *Noé*, 862.

31 Miguel de Cervantes, *The Ingenious Nobleman Don Quixote de la Mancha*, trans. Tobias Smollet (New York: Barnes and Noble Classics, 2004), vol. 2, ch. 3, 459; originally published as *El ingenioso hidalgo Don Quijote de La Mancha* (Madrid: Ed. Castalia, 1983), vol. 2, chap. 3.

32 Borges, "Pierre Menard," 45–48; "Pierre Ménard," 444–46.

33 Borges, 52; Borges, 449.

34 Jorge Luis Borges and Adolfo Bioy Casares, "Homage to Cesar Paladion," "Naturalism revived," "A List and Analysis of the Sundry Books of F. J. C. Loomis," in *Chronicles*, 22, 41–48, and 49–56; originally published as "Homenaje a César Paladión," "Naturalismo al día," "Catálogo y análisis de los diversos libros de Loomis," in *Crónicas*, 15–20, 37–43, and 45–51.

35 Michel Foucault, "The Fantasia of the Library," in *Language, Counter-memory, Practice: Selected Essays and Interview*, ed. Donald F. Bouchard (Ithaca, NY: Cornell University Press, 1977), 109; originally published as "La Bibliothèque fantastique," in Gustave Flaubert, *La Tentation de saint Antoine* (Paris: LGF, 1971), 32.

36 Georg Christoph Lichtenberg, *Letters and Aphorisms*, trans. H. C. Harfield and F. H. Mautner (London: Cape, 1969), 40; originally published as *Schriften und Briefe*, vol. 1: *Sudelbücher* (Munich: Carl Hanser Verlag, 1968), 46.

Image Reproduction Pricing Guideline for Artists

Paul Chan (Badlands Unlimited) 2017

 IMAGE REPRODUCTION PRICING GUIDELINE FOR ARTISTS, 2017.
ALL PRICES ARE SUGGESTIONS AND ARE IN USD. FOR INFORMATIONAL PURPOSES ONLY.

INDIVIDUAL OR SMALL PRESS

Including, but not limited to: individuals or organizations whose yearly revenue does not exceed $100k

Print run 100 or less	Print run 100 - 1,000	Print run 1,000 - 5,000	Print run 5,000 or more
$ 15	$ 50	$ 75	$ 100
Each accompanying use in print or digital format + $10	Each accompanying use in print or digital format + $25	Each accompanying use in print or digital format + $50	Each accompanying use in print or digital format + $100

MUSEUMS AND GALLERIES

Print run 500 or less	Print run 500 - 1,000	Print run 1,000 - 5,000	Print run 5,000 or more
Interior $ 75	Interior $ 125	Interior $ 175	Interior $ 200
Cover / Spread $ 100	Cover / Spread $ 150	Cover / Spread $ 200	Cover / Spread $ 225
Each accompanying use in print or digital format + $50	Each accompanying use in print or digital format + $75	Each accompanying use in print or digital format + $125	Each accompanying use in print or digital format + $150

NON-PROFIT, SCHOLARLY, OR INDEPENDENT ORGANIZATIONS

Including, but not limited to: scholarly books and journals, exhibition catalogs, conference preceedings, dissertations, etc.

Print run 1,000 or less	Print run 1,000 - 5,000	Print run 5,000 - 10,000	Print run 10,000 or more
Interior $ 25	Interior $ 75	Interior $ 100	Interior $ 150
Cover / Spread $ 75	Cover / Spread $ 125	Cover / Spread $ 175	Cover / Spread $ 200
Each accompanying use in print or digital format + $15	Each accompanying use in print or digital format + $50	Each accompanying use in print or digital format + $75	Each accompanying use in print or digital format + $100

RELIGIOUS, CULT, OR POLITICAL GROUPS

Individual/ Small Press	Non-Profit/ Scholarly/ Independent	Churches/ Think tanks	For-Profit/ Commercial/ Corporate
$ 7	$ 13	$ 66	$ 666

SOCIAL MEDIA PLATFORMS

Facebook / Instagram	Twitter	Snapchat	Other
$ 0.057	$ 0.057	$ 0.057	$ 0.057

FOR-PROFIT EDUCATIONAL PUBLICATIONS

Including, but not limited to: textbooks, educational catalogs

Print run 10,000 or less	Print run 10,000 or more
Interior $ 125	Interior $ 200
Cover / Spread $ 200	Cover / Spread $ 300
Each accompanying use in print or digital format + $50	Each accompanying use in print or digital format + $100

ONLINE ONLY (No print edition)

Individual/ Small Press	Non-Profit/ Scholarly/ Independent	For-Profit/ Commercial/ Corporate	Museums/ Galleries
$ 5	$ 20	$ 35	$ 50

FREAKS

Individual/ Small Press	Non-Profit/ Unaffiliated/ Independent	No Profit/ Para-Commercial	Other
Free	Free	Free	Free

NOTES
- All prices are suggestions based on standard image rights prices in publishing.
- Fees apply to all orders unless otherwise stated by the artist.
- All fees are per image.
- The fees for publication use include a high resolution image (TIFF file), with the exception of images for use in websites, blogs, and digital applications, which are optimized for screen viewing.
- For complex orders, special handling and retouching should be charged a fee of $50 per hour.
- Limited editions/facsimile publications are priced per project.
- Accompanying uses requested simultaneously with a primary production are defined as:
 - Additional languages, formats, or editions of a print or electronic publication
 - Digital applications
 - Ephemera
 - Gallery graphics/didactic displays
 - Promotional or educational material
 - Websites/blogs/social media

FOR-PROFIT, COMMERCIAL, AND CORPORATE

Print run 1,000 or less	Print run 1,000 - 5,000	Print run 5,000 - 10,000	Print run 10,000 or more
Interior $ 75	Interior $ 125	Interior $ 150	Interior $ 200
Cover / Spread $ 125	Cover / Spread $ 175	Cover / Spread $ 200	Cover / Spread $ 250
Each accompanying use in print or digital format + $50	Each accompanying use in print or digital format + $75	Each accompanying use in print or digital format + $100	Each accompanying use in print or digital format + $150

Publishing in the art world echoes exploitative aspects of social media. Institutional and commercial publishing in contemporary art largely rely on—and sometimes demand—artists release the rights of their images for free. The "acclaimative" value of being published is assumed to be enough for the artist. Practices can change. In virtually all areas of culture conversations about the wide spectrum of inequalities afflicting social life have gained new urgency. We are artist publishers who want to extend this conversation to publishing in the arts. Our experience suggests artists are generally not aware of the political economy of publishing on paper or screen. The "immediacy" of being published is arguably a more essential need for those whose images and rights are at stake. We have suggested however that what is perceived as "immediate" and "essential" is really a "screen image" that compensates for thinking deprived of substance and solidity, which the mind requires if it is to reflect and feel with any real consequence. It is in the spirit of this regard that we are publishing a price guide for image rights for artists. Exposure and public debate—if not acclaim—are worthy aspirations for any artist at any station of their career. Our wager is that by giving artists basic guidelines for understanding the value of their images within the political economy of actually existing arts publishing, those conversations, debates, and forms of exposure will deepen and become as lasting in culture as we have always hoped they would. — 2017

MA BIBLIOTHÈQUE

Sharon Kivland 2018

Sharon Kivland, "MA BIBLIOTHÈQUE," in *Publishing Manifestos* (beta version) (Berlin: Miss Read, 2018), 197.

Reading is both a virtue and duty. The editor invites authors she considers to be good readers. She agrees with Nabokov that a good reader, a major reader, an active and creative reader, is a re-reader. She knows her writers and they know her, even when they have not yet met. They have read each other, or believe themselves to have done so. They are flirtatious, ruffling pages. She likes those who do not hesitate to buy the books she publishes, but under certain circumstances will make excuses for those who do not. She promises to do her best. The best is reading.

The publication is the artwork.
Sara MacKillop 2018

Sara MacKillop, "The publication is the artwork.," in *Publishing Manifestos* (beta version) (Berlin: Miss Read, 2018), 199.

The publication is the artwork.

I am attracted to the publication as form (or many forms) e.g., the sequences of pages, privacy of viewing.

I am attracted to the interconnections surrounding self-publishing, distribution, community, and the many contexts the publication can find itself in.

I can make something cheaply, distribute it, and move on to the next idea or publication at speed.

Untitled

Jonathan Monk 2018

Jonathan Monk, "Untitled," in *Publishing Manifestos* (beta version) (Berlin: Miss Read, 2018), 201.

I have no publishing manifesto

:ria eht tsniaga dedaeH

León Muñoz Santini 2018

León Muñoz Santini, ":ria eht tsniaga dedaeH," in *Publishing Manifestos* (beta version) (Berlin: Miss Read, 2018), 207.

retfa

no

tuohtiw

gnidrocca

tpecxe

yb

rof

litnu

drawot

ecnis

morf

tsniaga

htiw

erofeb

ot

tsefinaM

rewol dna rehgih

drawrof dna kcab

thgir dna tfel

snoitcerid htob ni

repap no emit niag ot strats emit dna ti tnirp I ,ti yas I

emit evah I taht flesym llet I esuaceb tsefinam eW

kcalb ni ro

knalb ylremrof

thguoht a yb tfel gnieb si aedi na taht

aedi na gnitnirp era ew taht

gnihtemos gniod era ew taht su ot semoc aedi eht

tnirp ew

nehw

thguoht sedecerp sserp gnitnirp eht

gnikniht erofeb gnol

,eb ot

eht

gniyas erofeb su tseted yeht

,etanimircsid

sruoh kcalb sa steehs etihw eht

,sevael eht ni ecaps eht

,srettel eht fo tuoyal eht tub

ria evaH

.aedi derrulb a

revocerdna

 drow eht esiar ot deen uoy semitemos

,emitnaem eht ni ,taht semussa

,rohtua na fo aedi eht morf detrexe

,ecneirepxe citsiugnil eht dna rettel eht fo tnirp eht

:noitatneserper yraretiL

.emit erar a rof ro

erehwyreve tsomla emit eht lla tsomla rof ro

syawla tsomla ro

gnihton tsomla neewteb

detneserper eW

.tol a srehto

,detneserper era reven emoS

.detarapes era ew

,edoc eht nihtiw ,tub

edoc emas eht esu ot su seriuqer egaugnal a gnisU

.revocer nac ydobon ria eht ni saedi eht

:ria eht tsniaga dedaeH

Convolution
Paul Stephens 2018

Paul Stephens, "Convolution," in *Publishing Manifestos* (beta version) (Berlin: Miss Read, 2018), 203.

Convolution
has / hasn't been
will / won't be
is / isn't trying to be

Convolution: The Journal of Conceptual Criticism
Convolution: The Journal of Experimental Criticism
Convolution: The Journal of Critical Experiment
Convolution: The Journal of Before and After the Death of Theory
Convolution: The Journal of Textual Fetishism
Convolution: The Journal of Textual Artefactism
Convolution: The Journal of Contemporary Wreading & Riting
Convolution: The Journal of Readography
Convolution: The Journal of Logology Today
Convolution: The Journal of Predictive Intertext
Convolution: The Journal of Textualities Materialise
Convolution: The Journal of Paratextual Aesthetics
Convolution: The Journal of Visual Literature and Morality
Convolution: The Journal of Transatlantic Review
Convolution: The Journal of Irregular Publishing
Convolution: The Journal of Page & Footnote
Convolution: The Journal of This Journal

Re: publishing manifestos

Elisabeth Tonnard 2018

I have a common-place book for facts and another for poetry, but I find it difficult always to preserve the vague distinction which I had in my mind, for the most interesting and beautiful facts are so much the more poetry and that is their success.

From the journal of Henry David Thoreau, February 18, 1852

Notes Toward a Publishing Practice
Archive Books 2019

Chiara Figone, Paolo Caffoni, "Notes Toward a Publishing Practice," *Publishing Manifestos* (Cambridge, MA: MIT Press / Berlin: Miss Read, 2019).

It is Monday, the 8th of October, 2018, in Berlin.

Much of the impulse to publish is the compelling desire to disseminate stories for the intrinsic subversive potential they can yield. For the way they create cracks in dominant narratives. For the way they trigger the formation of alternative readings, plant the seeds for new understandings. Much of the publishing impulse comes from the intense relationship with languages and their potential.

Perhaps a pertinent place to start is to approach the many questions surrounding the very act of "making public." Questioning is the foundation of the publishing process. It is also that which forces the continual disengagement from congealed meaning, from the pitfalls of certainty. It is that which allows hypotheses to play a constitutive role in shaping the many ways of thinking the world.

- What does the practice of making public entail?
- What does it mean to make public here and now?
- What are the sources from which the compelling necessity to make public emerges?
- What are the implications in making public those concealed, undermined, or forgotten stories?

- How to find, select and edit stories in today's complex scenario of multiple worlds and temporalities?
- How to nurture the fundamental relationship with publics?
- How to establish a conscious standpoint?
- How to question the rules of the game?
- How to foster and prioritize polyphony over coded voices?
- How to perpetuate the act of questioning?

We could say that establishing terrains, mapping experiences, and defining the sources and conditions of frameworks and points of enunciation are the critical first steps in the foundation of a publishing practice.

We could say that a publisher doesn't solely publish books but authors as well. We could hint at the fact that publishing is the creation of an ecosystem where authors, translators, and editors are working to build a line of communication with different publics. Working toward the establishment of a bond of mutual trust. We could say that this ecology would feed learning and exchange, disseminate meaning beyond itself.

We could say that publishing is a collective practice in which we question the limits of our most certain ways of knowing, thinking, and doing. The very boundaries of systems of thought and knowledge production. We could say it is a space for the exploration of the possibility to think otherwise—to tirelessly question the order of things. It entails a crisis of the epistemological framing of our worlds. It is the product of an active vision, of a gaze which perceives what is not there, and actualizes it.

We could say publishing is a practice in which a critical approach manifests itself through the willingness to scrutinize fundamental truths, through not accepting given structures on the mere basis of authority, and addressing the violence they uphold. In this capacity, the practice of publishing entails exposing oneself to existing powers regardless of the consequences. We could say publishing is a practice of critical thinking, wherein the term critical is unbound from any negative connotations and instead understood as a symptom of crisis, as a mode of radical inquiry interfering with these existing relations of power while simultaneously questioning the validity of its own perspective.

We could say that the practice of publishing thrives on the desire to create moments of sharing, to bring together readers from across different contexts to explore how we can transcend national boundaries and discuss models for sharing and distributing knowledge. We could say that the practice of publishing should imagine a borderless world while simultaneously confronting the realities of borders.

We could say that mobility is immanent to the form of the book and as such it requires the engagement with multiple worlds. We could say that a book is an autonomous space-time sequence engaging with multiple temporalities. We could say that a book can problematize the myth of linearity, bear witness to the presence of the past within the

present, and highlight the juxtaposition of temporalities and of their resistance to categorization.

We could say that the practice of publishing should imagine processes of (un)learning and subjectively constructing non-hegemonic narratives—in the form of self-education, auto-didacticism, and self-learning—which protest and provide exit strategies from the normativity of education systems.

We could say that the practice of publishing is concerned with the nature and implications of filtering and amplifying contents, and with the potential of these two processes as transformative action.

We could say that the practice of publishing entails acting against the impoverishment of information, of meaning. It is to salvage information from the tissue of established—often historical—meaning, to loosen the weave and open it up to new readings and new meanings.

We could say that the practice of publishing always, thus, implodes the present fabric of meaning. The act of publication, therefore, corresponds to the act of protest, and the space of publication becomes a space of protest and con-

testation, where the possibility to un-weave repressive and hierarchical histories is (re)awakened.

We could say that, within this perspective, publishing the archive is especially powerful, as it is the product of an engaged, active gaze which dismantles (temporal) hierarchies. Thus, publishing the archive involves a literal unweaving of repressive narratives and, as a consequence, redefines and reappropriates the archive itself as a tool which no longer categorizes but is, rather, open to continuous unfixing, de-archiving, and re-archiving.

We could say that publishing is a protest act that recreates reality, or creates it anew. It is to protest the exclusionary principle which defines the archive when submitted to passive investigation. The dynamics of publishing thus become shaped by forms and means which actively participate in the erosion of this exclusionary principle.

We could say that the practice of publishing should master strategies of camouflage and coding through the political potential of the poetical.

We could—and should—see the practice of publishing as an essential site of resistance and protest.

Cassava Republic

Bibi Bakare-Yusuf 2019

Bibi Bakare-Yusuf, "Cassava Republic," *Publishing Manifestos* (Cambridge, MA: MIT Press / Berlin: Miss Read, 2019).

Cassava Republic Press was founded in Abuja, Nigeria, 2006 by Bibi Bakare-Yusuf and Jeremy Weate with the aim of bringing high-quality fiction and nonfiction for adults and children alike to a global audience. We have offices in Abuja and London. Our mission is to change the way we all think about African writing. We think that contemporary African prose should be rooted in African experience in all its diversity, whether set in filthy-yet-sexy megacities such as Lagos or Kinshasa, in little-known communities outside of Bahia, in the recent past, or, indeed, the near future. We also think the time has come to build a new body of African writing that links writers and readers from Benin to Bahia. This way we help to curate the Archive of the future in the present. It's therefore the right time to ask challenging questions of African writing—where have we come from, where are we now, where are we going? Our role is to facilitate and participate in addressing these questions, as our list grows. We are still just beginning.

Ankara Press is a new imprint bringing African romance fiction into the bedrooms, offices, and hearts of women the world over. Our mission is to publish a new kind of romance, in which the thrill of fantasy is alive but realized in a healthier and more grounded way. Our stories feature young, self-assured and independent women who work, play and, of course, fall madly in love in vibrant African cities from Lagos to Cape Town. Ankara men are confident, emotionally expressive, and not afraid of independent and sexually assertive women. Our sensuous books will challenge romance stereotypes and empower women to love themselves in their search for love, romance, and wholesome sex.

Ankara Press is also a labor of love; we spend a lot of time ensuring our novels are of high quality and are an absorbing read. Our goal is to raise the bar for the standard of contemporary romance writing and make African women feel proud and happy to own and read our books! We want our books to reflect the realities of African women's lives in ways that challenge boundaries and go beyond conventional expectations.

Bombay Underground

Bombay Underground 2019

Bombay Underground, "Bombay Underground," *Publishing Manifestos* (Cambridge, MA: MIT Press / Berlin: Miss Read, 2019).

Both Aqui and I work with kids and love making things. Together we run Bombay Underground and Dharavi Art Room.

We have been publishing zines and making artist books for almost twenty years now.

For us, the heart of the act of zine-making is rooted in physical interaction between zinester, zine, and the reader. The experience of handling zines in person can't be duplicated online. You would get the content but miss out on the physical experience.

Independent publishing is our grassroots response to the fact that most publishing houses and bookstores are either ignorant of radical literature or deliberately exclude such materials. For us, self-published ephemera like zines, handbills, and independent newspapers have always provided a glimpse into a part of history that includes the voices of marginalized individuals and groups.

Bombay Underground was formed as a need to actively/constructively solve problems. We make zines, indulge in interventions in the city, set up reading spaces, work with communities under-going forceful change. It's been almost twenty years now, and we are still consistently doing it.

We have been organizing Bombay Zine Fest and other zine exhibits and pop-ups in different venues and cities to share the works of different kinds of zine-makers from all around the world. All our activities have been totally independent, without any institutional or corporate funding.

We love what we do, and that is how everything gets done. There are definitely difficult times, but then we are also fortunate that some really nice friends who have witnessed us do what we do for so many years stand by us emotionally as well as with emergency resources.

As Aqui says, "The motive has always been to keep the underground alive!"

Yoda Press: A Manifesto

Arpita Das 2019

Arpita Das, "Yoda Press: A Manifesto," *Publishing Manifestos* (Cambridge, MA: MIT Press / Berlin: Miss Read, 2019).

Yoda Press was set up in the winter of 2003 and published its first title in the fall of 2004. From the beginning we were clear that our publishing list had to anticipate something new and unprecedented in Indian publishing and yet represent what we believed was as much a truth about India as what was being depicted by mainstream publishing. We were indeed influenced, even inspired, in such a decision by the work done by the first South Asian feminist Press, Kali for Women, which had come into being in the mid-1980s.

In the early 2000s in New Delhi where we were based, the LGBT movement was quietly gathering strength and was a few years away from pouring out on the streets of the capital with a force and voice that took the entire city, even the country, by storm and led to some of the most historic legal pronouncements and judgements in the history of modern India. At the time that we were setting up Yoda Press, however, no other publishing house was interested in queer writing. A young, dynamic, articulate, and nuanced generation of queer activists was passing out of law school and social work departments at that time, and reading their writing, mostly on the internet, we were certain that this was a list that needed our attention. We published our first LGBT title in the list in 2005. It was called *Because I Have A Voice: Queer Politics in India*. For the first time, twenty-seven members of the LGBT community came together in a nonfiction book where they wrote stories of activism, personal narratives of coming out to their families, transgender narratives of oppression at the hands of the law, and academic explorations into being queer in India. The book acquired cult status, very quickly becoming something of a manifesto for the LGBT community here, and remains in print till today. We had set out in 2005 with the intention to publish at least one title in this list every year. Fourteen years on, we have published seventeen.

Having initiated the LGBT list in collaboration with a young activist who would soon become one of the most important voices of the movement, Gautam Bhan, the rest of our list drew fuel and inspiration from it. We focused on genres such as popular culture, city writings, and new perspectives in Indian history, and every title in these lists, just like those in the LGBT list, was driven by one clear intention, that it smashed some aspect of patriarchy or a belief or mindset held dear by it. It was, and remains, our belief that many of our books would only make a difference in a country like India if they were available in at least one other Indian language, Hindi. In the case of three of our titles, therefore, one on the transgender community of the southern part of India, another on the fraught issue of relocation and rehabilitation of slum communities, and the third on the aftermath of communal riots in a part of North India, we published the Hindi edition before the English one, with the intent to reach out to that part of the readership, which was most directly affected by the subject of the book and hence would be benefited most by the publication of the book.

Post 2010, we began to feel that political dissent was a list we wanted to actively develop. The intent emerged out of the socio-political reality of the country and the rising right-wing wave which soon transformed into a full-blown right-wing national government in 2014. One of the ways in which we decided to do this was through graphic anthologies. We had already published a very successful graphic book on masculinities in India in 2009 called *A Little Book on Men*, another one that continues to remain in print till today, and drawing on that experience, we decided to publish the first graphic anthology on the Indian Partition. In a collaboration with the Goethe Institute, this book called *This Side That Side* came out in 2013 with more than forty storytellers and illustrators from India, Pakistan, and Bangladesh as contributors. The project was curated for us by one of the best-known graphic novelists of India, Vishwajyoti Ghosh, and the book received a glowing pre-publication blurb from Joe Sacco. Emboldened by the success of this ambitious endeavour, we launched a graphic anthology series called First Hand in 2016 which brings together graphic narratives on stories based on on-the-ground reportage in the country on issues such as climate change, violence against women, migration, the nexus between corporations and governments, the LGBT movement and queer identity, and so on. The second volume in the series came out earlier this year, focusing on the important issue of exclusion of various communities in India from even the basic standards of humane living, in partnership with the Centre for Equity Studies based in New Delhi. Our partnership with this prestigious organization started back in 2015 and has grown into a relationship of synergy and mutual trust. We now publish their very important annually produced *India Exclusion Report*, and also have a series of smaller books with them looking at areas of conflict in India, such as Muzaffarnagar and Kashmir.

Another list we have built is one on the Muslims of South Asia. These are mostly academic titles, and recently we have published two landmark titles on gender in Pakistan and another on Muslim women in India. The focus in this list has been around how the Muslim community in South Asia is as heterogeneous a community as any other, and yet, with the growing Islamophobia in the world as well as in this part of the world which insists on giving them a ghettoised identity, the challenges they face in continuing to engage with the society they are part of and the polity that is increasingly partisan toward them.

Having been a nonfiction publisher for the first decade of our existence, we decided to start a fiction imprint in 2017. We were very clear, however, that our fiction titles, like our nonfiction ones, would challenge the accepted idea

of how fiction should be written or what it should focus on. Our first fiction title was an experiment in speculative short fiction focused on bibliophilia, which was shortlisted for the prestigious Jan Michalski Prize for World Literature last year, and our second title was a translation to English of an award-winning Malayalam novel based in Mecca by the great Muslim author from our southern state Kerala, Khadeeja Mumtaz. We have now published six titles in the fiction list.

In the past couple of years, we have been getting more interested in the writing around mental health and psychotherapy in India. While both the practice and pedagogy around these subjects are now at a fairly mature stage in India, reading lists for students as well as go-to references for interested readers mostly contain books written by Western authors. Going forward, therefore, we are keen to develop a robust list, both academic and trade, on psychology and the psychotherapy practice in India both among the middle class as well as the underprivileged sections of our population. We have published three important books in this list over 2017–18 and intend to bring out one every year from now on.

A few days ago, the Supreme Court of India put out a historic judgment which decriminalized homosexuality in India for the first time since the country was under colonial rule. Two of our titles were cited multiple times in the body and footnotes of the judgment, just as another had been cited in a landmark judgment in 2016 recognizing the transgender community. Our LGBT list which has continued to thrive and change over the years in keeping with the changes in the movement now has more memoir and fiction.

The cycle appears to be complete, and another set of titles is all set to go to print.

Ixiptla

Mariana Castillo Deball 2019

Mariana Castillo Deball, "Ixiptla," *Publishing Manifestos* (Cambridge, MA: MIT Press / Berlin: Miss Read, 2019).

The Nahua concept of ixiptla derives from the particle xip, meaning "skin," coverage, or shell. A natural outer layer of tissue that covers the body of a person or animal, the skin can be separated from the body to produce garments, containers for holding liquids, or parchment as a writing surface. Its material attributes allow it to become a container or a coating. As an allegory, xip can be mold or cast, receptacle or costume.

Xipe Totec, "Our Lord the Flayed One," is an Aztec deity often portrayed wearing the skin that had been removed from a human sacrificial victim. His dress does not fit perfectly, so he shows his own hands and feet, while the hands and feet of the flayed skin appear hanging. Xipe may be recognized by observing the holes in the skin for mouth and eyes, through which the wearer of the skin can be seen.

Ixiptla is both a person capable of transforming himself into another, and an embodiment of the others he becomes, losing his skin and wearing the skin of someone else. Originally a Nahua word, ixiptla has been understood as image, delegate, character, and representative. Ixiptla could be a container, but also could be the actualization of power infused into an object or person. In Nahua culture, it took the form of a statue, a vision, or a victim who turned into a god destined to be sacrificed. Without having to visually appear the same, multiple ixiptlas of the same god could exist simultaneously. The distinction between essence and material, and between original and copy vanishes. For the first issue of the journal *IXIPTLA*, a group of anthropologists, archaeologists, artists, and writers have been invited to reflect on the role of the model, the copy, and reproduction in their areas of research and practice.

Since the nineteenth century, archaeologists have envisioned and implemented diverse techniques for capturing and replicating material evidence. The archaeologist collects fragments of material culture left by time, and while doing so, produces other objects in an attempt to better remember or observe those fragments. These techniques have included plaster molds, facsimiles, drawings, photographs, and scale models. When made, they emerge from a specific moment in time, producing a doppelgänger of the original milieu, which then takes its own course.

This edition of *IXIPTLA* is focused on the trajectory of such dislocated objects, which depart from direct contact with the original, and yet take a part of that original object along with them.

Queeres Verlegen

Queer-Feminist Book Fair 2019

Queer-Feminist Book Fair, "Queeres Verlegen," *Publishing Manifestos* (Cambridge, MA: MIT Press / Berlin: Miss Read, 2019).

Queeres Verlegen is dedicated to the political business of networking, discussing, listening, writing, and reading in a critical light and with a view to our common future.

Since 2015, various small publishers with a queer-feminist focus have presented their books and publications at the annual Berlin book fair Queeres Verlegen. Politically motivated people worldwide engage in the production of queer and emancipative publications, mostly on a collective basis. Queeres Verlegen celebrates their work by bringing it to a broader public once a year, free of charge, at a community venue, where book stands, readings, and discussions open up space for mutual appreciation as well as pointed critiques.

The event addresses the publishing process itself—even in its very name: Queeres Verlegen is about publishing, writing, translating, editing, proofreading, printing, supporting, and more besides. The participants are involved in small presses, political initiatives and associations, zine projects, and blogs, the structure and content of which are motivated by a queer-feminist approach. Their work is vital, even though largely invisible in overall society as well as in many subcultural "scenes." Our event doesn't simply present the final products of this work but also engages with conditions in publishing today and the various processes entailed. Which voices do we publish, and how do we choose them? Whom do we write for, and how? What do we (not) read, and why? Despite the given context, namely a capitalist book market which severely marginalizes queer publishing, we want to address these questions and so foster a politicized shift in language, form, and content.

Most of the readings and discussions are translated into the languages relevant to the respective year's program as well as into German sign language. We also host a "children's corner" and readings for children and young people. Our small Berlin-based collective consists of up to seven LGBT*IQ, who devise and produce this event without any commercial interest together with friends and allies.

Our event is thus not a book fair in the classical sense, and nor do we want it to be. Rather, we work to engage people's interest in the processes of queer publishing. We hope so to inspire them to become involved in making unheard (-of) voices heard—and in getting them read.

Queer Politics

Queer people still experience discrimination. While many social roles are successfully questioned, people in Germany and all over the world who don't conform to gender and sexuality norms experience uncertainty, pain, and exclusion on the streets, in institutions, at work, and in the family.

Queeres Verlegen aims to present and strengthen the many struggles of lesbian, gay, bisexual, trans*, intersex, and queer people still being fought on countless pages.

Queeres Verlegen relies on an understanding of the structures of oppression as being intersectional and historically intertwined both in their function and their effect. We stand against those norms and orders rooted in capitalism and displacement, colonialism and racism, the confinement of gender and sexuality, physical and psychological pathologization, and other such frames of inequality.

We (still) believe in (the) potential (of) connections and the possibility of situated and situational solidarities among marginalized people. We want the space of the event and people therein to be empowering, open, and sensitive while also reaching out and remaining accessible to a broad demographic—beyond those who consciously engage with queer politics in their daily life.

While not claiming to be immune to the structures we live in, Queeres Verlegen nurtures certain aspirations in thought and deed. The event aims:

- to promote a universal commitment to the political and social causes of all LGBT*IQ people—in tandem with a relentless critique of discriminatory norms and the structural orders of inequality as named above
- to contribute to queer-feminist discourse(s) by supporting small and marginalized publishers and publications
- to further expand the queer-feminist network in German-language and international publishing contexts.
- to open up space for marginalized voices and so strengthen opposition to the global rise of the New Right
- to present publications that engage with different forms of oppression and the many ways they intersect
- to provide a space for exchange on how queer publishing may strategically challenge social norms also in the publishing sector
- to develop collective visions and discuss concrete problems and practices.

Publishing

Publishing is one articulation of queer politics. The participants in Queeres Verlegen are united in their political commitment, in their readiness to take a critical stance and a global perspective on themselves and their work, and in their persistence and patience in publishing emancipative texts with little prospect of economic reward.

Molding language and text is a political act of vital importance—and it entails responsibilities. Emancipative publishing calls for sensitivity to the power of words, to honest attribution, and to pluralist discourse. Oppressions need to be named and named again—as tools in political claims, in poetry, in struggles for emancipation. Naming frames resistance, nuanced regard, a sense of connection, and potential solidarities. In a word, it lets us read one another.

Humor über alles

V. Vale 2019

V. Vale, "Humor über alles," *Publishing Manifestos* (Cambridge, MA: MIT Press / Berlin: Miss Read, 2019).

September 22, 2018, 10 a.m.[1]

Okay, here's my so-called manifesto, which is as open-ended as a manifesto could possibly be and still maybe be called a manifesto: perhaps let's call it an "uber-manifesto" or a "meta-manifesto" or an "anti-manifesto" or …

I am such a huge fan of chance, spontaneity, improvisation, the spirit of the flaneur, all those random impulses—not only impulses but random chance happenstances that life forces upon you … that the idea of writing, sitting down, and *writing* a manifesto had never ever occurred to me. Because I have such a great fear of putting something in print, that then starts jinxing my future! To "jinx" means to like bring bad luck (in slang), or something unforeseen that might be called in quote marks "negative." Just living is like being a flaneur all the time, I think—like, it's just by chance that I ran into you in this wonderful retro diner adjacent to New York Art Book Fair.

And so back on topic …

It's very important that all the work you do somehow be accessible to the youngest people, and you must always have young people around you because they are your reality check, or SUR-reality check. Because I am such a fan of Surrealism as opposed to realism that writing a logical, linear, verbal manifesto is somehow something to fear—if you're me. And I don't like fear—I try to avoid fear—but I actually try to avoid all emotions, because I feel like you can get through life easier the more mechanical your life is and the more you obey the laws (whatever THEY are) of allegedly being "alive" inside a multi-sensorial machine.

I feel if you identify as being a machine, you can simplify your life a lot. I see so many people's lives get totally screwed up by drugs, alcohol, and EMOTION, and therefore I think emotion is actually dangerous, and it's just better for me if I can avoid all that.

I invented a phrase called CMATT: C-M-A-T-T. And that means "clear mind all the time." That's why I avoid alcohol, drugs if at all possible—everything except maybe Penicillin, and that only once every twenty years in a dire physical emergency just to save your life.

So back to the "manifesto" in quote marks: I'm a fan of "no separation between work and play," "no separation between art and life" … And, I am such a fan of Surrealism.

M: And play.

V: Oh yeah, play. I'm in favor of eclipsing every possible boundary and category. Long ago I actually wanted to be an anthropologist, where you learn right away (in anthropology studies) that the most interesting work to be done is at the borders, boundaries, of what is acceptable, or you could say: of acceptability; and what is not quite acceptable yet, that is where avant-garde art is—it's at the boundaries of "acceptable." And then the more it's around and doesn't go away, it gradually becomes acceptable, so a hundred years later, a genuine revolution like Impressionism is now just old hat, it's just so normal—it's like something your grandparents like!

So it's always necessary to interrogate what is forbidden, what is—well, not so much forbidden with a capital "F" but what is not quite acceptable, and I love being a materialist. I look at clothes, I look at environments. I'm not so much a fan of what I call "Platonic Idealism" theory; I'm much more a fan of what we call "Skeptical Empiricism." "Marriage 'til death"—a lot of times that doesn't happen, because it was just a Platonic ideal and In Real Life— I like that phrase "IRL"—except I would change it to "ISL": In SURREAL Life, 'cuz life is more Surreal than real … but let's go back and say that in real life so many plans don't work out—I've seen it happen over and over.

At the same time I'm a fan of "temporary intention." In other words, let's say you want me to have the intention of writing a manifesto for you. If I have a routine, I would pose this question to myself at night and then wake up, and I would rush to the computer and write out exactly what I'm saying now—so, you ask me a question: "Write a manifesto now without even thinking" … well, we have the miracle known as a tape recorder. I pretty much use a tape recorder for all my publishing, because I want accuracy of speech! I love to capture people's precise enunciations, and this miracle that the tape recorder makes possible—never before in history could you have this.

For theory, or thought, or verbiage, to become "something manifest" for the ages which is captured on print on paper—I still think print on paper is gonna outlast the whole internet, that's all gonna be taken down by magnetic storms worldwide, as in Mad Max—a wonderful Australian film—so I'm also an apocalypse fan. I like the world's worst-case scenarios because they make me laugh, they bring black humor into my life.

I think nothing is more important than black humor and trying to live your life by black humor. And it doesn't mean you're strictly a pessimist—if you actually READ pessimism, it's actually black humor, it's actually very funny. You know E. M. Cioran's *The Temptation To Exist?* If you read this "pessimist" work it oughta make you laugh, and I think nothing's more important than laughter. So for all my work I've done historically, and hopefully in the future, you could say "humor über alles" and that's a wonderful German phrase I borrowed from Adolf Hitler—[laughter] I'm just kidding; it was "Deutschland über alles." I have studied the history of Germany because I felt that since everyone has so much fear and hatred of that German leader, I must find out why people are so emotionally vehement. Whenever people are super-angry about anything, I am interested,

but I kinda wanna remove all the anger and see what's deeper maybe, and less visible. I think that's our job in life: to interrogate the world of visible and audible (and all) phenomena, and then maybe we will come to some other conclusions.

So we're here to do work—that's all we're here for. We could die tomorrow, so hopefully, if you have done enough work, that will live on after you. And words on paper seem to be not such a bad historical recording mechanism, because I know my books have gone all over the world, and they can't kill them all.

M: It's good because you went into publishing, also. What about your publishing practice?

V: In order to get work done you have to interrogate yourself first to see "what are my abilities?"

It's important for you—for everybody—to develop all the potential they were born within their DNA, to the max—but we don't know what they are—and so you only find out what they are by working, and you ask yourself, "Well, as a machine, how much can I get done?" and I found that I was one of the world's fastest typists very early in life, and I'm also super accurate.

But I found that I was a terrible poet—I wanted to be a poet, because in his hierarchy of knowledge Aristotle put poets at the top. (I didn't know that anyone could be a poet but you have to CHANNEL, you have to interrogate your unconscious at night, and then wake up and just see what just flows out uncensored—it's very important. The analytical machine in your brain is not the same as the "channeling-poetry-generating machine" in your brain.) And so I gave up being a poet, but then I learned from Andy Warhol that I could tape-record conversations, and if you're lucky, they're funny, they're witty, they're insightful, they're everything you wanted—but they're much less work than asking anyone to sit down and write anything. Remember, we learned from Burroughs and Gysin that just any two people talking form a Third Mind. And the Third Mind can often WAY, way, way, transcend … it's not 1 + 1 = 2, it's 1 + 1 = something definitely 3 or MORE.

Baby: [cries]

V: [laughs] I don't blame him—see, he's too smart to just go along with words.

Even though conversations are forcibly linear, we try to be as Surreal as possible and dodge and evade and take evasive tactics! We try to avoid the prison, the huge world penitentiary, the global penitentiary of LOGIC that imprisons us, we try and escape through epiphany, through miracles, through accidents, through chance, and—

B: [cries]

V: See? That's my most ruthless critic now, this child!
B: [cries]

V: And they always tell the truth, unlike most people.

So you know, there are many words that I feel oughta be totally expunged from all working vocabulary. One of them is "truth." Actually, all words having to do with religion I try to avoid. Most words having to do with emotion I try to avoid.

I also try to simplify my life. I'm against filling my mind with one million designer brand names from the art world, and the world of what they used to call "applied arts": everything having to do with interior design, clothing—all design in fact. At the same time I'm a huge fan of design, a huge fan of Dieter Rams—his Ten Principles of [Good] Design are like the REAL Ten Commandments (not what Moses said), because everything in our life is a question of design—and I'm a minimalist. Dieter Rams said, "The best design is no design at all," or the most minimal, or the most invisible. 'Cuz good design tells you what the functionality is without needing a narrator to explain it to you—you look at something, and you instinctively KNOW.

Also I think that in life everything is PERSONAL. Like us talking now!

M: I have a question, do you want this to be printed unedited?

V: You transcribe it and send it to me and I will make it very minimal.

Here's my editorial policy: 1) edit for wit 2) every word must earn its keep (but, if you remove too much, you risk damaging the speaker's style). And 3) no typos! In other words, you try to be supremely accurate. Because I've seen so many bad transcriptions, that's why I usually transcribe myself.

M: That was what I suggested: you could probably do that better—

V: I don't want to—I'm too lazy! But if you just send me a transcript I'll edit it myself

M: Okay, I'll have someone transcribe it.

V: But I'm against censorship just to make myself look more grandiose! I'm not gonna substitute a bunch of more esoteric academic words, 'cuz I'm a huge fan of clear speech. [Suddenly a large sunflower appears in M's hand.] Oooh, Van Gogh: that's lovely—that's fantastic. The Van Gogh sunflower. Van Gogh *and* William Blake: "Oh sunflower, weary of time." Well I'm not weary of time, personally—to me time barely exists.

What I seek in life is true luxury. And to me luxury is basically two components: time and space. Real luxury is

having as much free TIME as possible to do nothing, and to think, and to channel. And SPACE means maximum ability to travel and see the world. Like William Burroughs said: "It is necessary to travel, it is not necessary to live." [Laughter.] I love that statement. I learned that when I was a kid.

M: By the way, I think the title of your manifesto is "humor über alles."

V: Oh yeah! Yeah "humor über alles." That's as far as I can go, for now, toward crafting what I kind of call either an anti-manifesto or an über manifesto, or an evasive manifesto or a humorous manifesto. "Umour." U-M-O-U-R, that word, is so important. Was it from Alfred Jarry?

M: Let's see if my thing recorded [it did] … Sweet, thanks.

V: Hey, and watch my bag—Where's the bathroom? That's where I was going when I ran into you! [end]

Author's Note
By email Michalis Pichler asked me to produce a "manifesto" for my independent publishing, but I was busy preparing for the New York Art Book Fair 2018. (He said he had met me five years ago.) I accidentally encountered him at a diner and on the spot said I would tape-record a kind of "manifesto" for him right then and there. He agreed and here it is, somewhat edited by V. Vale.

zubaan manifesto

zubaan (Urvashi Butalia), ed. 2019

zubaan (Urvashi Butalia), "zubaan manifesto," in *Publishing Manifestos* (Cambridge, MA: MIT Press / Berlin: Miss Read, 2019).

zubaan is an independent feminist publishing house based in New Delhi, India. It grew out of India's first feminist publishing house, Kali for Women. Founded by Urvashi Butalia, who was cofounder of Kali for Women, zubaan was set up to specifically continue Kali's work as well as to expand and grow in new directions in response to changes in women's movements in India. zubaan has inherited half of Kali's publications, so reprints of many backlist titles are assured.

The word "Zubaan" comes from Hindustani and means, literally, "tongue," though it also carries other meanings, such as voice, speech, and language. In several Hindustani-speaking cultures, when women begin to speak up and claim speech as their own, a common saying is to note, critically and occasionally fearfully, that their "zubaan" has opened up."

zubaan's Vision: A feminist world where all women's rights, and their claim to equality and dignity, echo in their daily experiences.

zubaan's Mission: To assist and grow the field of knowledge production by women and about women, through a publishing platform that participates in the evolving discourse via a for-profit, feminist model.

zubaan's Goals: To be an evolving and feminist publishing platform that (a) creates a body of knowledge about women in India, (b) showcases the diversity of identity and experience within this category, (c) is instrumental in creating multiple debates and discussions about women in India, and thereby (d) builds accessibility (in the market and otherwise) to voices and stories outside of the mainstream narrative, with an aim to blowing apart the category.

A Quick History

zubaan is the successor company of Kali for Women, India's first feminist publishing house (established in 1984), and was founded in 2003 when Kali stopped operations. Like Kali, zubaan existed solely as a nonprofit Trust, registered in India under the Societies and Trusts Registration Act, until 2014. From 2012–14, senior staff at zubaan surveyed the Trust's market position and operating limitations with the view to securing a sustainable future, and the decision was made to separate the Trust's grant-based activity and its publishing. Since the establishment of Zubaan Publishers Pvt. Ltd (ZPPL) in 2014, functioning and activities have slowly separated to evolve a potentially profitable social impact company, which left behind a Trust that could partner with other NGOs to continue its legacy to community action, research, and support.

zubaan's main objective is to publish books about and by women and to create, nurture, and sustain a feminist workplace and institution, as well as to put in place feminist practices in all its interactions and functioning. It was set up specifically to build a body of knowledge about women in India and provide a platform for voices from the margins, taking into account the ways in which women are marginalized due to their location in systems of caste and class, sexuality, religion, and region, among others.

In creating and expanding the space for discussion within women's movements in India, zubaan sees itself as, and is, very much part of these movements. Alongside this, it performs the work of an archivist and knowledge partner of women's movements, steadily building up a storehouse of academic and literary work from within. Its aim is to survive and thrive as a sustainable company that maintains and creates new feminist knowledge, and to demonstrate that this aim is born of a real need that manifests in both a traditional publishing market and in activist and academic spaces.

zubaan's Publishing

While zubaan is continuing to publish in areas similar to its predecessor, it is also expanding into other fields. This expansion is based on the understanding and realization that the women's movement, the realities of women's lives, in India as elsewhere, have changed and expanded considerably; literature to do with these movements, literature that reflects women's lives, must change and expand as well.

Some of the distinct lists that have been built up over the years at zubaan, as well as new focus areas of the publishing programme, include:

- gender and reproductive health sexuality
- gender and caste
- gender and conflict
- gender and architecture
- gender and law
- gender and history/national movement
- gender and economics
- sexualities/gender identities
- violence against women
- the Northeast of India (nonfiction and fiction)
- fiction and translation
- readers/anthologies on women's movements/feminism
- biographies/autobiographies/memoirs

zubaan's Objectives

- to work toward increasing and expanding the body of knowledge on and by women in India in particular and in the Global South in general
- to work toward building up a culture of translating works by Indian writers (particularly women writers) within and between the Indian languages

- to provide opportunities, funding, and resources for writers and researchers from marginalized communities
- to counter the lacunae of mainstream publishing by ensuring representation of minority and historically oppressed/marginalized cultures and identities in the established literary market
- to provide a forum where women writers can debate the issues they are concerned with, and a space where they can publish and be read
- to ensure that women's writings are given their rightful place inside curricula and syllabi in universities, educational institutions, and schools
- to provide assistance to women's groups and NGO activists in editorial and production skills
- to hold workshops in creative writing for young girls and women
- to encourage well-known women writers to contribute at least part of their work in the form of stories, short novellas, etc. for the production of post-literacy materials for adults and to publish these, in collaboration with NGOs and others, in several Indian languages
- to increase and expand the body of knowledge about the girl child and female children in India

Appendix

Biographical Notes

AND Publishing is run by Eva Weinmayr and Rosalie Schweiker and is based in London.

Oswald de Andrade (1890–1954) was a Brazilian writer and a key figure of the Brazilian modernist movement.

Archive Books is run by Chiara Figone and Paolo Caffoni and is based in Berlin.

Art-Rite (1973–78) was a newsprint art magazine edited by Walter Robinson and Edit DeAk and distributed for free in New York.

Rasheed Araeen is a cofounder of the magazine *Black Phoenix* (1978–79) and founder of the magazine *Third Text*.

Tauba Auerbach is an US American artist and publisher of Diagonal Press and is based in New York.

Michael Baers is an US American artist based in Berlin.

Bibi Bakare-Yusuf is cofounder of Cassava Republic Press and, since 2006, is based in Nigeria.

Ricardo Basbaum is an artist and writer based in Rio de Janeiro.

Derek Beaulieu is a Canadian writer and publisher based in Calgary.

Bernadette Corporation is an art collective founded in 1994 and based in New York.

Riccardo Boglione is a writer and the founder of *Crux Desperationis*, an international journal devoted to conceptual literature, based in Montevideo, Uruguay.

Bombay Underground is a community project and zine fair run by Aqui Thami and Himanshu S. and is based in Bombay.

Jorge Luis Borges (1899–1986) was an Argentine writer of poems, translations, essays, literary criticism, and short fiction.

bpNichol (1944–1988) was a Canadian poet and editor at *grOnk*, Ganglia Press, Underwhich Editions, Coach House Books, and *Open Letter*.

Kate Briggs is a writer and translator based in Rotterdam.

Broken Dimanche Press is a publishing house and project space run by Irish writer John Holten and Danish poet Ida Bencke and is based in Berlin.

Eleanor Vonne Brown is an English artist who runs the project space X Marks the Bökship in London.

Urvashi Butalia is an Indian writer and publisher. She cofounded Kali for Women and founded zubaan Books.

Ulises Carrión (1941–1989) was a Mexican poet and artist based in Amsterdam, founder of Other Books and So, and a seminal figure in bookworks, mail art, and rubberstamp art.

Mariana Castillo Deball is a Mexican artist based in Berlin.

Paul Chan is a Hong Kong-born artist, writer, founder of Badlands Unlimited, and is based in New York.

Chimurenga is a Pan-African platform of writing, art, and politics, publishing under the motto "Who no know go know," taken from Fela Kuti.

Arpita Das is an Indian writer, cofounder of Yoda Press, and is based in New Delhi.

Guy Ernest Debord (1931–94) was a French author and a central figure of the Situationist International.

Anita Di Bianco is an US American artist and film and video maker.

Constant Dullaart is a Dutch artist based in Berlin and Amsterdam.

Craig Dworkin is an US American poet and professor of English at the University of Utah.

Ntone Edjabe is a Cameroonian journalist, activist, DJ, editor, and writer based in Cape Town.

Zenon Fajfer is a Polish poet, playwright, and a key representative of the avant-garde in contemporary Polish literature.

Robert Fitterman is a conceptual poet and professor of creative writing at New York University.

Marina Fokidis is an author and curator based in Athens.

General Idea (1967–94) was a collective of Canadian artists: AA Bronson, Felix Partz, and Jorge Zontal. They published *FILE Megazine* and founded Art Metropole in Toronto.

Annette Gilbert is a German scholar who teaches Comparative Literature in Erlangen.

Girls Like Us is a feminist magazine based between Amsterdam, Brussels, and Stockholm, founded by Jessica Gysel.

Gloria Glitzer is Franziska Brandt and Moritz Grünke, two artists who do books in Berlin.

Marianne Groulez is a French writer based in Paris.

Alex Hamburger is an experimental poet based in Rio de Janeiro.

Karl Holmqvist is a Swedish artist and poet based in Berlin.

Lisa Holzer is an Austrian artist and cofounder of Westphalie Verlag.

Mahmood Jamal is an Urdu poet and cofounder of the magazine *Black Phoenix* (1978–79).

Tom Jennings is an US American artist and was copublisher of the zine *Homocore* (1988–91).

Ray Johnson (1927–1995) was an US American artist and a seminal figure in mail art.

David Jourdan is a French artist and publisher of Westphalie and is based in Vienna.

Sharon Kivland is an artist and writer based in London.

Kione Kochi is an illustrator and translator based in Ibaraki, Japan.

Kwani? is a leading African literary magazine based in Nairobi.

Bruce LaBruce is a Canadian artist, filmmaker, and pornographer based in Toronto.

Tan Lin is an US American writer and professor of creative writing at New Jersey City University.

El Lissitzky (1890–1941) was a Russian architect and a major figure in Suprematism and Constructivism.

Alessandro Ludovico is a media critic and editor of *Neural* magazine and is based in Bari, Italy.

Sara MacKillop is a British artist based in London.

Steve McCaffery is a Canadian poet and professor of English at the State University of New York at Buffalo.

Jonathan Monk is a British artist based in Berlin.

Simon Morris is a writer, founder of information as material, and a professor at the School of Architecture, Art and Design at Leeds Beckett University.

Mosireen is an activist and media collective in Cairo and has been active since the Tahrir Square revolt.

León Muñoz Santini is a Mexican designer and publisher of Gato Negro Ediciones and is based in Mexico City.

Takashi Murakami is a Japanese artist based in Tokyo.

Deke Nihilson is an US American activist and musician based in Portland and was copublisher of the zine *Homocore* (1988–91).

Aurélie Noury is a French artist and publisher of editions Lorem Ipsum and is based in Rennes.

Johnny Noxzema is a Canadian artist and was the editor of *BIMBOX* (1990–94) and is based in Toronto.

Clive Phillpot was the head of the library of the Museum of Modern Art from 1977 to 1994 and wrote seminal texts theorizing artists' books.

Michalis Pichler is an artist and writer based in Berlin who cofounded Miss Read in 2009.

Vanessa Place is an US American writer and criminal appellate attorney based in Los Angeles and New York.

Seth Price is an artist based in New York and was a cofounder of the art and publishing collective Continuous Project.

The **Queer-Feminist Book Fair** takes place annually in Berlin and is organized by a collective.

Riot Grrrl is an underground feminist punk movement that began in the early 1990s in the US with zines and bands like Bikini Kill, Bratmobile, and Heavens to Betsy.

Carlos Soto Román is a Chilean poet.

Allen Ruppersberg is an US American artist based in New York and Santa Monica.

Joachim Schmid is a German artist and photographer based in Berlin.

Oliver Sieber is a German photographer based in Düsseldorf.

Paul Soulellis is an US American artist and professor at the Rhode Island School of Design and is based in New York.

Matthew Stadler is an US American author, editor, and cofounder of Clear Cut Press and is based in Portland.

Gertrude Stein (1874–1946) was an US American writer and a seminal figure of early modernism.

Paul Stephens is a writer, scholar and editor of the journal *Convolution*.

Hito Steyerl is a German visual artist, writer, filmmaker, and theorist based in Berlin.

Mladen Stilinović (1947–2016) was a Croatian conceptual artist, a part of Grupa šestorice autora (Group of Six Authors), and was active in Zagreb between 1975 and 1979.

Katja Stuke is a German photographer based in Düsseldorf.

Temporary Services is Brett Bloom and Marc Fischer, who started Half Letter Press in 2008, and is based in Chicago and Auburn, IN.

Nick Thurston is a writer, coeditor of information as material, and a lecturer at the University of Leeds.

TIQQUN was a French collective of authors and activists formed in 1999; they published two philosophical journal volumes.

Elisabeth Tonnard is a Dutch artist and poet based in Leerdam.

V. Vale is a writer, founder, and publisher of *Search & Destroy* and *RE/SEARCH* and is based in San Francisco.

Binyavanga Wainaina (1971–2019) was a Kenyan author and founding editor of *Kwani?*.

Eric Watier is a French artist.

Erik van der Weijde is a Dutch photographer. *4478zine* (2003–16) was his publishing imprint.

Lawrence Weiner (1942–2021) is an US American artist and a central figure of Conceptual art.

Eva Weinmayr is a German artist and copublisher of AND Publishing, based in London.

Jan Wenzel is a German publisher and cofounder of Spector Books, based in Leipzig.

Stephen Willats is a British artist and founder of *Control Magazine* and is based in London.

Gil J Wolman (1929–95) was a French artist, author, and member of the Lettrist and Situationist International.

zubaan is a feminist publisher based in New Delhi.

Name Index

COLOPHON

Publishing Manifestos

Authors: AND Publishing, Oswald de Andrade, Archive Books, *Art-Rite*, Rasheed Araeen, Tauba Auerbach, Michael Baers, Bibi Bakare-Yusuf, Ricardo Basbaum, Derek Beaulieu, Bernadette Corporation, Riccardo Boglione, Bombay Underground, Jorge Luis Borges, bpNichol, Kate Briggs, Broken Dimanche Press, Eleanor Vonne Brown, Urvashi Butalia, Ulises Carrión, Mariana Castillo Deball, Paul Chan, *Chimurenga*, Arpita Das, Anita Di Bianco, Guy Debord, Constant Dullaart, Craig Dworkin, Ntone Edjabe, Zenon Fajfer, Marina Fokidis, General Idea, Annette Gilbert, *Girls Like Us*, Gloria Glitzer, Marianne Groulez, Alex Hamburger, Karl Holmqvist, Lisa Holzer, Mahmood Jamal, Tom Jennings, Ray Johnson, David Jourdan, Sharon Kivland, Kione Kochi, *Kwani?*, Bruce LaBruce, Tan Lin, El Lissitzky, Alessandro Ludovico, Sara MacKillop, Steve McCaffery, Jonathan Monk, Simon Morris, Mosireen, León Muñoz Santini, Takashi Murakami, Deke Nihilson, Aurélie Noury, Johnny Noxzema, Clive Phillpot, Michalis Pichler, Seth Price, Riot Grrrl, Carlos Soto Román, Allen Ruppersberg, Joachim Schmid, Oliver Sieber, Paul Soulellis, Matthew Stadler, Gertrude Stein, Paul Stephens, Hito Steyerl, Mladen Stilinović, Katja Stuke, Temporary Services, Nick Thurston, TIQQUN, Elisabeth Tonnard, V. Vale, Binyavanga Wainaina, Eric Watier, Erik van der Weijde, Lawrence Weiner, Eva Weinmayr, Jan Wenzel, Stephen Willats, Gil J Wolman, zubaan

Editor: Michalis Pichler
Idea Development: Yaiza Camps, Moritz Grünke, Michalis Pichler
Design: Moritz Grünke, we make it
Design Assistance: Olivia Lynch, Henrique Martins
Copy Editing (Introduction): Craig Dworkin
Proofreading: Mark Soo
Production Assistance: Raul Fernandez Gil, Natalia Saburova, Alexander Zondervan
Flap Interior: Karl Holmqvist
Paper: Munken Print White 1.5
Printing and Binding: ARGRAF • Printed in Warsaw, Poland.

ISBN paperback (2022): 9780262544924, 9783962870034
ISBN hardcover (2019): 9780262537186
Library of Congress Control Number: 2018967128
Library of Congress Cataloging-in-Publication Data is available

Copublishers:

Miss Read • Berlin • missread.com
The MIT Press • Cambridge, Massachusetts • London • mitpress.mit.edu